68

TELEX 70155 LIME EI

In God's Country

ALSO BY DOUGLAS KENNEDY

Beyond the Pyramids: Travels in Egypt

In God's Country

Travels in the Bible Belt, USA

DOUGLAS KENNEDY

★★★★★★★★★★★★★★★★★★★★★★★★★★

UNWIN

HYMAN

LONDON SYDNEY WELLINGTON

First published in Great Britain by Unwin Hyman, an imprint of Unwin Hyman Limited, 1989

Unwin Hyman Limited
15/17 Broadwick Street, London W1V 1FP

Allen & Unwin Australia Pty Ltd
8 Napier Street, North Sydney, NSW 2060, Australia

Allen & Unwin New Zealand Pty Ltd with the
Port Nicholson Press
Compusales Building, 75 Ghuznee Street,
Wellington, New Zealand

British Library Cataloguing in Publication Data

Kennedy, Douglas
In God's country : travels in the Bible belt, USA.
1. United States. Christian doctrine. Fundamentalism
– Sociological perspectives
I. Title
306'.6

ISBN 0-04-440423-9

Set in 11 on 13 point Palatino
Printed in Great Britain at the University Press, Cambridge

For my parents, Thomas and Lois Kennedy.
For Grace Carley, per usual.
And to the memory of my grandfather, Milton Braun (1895–1983):
A New Yorker who frequently travelled South.

Contents

Author's Note

Get cornered by a Yank at a party – so many a non-native believes – and after five minutes you'll know everything you've ever wanted to know about him. Because within that time, he will have told you that, just last week, his wife ran off with a Venezuelan tennis pro. Or he'll let you know that he can't 'access his love strategy' with women. Or, if you're really unlucky, he might spend a half-hour giving you an up-to-date report on the state of his internal plumbing.

To the outside world, we're a nation of perpetual self-obsessives who are terrifyingly direct. And when it comes to detailing aspects of our lives to complete strangers, it is often hinted that we should take a cue from our more 'refined' friends on the other side of the Atlantic who generally deep-six such personal details in that filing cabinet marked 'Classified Information'. But, alas, we know no shame.

Of course, what so many non-Americans don't realize is that, in a big, young country like the US (where, unlike the United Kingdom, people don't really 'know their place') the American tendency to 'tell all' about yourself is a form of social shorthand. It defines where you stand – and, more importantly, *who you are* – within an exceedingly fluid, mobile society.

It is an undeniable truism, therefore, that Americans like to exchange confidences. And to travel a large region of the country – as I did – is to share in quite a few confidences. So, to preserve the anonymity of many of those who appear in this book I have frequently changed names, occupations, and other personal details. The chronology of events, the whereabouts of meetings, and the names of certain organizations or groups

have also been tampered with. Occasionally, for the sake of the narrative, I have also amalgamated people's stories. Just as, no doubt, they amalgamated aspects of the stories they told me.

After all, we are ultimately the story we invent for ourselves.

'Blessed is the nation whose God is the Lord: and the people whom he hath chosen for his own inheritance.'

– Psalms 33:12

'Make not my house an house of merchandise.'

– John 2:16

'I wonder what it was like here. Before Christianity.'

– Stewart Parker, *Pentecost*

Prologue: Great Awakenings

★★★

Sheila sold life insurance on the Upper East Side of Manhattan and frequently talked in tongues. She was a woman in her early forties; a stylish and aerobically sleek New Yorker who exuded high-octane drive and efficiency. So much drive, in fact, that when we met for lunch at a Third Avenue café, she said that she could only spare 35 minutes for our meeting, as she was closing a big deal 50 minutes from now and didn't want to be late for that far more lucrative appointment. This, I came to discover, was Sheila's style – her day was mapped out with the technocratic precision of a time-and-motion analyst. A minimum of ten hours at her office. Two hours at the gym. Three hours of 'quality time' with her kids. And at least one hour twice a day spent in private consultation with her Lord and Saviour, Jesus Christ.

It was during these quiet moments with Jesus that the presence of the Holy Spirit would often rise up within her and she would begin to babble in her own private 'prayer language'. In fact, whenever she felt an anxiety attack coming on, she would force herself to talk in tongues, as it was the best antidote she had against her constant bouts with hypertension.

'You know, before I met the Lord,' Sheila said, 'I'd always reach for the Valium anytime I felt myself starting to get kind of shaky. But now, I just reach for the Holy Spirit and *activate* my prayer language, and I get the sort of relief and comfort that Valium could never give me.'

Sheila had only discovered the relief and comfort of talking in tongues six years ago after her husband, Dave, was diagnosed with pancreatic cancer. He was handed this death sentence three

1

days before his 35th birthday. And during the next 15 months –
as he underwent massive courses of radiation and chemotherapy
– Sheila felt herself slipping into a very deep personal abyss. For,
as she readily admitted, Dave was the centre of her life. They'd
both grown up in the same small town in Michigan and, in the
time honoured tradition of homespun Americana, had been high
school sweethearts. They'd even attended the same university
together, and were married a week after receiving their degrees.
Then came the big move to the big city. Dave was a would-be
journalist, Sheila a hopeful actress, so New York – that vertical
playpen for the ambitious – was the obvious arena in which to
test such aspirations.

But, as they soon discovered, Gotham was brimming with
would-bes like themselves. And after two years of urban *La
Bohème* – during which they lived in a classic cold water flat
while Sheila scrambled unsuccessfully for auditions and an agent,
and Dave learned that the *New York Times*, *Time*, *Esquire*, and
the *Daily News* (to name but a few of the publications upon
whose doors he knocked) would survive without his services
– they decided that it was time to trade creative ambition for
domestic comfort. So, Dave eventually landed a job with a public
relations firm, Sheila found some temping work as a secretary in
an insurance company, and they began their gradual ascent into
upward mobility. As Dave's career as a publicist began to gather
momentum, they traded their low-rent meatlocker of a flat for
an all mod-cons one bedroom apartment in the East 80s near the
river. When two children – a boy and a girl – made an appearance
within 18 months of each other, Dave's accelerated progress up
the corporate ladder meant that they could upgrade their accom-
modation once again, and move to an even larger apartment that
was ten expensive blocks south of their previous address.

In short, Dave and Sheila settled into Manhattan-style *la vie
domestique*, weathered the predictable showdowns that accompany
most marriages, and essentially considered themselves lucky to
possess that rarest of commodities: a degree of contentment with
each other and with their status in life.

But then Dave fell ill, the diagnosis was cancer, and things
began to unravel. The course of chemotherapy he had to endure
was brutalizing, the cost of the treatment astronomical (since his
company's health plan only covered a fraction of his hospital
bills). As his condition deteriorated, so too did the psychological
stability of his wife and children.

2

'It got to the point', Sheila said, 'where the kids – who were only eight and ten at the time – became frightened any time they saw their father, because he'd lost all his hair and had literally shrunken in size. And when his doctors finally told me that the chemotherapy – which had completely depleted every penny we ever saved – was doing no good, and that Dave's cancer was terminal, I started coming apart, and doped myself up on every kind of tranquilizer I could find. That's when this aunt of mine decided that we all needed some spiritual help and told me about Father Lucca.'

Father Lucca, it seems, was a Catholic priest in New Jersey who was very much involved in the charismatic movement within his church, and had also gained some celebrity in his parish as a man who could heal through the 'laying-on of hands' (though, as Sheila was quick to point out, 'Nobody really heals but the Lord'). Her aunt had even had a 'born-again experience' while attending one of Father Lucca's healing sessions, during which the entire congregation joined with the priest in laying their hands upon a little boy who had one leg shorter than the other. And having first gone to the trouble of measuring the kid's stunted leg both before and after this ceremony, the group was overjoyed to discover that their efforts had brought about divine intervention, as the leg had grown a full inch in the process.

Now, Sheila was initially rather sceptical about such tales of lengthening legs. For though she and her husband had been raised in the Catholic Church and shared a basic belief in the tenets of their faith, they never considered themselves to be deeply religious people. But given the desperate state of Dave's health, she was willing to try anything that might prolong his life, and decided that a journey across the Hudson to one of Father Lucca's healing sessions was worth a shot.

As it turned out, it proved to be a pivotal journey, for during the course of their evening with the priest two things happened: (1) When Father Lucca laid his hands upon Sheila's brow in an effort to release some of her built-up tension, she was immediately *slain in the spirit* – which is basically something akin to passing out in a sort of prayerful ecstasy after a man of God transmits to you, through his hands, a jolt of spiritual Seconal from the Almighty; (2) Dave – who was so weak from the chemotherapy that he was confined to a wheelchair – actually stood up and walked for several minutes after Father Lucca bade him break the shackles of his cancer.

3

'When I saw Dave get out of that wheelchair', Sheila said, 'I suddenly felt this electrical charge that went from the top of my head right down to the soles of my feet, and was followed by this overwhelming sense of peace. And at that moment, I was filled with the love of Jesus and born again.'

After that evening, Sheila and Dave attended Father Lucca's services on a regular basis. 'It was a great comfort to us, because even though my husband ultimately didn't receive physical healing – since he died two months later – he did receive a wonderful *inner healing* before he passed on.'

At the same time, Sheila discovered that her new-found 'commitment to Christ' gave her a profound sense of certainty. The certainty that Dave had received the gift of eternal life. The certainty that she would be eventually reunited with him in heaven. The certainty that she had the unconditional love of her Lord. The certainty that, with Him at her side, she could find the strength to overcome her grief, and support her kids on her own.

It was Jesus who told her that she could sell life insurance. It was Jesus who told her that she could be a successful businesswoman. It was Jesus who provided the discipline by which she structured her day.

But this ever-intensifying faith brought with it a challenge; a challenge to maintain her devotion to Jesus in the face of repeated blitzkriegs by the forces of Satan. For Sheila was convinced that the Devil had targeted her children for corruption, and was doing his best to penetrate the righteous and reverential defence system which she had constructed around her family. She even had concrete proof of his evil at work, in the form of a record which her son Jerry owned.

'My son had unknowingly bought a record which was Satanic', Sheila said. 'When he played it backwards, it contained the message, "God is dead", which frightened all of us terribly. So, one evening I decided that I could no longer be intimidated by such wickedness, and I called my son and daughter into our dining-room, and I placed that Satanic record on the dining-room table, and I put a statue of the Virgin Mary next to it. Then we all joined hands and stood in a little circle around the table, and I said over and over again, *In the name of Jesus Christ, I bind you and cast you out. . . In the name of Jesus Christ, I bind you and cast you out.* And suddenly. . . the statue moved! The Virgin Mary turned its back on that Satanic

4

record! And the very next day, my kids took that record out to Central Park and tried to burn it. But Satan wouldn't let it burn. So my kids had to smash it. Smash Satan's record into little pieces.'

This was not an isolated incident, however. Rather, it became the first of many skirmishes that Sheila and her children had with the Devil – a repeated series of confrontations which led her to look for an ally in the spiritual field. That was when she turned on her television one morning and discovered Richard Roberts. He was a televangelist in his late thirties, with easy charm and 'deep spirituality'. He was also the son of Oral Roberts – one of America's truly legendary evangelical empire builders, who was renowned for his powers of healing and for recently raising $8 million from his flock by announcing that God was going to 'call him home' if the money wasn't forthcoming. And though Sheila didn't care much for Oral's brand of proselytizing, she was immediately dazzled by Richard. He preached a message which exactly coincided with her evolving 'belief structure': a message that miracles can happen, and that you can defeat the temptations of Satan through faith. What's more, his was a non-denominational ministry. It wasn't affiliated with a specific church or a specific set of doctrines, so the entire basis for his preaching was the Bible *and only* the Bible – a fact which greatly appealed to Sheila, who was increasingly beginning to see Catholicism as a religion burdened by dogmatism and superstition, and one which (with the exception of Father Lucca's brand of charismatic healing) couldn't fulfil her need for tangible godly gratification.

So Sheila became a devotee of Richard Roberts, loyally watching his programme every day, loyally tithing as much money as she could afford to his ministry. And after a year of dispatching constant donations to his headquarters in Tulsa, Oklahoma, she received something of a surprise when Roberts himself called her up one day and said that he and his wife were coming to New York, and would very much like to meet such a conscientious and generous member of the faithful.

This meeting turned out to be another important benchmark in Sheila's development as a born-again Christian. Besides being completely awed by this face-to-face encounter with her small-screen religious guidance counsellor ('We even had the chance to pray together!' she said), she was also quite stunned when he gave her his private home number and said that she should call

him up anytime she needed his fellowship or spiritual assistance.

As it turned out, she needed his assistance very soon thereafter, because her teenage daughter, Suzy, started being courted by a guy from her school; a guy who told her that his parents had been members of a coven.

'Now when my daughter told me that a Satanist wanted to take her out, I forbade her from seeing him', Sheila said. 'But he persisted in bothering her, and one night I came back to the apartment to discover that he had dropped by uninvited, and was talking to Suzy in her bedroom. When he saw me, he suddenly became. . . well, I've never seen such hatred in a person's face before. It was terrifying. So terrifying that the only thing I could think of doing was raising my arm and saying, *In the name of Jesus Christ, I bind you and cast you out. You're not wanted here*. And as I spoke, his head started shaking crazily and the hatred left his face and. . . it was over.

'And then he turned to me and gave me a big smile and said, "You're good – you're very good." Then he admitted to being a member of the same coven as his parents. And he told me that the Devil wanted my daughter.'

In fact, Satan so desperately wanted Suzy that he began to give her terrible nightmares in the days that followed this incident. That's when Sheila reached for the telephone.

'I called Richard in Tulsa, and I told him all about Suzy's bad dreams, but I didn't mention anything initially about our encounter with the Satanist from her school. Do you know what Richard said? He said that he wished he could lay his hands on Suzy's head because he could discern that the Devil was after her. So what Richard did instead was to pray with her over the telephone. . . he *led* her to Jesus over that phone line. And when they hung up, there was blood in Suzy's mouth and she got really frightened again, but I told her, "Don't worry, honey, that's just Satan's way of aggravating you." So she decided to read from the Bible. And do you know what happened? As soon as she opened the Scriptures, all the lights in our apartment blew. And when Suzy started crying, I said, "Now come on, hon, you know who that is. And you know that all he's trying to do is make you scared." '

Since that night, though, the Devil has largely left Suzy alone. And Sheila attributes this state of *détente* between Satan and her family to the fact that they have all become such pious followers of Christ.

6

'We're hawkish Christians', she said, 'and the Devil knows he's going to have a real fight on his hands if he ever tries to mess with us again.'

In fact, Sheila now attributes just about every positive event in her life to her joint partnership with the Almighty. And when I asked her if she didn't give herself some credit for her success in business and as a mother, she looked up from her spinach salad and said:

'You don't understand. When I first learned that my husband was going to die, I was terrified – not simply at the thought of life without Dave, but also at the idea that I would have to cope with all those responsibilities that he used to shoulder. But *now*, I don't have to worry about all that responsibility anymore. I don't even have to worry about getting through the day, or doing anything myself, because the Lord is there with me. And when it comes to making decisions. . . well, it's the Lord who makes them for me.

'He's the man who's in charge of my life now. *He* calls the shots.'

Sheila was right – I didn't understand. I didn't understand how a woman so totally at home in that hyper-assertive and predatory world of Manhattan corporate life, could simultaneously talk about Satanic records and revolving statues of the Virgin Mary. I didn't understand how anyone who resided in that Perrier-and-Ralph Lauren landscape of the Upper East Side could also frequently speak in tongues. I didn't understand the chilling calmness which underscored her voice when she casually mentioned that she had often been 'slain in the spirit'. And, more importantly, I didn't understand her fervent belief that God was now the captain in charge of her journey through temporal life, and that she was travelling on the mental equivalent of autopilot as He did all the work for her.

In short, I didn't understand Sheila. Hers was a story that I might have bought had it come from, say, the archetypal toothless mouth of some semi-literate, mountainey woman living in a Tennessee shotgun shack. But not from the carefully painted lips of a seemingly worldly New Yorker. And yet, I quickly realized that this presumptuousness – my belief that such baroque expressions of religious faith could only be found

in the hinterlands of the United States – simply re-emphasized my complete lack of comprehension of the phenomenon to which Sheila belonged.

For, if one believes the pollsters, then around 25 per cent of all Americans have undergone an experience similar to that of Sheila – the experience of being born again as a Christian.

It is an experience which has become synonymous with the religious revival that has swept the United States since the beginning of the 1980s. It is an experience which has been linked to the rise of televangelism and the increasing political power of certain Christian fundamentalist groups. And it is also an experience that many observers interpret as a widespread craving for some sort of faith or belief in a society which has supposedly lost its sense of moral mission and is now travelling on a road to nowhere.

Ultimately, though, the basic premise behind this experience is a Biblical one. In the Book of John, we learn how Nicodemus – 'a man of the Pharisees . . . a ruler of the Jews' – approached Jesus one evening and said unto him, 'Rabbi, we know that thou art a teacher come from God: for no man can do these miracles that thou doest, except God be with him.' And Jesus, in turn, replied, 'Verily, verily, I say unto thee, Except a man be born again, he cannot see the kingdom of God.'

Now this answer totally confused Nicodemus, who had problems visualizing the idea of going through the mechanics of a second birth within one lifetime: 'How can a man be born when he is old? Can he enter the second time into his mother's womb, and be born?'

But, of course, Jesus wasn't theorizing about anything as improbable as a physical rebirth. Rather, he was talking about *the* major spiritual event of any true believer's life. For though man may enter the temporal world via the usual nuts-and-bolts of human reproduction, he won't gain admission to the eternal world unless he undergoes a *Christian* rebirth – an absolute re-affirmation of his faith in Christ. It doesn't matter whether or not he was previously baptized as a Christian. A man must experience a profound spiritual renewal, which doesn't necessarily involve being anointed with water, but which most certainly entails making a commitment to Jesus, and asking Him to be his Lord and Saviour. And in that same chapter of the Gospel According to St John, we are clearly informed that those who make this commitment will receive the ultimate

8

gift, while non-believers are going to find themselves out on the street:

> *For God so loved the world, that he gave his only begotten Son, that whosoever believeth in him should not perish, but have everlasting life.*
> *For God sent not his Son into the world to condemn the world; but that the world through him might be saved.*
> *He that believeth in him is not condemned: but he that believeth not is condemned already, because he hath not believed in the name of the only begotten Son of God.*
> *And this is the condemnation, that light is come into the world, and men loved darkness rather than light, because their deeds were evil.*
> *For every one that doeth evil hateth the light, neither cometh to the light, lest his deeds should be reproved.*
> *But he that doeth truth cometh to the light, that his deeds may be manifest, that they are wrought in God.*

Doing truth. Coming to the light. Being saved. Whatever terminology you want to use, the bottom line underscoring every experience of Christian rebirth is this: by inviting Jesus into your life, the free offer of non-stop post-mortem service to the Kingdom of God is yours for the asking. This personal covenant with Christ also entitles you to the fellowship of other Christians who have been born again, and who – in many cases – are actively involved in creating their own facsimile of God's Kingdom upon the earth.

And indeed, this impulse towards the creation of heaven on earth has always been an implicit part of the American religious landscape. In fact, it could be argued that the very premise for the American nation arose out of a Christian experiment, and one in which the notion of building a spiritual utopia in the wilderness was central to its creation. For the Puritans who arrived to found the Massachusetts Bay Colony in 1630 were, at heart, zealous religious visionaries who considered this virgin territory to be fertile ground upon which to sow a 'garden of the Lord'. But this garden would not be cultivated along the doctrinal lines of the Church of England to which they belonged in their native country. Rather, theirs would be an emergency edition of Anglicanism – stark, lean and ascetic, a mirror of the elemental life they would be living in this new colony. And

9

besides excising all frills from the very act of worship, they would also excise secularism from the business of government. In their godly community, only the holy would be enfranchised as full citizens and enjoy the right to vote. However, to become a freeman, not only would you have to be a committed member of the church, but also one who was known to have had a conversion experience. And your election to freemanship would have to be approved by the other members of this spiritual élite – your minister, his church officials and other freemen in his congregation.

In other words, the first major colony in the United States initially operated as a theocracy; a government controlled by a small section of the community whose piety had been certified. And though many new arrivals eventually rebelled against the icy precepts of this 'purified' colony, the Puritan ethos still became a foundation upon which the American persona was built. Browse through any history of colonial New England, and you will inevitably find striking parallels between the social and moral principles espoused in the postnatal America of the 1640s, and those still considered to be of key importance in the evolved America of today. Out of Puritanism came the intense work ethic, the belief in productively using every moment God has given you, and the disdain for idleness which continues to inform the rough-and-tumble 'my time is money' world of contemporary American business.

But Puritanism was also responsible for adding another essential ingredient to American mythology: the mythology of *The Promised Land*. To the early inhabitants of Massachusetts, the Atlantic was their River Jordan which they crossed in order to forge a New Canaan, where sinful man would not only find redemption through good works, but would also join a community of latter-day Chosen People to create a 'City upon a Hill'; a place in which the Lord's pilgrims would show the rest of the world how to lead the true Christian life. Considered now, this seventeenth-century vision of America as 'a beacon of light in a world of darkness' has almost become something of a twentieth-century sales pitch (especially as it was invoked several times by Ronald Reagan during his presidency). It defines a world-view – a profound national faith in the inherent moral supremacy of America and its institutions. But it also serves to underline an equally deep-rooted belief that *somebody up there likes us*; that we are, verily, citizens of God's Country.

10

A land anointed by the Lord. One nation under God. The Puritan ideal of building a Christian utopia may have come asunder in the early eighteenth century – when New England's merchants began to prosper and colonial Americans discovered a second, equally impassioned religion called making money – but their conviction that they were the Almighty's Elect still managed to take up residence in the American consciousness, and remains on the premises today. If you poke a little deeper around the annals of colonial history, you'll also discover that this move away from Puritan orthodoxy in the mid-1700s sparked off a religious revival known as the Great Awakening. This was a wholesale campaign among New England Congregationalists and Southern Presbyterians to combat a decline in church attendances and what they saw as a growing rejection of the stern Calvinistic principles upon which the colonies were built. And they used heavy-duty emotional tactics to get people 'back to the Lord'.

In fact, the two major evangelical figures of this period – Jonathan Edwards and the Rev. George Whitefield – were early exponents of Bible thumping. Whitefield especially believed in playing the Christian showman, and became famous for his New England 'crusade' of the 1740s, during which he covered 800 miles by horseback in 75 days, preached 175 exceedingly loud sermons, and engaged in all sorts of ranting-and-raving theatrics at the pulpit. He can also be credited with introducing hysterical audience participation to the business of religious revivalism, as accounts of the day speak of Whitehead's ability to kick-start the spiritual passions of his congregation – to get them to shake, rattle and roll in a torrent of pious ecstasy. And though the strait-laced Puritan majority found this raucous display of faith to be the personification of bad taste, an emotional form of popular religion had nonetheless taken root in the New World. It was a religion which preached a very plain message – a society that becomes secularized is a society on the road to damnation. But a society that sticks to the *fundamentals* of Christianity (as laid out in the Scriptures), that maintains a strict moral code, and that emphasizes the importance of Christian rebirth, is a society that can call itself a true Kingdom of God.

So, ever since the early childhood days of the United States, there has been this tradition of *Christian revival* – a period when the nation's popular evangelists lead a highly emotive backlash against what they perceive to be the moral laxity of the times. There was, for example, a Second Great Awakening

in the 1840s, during which the hill country of upstate New York and central Pennsylvania became a 'we try anything' breeding ground for such new religious movements as the Pentecosts and the Mormons, not to mention a variety of extremely questionable spiritual groups. Eight decades later, the 1920s version of latter-day Puritans would be the political force behind Prohibition, as well as the prosecution of a Tennessee schoolteacher named Scopes on a charge of teaching the Darwinian theory of evolution to his students.

And, therefore, if one believes the commonly held theory that United States history operates like a washing machine – it has its very own set of cycles which it constantly repeats – then the current wave of popular religious fervour in 1980s America could be seen as nothing less than a new Great Awakening. A contemporary attempt to turn back the flood-tide of secularism and resurrect the Puritan dream of a Kingdom of God in a Promised Land.

That's one interpretation. Another is that this new Christian revival is linked to a very contemporary American obsession: *feeling good about yourself*. In fact, ever since Ronald Reagan landed his heftiest role as President of the United States, the general perception of the country beyond its frontiers has been that of big self-righteous tough guy who went through an extended personality crisis (Vietnam, assorted assassinations, Watergate), but is now desperately trying to reassert his self-esteem by telling himself how wonderful he is.

This was the sort of placebo which Reagan fed his compatriots for eight years, and which – judging by his consistently high popularity ratings – the American public couldn't get enough of. No wonder, therefore, that Reagan's presidency also witnessed the rapid rise of Feel-Good televangelism and the political resurgence of hard-line fundamentalist Christianity. The message of all small-screen crusaders for Christ is basically one of finding wall-to-wall inner peace by inviting Jesus into your heart (and, of course, by tithing as much cash as you can afford to their electronic ministries). Similarly, the religious right preaches a doctrine of reassurance. It reassures its large flock that their Christian morality is the only true morality; that they are Jesus' special assault squad against the forces of secular humanism; and that their reward for being Christ's own marines on earth will be admission to his barracks in the sky.

12

Spiritual security in the temporal life; eternal security in the life hereafter. Is this the simple sales pitch which has made televangelism such a remarkable growth industry? Or is there, as many have argued, a fiendishly darker side to such fundamentalist Christian operations? A desire to break down the traditional constitutional barriers between church and state, and impose a pietistic vision on the federal government? But, then again, ever since several 'picture tube men of God' were revealed to have engaged in a bit of missionary-position proselytizing, hasn't the entire Christian television business gone into a nose dive, thereby diluting its power as a political pressure group?

Start exploring the potential implications of this new Great Awakening, and you immediately find yourself in a labyrinth of conflicting political and sociological interpretations. And yet, every time I picked up a book which warned me of the campaign of 'holy terror' that the fundamentalists were waging against America's traditional liberties. . . every time I watched a television documentary which confirmed that there were a substantial number of solid citizens out there who believed that *thy kingdom come, thy will be done* was a political directive from on-high to turn the United States back into a New Jerusalem. . . every time I read an understandably caustic article about some up-and-coming religious charlatan who claimed that God had implanted her with a brand new heart, pancreas and thyroid. . . in short, every time I found myself confronting the peculiarities, aberrations and conspiracy theories which hover around the entire issue of fundamentalist America, the same questions kept nagging me. *Why* do people become born-again Christians in the first place? What sort of crisis, need, sense of emptiness, or overwhelming conviction pushes them into making possibly the most profound commitment of their entire existence? Moreover, what kind of citizen belongs to this silent army of believers? And how has their covenant with Jesus altered their life?

The more I considered these questions, the more I realized just how little I knew about a major spiritual province of contemporary American life – a province which was responsible for the creation of the first important new subculture in the United States since the hallucinogenic optimism of the 1960s. But if my understanding of this devout domain was limited, then so too was my knowledge of the actual region of the country which claimed to be the mission control centre of this religious revival. For though America's born-again Christians obviously didn't congregate in

13

one particular corner of the nation (as my meeting with Sheila on the Upper East Side of Manhattan clearly proved), most of the religious fervour of recent years still had been largely emanating from that traditional happy hunting ground for evangelists: the Bible Belt.

It has been said that the Bible Belt isn't really a geographic territory, but a state of mind. Perhaps this is because the term 'Bible Belt' has always been used as a catch-all expression to define that expanse of the American South and Southwest which – from the 1870s onwards – welcomed just about every itinerant preacher and tent revivalist who crossed its threshold. The defeat suffered in the Civil War has often been put forward as a reason why the Southern states were so susceptible to the tenets of Christian fundamentalism – as a broken people with a broken economy found sustenance in a vision of an omnipotent, angry God who could not only work miracles, but could also 'kick a little ass' and wreak vengeance on His enemies. And if the Confederacy had failed to establish its own earthly hegemony, then the inheritors of this vanquished nation could, at least, console themselves with the idea of eventually gaining admittance to the Almighty's celestial hegemony.

The fact that the South largely remained an economic and social fossil until the early 1970s might also account for the deep, permanent inroads that Christian fundamentalism made on the consciousness of the region – inroads that amplified a general bad news perception about the area. Indeed, any 'Yankee' like myself who grew up in a northern state during the 1950s or 1960s was generally schooled in the idea that 'down South' was America's neanderthal neighbourhood – a baroque landscape of unparalleled ignorance and bigotry. A place peopled by illiterate poor white trash, good ole boys driving pick-up trucks with gun racks, and overfed cops who wore reflector sunglasses, referred to the black population as *nigras*, and turned a blind eye to the occasional lynch mob. In fact, it was supposed to be so damn low-life that – according to one popular joke from my adolescent years – the only 16-year-old virgin you'd find in the state of Alabama was someone who'd been able to out-run her brothers and out-talk her father. Of course, it was also a no-go area for any outsider – especially a Yankee – since the folks down there didn't

take too kindly to the idea of any stranger poking his nose in their business, and (according to another popular northern myth) might just register their displeasure with a blast or two from a shotgun.

Now, however, all the talk was about a 'New South' which had dismantled the apparatus of racial segregation, and was promoting itself as high-tech and cost-efficient. And it struck me that by undertaking a journey through the contemporary Bible Belt, not only would I be traversing the principal realm of American Christian revival, but I would also be encountering a territory which itself had undergone something of a revival.

It was a territory about which I knew nothing. Having spent my first 22 years on the island of Manhattan, I had a typical New Yorker's vision of the United States: the country began in Washington, DC and ended in Maine, and there was an open-air asylum called California a safe 3,000 miles away. Add to this the 11 subsequent years I'd spent living in Ireland (before moving to London), and you can see why, from a distance, the American South appeared as alien to me as Mauritania. To travel there would, I sensed, almost be like encountering a foreign land – especially as I would be loitering in the Bible Belt as both an absentee American, and as a non-believer. Being the by-product of a Catholic father and a Jewish mother – educated in a Dutch Reformed Protestant school and dispatched to a Unitarian church every Sunday throughout my childhood and adolescence – I've always considered my religious background to be the doctrinal equivalent of a five-car pile-up. And though I've not been associated with the Unitarian church during my adult life, I still hold with its basic tenets – the concept that God is not a tangible supreme being, but a personal idea; the belief that there is no such thing as 'one true religion', but that all expressions of faith are equally valid; the notion that Jesus was not the son of God, but a teacher who provided us with the ultimate example of how we should ideally treat each other on the planet.

So, if challenged as to whether I believe in God and a life hereafter, I would probably answer in classic Unitarian fashion and say: if, in the course of a journey, I came to a fork in the road and was forced to choose between one route leading to heaven and another leading to a discussion about heaven, I would unhesitatingly choose the latter option. Or, to put it another way, I am someone who has never been able to buy the idea of worshipping an Almighty God, but who nonetheless believes that faith

15

is perhaps the most important impulse in life – the fundamental means by which a vast majority of people get through the day.

My journey, therefore, would be a journey into the realm of the faithful – a journey into the quirks and the profundities of a born again American South. I knew that I was dropping myself into a vast complex canvas – especially since, geographically, the contemporary Bible Belt resembles a cartographic rectangle. It stretches from Florida to Virginia in the east, moves due west through Tennessee and Arkansas into Oklahoma, hangs a left down to Texas, and then makes a bee-line across Louisiana, Mississippi and Alabama before ending up back in Florida. To try to cover every corner of this landscape would be as pointless as trying to make contact with every Christian denomination or sect which lined this route. And anyway, I didn't want my travels to have any purposeful plan or specific itinerary. My means of transport would naturally be a car – the romance of America, after all, *is* the road – and I'd simply set off on a June day down a cool ribbon of highway and see where the random nature of events would bring me.

One thing I did know in advance, however. To a confirmed Christian, there is no such thing as fluke or happenstance in life – as every event is somehow personally directed by the Almighty, and part of His divine plan. To a confirmed traveller, on the other hand, a journey is nothing but a sequence of flukes and accidents – as many people have pointed out, it's living in a fiction of your own making, only you never really know what the next stretch of narrative is going to be. For example, it was a chance meeting with an old friend – now in the insurance business – which led to lunch with his associate, Sheila, who also just happened to speak in tongues. Later that evening, it was happenstance which saw me duck into a restaurant in Chinatown, where, at the end of the meal, I was served a fortune cookie with my bill. And when I cracked open the shell of the cookie, I was confronted with the following message: *Why look for paradise when it is all around you?*

Had I been a believer, I might have thought: *somebody* is trying to tell me something. But – as a mere itinerant, about to loiter in the Bible Belt – I simply took this as a cue to head south.

CHAPTER 1

North of the Border

★★

I caught a plane to Miami. En route, the pilot informed us that we would be hugging the shore all the way down. I sipped a glass of candied champagne, and peered out a grimy window at the periphery of the eastern seaboard. From this vantage point, the United States had a new-minted quality to it. No signs of life. No hints of human habitation. Just a long thin shingle of coast – unblemished, immaculate. I knew, of course, that this was pure visual deception; that down below, at ground level, the detritus of the twentieth century had blemished much of the water's edge. Up here, though, it was easy to succumb to the temporary illusion that I was skimming the surface of a New World.

But then came Florida. The Gold Coast. That gimcrack strip of resorts and retirement communities ribboning the Atlantic. It was a gambler's landscape; an architectural crap-table of white cubed buildings which, at first sight, looked like a panorama of loaded dice. We banked steeply to the west, and suddenly this testament to high-stakes property development dropped away as we crossed a flat, spongy plateau of deep green swamp. The abrupt visual shift was unsettling – one moment we were hovering above a New World cityscape; the next, atop of something Third Worldish and jungly. North America had temporarily become the Amazon; hyper-development had been wiped clean by the bush, and the wilderness appeared enveloping. That is, until the aircraft shifted course and, banking back east, came rushing in over the tangled concrete geography of downtown Miami.

A brief encounter with the tarmac of Miami International Airport is all you need to realize that you have landed in

17

some sort of way-station between two opposing segments of the western hemisphere. Planes from Venezuela, Colombia, the Cayman Islands, Surinam, and Guatemala were docked near to where our aircraft finally berthed, and the terminal itself was bi-lingual, as all the signs and announcements were rendered in English and Spanish. Walking to the baggage claim area – passing a pair of Latin gentlemen in dark glasses and sharp serge suits loitering near one gate (their eyes darting around the swarm of new arrivals). . . dodging queues of passengers checking in for flights to Antigua, Port of Spain, Dominica, and Tegucigalpa – I couldn't help but pick up some of that clandestine aroma for which contemporary Miami is famous. It is – according to recent travel magazine cliché – a latter-day Casablanca: a city which has become a kind of illicit souk with a decidedly South of the Border flavour to it. It has the largest Cuban population outside of Havana. Refugees from assorted Central American battlegrounds – as well as from Haiti, the Dominican Republic, and Vietnam – have turned the metropolis into an emigrant camp. It's the bourse of the American cocaine industry; a place which – thanks to its easy access to South America, and to offshore tax havens – has become a favoured residence of 'businessmen' trading in controlled substances. The Nicaraguan Contras run their United States base of operations from here, but so too do a variety of other lunatic fringe governments-in-exile. It's home to some of the most notorious black slums in the country, and to some of the nation's richest enclaves. And in the midst of all these cultural contradictions and dubious activities are the gringos – the slick young professionals, not to mention that sizeable contingent of America's geriatrics who have chosen to serve out the twilight of their lives under that high-intensity Florida sun.

Viewed from afar, Miami struck me as one of the most stratified, complex and exuberantly corrupt cities in the United States: a town in which you could probably devote an entire career to chronicling its extremities and its ethnic internal combustion. But while this heady municipal backdrop intrigued me, it was Miami's sense of transience – the idea of a floating population attracted to its sub-tropical promise of a better life – which ultimately made me decide to begin my travels in Florida. For a place which possesses an Eden-esque allure for a wide spectrum of migrants must also be a place where the desire to discover paradise is exceedingly strong. Which, of course, also means that it is an obvious arena for Christian evangelism to operate in.

After retrieving my bags, I moved on to the Avis counter and rented a car. A 1988 Ford Mustang. Colour: blood red. Cylinder capacity: 2300 CC. Acceleration: 0 to 60 in 11 seconds. Other features: Aerodynamic styling. Air-conditioning. Cruise control. Automatic transmission. Power steering. Power brakes. Electric windows. And a quadrophonic stereo which, when cranked up to full volume, could easily disturb the peace in a neighbouring county. It was, in short, a real American road warrior. And the perfect set of wheels in which to navigate the southlands.

I negotiated my way out of the airport and joined the coagulated flow of cars pushing their way on to the turnpike. The day was steam-bath hot – the mercury inching near three figures, the humidity reaching a similar punch drunk level – and while waiting for the Mustang's air-conditioning to take effect, I sat sweating in the afternoon rush hour traffic. On the radio, a local station blared the Rolling Stones. Mick Jagger sang of his inability to achieve any sort of life-enhancing satisfaction. It was the perfect commentary on my present condition – on the road, yet standing still; encased in a climate-controlled vehicle, yet succumbing to the feverish temperature; and wondering whether all of Miami might just resemble this bleak stretch of tarmacadam – a road hedged in by an elaborate mosaic of billboards advertising every rental car company in south Florida.

Eventually, though, there was a break in this logjam of commuter traffic, cool conditioned air filled the car and – watching the last rent-a-pink-Cadillac sign fall away behind me – I threaded my way down the turnpike to an outlying district of the city called Kendall.

At first sight, Kendall appeared to be a non-stop sequence of shopping malls, spread out at half-mile intervals. At second sight, it still appeared to be a non-stop sequence of shopping malls, spread out at half-mile intervals. And, in fact, the hotel in which I had booked a room for that night was located in the corner of the suburb's newest shopping mall, 'Kendall Town and Country'; an attempt to combine a pastel coloured 'back to the hacienda' style of building with the consumerist ethic. If the Moors had been contracted to build Las Vegas, this sort of architectural spread might have been the result.

According to her plastic name tag, the woman behind the reception desk of the Wellesley Inn was called Patti. She was in her late forties, and possessed the sort of terminally fatigued eyes which made you wonder just how many bad marriages she

19

had weathered, and whether this was one of three jobs she was currently working to keep the rent paid. And yet, despite her dyed blonde aura of world-weariness, she still forced herself to be animated; to wish me a 'real nice time here', and then say, 'I think you're gonna like us. We got free doughnuts for breakfast and all the coffee you want. And if your tastebuds need some excitement, why there's four real good restaurants in the Mall.'

I knew, of course, that Patti turned on the manufactured charm for every Wellesley Inn guest. But though it was easy to disparage such have-a-nice-day banter as synthetic, there was something curiously moving about her ersatz *politesse*. For it pointed up the need to display an optimistic front to the world which is so implicitly and bittersweetly American. And it reminded me that the business of selling yourself is a business that every American engaged in.

My room was pure Motel Aesthetic: the regulation acre or two of plush beige carpet; the regulation acre or two of firmly sprung American bedding; the regulation acre or two of colour television screen. I hit the remote control and *Divorce Court* filled the picture tube. This was a classic 'daytime drama' which had been running for the past 20 or so years, in which reconstructions of actual divorce cases were acted out in a mock courtroom. On the screen was a woman who looked like she'd last slept in 1980. She compulsively kneaded her hands together while stealing glances at a man on the other side of the court; a man who was evidently her 'husband' and had a 'I've been pissed off since the day I was born' scowl on his face. Underneath this image of marital disharmony, an announcer spoke in a low, terse voice:

'Mr Liebowitz claims that his wife made their marriage unbearable after she developed a phobia about roaches and wouldn't keep any food in the house.'

Not in the mood for domestic surrealism, I switched channels. On a nearby station, there was a talk show. The guest was a ten-year-old kid from some hamlet in North Carolina. He'd made national news after his father – a small-time itinerant preacher – sent him out to spread the word of God on street corners of the nearest big city. The kid was dressed in a dark suit with wide lapels, which made him look like one of those dwarfs who always played pint-sized thugs in gangster films of the 1930s. The talk show host asked him if he'd demonstrate his style of preaching, and the kid stood up, waving a bible in one hand while gesticulating towards the camera with his fat little index

20

finger. For such a small person, he had a terrifyingly bombastic voice, and he roared at full throttle through a couple of lines of Matthew:

'But I say unto you, That whoever looketh on a woman to lust after her hath committed adultery with her already in his heart. . . And if thy right hand offend thee, cut it off and cast it from thee. . .'

After the kid finished bellowing, there was a polite round of applause from the studio audience, and then the talk show host asked him to explain to the folks at home the meaning behind the Scripture he'd just shouted. The kid was suddenly drained of all his swaggering self-confidence, and became evasive.

'Like, y'see, why I'm shoutin' is 'cause I'm speakin' th'orders of God. And I know what them orders mean, but it's just kinda hard for me t'understand 'em.'

Knowing what God means, but not understanding God. A common dilemma, no doubt. And a reminder to me that it was time to call Cathy. Because – as Cathy mentioned to me when we first spoke – she herself had thought that she knew God, but eventually came to the realization that she didn't understand Him at all.

Cathy was the reason I'd ended up in Kendall. In fact, it was she who recommended that I stay in the Wellesley Inn, as it was a mere five-minute drive from her house. She'd been a bit wary when I initially phoned her up and said that a New York organization called Fundamentalists Anonymous had recommended I speak to her. She'd heard that routine before, she told me, and then put me on hold while she rang the head of Fundamentalists Anonymous to make certain I was legitimate. When she came back on the line, she apologized for her initial coolness, and for vetting me so carefully. It's just that ever since she had left the Jehovah's Witnesses a year ago, she'd been continually hassled by her former brethren in Christ. It was a campaign of intimidation which left her wondering how she'd ever been a believer in the first place. And given their tactics, she wouldn't be at all surprised if a Witness called her and pretended to be a writer working on a book about born-again America, in an attempt to trick her into a face-to-face meeting, during which she would be brought to heel for daring to repudiate the faith.

As I came to discover, this sort of paranoia is common-place amongst former members of fundamentalist churches (who are known in born-again parlance as 'backsliders'). In fact, when I first made contact with Fundamentalists Anonymous, I

was treated with something approaching hostility. This national organization, based in Manhattan, acts as a political lobby against neo-conservative organizations, and also runs support groups across the country for backsliders. Its co-founder, Jim Luce, refused to see me until I gave him the name of an acquaintance on the *New York Times*, who vouched that I was whom I said I was. But, even then, I was only given the address of FA's midtown office on the condition that I tell no one else of its whereabouts, and that I would memorize the address and not write it down.

Such subterfuge initially struck me as low-grade Le Carré. That is, until I finally met Jim Luce – a very pleasant, very buttoned-down former Wall Street banker in his late twenties, who helped start FA after a niece of his joined a religious cult. And he explained exactly why FA was cloaked in such high security:

'We're taking on a multi-million dollar business here, which means we're not exactly popular. And I've lost count of the number of death threats I've received from so-called Christians.'

After this little revelation, Cathy's initial reluctance to meet me made quite a bit of sense. But once she received my 'clearance' from FA, she then insisted that I join her and her 'guy' for dinner as soon as I hit Miami, and told me to call her when I'd gotten settled into the Wellesley Inn.

Which is what I did after catching that talk show featuring the miniature Bible thumper. As it turned out, Cathy was also glued to the same programme – 'You're watching that little creep too?' – and gave me directions to her 'condo' while the kid's stentorian voice bellowed some more in the background.

Cathy lived in a housing development with the aromatic name of Tropical Mist – one- and two-bedroom townhouses, finished in bleached, weather-beaten wood for that wind-swept, *sur-la-mer* look. In fact, just about every corner of Kendall which wasn't occupied by a shopping mall was taken up by one of these beach-housey suburban clusters. This was, without question, an upwardly mobile quarter of Miami, and one in which young professionals apparently didn't mind living in developments which sounded like a line of bathroom deodorants: *Gladewinds. . . Spanish Trace*. In the parking bays of Tropical Mist, Porsches vied with Triumph TR7s and Corvettes for status domination – though Cathy told me that, in the midst of this heavily mortgaged automotive landscape, I would spy a modest Toyota; a sign that I had reached her front door.

Cathy surprised me. Speaking with her on the telephone, I had reckoned that she was a woman in her mid-thirties. But she was only 25 – a slightly chunky doctor's receptionist who was pleasantly attractive in that wholesome sort of a way which is unashamedly American. Her boyfriend, Jake, was around the same age – a physiotherapist in a local hospital – and someone who evidently spent a lot of time at the gym, as he exuded muscular nice-guy charm.

Their flat was tastefully decorated in a Habitat-y style – all smooth white surfaces and veneered pine; the first home of a young couple. Only, as it turned out, Cathy had been in another domestic set-up during what she called her 'previous life'. And settling down on the imitation chesterfield, she told me a bit about that life and her marriage to a Jehovah's Witness.

Cathy grew up in Miami: Jewish and comfortably middle class. Hers, she said, was a highly unremarkable childhood – a happy period of her life that she managed to get through without too many scars (which, given most people's grim memories of growing-up, probably made it quite a remarkable childhood). She even managed to have a close relationship with her mother, as well as a trouble-free passage through secondary school and a local university.

In short, up until the time she met Barry, nothing in her life had ever been askew, or had ever left her feeling so vulnerable that she would find it necessary to turn to a fundamentalist Christian group as a way of defining herself. Which is exactly what Cathy did around six months after leaving university. She'd discovered that a degree in Fine Arts wasn't exactly a ticket-to-ride in Miami and – after a lengthy dose of the unemployment blues – was finally forced to take a temporary job as a clerk in a courier company; a job which was less than inspiring, but which at least allowed her to meet the payments on her car, and contribute something towards the cost of living at home.

While working at that courier company, she met a fellow clerk named Barry; a pleasant, athletic sort of a guy from upstate New York who was several years older than her. They sat near each other in the office, and soon started sharing their lunch hour together. Then, he invited her out a few times to dinner or the occasional movie. Quite the gentleman, Barry – even after they'd been seeing each other for several weeks, he still never tried to put the moves on her. In fact, the only surprising thing which Cathy discovered about Barry was that he was a Jehovah's

Witness, and had been converted to the faith three years earlier. It was a revelation that – she was surprised to discover – really didn't bother her. And when he asked her if she'd like to go to a Witnesses lecture, she figured, 'Why not?', even though, 'My Mom nearly had cardiac arrest when she learned I was going to that meeting.'

But Cathy – who was becoming increasingly smitten with Barry – still went to the lecture. A lecture where Barry stood up and introduced Cathy to all the other Witnesses as his 'very good friend' (a comment which pleased her no end). A lecture where Barry then launched into a long explanation about *The Truth*. That, she discovered, was what Witnesses called their religion: *The Truth*. And she learned that the name Jehovah's Witnesses came from Isaiah 43:12 – *Ye are my witnesses, saith Jehovah, and I am God*.

And she learned that Jehovah's Witnesses have been serving God for over 6,000 years.

And she learned that Christ himself was called 'the faithful and true witness' in Revelations 3:14.

And she learned that Jehovah is the one and only God and that, ever since the Garden of Eden, Satan has always attempted to undermine His sovereignty.

And she learned that God's main goal is to re-establish His sovereignty on earth and that He dispatched Jesus to the temporal world not only to be the ultimate godly sacrifice, but also to get the ball rolling for His eventual take-over of the earth.

And she learned that this take-over was close at hand; that, in 1914, major events took place up in the sky, when Christ claimed control of heaven and tossed Satan out, thereby leading to bad times on earth (like the start of the First World War).

And she learned that a 'great tribulation' is very much on the horizon, during which God is going to destroy all wickedness upon the earth and close down the Devil permanently.

And she learned that, when this happens, Christ will reign for the next 1,000 years: 'And all that breathe will praise Jehovah.'

It was quite a lecture. At the end of it, one of the Elders of the Kingdom Hall came up to Cathy and said, 'Sister Dumont, I am so pleased to meet you. Especially since I bet you've been given a real hard time about coming here tonight. A real hard time indeed.'

Now the fact that this Elder instinctively knew all about her mother's objections truly amazed Cathy, and made her

immediately feel comfortable within this community. What she didn't realize until much later on was that this was a typical Witness welcoming tactic, and one designed to begin the process of setting up the idea of 'us versus them' in the mind of the potential convert. For as that same Elder told her, 'The Bible prophesized that there was only one true religion. And in the Gospels, Paul himself said there is only "one faith". So, whenever anyone gives any of us a hard time about being a Witness, all we have to tell them is that we are a member of the one true religion.'

After that initial lecture, Cathy began to attend Witness meetings on a regular basis. Barry accompanied her to each and every one of those meetings. And soon, Cathy discovered that three nights a week were being taken up by the Witnesses' indoctrination course. At the end of it, however, she was welcomed into the fold with a chilling warning: 'Now that you know *The Truth*, if you leave it you go back to Satan's world.'

Naturally, Cathy was initially bemused by such premonitions of damnation: 'I thought, "All of this talk of Satan is a bit silly, isn't it?" But still, there was 10 per cent of me which said, "Well, at the first meeting, they *did* know I'd been given a terribly hard time by my mother for coming here." And then Barry kept telling me that I was born to be part of *their* world, and that the rest of the world was run by the Devil. And though that got me real scared, I kept thinking, "But what if they're right?" And everytime I had thoughts like that, I found I got more deeply involved with the Witnesses. And I really started to be convinced that there were a lot of lost sheep out there who didn't realize they were agents of Satan, and that I really must convert them to *The Truth*, so they can be resurrected after they die.'

Indeed, the Witnesses don't believe that the after-life offers the usual up/down options of heaven and hell, with purgatory acting as a demilitarized zone inbetween. To them, heaven is home to 'spirit creatures', and only a select 144,000 souls – the figure given in Revelations 7:4 – will actually inherit the Kingdom of God and thereby gain admission to its celestial surroundings. For the rest of mankind, it's a one-way ticket to hell. However, hell – according to the Witnesses – isn't some fiery theme park for lost souls. Rather, they see it as a holding pattern – you sit in your grave, hoping to be resurrected in time for the 1,000-year reign of Christ. And, as an added bonus, those who are resurrected will be given the gift of eternal life, since the end of Christ's rule

will also see the abolition of death and hell as physical realities, as the earth will revert back to the paradise that God originally created.

No wonder that any true Jehovah's Witness considers it his or her duty to bring non-believers to *The Truth*, so that they too can avail themselves of this golden opportunity for resurrection and life eternal. No wonder that a key part of Witness indoctrination is being taught how to proselytize – especially since it is drummed into the heads of new recruits that the world is going to end, and it is their responsibility to convert as many people as possible. . . otherwise, their blood will be on their hands.

No wonder that Cathy tried to convince her family and friends that they simply must start attending Witness meetings.

'My mother couldn't believe that I was begging her to become a Witness. She cried. She yelled. She screamed. She even tried to get me to see a rabbi. And all my friends were saying, "They're crazy. . . *you're* crazy." But everytime somebody told me that the Witnesses were nuts, I kept remembering what that Elder told me at that first meeting I attended – if you're a member of the one true religion, you don't have to worry whether people think you're mad, because you know you have *The Truth*.

'And the harder people tried to get me to leave the Witnesses, the more resolute I became about staying. Probably if people had left me alone, I mightn't have gotten so deeply involved with the church. Because, you know, there are many people who get involved in groups and cults who aren't going through a major crisis at the time; who aren't reacting to an earth-shattering event that has left them feeling vulnerable. Sometimes, it all just comes down to *transition*. That was the case with me, anyway. I mean, I really wasn't feeling a loss in my life. All I wanted to do was make that transition from living at home to setting up my own home, and I saw Barry as a way of getting out of the house. And since Barry was a Witness, *I* became a Witness. It was as simple and unthinking as that.'

Such an 'unthinking' attitude eventually led to all of Cathy's free time being taken up by the Witnesses. 'If I wasn't at a meeting or at Bible study, I was preparing for Bible study. And if I had to skip a meeting, then Barry or one of the Elders would tell me that I shouldn't try to step out of line.'

Her marriage to Barry a year later also meant that she had to toe the line when it came to the actual wedding – which, of course, had to be a Witness ceremony. No Best Man. No showering of

rice over the newlyweds. No toasts. No booze. No dance band playing 'We've Only Just Begun' and other nuptial favourites. And when Cathy announced that she wanted music during the service – in this case, Pachebal's well-worn 'Canon' - she was informed that she would first have to research the origins of the music, as the Elders wanted to know the reasons why Pachebal wrote his greatest hit before they would approve its inclusion in the ceremony. Was it composed for a religious purpose? For a specific church? Only when Cathy could demonstrate that Pachebal's 'Canon' was totally secular in conception was she allowed to incorporate it into the service.

Then, immediately after their marriage, their lives underwent a slight geographic and climatic upheaval when Barry came home one day and announced the following: the Witnesses had instructed them to quit their jobs at the courier company, close up their apartment, and move back to his home town in upstate New York within the month, as he had been assigned to help run the conversion effort in that frosty corner of the Northeast.

So Cathy and Barry moved to a small burgh in the Adirondack mountains of New York, in the middle of January. An arctic January, where the temperature was 90 degrees cooler than it had been in Miami. Where they were billeted in a tiny two-room flat in a badly heated modern apartment block. Where they didn't know anybody except the other members of the Witness congregation whom they met at the local Kingdom Hall. Where she got a waitressing job, and he found part-time work as a plumber to keep their bills paid while he led the crusade for new New York Witnesses. But the dreary work and the dreary accommodation didn't bother Cathy initially because she thought she was happy. 'Or, at least, I was really trying to believe I was happy.'

However, while convincing herself of her happiness, Cathy also had to spend quite a few hours each week helping her husband proselytize. And she began to learn quite a few tricks of the trade when it came to ringing doorbells in search of new believers.

'Witnesses are taught to be very thorough and utterly persistent in their tactics to win disciples. Like if I came to the door and tried to talk to you about *The Truth*, and you said, "Look, I can't talk right now – I'm having people over for dinner", I'd go back to my car and write down details of your name, where you lived, the kind of house you owned (so I'd have an idea of your income bracket, which would help me determine the approach I'd take

27

with you), and the fact that I interrupted your dinner. Then, when I returned to see you again several days later, I'd say, "Hi, Doug. How was your dinner the other night?" And that would immediately put me on a personal footing with you.

'I also had a book issued by the Witnesses, which essentially covered just about every question I might be asked about *The Truth*, and also taught me how to respond to any objection or conversation stopper that might arise. So if you told me you were an atheist, I'd have a way of dealing with that. Or if you demanded to know why the Witnesses objected to blood transfusions, I would immediately tell you that blood is your life force, and only God has the right to give and take it. I had an answer to everything.'

Or, at least, Cathy thought that she had the answer to everything. That is, until something strange happened. Something that began to make her engage in an activity which no true Witness should ever engage in: asking questions about the tenets of her faith. And the event which triggered off the beginning of her doubts was that national technological trauma: the destruction of the space shuttle Challenger. It was a big bang which had a particularly tragic resonance in the Northeast, as one of the astronauts killed aboard the Challenger was a New Hampshire schoolteacher named Christa McAuliff, who had been fêted the previous year by her home state when she became the first civilian chosen by NASA to participate in the space programme.

When it was announced that there was to be a memorial service for Astronaut McAuliff in a nearby town, Cathy made the mistake of telling Barry that she was planning to attend it. The next thing she knew, her husband was on the phone, conferring with an Elder at their Kingdom Hall; an Elder who then asked to speak to Cathy and informed her that she shouldn't attend the service, because all 'they' were going to do was praise the fact that McAuliff was a great American. And Witnesses – as she was strongly reminded – cannot take part in any ceremony which celebrates allegiance to a nation and its flag, as the Ten Commandments state that bowing down to, or serving, a graven image is heavy duty sacrilege. So, since Christa McAuliff was essentially serving a graven image (i.e., the United States of America), honouring her sacrifice to the nation was deemed to be blasphemous.

'You see, Witnesses don't really care what country they are in,' Cathy said. 'Only the after-life is important to them. And

28

that Elder told me, "Christa McAuliff is an agent of Satan. You should be happy that she is dead, because that means she can be resurrected later. And you're forbidden to go to her memorial service" – an order which, like a good believer, I had no choice but to follow.'

But though she followed this directive, she found herself quietly resenting it. And when, several months later, she had a major confrontation with Barry over the religious implications of a Mother's Day card, she realized that her days in the Witnesses were numbered.

'What happened was this: Barry came home one evening from work and saw a Mother's Day card on my desk. And he got real upset and said, "Why did you bring this sacrilege into our house?" And I told him it was just a card for my Mom; that Mother's Day still meant a lot to her and to me, especially as it was a way for us to keep in contact since we'd had that big falling out over me joining the Witnesses. Anyway, before I knew it, Barry was on the phone again to that goddamn Elder, and then the Elder started telling me how I was celebrating a pagan holiday and worshipping something profane. But I said, "Lookit, I'm not talking about sacrificing children on my front lawn; I'm just talking about sending my Mom a card."

'And when they still insisted that a Mother's Day card was ungodly and sinful, I suddenly had this *snapping* sensation inside my head. And I started asking myself: "Hey, what's wrong with this picture? And why am I in it? What the hell am I doing in this cult?"

'You see, when you're in a cult – and the Witnesses really are a cult – you feel numb all the time. You lose your sense of humour. You put on a lot of weight. You don't care how you look. And since you honestly feel that the world is probably going to end tomorrow, you don't have much to laugh about. You're not interested in the real world at all. So when I *snapped*, it was like coming out of this long waking sleep; like not feeling mentally drugged anymore. And that's when I started refusing to go to meetings at the Kingdom Hall.'

As soon as Cathy started 'backsliding', she was relentlessly visited by just about every member of her local Witness congregation, all of whom begged her not to leave *The Truth*. At the same time, Barry kept kneeling down in front of her, praying for her return to the fold. When it became apparent that she wasn't responding to prayerful intervention, her husband brought out

the heavy psychological artillery. 'I'd hoped we were going to live in paradise forever', Barry told her, 'but now you're going to go off and kill yourself.' Other believers took up a similar theme, informing her that if you have come to know *The Truth* and then speak ill of it, you'll immediately be labelled an apostate, and the Almighty will take out a contract on you. And Cathy was constantly informed, 'God will kill you. He'll have a car hit you on the street. He'll give you cancer.'

Comments like this eventually left Cathy with no option but to leave town – especially since Barry finally refused to talk to her anymore, and all the other Witnesses also 'disfellowshipped' her (which means that they swore neither to speak or even look at her). So she ran back to Miami and straight into a nervous breakdown.

'Because of what Barry and the others kept telling me, I really was convinced that I was going to die. And I remember that, after I got home, my Mom arranged a little birthday party for me – the first birthday I'd celebrated in years, since the Witnesses also think that stuff like blowing out candles on a cake is ungodly. So, though I felt this real rush of excitement when all my family started singing "Happy Birthday", and my Mom brought out this cake with candles, I also couldn't help thinking, "God is going to get me. . . God wants me dead." '

Worst yet, after initially disfellowshipping her, the Witnesses then changed course and began to call her up repeatedly, imploring her to rejoin their community in New York. Barry also joined in these daily long-distance pleas for her spiritual rebirth, and it got to the point where her family had to screen all phone calls to Cathy, as she was starting to crack even further under this constant barrage of supplications.

'It literally took a year – and three sessions a week with a psychotherapist – until I began to feel as if I was getting over the whole experience; that I could pick up my life again and start thinking about work. But I still have residual effects. Like I can hardly remember any current events that took place during the entire time I was a Witness (except, of course, the Challenger business, which had a direct bearing on me and the church). It was like memory loss. And now I constantly think I'm 22, even though I'm really 25. It's like those years were erased for me.'

Jake – who had been discreetly grilling hamburgers in the kitchen while we talked – finally decided that it was the right

chronological moment in Cathy's story for him to make an appearance in the conversation.

'You shoulda seen Cathy when we first met. Real overweight, and kinda crying all the time. But, you know, once she started going to the gym where I work out and getting herself into some sorta shape, and once she landed that job with a paediatrician, she started finding some self-respect again. Started being able to put some real distance between herself and those years in the Witnesses. But, I tell ya, you should see the look on her face every time we go by a Kingdom Hall. That look – it makes you real glad she don't have access to a nuclear weapon or anything like that. It's a seriously *mean* look. . .

'How you like your hamburger, by the way?'

After dinner, Jake said to Cathy, 'Show Doug your closet – it's something he'd be real interested in seeing.' So Cathy brought me to their bedroom and showed me her closet. It wasn't an ordinary closet filled with clothes and personal effects. Rather, it was fitted out like a miniature study for a claustrophobic – a storage space, lined with bookshelves and two bulky filing cabinets, which acted as a repository for Cathy's vast collection of literature and documentation on fundamentalist churches and Christian cults. Literature and documentation which she had been collecting over the past year, and which she now used in her volunteer part-time work with a cult-awareness organization in Miami. It was an organization which helped publicize the dangers of 'control-oriented' religious groups, and which sent former cult veterans like Cathy out to schools to tell cautionary tales about how easy it is to get ensnared by such extreme congregations.

'You know why people get into cults or get born again?' Cathy said. 'It's because we've got so little direction now in this society. And so much boredom. I mean, talk with people and you'll discover just how many folks out there believe that they've done nothing with their lives. And the reason they're attracted to cults is because the cults say, "Let's build idealistic worlds where we will *all* have a sense of purpose. And where we'll have eternal life with no hassles." '

She yanked open a drawer of one filing cabinet, and pulled out a flimsy looking magazine: *The Watchtower: Announcing Jehovah's Kingdom*. On the mast-head page, the editors announced that their monthly tract had an average print run of 12,315,000 copies. Moreover, it was published in just about every extant language imaginable: from French and Japanese to Greenlandic, New

Guinea Pidgin, Malayalam, Samoan and Urdu. And in between articles like, 'Young People Ask. . . Why is it so Hard to Avoid Masturbation?', there was this extraordinary religious painting. Etched in a primitive representational style, it depicted a group of technicolourful peasants from a variety of technicolourful lands, dressed in traditional native costumes, and reaping a bountiful harvest of fruits and vegetables in a pastoral landscape. Underneath this bucolic scene was a caption: *True religion will satisfy all our needs*.

Cathy said, 'When I look at stupid shit like that, I really can't figure out how I once believed it all.'

She shook her head and laughed – a hollow, self-deprecatory laugh. But then, her voice went small and sad and rueful.

'I tell you, though – the hardest thing for me to cope with now is the realization that there's no paradise to go to one day. That there's no life at all beyond this one. That when I die, I'll just end up as nothing in a box, in the ground.

'That's been the toughest thing about losing my faith – knowing that there's no hope of resurrection. Knowing that *this* is it.'

I left Cathy's condo and drove. Past the shopping malls. Past the woody chalets of Floridian suburbia. Down to the intersection of US1, hanging a left until I hit its junction with I–95. American road cartography is a game of jargon and numbers: *I* is for *Inter-state* – the big-league highways that criss-cross the country; *US* is for *US Highway* – the pre-Second World War dual-carriageways which also zigzag around the continent; and *Rt* is for any provincial or county road which is slow as hell to drive, but is also guaranteed to bring you deep into the American hinterland.

And here, in Miami, the interstate was a concrete cobweb which ensnared the city; an elevated meshwork, in which low-slung automotive smoothies bobbed and weaved around vehicles from the Nixon era. But while I-95 may have been the city's one economic common ground – the place where status-on-wheels met ghetto-on-wheels – it also served as an arena for urban aggression. Steeply banked and riddled with tricky curves, it was the sort of highway which encouraged you to drive fast and loose, especially since you had the added thrill of driving recklessly one hundred feet above the ground. What's more, since the road itself literally bisected downtown Miami,

the high-octane buzz of competing for your own small stretch of I–95 was amplified by the high-octane architecture of the city's business district. But this was no mere collection of glass and steel towers. Rather, there was a gaudy self-assertiveness to this cityscape, as best characterized by Miami's most audacious new structure, the Centrust Tower – an illuminated lipstick tube scraping the sky. Nearby was another post-modernist slab – a vertiginous apartment block which looked like a lofty roasting tin, covered in aluminium foil and ready for the oven. And then there was the quasi-cubist office building which most Miamians probably considered to be the height of visual wit because it actually had a large empty space adorning its mid-section – a gap big enough to fly a small helicopter through.

It was, in short, fast-lane design to mirror a fast-lane city. And it immediately told you that Miami had a corporate culture which believed that the world of high finance was a narcissistic one; a place where big bucks bought you the right to imprint your own flamboyant vision of success upon a metropolis. Here, you sensed that style was used solely as an economic indicator; that, like any boom town with a transient population, Miami and its citizenry strove for the trappings of instant affluence. The Corvette with its smoked-glass windscreen was but an extension of the corporate tower with its smoked pane interior where the guy who owned the Corvette probably worked. It was as if the ultimate reward for being a winner in Miami was the ability to isolate yourself from the rest of the city behind tinted glass; to stay cruising at high altitudes on I–95, with the windows rolled up, the air-conditioner cranked up to arctic, and the quadrophonic stereo playing something shit-kickingly electric at full throttle.

Sunstruck high-income bracket bliss. That is, as long as you didn't have to confront what was happening below you at street level. As long as you never took that wrong turn (as I did) which led you onto that wrong ramp, which then landed you in the middle of that very *wrong* place on the metropolitan map of Miami: a place called Overtown. An area most residents of the city filed under 'no-go'. A district you'd only want to enter if you were in the market for a couple of vials of crack, or happened to be in the high-risk business of loan-sharking.

Overtown – a land of shadows, occasionally illuminated by the rare pool of streetlamp light and the frequent fire in a rubbish tip. Overtown – burnt-out buildings, tenements in a terminal condition, and small clusters of people loitering on street corners

33

in the company of a boom box that was blasting some incoherent rap into the night. Overtown – the venue a couple of years ago for a murder that's still talked about in a city which generally takes murder in its stride; a murder where a pair of British tourists also took that same wrong turn off I–95, and made the mistake of asking a group of Overtown street dudes for directions. The dudes replied with two blasts from an automatic weapon, and the tourists left Overtown feet first in a pair of body bags.

As American mean streets go, Overtown's are reckoned to be some of the meanest. And having lost myself in its labyrinthine confines – and very much sensing that roaming these dark urban byways in a flash new rented car was an open invitation to grievous bodily harm (or worse) – I pulled into the first filling station I could find to seek geographic guidance. The guy behind the pump was an elderly gent sporting no front teeth and an Atlanta Braves baseball cap. He took one look at my very white face and raised an eyebrow disapprovingly.

'Yo, son, what d'fuck you doin' round here?'

'Trying to find a way onto the highway', I said.

'I reckon that to be one good fuckin' idea, son. One real good fuckin' idea.' And he pointed the way back to I–95.

But before I got there, I passed a local Baptist church, with a billboard by its entrance. A billboard which read: *Have You Been Slain in the Spirit?*

It was a question I didn't feel like pondering at the moment.

The next morning, while driving north in the direction of Fort Lauderdale, I discovered what a *Dynamoment* was. I had the radio tuned to a local religious radio station, WMCU – 'The Voice of Miami Christian College' - and was listening to a terribly up-beat, life-affirming song about the Lord giving all of us the strength to make it through the day. It was performed by an octet of velvety voices – the same generic velvety voices who are heard singing Christmas carols on supermarket loudspeakers every December. After this, an announcer came on the air:

'Just as we need vitamin supplements to give our bodies an additional lift, so we also sometimes need a *spiritual* supplement to give our inner beings that pick-me-up it so wants. And that's why we've developed *Dynamoments* for busy people who need that little boost in their daily lives. It's a cassette tape with

a sequence of two and-a-half-minute biblical supplements, which you can play in the car, at the office, on the beach at the weekend. . . So anytime you've got that scriptural hunger, and need that lift which only the Bible can give you, reach for a *Dynamoment*. . .'

I snapped off the car radio, and turned down a boulevard adorned by the usual suburban non-stop vista of shopping malls. At one point, I made a wrong turn off this main drag and discovered that directly behind all this affluent sprawl was an out-and-out slum: a row of tiny breeze-block bunkers with tar-paper roofs, fronted by a dirt road where garbage festered in the heat and a group of kids in cast-off clothes used a Coke can as a makeshift football. The transition was startling: it reminded me of one corner of Cairo where the Egyptian beau monde sipped lemonade at the former British Officers' Club while, only footsteps away from this establishment, the local peasantry lived in corrugated aluminium huts. South Florida evidently also specialized in such bleak juxtapositions of wealth and destitution. Only, of course, you could almost comprehend such cruel ironies in a country like Egypt which, besides being a post-colonial society, was also a member of the so-called 'developing world'. South Florida, on the other hand, was very much part of an intensely *developed* world, and one in which the sight of families of five living in kiln-like concrete shanties simply made you wonder whether such a scene was the logical outcome of Social Darwinism: those who can economically compete get to go to the shopping mall, those who can't end up crammed into two airless rooms under that high-intensity Florida sun, and probably think themselves lucky to live in such a radiant climate.

I continued on this desolate road until I hit the North Federal Highway, and was yanked back into a more well-heeled vision of Fort Lauderdale. And a mile or so down the highway – nestled inbetween a discount liquor store, the Olive Garden Italian Restaurant, and some fast-food joint offering a 99¢ Chili Dog Special – was the Coral Ridge Presbyterian Church. It was an imposing new structure which had been designed in an architectural style that could best be described as Space Shuttle Ecclesiastical. The main body of the church was shaped like a low-lying set of concrete wings, and was visually subservient to a towering central spire; a gleaming white needle which looked ready to blast off at any moment. A small platoon of school buses was parked at the extreme rear of the church,

near another cluster of modern buildings which housed Coral Ridge's own private school, Westminster Academy. Shaded by palm trees, enveloped by landscaped gardens, driving onto the grounds of this Presbyterian church was like entering a model industrial park which exuded corporate efficiency.

I had come to Coral Ridge to meet a television evangelist. His name was Dr D. James Kennedy and, besides being the founder of this church, he was also considered to be one of the leading small screen proselytizers for Christ in America today. Only Kennedy was no hyper-hysterical Bible thumper like Jimmy Swaggert, who sold salvation while constantly begging you to take your VISA card to the limit on his behalf. Rather, he was noted for being the antithesis of a Christian huckster – a sober-visioned, morally righteous, financially scrupulous evangelist in the Billy Graham mould. And since I was intrigued to learn of a minister of the Gospel who beamed his message nationwide via satellite for no apparent big-time financial gain, Dr Kennedy seemed like a televangelist worth talking to.

I parked my car near some tennis courts and then wandered back to the church, entering a side door which led to a corridor of offices. Along this corridor was a vast map of the United States, covered with multi-coloured push-pins. The push-pins represented every sizeable community in the country which received transmission of D. James Kennedy's weekly programme. With the exception of a few mountainous parts of Nevada and Arizona, the entire continent seemed to be awash with those technicolour pins. The map said it all: D. James Kennedy was everywhere.

Dr Kennedy's secretary was a cheery middle-aged woman who loaded me down with selected 'literature' on the Coral Ridge ministry before Dr Kennedy himself came out to greet me. He was a man in his late forties; lean and trim, with a no-nonsense handshake and a no-nonsense way of look-ing you straight in the eye with the sort of gaze that said, 'Don't think for a moment that I trust writers.' He had an almost military bearing – his blue blazer, grey flannels and old school tie gave him the cut of an admiral in civvies, or of a Republican presidential candidate. And I sensed that he was a 'take charge' sort of a guy – a natural commander and skilled tactician who, once he decided upon an objective, would move substantial segments of heaven and earth to achieve it.

After exchanging the usual mindless pleasantries about sharing the same surname, Dr Kennedy ushered me into his office. Very much the 'study' look: a big rosewood desk; big burgundy leather armchairs (with buttons); light blue drapes which closed off the outside world; and framed photographs. Photographs of Dr Kennedy with Ronald Reagan. And of Kennedy and his wife with George and Barbara Bush. Like the map in his office corridor, these photographs spoke one word: *clout*.

I mentioned to Dr Kennedy that I had called his secretary for an appointment after catching his programme one evening in New York, and that I was not only interested in his approach to proselytizing, but also in learning how someone ended up as an evangelist on television in the first place. He gave me a quick smile, as if to acknowledge that it wasn't exactly the sort of occupation or career that one aspired to when young. And, as it turned out, Kennedy himself hadn't been brought up in a terribly pious household. Though raised a Methodist and sent to Sunday School, his religious education had been a nominal one, especially as neither of his parents were church-goers, but were 'social Christians' at best.

It wasn't until Kennedy was in his early twenties and living in Philadelphia that the call from the Lord came. And the sign from on high that was sent to this future religious broadcaster arrived, ironically enough, over the airwaves.

'I was asleep in bed one Sunday morning when my clock radio went off, and I heard this voice. A voice which said, "If you were to die today and God asked, 'What right do you have to enter heaven?', what would you say?" And I sat right up in bed and thought, "What *would* I say?" '

The voice belonged to a Presbyterian minister named Dr Donald Barnhouse. And for the next couple of days, the question Dr Barnhouse posed kept troubling Kennedy, to the point where it forced him to go out and buy a copy of that American religious classic, *The Greatest Story Ever Told* – a wide-screen, technicolour history of Christ's life written in an *école de Reader's Digest* literary style. The book evidently had a profound effect on Kennedy's metaphysical world-view, because as soon as he finished it, he knelt down and asked Jesus to come into his life.

'Here I was – the manager of an Arthur Murray Dance Studio. . . what I guess you could call "a swinging single" – and even though I didn't know a single Christian, I knew that my whole life had changed. Because the morning after I said

37

that prayer, I woke up and realized that I was going to live forever with Jesus. And I thought: "Now *that* is fantastic." '

What was also fantastic was his discovery of divine providence – that form of spiritual happenstance, where you realize that all twists of fate are really contrived by the Almighty. In Kennedy's case, it was divine providence which led him to a Presbyterian church the first Sunday after Jesus became his Lord and Saviour.

'I was only eight days old in the Lord. And if I didn't know a single Christian, then I also didn't know one Presbyterian from another. So it wasn't just a happy accident that the first church I visited was the local Presbyterian church near my apartment.'

But though God brought him to that Presbyterian church, He didn't make his ultimate intention clear to Kennedy for quite some time. In fact, it was well over a year after his conversion – during which Kennedy attended the church's adult Sunday School – that he began to feel the need to hang up his Arthur Murray dancing pumps and enter the ministry.

'Now, at first, I resisted this sense of calling – and I resisted it *manfully*. I mean, I *loved* my job. Danced 80 hours a week, and couldn't get enough of it. But gradually – very gradually – I began to lose interest in the cha-cha-cha and the foxtrot. Really started to hate going into the studio, because it seemed downright trivial in the light of the momentous spiritual things that were going on in my life.

'Finally, the torment got too much. I said, "Lord, please give me some peace. I'll do anything you want. . . just give me some inner peace." Do you know what happened? Quit my job the very next day and went back to college, and then on to a seminary in Atlanta. And after I was ordained, I came down here with my wife in 1959 to try and start a ministry.'

It is, of course, a recognized fact that all American empire builders must begin their careers in the humblest of circumstances and construct their dominions out of virtually nothing (for if they do otherwise, they contradict the national obsession with rags-to-riches mythology). In Kennedy's case, he first started preaching on Sundays in a 'cafetorium' - a curious hybrid word which is used to describe a school auditorium that can also be transformed into a cafeteria. And it was in the cafetorium of a Fort Lauderdale elementary school – with the toxic aroma of the previous week's school dinners still hanging in the air – that Kennedy first staked his claim to be a Presbyterian minister.

What's more, the handful of people who initially came to hear him spread the Word were recruited by Kennedy himself, through that old tactic of simply knocking on doors and asking the good Christian citizens of Fort Lauderdale to give this new preacher a shot.

The tactic paid off, for three years later Kennedy had a large enough flock to move into a small abandoned church on nearby Commercial Boulevard. But though he now had an actual house of God of his own, he realized that going door-to-door was pure amateur night when it came to building up a congregation. So he got another local minister to teach him the technique of *witnessing for Christ* – of getting out from behind the pulpit and sharing the Gospel on a one-to-one basis. Then, as the church began to grow and Kennedy mastered this witnessing technique, he, in turn, trained a group of church workers in this method of winning souls – a method which Kennedy said was akin to 'teaching somebody how to fly'.

'Well, once I had my workers out there in the field, witnessing throughout the community, it was only a matter of time before *spiritual multiplication* began to happen. And you can now see the results of that multiplication – this church, which has a congregation of over 5,000; our school; and our television programme which is seen in 200 cities and towns across America, not to mention 93 countries as well.

'And, I tell you, I really do believe that spiritual multiplication is the greatest work you can do in life. Because it means taking the Gospel and sharing it with the world. As Jesus said, 'Yea shall be witnesses unto me.' So my job ultimately is to train and equip lay people to share the Word. Especially since Christianity is growing worldwide. And in America, there's a big change happening in the churches – and that change is the Gospel. For example, before we were married, my wife used to go to a Presbyterian church four or five times a week. Used to sing in the church choir and teach Sunday school. But she wasn't a Christian. Because she didn't know *the Gospel*. The Gospel – the way to eternal life – was never taught in the mainstream churches.

'In fact, if you asked people, "How does one get to heaven?", the majority of folks wouldn't know the answer – though they'd probably say something like, "The only way to get to heaven is by being good, or by loving thy neighbour." But that's not the message of the Church. Rather, the Church's greatest message is

39

this: in spite of the fact that none of us is good, God loves us. And if we trust in Him, we will be given the gift of eternal life.

'But this gift presents us with a paradox. Because most people think that the motive behind Christian living is trying to *gain* eternal life. But no one will ever do enough to *earn* heaven, so no good deeds are ultimately good if you're only doing them to buy a place in heaven.

'Heaven, therefore, is a gift. And this gift is Incredible Good News, for an infinitely gracious God will grant us eternal life if we simply invite him into our hearts. In fact, all of Christian life is an expression of our love affair with Jesus Christ.'

He paused for a moment and gave me the sort of sympathetic smile that had a definite *Can't You See the Light?* subtext to it. It was then that I realized Dr Kennedy's homily wasn't simply a statement of pious conviction; he was also 'witnessing' me. And his arguments were – on one level – beguiling. After all, even the staunchest of atheists must secretly possess some hope that there is a realm beyond temporal life; that death is not an everlasting power failure, but a definite rite of passage into some new phase of being. And here was Kennedy offering me – as he offered all those viewers coast-to-coast and overseas every week – an antidote to my own mortality. All I had to do was bow my head and say a prayer, asking Jesus to come into my heart, and the gift of life ever-after was mine. A simple procedure requiring a great leap of faith which I knew I just couldn't make. But listening to Dr Kennedy give me the 'party line' in his smoothest spiritual bedside manner, I could easily understand why so many folks were willing to take that plunge into the province of belief.

It was so reassuringly fundamental, this idea of heaven. Not only did it provide you with an answer to the greatest of all mysteries, but – by promising you a hassle-free tomorrow – it also cushioned you against that aching sense of defeat which underscores so much of life. No wonder that the word 'evangelical' is derived from the Greek for 'good news'. That was Dr Kennedy's business – disseminating this 'good news' – and if you could buy the concept he was promoting, then it was probably the best news you were ever likely to encounter. Because – let's face it – you can't do much better than being told that, thanks to a basic act of faith, you're going to live forever.

'I tell you something, Doug – 35 years ago, God put the screwdriver into the screw of my mind and He turned it upside down. Made me see things in a totally new perspective. And

He can do that for anybody – anybody who simply reaches out for Him.'

Once again, he gave me that sympathetic *Don't You See What You're Missing?* smile as if to say, 'Think about it.' To get us off the subject of my potential conversion, I asked him whether he resented being labelled a 'televangelist' – especially since the epithet conjured up the image of a religious cheap-jack.

'Let me put it this way: I am a Presbyterian and I am an evangelical, but I am definitely *not* a fundamentalist. I am a pastor and I am a theologian, but *not* a charismatic. In fact, I'm the only national television minister who has a PhD. And I do believe that the majority of fundamentalists are downright anti-intellectual – to the point where, if you spent a Sunday morning watching them at work on television, you'd probably reach the conclusion that all Christians were insane.

'Still, despite its excesses, televangelism has nonetheless managed to reach so many people who weren't hearing the Gospel before. Of course, most televangelists are fundamentalist and charismatic, but – like I just told you – we're not, and we're now the fourth largest television ministry in the country.

'But I want to be very, very clear about one thing: I have *never* taken a penny of any of the money we've raised for the ministry. And anyone who wants to inspect our books can see for themselves that we are totally above board.

'Of course, we're funded by the support of viewers who want to send us money. And I probably spend around 20 seconds of our hour-long programme asking for funds. We offer a book, and we say that the church can't support itself on its own; that our ministry has to receive donations in order to continue. But I make that plea for only 20 seconds. Consequently, we don't receive half the money that Jerry Falwell gets for his programme. Still, I refuse to spend half my time on the air asking for hand-outs.'

With that, we left Dr Kennedy's office by a side door and walked straight out onto the altar of his church. The effect was a bit like walking onto the stage of an empty theatre, for the church pews were laid out in a fan-shaped design, with banks of lights overhanging a balcony, beneath which was a control room with television cameras. Behind the pulpit was a panoramic choir loft and a jumbo-jet style organ which conjured up memories of the old Mighty Wurlitzers that used to grace the big Picture Palaces of the 1930s. Standing there, looking at that majestic sweep of empty pews which thousands would fill every

41

Sunday – picturing the hundred-strong robed choir encircling the rear of this ecclesiastical amphitheatre – it was easy to grasp the sheer aura of power that must envelop anyone who ascended that pulpit to preach. This wasn't merely a church – this was an arena in which a Christian viewpoint was beamed to the world. It spoke of high ambition and profound conviction. And I suddenly realized why Dr Kennedy ushered me in here after unequivocally stating that he was financially scrupulous: he wanted to demonstrate what his ethical determination and his faith had wrought. But, as he was quick to point out, the ministry he had built was merely one small Christian bulwark against a society that was still predominantly composed of non-believers.

'There's no doubt that this country began as a Christian experiment. And there's no doubt that this country had a Christian consensus well into the mid-nineteenth century. But then the secular humanists came along and made major inroads into our institutions. And what worries me most about these secular humanists is that they believe man is the measure of all things; that man will determine what is right and what is wrong. For them, time has no reference to eternity. They cannot see beyond the grave. So both eternity and God are dropped from the equation. They cannot grasp the fact – as we Christians do – that God is the sum of all things. The Alpha and the Omega. The beginning and the end.

'But I think that America is now witnessing the sort of Christian revival which will ultimately reject secular morality and return to the morality of Jesus. We're a long, long way from the City on a Hill which the Puritans wanted to build, but that doesn't mean we can't begin the process of making our way back up that hill again.'

And here, off a gasoline alley in Fort Lauderdale, Dr D. James Kennedy was encouraging the nation – and the planet itself – to join him in that ascent towards a vision. A vision of a City of God.

Back in the secular world, the citizens of Florida were caught up in more hard-boiled preoccupations. Like the alligator scare in the West Florida town of Venice. It seems that some kid was out walking his cocker spaniel puppy near a pond in Venice and

made the mistake of turning his back on the pooch for a moment. Because the next thing he knew, there was no dog. In fact, all that was left behind was a small pool of blood.

A couple of days later, however, the mystery of the disappearing dog was solved when an itinerant alligator finally ran out of luck in that same Venice pond, as he was blown away by a local hunter. And when that big game trapper opened up the 'gator's stomach, he found a half-dozen undigested dog collars lodged in his gut.

This news item – which I caught on my car radio while driving back to Miami – caused me to do a double-take when I simultaneously roared by a billboard advertising the Hollywood Dog Track. It turned out to be a fortuitous double-take because it made me take notice of a small sign housed between the hoarding for the greyhound track and one for Waterbed City ('The Sleep Specialists'). The sign belonged to a local television station – 'TV 45: Family Television' – and read: *Need Prayer? Turn 2 Blocks West.*

I immediately got off the highway at the next exit and turned two blocks west. And just beyond a Coca-Cola bottling plant, I came upon TV 45. It was located in a caravan park; a low-lying brown concrete building fronted by a satellite dish and a hefty antenna. Over its front entrance was a plywood cut-out of five outstretched fingers which were so plump that they appeared to have been infected with elephantitis. Under this were the words: *His Hand Extended.*

This was the South Florida headquarters of TBN: the Trinity Broadcasting Network, one of the major religious satellite stations in the United States. I parked the car and wandered into the foyer; a foyer with spongy white shag carpet, metallically shiny floral wallpaper, and photographs of TBN's founder, Paul Crouch, saving souls in a variety of exultant poses. Crouch – a California-based evangelist – looked a bit like a game-show host: carefully coiffed silver hair, jet white capped teeth, and a predilection for blue blazers with big country club crests on the breast pocket. Put your imagination to work and you could almost smell his aftershave off one of the framed photos. A small chapel was located in one corner of the foyer, decorated with the same sort of representational 'Scenes from the Bible' artwork that Cathy had shown me in her old Jehovah's Witnesses brochures. An open Bible stood in pride of place near the reception desk, and overhanging this entire scene was a plaster-cast globe of

43

the world, crowned by a halo in the shape of a message: Trinity Broadcasting Circles the Planet Earth.

'You wanna prayer partner?' the young black woman behind the reception desk asked me. ' 'Cause if you wanna prayer partner, you'll have to come back in an hour, 'cause they're all out to lunch.'

I said I wasn't looking for a prayer partner; I was just looking around.

'Can't look around. Not allowed. But if you wanna come back tonight when we're taping a Christian current affairs programme called *Feedback*, you can be part of the studio audience.'

So I killed the afternoon wandering around the low-life quarters of Miami Beach before speeding back to TV 45 for the taping of *Feedback* at 7pm. The car park was now dotted with vehicles adorned with bumper stickers like *Honk If You Love Jesus* or *I've Found It*. Inside the studio were about three dozen people, seated in a couple of rows of folding chairs which faced a small set: three high-tech chairs and a neutral grey backdrop, illuminated by a small bank of television lights. The audience members spanned a surprisingly large number of age groups and social strata. There were a handful of middle-management types in shiny off-the-peg brown-on-brown suits, interspersed with some real American gigolo characters – all open-neck silk shirts, hairy pectorals, and gold chains. Most of the women seemed to favour trailer-park stretch pants and flowery acrylic blouses, though there were a few ageing blonde cheerleaders who were downright Southern belle-ish in frills and lace. One of these latter-day Scarlett O'Haras was the absolute epitome of milk-fed, corn silk Dixie femininity – so much so that she immediately won the attention of a guy in a Polynesian shirt, with a patchy beard, manic eyes and a face that had been ruthlessly pitted by acne. He approached her and flashed a hyper-active smile.

'I just have to tell you that you are beautiful,' he said, 'like real beautiful. You want to get married?'

'I'm married to Christ,' she said, and turned back to the Bible lying open in her lap.

There was a burst of applause from the studio audience when the host of *Feedback* – Carlton Pearson – stepped out onstage to do a little pre-broadcast warm-up. He was a black dude in his late twenties – slick and heavily deodorized. His suit was electric blue serge; his footwear, black alligator boots with stacked heels. A gold pinkie ring embellished his left hand, while a thin gold

bracelet dangled from the opposite wrist. A one-time street dude from Tulsa, Oklahoma who got righteous after he found the Lord (as he informed us later in the programme), Pearson was considered to be an up-and-coming televangelical star. He had his own charismatic church in Tulsa and was becoming a popular crooner-cum-preacher on the national Christian entertainment circuit. He spoke elegantly, though he punctuated his patter with ghetto patois ('Jesus is gonna git upside your head'), as if to prove that he still had street credibility. Tonight, he explained, they would be taping two programmes, so would we please stay for both shows as they needed the audience. Then he said that the first show would deal with a Christian's response to the new anti-smoking laws that were being launched across the country, and he introduced us to a doctor and a local anti-tobacco campaigner who would discuss this 'Christian issue' with us.

As 'question time' shows go, *Feedback* was pretty run-of-the-mill stuff, though it did have its occasional moment of quirky inspiration. Like when one woman from the audience stood up and said that, as a smoker, she felt guilty everytime she lit up because she knew she was 'defiling the temple of the body'. And the doctor on the panel – who looked like he was considering Sumo wrestling as an alternative career – agreed with her, saying: 'I'm a Christian and I weigh 280 pounds, which means I'm defiling the temple as well.'

This comment was greeted with spontaneous applause. But then the guy with the Polynesian shirt raised his hand and asked the doctor, 'Brother, why shouldn't I smoke the tobacco which God put on this earth for me to enjoy?' Spontaneous boos now filled the studio and the doctor never got to answer the question.

At the end of the programme, Carlton reminded us that smoking was sinful because it tended to demolish the temple of the body prematurely, but that we must show Christian charity when dealing with those attempting to break this evil addiction. Then he gave us a 1,000-watt smile, told us that God loved us, and signed off.

During the break between programmes, I got chatting with my neighbour in the studio: a woman in her sixties named Brenda. She said that she originally came from a tough Irish area in South Boston and she certainly looked like a tough 'Southie' who, after four decades in Miami, still retained her Massachusetts accent.

She'd moved to Florida in 1946 and hadn't been back to Boston until last year when she retired from her job as a clerical worker in a municipal office and also buried her husband ('Forty years of two-packs-a-day finally got him'). But the New England winters proved too much for her, so she returned to live out her days under the Miami sun. The death of her husband also brought her back to the church and introduced her to TV 45, where she attended the taping of shows like *Feedback* as often as possible, because they got her out of the house where she was on her own all the time, and also gave her the opportunity to meet other Christians. 'And anyway, I really like watching Carlton at work', she said. 'Ever hear him preach? Great preacher. Real nice boy too.'

I excused myself to go to the loo, and passed through the adjoining room where volunteers manned banks of phones, running the TV 45 prayer lines – a service whereby members of the public could phone in for a bit of on-the-line meditation with a 'prayer partner'. A biscuit tin was positioned on a table nearby, with a notice taped to the top of it: *These cookies are for prayer partners only.*

Another word of warning was posted on the staff bulletin board: *If you get any calls from any of the media – we have* NO COMMENT *about any other ministry. They should call the California office for further information.*

The management of TV 45 evidently believed in maintaining a very tight lip when it came to the public distribution of its corporate viewpoint, not to mention its corporate cookies. Joey, on the other hand, clearly believed in telling anybody anything. Or, at least, that was my impression of Joey after he told me that he was Joey from Detroit. Joey who was a dental hygienist. Joey who wore a Filipino shirt which covered his early middle-age spread. Joey who rested his big calfskin-bound bible on top of the urinal next to mine in the gents, and instigated the following conversation:

'Here for last night's show?'

'No', I said. 'What were they discussing?'

'AIDS – a Christian's response to the threat of AIDS.'

'What *is* a Christian response to AIDS?' I said.

'Abstain from sex and pray.'

'Prayer can cure AIDS?'

'Sure it can,' Joey said. 'I mean, prayer cured my genital herpes.'

'Really?'

'You bet. In fact, I had the first case of genital herpes in the Midwest. That was in the 1960s, of course. Hippy days. Doctors didn't even know what it was.'

'You were a flower child?' I said.

'Yeah, I was into all that stuff. I was a drug addict. An alcoholic. A cigarette smoker. *And* I had genital herpes. But it all went away when I was saved. . . the moment I kneeled down in a friend's kitchen and he brought me to Jesus.'

'And your herpes cleared up immediately?'

'On the spot.'

'That's an extraordinary story.'

'Anything is possible with the Lord.'

I returned to the studio, where the second programme was getting underway. This edition of *Feedback* dealt with 'a Christian's response to Street Gangs' - and a Miami detective, an evangelical minister and a former gang member essentially reached the conclusion that street gangs were dangerous to your health. At the end of the taping, I went up to the stage and introduced myself to the Rev. Tony Waters – the evangelical minister who worked with the local hoodlum fraternity. He was an Italianite-looking guy in his early forties; muscular, five o'clock shadowy, with a sharp suit and a side-of-the-mouth vernacular.

'If you wanna interview me tonight, *fudgedaboudit* – I got plans,' he said when I mentioned I'd like to hear about his ministry. 'But come by my office t'morrow and, yeah, okay, I'll talk t'you.'

'That a Brooklyn accent?' I asked, explaining that all my family were originally from that part of the world.

'You got it in one. Grew up in Brooklyn. And started being a Wiseguy there.'

'A Wiseguy?' I said.

'Yeah, a Wiseguy' the Rev. Tony Waters said. 'A member of the Mafia.'

The Rev. Tony Waters at work:

'Lookit, Shirley. . . I have never, *ever* lived off blood money – which means prostitutes or drugs. And, y'know, I did try to help you. What I did for you was free, gratis, y'understand?. . .

Yeah, yeah, yeah, I know all about Estelle. I mean, she's a better friend of mine than she is yours. And I helped her outta bad thing last year when her kid got killed right in front of her, right outside her front door. . . yeah, it was real bad, y'know, but I pulled her outta it. . . okay, but, like, what I'm tellin' you is that I will help *anybody* who needs it. Y'know what they say – "Keep your enemies close and your friends closer." And y'know another thing *I* say – "Man makes friends and God forgives them." So don't go t'hell for a pack of cigarettes, you got me. . .?

'All right, all right. . . I see your point. But, Shirley, believe me. . . I know Paul Anka. And Frankie Vali of The Four Seasons is a very dear personal friend of mine. So what I'm tellin' you is this: I *know* quality and you got quality. I mean, I got this sister – we don't talk no more – but I got this sister who opens for Engelbert Humperdinck at Caesar's Palace in Vegas, so like I'm sayin', I *do* know quality when I see it. So, you hang in there, okay? And remember: God loves ya, right?'

He rang off and then turned to me and explained that he had been ministering to a young woman who was attempting to make a go of a singing career, but had run into contractual difficulties and a drug dependency problem.

'Trying to pull her outta this mess', he said. 'With the help of the Lord, of course.'

The Rev. Tony Waters ran a storefront operation called Inside Ministries – *Inside* referring, naturally, to 'the slammer'. And this being South Miami, his storefront mission was located in a shopping centre, sandwiched in between Hearing Aid World and Nail Impressions. It was a simple office with two desks, framed photographs of Waters in full proselytizing flight, and a couple of bookshelves filled with volumes like *Changed Lives in San Quentin* and *They Call Me The 'Catch Me' Killer* and *Al Capone's Devil Driver*. A poster advertising the work of his evangelical outfit covered one entire wall. It read:

INSIDE MINISTRIES:
To Open Up the Eyes of the People
To Turn Them From DARKNESS TO LIGHT
To Raise Up GOD'S WORD AS A STANDARD
TO ESTABLISH THE LORDSHIP OF JESUS!

It's time for Americans to do for Americans. That's what Tony Waters and Inside Ministries are all about.

Through Inside Ministries, the dynamic Rev. Waters has been ministering to the public and to prisoners throughout the United States for a number of years.

Our dedication is to take action. We want to restore hope and human dignity to the hungry, the homeless, and to guide our youths to a better America yet to come.

AMERICA – GET READY FOR GOD'S FORGIVEN THIEF!

'You were a thief?' I asked the Rev. Tony Waters.

'Yeah, I was a thief,' he said with a smile which hinted that, though he might have adopted an evangelical exterior, he was still a Wiseguy at heart. 'But not just some ordinary thief. I was a real big time thief.'

He certainly came from impressive criminal lineage. His father was an associate of several legendary New York Mafia bosses. And since Daddy was a racketeer, Tony's career choice was an obvious one. At the age of 16, he was already learning the business of burglary. And after serving a three-year apprenticeship, he began to establish a reputation as one of the top burglars in the country who – with his band of accomplices – became known in the tabloid press as 'The À La Carte Criminals', because they cleaned out the homes of the wealthy while they were out at supper.

So Tony became a fully-fledged 'soldier' of the Mob, and had a flourishing eight-year career in crime. A career which had its fringe benefits – like the ability to bankroll a Rolls, a Ferrari and a Lincoln Continental, not to mention a $250,000 house on the outskirts of Miami with an Olympic-sized swimming pool. 'I used to spend $1,000 a day. . . on foolishness', he said. And though he'd had 24 previous arrests – including three for homicide – none of them ever stuck. That is, until a former associate of his got busted for murder in New York and did a deal with the law – you give me immunity from prosecution and I'll give you 'The À La Carte Criminals'.

Which means that Tony Waters got done – on 'circumstantial evidence', according to himself, even though the prosecution still managed to nail him for robberies at the homes of a number of leading industrialists who form a major part of the corporate ruling class of America. And Tony didn't just

49

get found guilty of first-degree larceny – he got found guilty of first-degree larceny several times over and was handed down a spectacular 52-year prison sentence. What's more, he soon lost everything. The Internal Revenue Service hit him for a back bill of $1.5 million. His home was repossessed. His cars were sold off to pay his legal expenses. His wife divorced him a year after he was sent to the slammer.

Worst yet, after almost 5 and a half years 'inside', he was paroled, but managed to violate his parole after his release and was dispatched back to the joint for another six-year stretch. Altogether, he served 12 years of his sentence. Check that: 'I did 11 years, six months, nine days.'

What saved him from serving an even longer portion of his sentence? Simple: during part two of his stretch in the Florida federal pen, he Got Saved.

'Like I was raised a Catholic, but that was, y'know, *religion*. You can know all about God and still not *know* God, if y'see what I mean. But when I went back inside for the second time, I met the Lord. I saw the need for Him and realized that I was a sinner. And I also realized that the Bible was real, and that God Himself was real.'

Besides meeting the Lord, he also discovered his true vocation in life and – courtesy of a correspondence course – he was ordained as a minister of the Church of God, a Pentecostal organization based in Cleveland, Tennessee. And while serving out the remainder of his sentence, he began to minister to his fellow inmates. One of these was a gentleman named John Spenkelink, who had the unenviable distinction of being the first person in recent Florida history to be executed in the state's electric chair after the US Supreme Court lifted its moratorium on capital punishment. Spenkelink had been sentenced to death at the beginning of the 1970s for killing a man during a robbery, and Tony 'witnessed' him a couple of hours before he went to the chair.

'I asked John if he was frightened. And he said that a man chooses the way he goes in life, and he'd made his peace with God and hoped he was going to a better place. That's when I understood that God can forgive anything – anything, that is, except blasphemy. That's when I realized that *I* was God's *forgiven* thief.'

Upon his final release from prison, the forgiven thief went to the northern Florida city of Jacksonville and began preaching in

50

a local Church of God. After a stint there – 'getting my ministerial act together' – it was back down to his former criminal turf of Miami, where he set up Inside Ministries, working largely with kids who are considering crime as a career option.

'I try to keep 'em off the streets and find 'em jobs. And I tell 'em that I only now realize just how much of my young adult life I lost by being in the slam. Like I tell 'em – you gotta make a commitment t'change your life. You gotta take your Browning automatic down to the church, lay it on the altar, and ask Jesus Christ to become the one and only Boss in your life. Because unless God gets a holda you, you're lost. And Americans now see the moral need for Jesus Christ. Y'know why? Because they see that the end of time is near. Give or take five years, it's gonna all be over. The rubber bands are stretched about as far as they can go. And that's why you have all this upsurge of Christian activity right now – 'cause God is calling one last revival before He shows up down here.'

What sort of signs would mark the beginning of the end? Tony said it would all begin with a deep economic depression – 'back to the days of people eating outta garbage cans' – followed by moral decay taking over family life completely. 'But the good news is that, just when things start to look really terrible, Jesus will make His stand and His saints will be taken outta this situation, because we're just pilgrims passing through.'

But, as one of Jesus' 'saints', the Rev. Waters believed that he wouldn't be making an exit off the planet thanks to nuclear war, since he never found a reference to an atomic holocaust in the Scriptures. Given that, he did feel that some kind of Armageddon would call a halt to life on earth. And though he admitted to fearing death at times – 'especially since I wanna make certain I'm ready for it' – he was still looking forward to the post-Armageddon Reconstruction period: ''Cause then we'll walk with Him in heaven before coming back to rule the earth.'

I said that ruling the earth in the next life must seem like an attractive proposition to quite a number of people. The Rev. Tony Waters thought that one over for a moment. Then he gave me another Wiseguy smile and said:

' 'Course it is. I mean, why d'you think I get so much cash for my ministry from former Mafiosi?'

51

Tomas was called Thomas professionally. Tomas was called Tom by his American-born wife. Tomas was called Tommy-Baby by the 'marketing guy' he played tennis with twice a week.

'That's what I like about this country,' Tomas said. 'You can reinvent your name to suit every situation. You can reinvent everything about yourself.'

Tomas knew a thing or two about reinvention. He arrived in Miami as a five-year-old kid from Havana; a refugee from the Castro regime. His father had been one of Cuba's more eminent academics. But after Batista fell, Papa reached the conclusion that he wasn't temperamentally suited to the new ethos of sugar-cane communism which Fidel was imposing on the *nacion*. So he instructed his wife and two young children to pack a suitcase each, and they caught one of the last boats travelling freely between Havana and Florida.

That was 1960. Now, 28 years later, Tomas was Thomas was Tom was Tommy-Baby. In other words, a true American.

I first met Tomas in Italy during the mid-1970s. We were both students at the time, and during a term break from Trinity College Dublin, I made my way down to Florence to visit a mate who was ostensibly studying in that city's university for a year. Tomas was also enrolled in the University of Florence, and had become a friend of my friend. From my vague recollections of my sojourn there, I remembered Tomas as a latter-day bandito with shoulder-length hair and a Zapata moustache, speaking English and Italian with a mild Spanish inflection, and practising the same hedonistic philosophy which every sensible student was still fortunate enough to practise during that relatively insouciant decade.

But the 34-year-old man who greeted me in the foyer of his law offices on a haute commercial boulevard in Miami had long since discarded his 1970s identity. There is always something curiously poignant about re-encountering a friend or acquaintance after a long absence and seeing how time – in association with the usual compromises and emotional bruisings of adult life itself – has inevitably altered their sensibility. In the case of Tomas, the Latino bandito had become one of South Florida's most successful divorce lawyers, with all the encumbent trimmings: sleek art deco offices, beautifully cut corporate honcho suits, a wholly American accent (the slightest hint of his Havana roots having been bled completely from his voice), a gunmetal-grey Porsche, and the sort of inspired caustic wit which comes with

52

picking through the domestic wreckage of people's lives day after day. When his secretary ushered me into his office, he pumped my hand, told me I'd gotten fat, and then said:

'Just made some money cutting this client loose from a husband who was a real charmer. Liked to use her as a punching bag, and thought a woman's place was in the stove – that kind of enlightened behaviour. Nailed that asshole for the sort of alimony that looks like the GNP of Guyana. Come on, I'll buy you lunch on the proceeds.'

We drove into Little Havana – the old Cuban district of Miami. Entering this quarter was like crossing an international frontier. It wasn't just the fact that every road sign and billboard was in Spanish; the very look of the district was pure south of the border. Low-lying stucco architecture with Hispanic arches. Venerable courtyards where elderly gentlemen sat hunched over chess boards. Exuberantly tacky nightclubs gift-wrapped in neon. Even the used car dealerships had a certain sort of raffish, retro charm. On casual inspection, this was a world of zoot suits and Fedoras; an agreeably unshaven 1940s urban landscape, in which you almost expected to see Delores Del Rio being pursued by a young Orson Welles. Granted, I knew that this film set charm was illusory; that the contemporary realities of Little Havana were far more complex than such a naive first impression. And yet, what intrigued me most about this *barrio* was that, like so much of Miami, it was a larger than life set piece. It was as if the sheer extremities of the city – the scenic mood swings from wealth to poverty, the ethnic pile-up – turned every district into something approaching overblown archetype.

Even the Cuban restaurant where Tomas brought me to lunch took on the appearance of a stage setting, in which all the personnel had been supplied by Central Casting: a quartet of rotund, thickly moustachioed businessmen with serge suits and slicked-back hair, arguing a point in rapid-fire Spanish; an octogenarian gentleman sitting in one corner – his eyes shielded by dark glasses – and dressed in a white linen jacket that was probably popular in the Havana of 1946; and venerable waiters in immaculate livery who all but clicked their heels when they took your order.

'Welcome to real old Cuban-America,' Tomas said. 'A disappearing Cuban-America. Especially since the community has been terribly divided since Castro sent the scum of his jails – the *marielitos*, the black Cubans – to Florida in the early 1980s.

They gave us a bad name, these *marielitos*. They made us all look like cocaine dealers who settle arguments with machine guns. But they are not traditional Cuban-Americans. Traditional Cuban-Americans are honest businessmen who make an honest dollar. Believe in this country. Hate Communism. Voted for Reagan and will vote for Bush.

'I mean, look at me. When my family and I arrived here, we had nothing. Now. . . look at my law practice. Look at the fact that I have driven us here in my Porsche and will buy us lunch on my AMEX Gold Card. How can I not love this country? Especially when it gives you the freedom to start again – to reinvent your entire life. Maybe you've been away too long, but that's what the American life is all about – reinvention.'

Reinvention – that word again. But the more I sauntered around Miami, the more I began to understand its true New World definition. For this was a metropolis which stood as a testament to that national belief in individual mutability; the ease with which you could cast off one identity, assume another, and discover that the new converted 'you' was accepted by society-at-large without precondition. And when I thought back to the born-again Christians I had met down here – the former Arthur Murray dance teacher turned Presbyterian televangelist; the now herpes-less flower child turned Christian dental hygienist; the Wiseguy turned Church of God preacher – the word 'reinvention' loomed large again. Like Tomas, they too had transformed themselves and had found a new identity in the process. But wasn't the search for 'identity' a central quest in all American life? And didn't the vast social and geographic mobility of the country encourage people to seek some sort of spiritual identity? In fact, wasn't the need for 'conversion' a logical need in such a rootless society?

At such an early stage of my journey, I had no answers to such questions – only (1) a notion that, in a nation which considers personal transformation to be an inalienable right, Christian rebirth must rank high on the list of options available for anyone wanting to change themselves; and (2) a desire to get on the road and see what the next stretch of territory would yield. So I told Tomas that I was going to haul myself out of Miami later that afternoon, and that I owed him lunch when I returned three months from now.

'I should be here,' Tomas said drily. 'So should Miami. But you never know. Like we say down here, things change.'

CHAPTER 2

The Hothouse

★★★

I drove coast-to-coast in just over two hours, trading the Atlantic for the Gulf of Mexico as I bisected Florida along Rt 41 – a two-lane blacktop that cleaved its way through the northern extremities of the Everglades. Negotiating this narrow strip of tarmacadam was like speeding through a dense thicket which occasionally opened up to reveal patchy vistas of swamp. And billboards. Dozens of billboards. Billboards for alligator wrestling shows. For airboat tours. For a theme park called Shark Valley, and a couple of ersatz Indian villages. Not to mention a road sign cautioning all comers that they were now passing a Panther Crossing.

Swamp. Bush. Tarmac. Billboards. . . Swamp. Bush. Tarmac. Billboards. The landscape along Rt 41 operated according to the scenic film loop principle – if you think you've missed it once, hang on – it's about to be rerun again. There was, however, one intriguing (and somewhat dangerous) variant to this cyclical sequence of panoramas – the white hot sunlight which had a mirage effect, making the road appear aqueous. I'd never seen such a water-logged road before. Come to think of it, I'd never seen such a water-logged road that was actually bone-dry – a fact which made me follow the lead of every other driver and turn on my headlights in an attempt to counteract this optical sleight of hand.

It was something of a relief, therefore, to drive into dusk and to hook up with the interstate just outside the town of Naples – an interstate which brought me past Venice (home of the now deceased cocker spaniel-eating alligator) and into the city of Sarasota, where I was planning to slouch for a few days. I had family here; an aunt and an uncle who lived on a spit of land in

55

the Gulf called Siesta Key – a tastefully opulent lagoon which is filled with tastefully opulent folks from the Northeast who have retired in this corner of the Sunshine State.

But Sarasota – as I discovered – was a curious divided community. For unlike a big-league American city – where the divisions between race and status were nakedly manifest – this was a town in which a far more subtle class barrier existed; a line of demarcation that separated the white wealth from the white working class, whose principal function in Sarasota was to cater for the needs of the white wealth. And, from what I could gather, the city largely survived on a retirement and tourist economy. If you had the cash, Sarasota was a congenial spot in which to wear pink blazers and white shoes, attend subscription seasons of concerts and musicals in the civic auditorium (where everyone else seemed to be wearing pink blazers and white shoes), and pass the time through constant eating out and shopping.

If, on the other hand, you didn't have the cash, you were probably wearing clothes bought in the local J.C. Penney's; you were probably taking tickets in the civic auditorium; you were probably waiting on tables in some designer restaurant; and you were probably attending a church like the Faith Assembly of God, which is where I ended up on my one and only Sunday in Sarasota.

The Faith Assembly of God was located on the 'other side' of Sarasota. The inland side away from the high-price coast. The semi-detached side, with the big gimcrack shopping malls. The side of town where your local restaurant was some pre-fab emporium like Sizzlin' Steaks or Chillies Take-Away Tex-Mex. The church itself was around the corner from Sizzlin' Steaks – a functional red-and-beige brick building, with a sloping roof adorned by a large plain cross; a suburban American vision of religious asceticism.

I'd found my way to this church after scanning the advertisements on the Church News pages of the *Sarasota Herald Tribune* earlier that morning – and scanning them like a punter sizing up the field. I was looking for a service to attend, and I wondered: do I put my money on the Church of Christ? Or Charismatic Healing? Or several varieties of Southern Baptists? Eventually, I settled on the Faith Assembly of God because it was a charismatic church – which meant that the service wasn't exactly going to be a low-key, introverted conversation with God – and also because the Assemblies of God were one of

56

the fastest growing Pentecostal religious groups in the United States today.

Pentecostalism – as any dictionary will tell you – is a catch-all term used to describe a wide spectrum of Christian 'assemblies' who emphasize the charismatic aspects of Christianity, and adhere to a fundamentalist interpretation of the Bible. More importantly, an implicit tenet of Pentecostalism can be found in the Acts of the Apostles (2:1-4); a passage in which the disciples of Jesus, on the seventh Sunday after Easter (Pentecost), come face-to-face with the Holy Ghost:

> And when the day of Pentecost was fully come, they were all with one accord in one place.
> And suddenly there came a sound from heaven as of a rushing mighty wind, and it filled all the house where they were sitting.
> And there appeared unto them cloven tongues like as of fire, and it sat upon each of them.
> And they were all filled with the Holy Ghost, and began to speak with other tongues, as the Spirit gave them utterance.

This 'speaking with other tongues' has a technical name – 'glossolalia' – and is a gift which Pentecostalists maintain is transmitted through a 'baptism of the Spirit' similar to that received by the Disciples. To be a Pentecostalist, therefore, is to believe in the power of the Holy Ghost, and to also believe – as the apostle Paul demonstrated in the Book of Acts – that those who receive the Spirit also acquire such fringe benefits as the power of healing and the gift of prophesy.

Now when American Pentecostalism was born in the 1840s, it was this no-holds-barred, shake-hands-with-the-Spirit, in-the-name-of-Jesus-Christ-I-command-thee-to-cough-up-that-malignant-tumour kind of pious ecstasy which gave such charismatic sects the reputation for being a primitive and somewhat beserk form of religion. And during the first two decades of this century, when there was a strong fundamentalist backlash against the Darwinian theory of evolution and other such secular ideology, it was the Pentecostalists who were at the vanguard of this 'old time religion' revivalism.

These days, however, the Pentecostalists have gone legitimate. For though they still very much believe in a fundamentalist interpretation of the Bible – and, of course, in the baptism of the Holy Spirit – they are no longer regarded as a 'freak

show' by members of the more mainstream (and less spiritually frenzied) Christian churches. Perhaps this is not only due to the fact that their charismatic displays of faith have become an accepted part of the general Christian curriculum, but also to the sheer scope and diversity of their national membership. Open up a telephone directory in any medium-sized American city and look under Pentecostal churches, and you will inevitably find at least two dozen listings: from the Apostolic Overcoming Holy Church of God, to the Fire-Baptized Holiness Church, to the International Church of the Foursquare Bible. But in the midst of all these ornamentally named congregations, it is the Assemblies of God which is considered the main 'market leader' – the most prominent Pentecostal denomination in contemporary America. And so, attending the Sunday service at the Faith Assembly of God was a bit like walking into a small sub-division of an expanding nationwide religious franchise.

Certainly, the functional design of the Faith Assembly gave it that 'local outlet of a big conglomerate' look which one usually associated with Howard Johnson's. And inside, this no-frills style continued, as the chapel itself was a small schoolish auditorium – simple rows of pews; a long narrow stage which served as an altar; a choir loft that looked like a bandstand; and another small platform housing a portable organ, a small piano and a set of drums. A plain wooden cross had been placed flush against the centre wall, re-emphasizing the sense that, within this house of God, there was little visual distraction to sidetrack you from your communion with the Spirit.

As I came in, I passed by a poster – *Win With God* – and was then confronted by a middle-aged man in a check jacket, a wow-'em plaid tie, and a big toothy smile. He handed me a programme and said, 'God bless you for coming today.' I took a seat in a rear pew and sized up the congregation. They were, by and large, clustered in family groups; the parents ranging in age from their twenties to their fifties. And they all appeared to be solid sunbelt citizens, dressed in the 'Sunday Best' of America's struggling middle class: polyester sports shirts, double-knit leisure suits, and frilly dresses patterned with gardenias.

A silver-haired woman organist played muzaky, low-key inspirational numbers while the faithful filed in and embraced their fellow parishioners with devotional passion. One woman came by my pew and said, 'Good morning, brother'; to which I

immediately replied, 'Good morning, sister', and won myself a smile and her Assemblies of God seal of approval.

All this spiritual *bonhomie* – the cinemascope smiles, the reverential bear-hugs – was fascinating. It was as if I had crashed the meeting of a very select club; a club where the members indulged in vaguely self-congratulatory expressions of fellowship. Not that there was anything terribly smug about this group; rather, I sensed that I was among a flock who considered themselves blessed, who had been let in on a divine secret.

I also noticed a fiftyish man in a steel grey suit, with a rose pinned to his lapel and a small transitorized microphone serving as a tie pin. The microphone was a dead give-away; this was Pastor Russell Cox, the man in charge here. He was working the aisles, doing a great deal of hand-clasping and embracing and grinning, and was accompanied by a young assistant, dressed in an almost identical suit, and also engaged in a great deal of hand-clasping and embracing and grinning. And then the yellow-robed choir filed on to the stage, accompanied by a pianist, a drummer, and a quintet of singers in their twenties who carried nightclub entertainer microphones crowned with big red bulbous foam tops. It was obviously showtime.

They broke into a tune called *Hosanna*, and the entire congregation stood up and essentially 'took off' with the song. This was no ordinary hymn, however, even though the lyrics delivered a solid ecclesiastical message:

> *Hosanna, Hosanna, Hosanna in the highest*
> *Lord we lift up your name with hearts full*
> *of praise. . .*

What made this 'hymn' so unusual was the bossa-nova beat it was sung to. It was 'easy listening inspirational', with a little 'Amen!' thrown in for good measure. But then, in the midst of all this perky fly-me-to-the-moon sort of crooning, the hymn would abruptly end and the pianist would engage in a sung prayer – 'O, you are the Almighty, O Lord! O, you are the King of Kings!' – while the congregation simultaneously shouted out words of praise. This went on for over 15 minutes and became downright raucous, especially as all the adult parishioners swayed wildly while calling out their thanks to God, their arms held aloft to the sky.

This pattern of shifting between an upbeat hymn and interludes of half-sung, half-howled, praise continued through three more musical numbers: 'I Will Rejoice', 'Arise and Sing' and 'The Name of the Lord'. The lyrics of this last hymn were particularly revealing:

> *The name of the Lord, it's like a strong tower.*
> *The righteous shall run unto it and be glad.*
> *Then they'll go forth in victory*
> *Triumphing over the enemy,*
> *Yes, they'll go forth to kick in the gates of Hell,*
> *For they are the Army of God,*
> *Yes, they are the Army of God.*

No doubt about it – at the Faith Assembly you were indeed among the Army of God; the SAS for Jesus. And this platoon belted out that number with such passion that things hit a fevered pitch, with the choir going into overdrive, the solo singers pummelling their tambourines, and the pianist acting as if he'd just mainlined Dexedrine. A display of raw unbridled charismatic ecstasy which reached a rapturous crescendo and then died, as the music switched back to subdued spiritual favourites, a signal that it was now Meditation Time. However, this silent introspection only lasted a minute or so before someone in the congregation extemporaneously yelled out a passage from the Scriptures. Soon, everyone was being moved by the Spirit and vocalizing some Biblical favourite. And these spontaneous recitations were greeted with 'Amen!' and 'Hallelujah!' and even bursts of applause.

While all this high-octane exaltation was going on, Pastor Cox had his eyes snapped shut and was clapping his hands in flamenco dancer style (his left hand held flat out, his right hand acting as the percussive force). I stole a quick glance at my watch – an hour had elapsed since the beginning of the service, and the congregation was showing no signs of vocal or spiritual fatigue. In fact, their appetite for such rhapsodic worship appeared insatiable – as if this was their weekly fix of some all-powerful narcotic, and they were going to ingest as much of it as was physically possible. And though I couldn't share their

holy elation, I certainly could understand its attractions: the sense of shared spirituality, of mutual support, of triumphant purpose. Outside this devout assembly, you might find yourself swamped by the mundanities of life, but within its confines you were a member of the select. A warrior for Christ. And you had a sense of mission in both the temporal world and in the life hereafter – something Pastor Cox emphasized in his first homily of the morning. Reminding the congregation that today was Father's Day, he asked every man over the age of 13 to stand up whether or not they were a father ('Because if you're not a father, you have the capacity *to be* a father'). Then he said:

'I call upon every man in this sanctuary to order their households in a Christian manner, and to be Christian fathers. And remember: manliness is *Christliness*. We are men in Christ's image. And now I call upon the women in this sanctuary to stand up and acknowledge that manliness is Christliness; that your husband or your father is the head of your household.'

Every woman in the church was on her feet within seconds – to dissent from such an edict, I gathered, would almost be considered irreligious at the Faith Assembly of God. For this was Serious Fundamentalist Country – as I further discovered when Pastor Cox launched into his second homily of the morning: 30 minutes of Pentecostal shock treatment entitled, 'Jesus: The Man for All Reasons'. Taking John 8:23–4 as his starting point ('Ye are from beneath; I am from above: ye are of this world; I am not of this world. I said therefore unto you, that ye shall die in your sins: for if ye believe not that I am *he*, ye shall die in your sins'), we were treated to a zealous, combustible sermon about our duty to look upon Jesus as our Saviour, our King. But what was most intriguing about Pastor Cox's thoughts for the day – besides the fact that they were delivered in a cyclonic whirlwind of evangelical rhetoric – was the underlying gist of his message, as it essentially reinforced the 'us versus them' philosophy which informs the world-view of any religious fundamentalist. A few highlights:

'God does not turn to the Bible and say, "You disobeyed this! You disobeyed that!" No! God hangs a tape recorder around your neck, which plays back your transgressions to you.

'Let me suggest to anyone playing games with God this morning – God *ain't* playing games. It's life or death. It's eternity with God or eternity without God. The reason why you and I must believe in Jesus Christ is: if we don't we'll die in our sins. For us to come

61

into the presence of the Lord, there has to be the experience of Jesus Christ or we die in our sins.

'What is that sin? It is the sin that comes to you or me because we trust in everything *but* Jesus Christ. God has to touch us in the place of our strength in order for us to fully trust him.

'Am I making sense at all? Am I getting inside your heads? We do not have any strength without God. Only in God do we stand upright. Sin is no problem to God. Jesus has no problems with your sins. As vile as they may be – as socially unacceptable as they may be – Jesus has no problems with your sins. But. . .

'WHAT HE CANNOT HANDLE IS WHEN HE IS NOT LORD! WHEN HE IS NOT LORD! YOU READING ME LOUD AND CLEAR?

'For any person in this building trusting other than in Him, I ask. . . no – I COMMAND YOU – in the name of Jesus Christ, repent. Change your mind. Turn around. Come to the Lord. DO IT NOW!'

There was a bedazed silence in the sanctuary; the sort of numbed hush which usually follows an automobile accident. Suddenly, I understood why Cathy – the ex-Jehovah's Witness I'd met in Miami – said that the worst thing about leaving The Truth was the realization that there was no paradise to go to when she died; that death was finite. Pastor Cox was basically telling me – and every other silent doubter in that assembly – the same thing. If I accepted Jesus as my Lord, all my sins would be forgiven; if I didn't, not only would I die in my sins for such blasphemy, but I would be condemned to an eternity in total darkness. There was no middle ground between faith and doubt in the Pastor's view – either you were in or you were out. . . and I was definitely out. So I slipped out of the pew and inched my way towards the rear of the chapel while he asked 'those in spiritual trouble, those 'rastling with God this very moment, those in need of healin' hands' to come forward and kneel at the altar. As several couples – some of whom were crying – made their way down the aisle to receive Pastor Cox's healin' touch, I pushed open the main door to the church. Sunlight momentarily flooded the Faith Assembly of God, but nobody appeared to take notice of this flashbulb pop from the heavens. For they were all still communing with their Lord and Saviour; all still attempting to stave off the darkness eternal.

62

In the studios of GRACE FM, Wally was on the air, wishing Sarasota a good morning.

'It's a beautiful day, folks. A beautiful sunny day. So take a moment or two to thank God for this beautiful sunny day. And remember, folks: stay in His Grace and He will bless you.'

GRACE FM was a Christian radio station which operated in a small industrial park on the outskirts of Sarasota. It was a slick operation: state-of-the-art equipment; stacks of CDs; tasteful Danish modern interior decor, augmented by a few homey touches – like a lot of religious paintings from the five-and-dime school of Biblical art. Still, despite the occasional oil portrait of Praying Hands, the atmosphere within GRACE FM was that of an up-and-coming outfit which believed in presenting an enterprisingly glossy corporate image to the world.

Wally was in his mid-twenties; a Georgia boy with a stillborn moustache and a smooth presentation style. He struck me as the perfect Christian soft rock disc jockey – he possessed just the right sort of sincere, feel-good voice and the proper amount of professional glibness needed to 'sell' this ministry, yet still sound reasonably contemporary.

'Now here's the latest hit single from The High Places Band. And while I spin it, we're gonna have a little competition: the thirteenth caller who rings me up and tells me what God has done in his or her life today will win two free tickets to a concert next week in Sarasota by everyone's favourite Christian band, The Imperials. . .'

Immediately, the buttons on the studio telephone were ablaze. The thirteenth caller was a ten-year-old girl named Suzy.

'Well howdy, Suzy. So what's God done for you today?'

'Well Wally, I got stung real bad by a bee yesterday, and I prayed real hard to God last night that the pain would go away, and when I woke up this morning it was gone.'

'Now how 'bout that! You prayed and the pain went away. Prayer is a wonderful thing, Suzy. Especially since you've just won yourself two tickets to that Imperials concert. So you have a good time, and God bless you.'

Wally hit the play button on the studio CD player, and a song called 'The Road to Heaven' went out over the air. It had a Bob Marley-esque reggae beat to it, but its lyrics certainly weren't ganja-influenced:

The road to heaven is a walk with God
From darkness into light
As sure a path to travel
Up to eternal life.

While this number played on, Wally told me a bit about his background: 'I was born into a church-going family in Rome. We're talking about Rome, *Georgia*, of course. Strong Baptist family. And when I was 12, the Lord called me to the ministry. 'Course it wasn't really a voice that I heard when this call came. Wasn't really an audible voice. No, it was just a feeling I had. A feeling that I was meant to serve the Lord. And, for quite a few years, I tried to walk away from that voice. Even though I remained a church-goer all during college, I still tried to steer away from ministry-oriented work. So I first got a job on a *secular* radio station in Rome, but that voice – the *feeling* I had – told me that I had to do something more. . . *substantial* with my life. Something more *meaningful* than being a Top Forty DJ. 'Cause though I loved the Top Forty sounds, there was no *praise* involved in the work. No sense of spreading the Word, if you know what I mean. So, when I heard through the professional grapevine that a new Christian radio station was opening down here in Sarasota and was looking for personnel, well. . . I prayed real hard and went for it. And the Lord cleared the way for me, 'cause I got the job.'

Wally had to break off to run a series of advertisements. For the Radio School of the Bible. For Lamplighters Drama – a local Christian teenage theatre group. And for the Christ Evangelical Lutheran Church – 'where hopeless marriages are restored'. Then he spun another track – a Karen Carpenter-style, touchy-feely song about Jesus wanting to make your life worth living ('That's what He came down here for') – and picked up his monologue again.

'I tell you, I came to GRACE at the right time. Just the right time. 'Cause the Christian music business is really beginning to take off. You ever hear of Amy Grant? She's the biggest 'adult contemporary' Christian artist around today. And besides being one talented Christian lady, she also has real commercial *crossover appeal* – which means that non-Christians are now buying her records and she's getting big air time on the secular music stations too. Well, Amy's just the start of things to come – just shows how the industry's expanding. Like on GRACE, we only used to play Nashville artists with a proven ministry. But

now we're playing Christian music from all over the country. And Nashville is no longer the only place for Christian music. You got Christian heavy metal coming out of LA. You got Christian "Contemporary Country" coming out of Waco, Texas. You got Christian rap music coming from Detroit. . . Of course, like I said, any artist who's played on GRACE has to be part of a ministry. Just like all our staff members here have to be part of a church. And all artists have to minister needs. To talk about Jesus. But not just talk – they have to *live* Jesus.'

It was time for Wally to hand the microphone over to a talk show host named Sandi Cousins. But before he signed off, he ended his broadcast with a little homily: 'In all that you do today and tonight, share your light with the Lord.' Then he asked me if I'd like to join the staff in their morning Prayer Break.

We walked into the foyer where four other GRACE staffers were gathered, including the station's managing director, Bill Butler – very tanned, very fit, very thirtyish, with a real 'I'm a take-charge kind of a guy' aura about him. Prayer Breaks, he explained to me, were conducted by each staff member on a rota basis, and this morning it was the turn of GRACE's receptionist, Christie, to lead the group. She chose a reading from the Scriptures that concerned itself with prayer partnership, and then recounted a story about a friend of hers who had this little pet puppy which she adored, but which had the bad sense to eat his way through an entire box of mothballs. And like anyone who's ever eaten his way through a dozen or so mothballs, the dog fell sick. So sick, in fact, that he was on the brink of checking out of life on a permanent basis. And the local vet wanted to put him down because he felt the dog was a terminal case. But Christie's friend begged the vet to hold off for a day or two and then asked Christie to join her in a long prayer session for the puppy. And so they prayed for several hours, repeatedly asking God to spare the dog's life. And the very next day, the vet rang to say that the puppy's condition had miraculously improved; that he just might pull through after all. Which, of course, he did. Which, of course, is tangible proof that there is *power* to be found in prayer partnership.

After this Dynamoment, everyone joined hands in a circle while Christie thanked God for the fellowship of GRACE FM. Then it was back to work. Bill Butler invited me into his office for coffee. Like D. James Kennedy in Fort Lauderdale, he too favoured burgundy leather armchairs and lots of mahogany – a Sears Roebuck Goes to Pall Mall version of an Anglicized study. And

parking himself behind his big Dickensian desk – a desk littered with framed photographs of his wife and kids – he explained that being a Christian businessman was, on one level, like being any other businessman: you targeted your market; you played hard (but fair) against the opposition; you kept your eyes firmly set on the bottom line. The only real difference, in fact, between an ordinary businessman and a Christian businessman was that the Christian businessman was ultimately concerned with spreading the gospel of Jesus Christ and acting as an evangelical force in the community. And for a listener-sponsored Christian music station like GRACE FM, their 'profit' was counted in the number of souls they were winning over to the Word – which meant that Bill Butler monitored the Sarasota radio ratings with stockbrokerly interest.

'This is GRACE's second year in operation, and we're now Number One across the board in the evenings. It's a phenomenon that has alarmed a lot of broadcasters around here, because we're not only beating out the leading "beautiful music" station in Sarasota, but the rock and "adult contemporary" stations as well.

'And do you know why we're winning? It's not, I think, because people necessarily want to hear our message. No, Doug – it's the *spirit* of what we do. We're positive. Uplifting. Encouraging. GRACE FM isn't negative. It isn't talking suicide or violence. We choose music that inspires, that brings grace. And that makes us a tremendous evangelical tool – especially since a lot of people who are listening aren't Christians.' He paused and gave me a salesman's go-for-it smile. 'Not yet, anyway.'

And for Bill, Christian radio wasn't simply a job – it was a way of life. And he considered himself to be something of a pioneer when it came to Christian rock programming, as most born-again station owners were profoundly conservative, and only allowed Pat Boone-ish spiritual music to be broadcast. Bill, on the other hand, believed that to bring people to Jesus these days, you had to talk the musical language of the times. And at GRACE that language was soft rock: 'the sort of rock that's melodic, but has real spiritual *muscle*.'

But to make that spiritually muscular music appeal to the widest possible audience, Bill had banned all on-the-air pleas for money, because he figured that he could win more non-Christians over to GRACE FM if they weren't blitzkrieged with the kind of financial proselytizing that had come to characterize so much

of contemporary religious broadcasting. Instead, the station ran a once-a-year 'shareathon' where, over the course of a few days, they raised their annual operating budget of $630,000 through listener donations, and then called it quits once that figure was reached.

'I really despise all those "MasterCard For Jesus" tactics which so many of the televangelists use', Bill said. 'Especially since it's created a real crisis in Christian broadcasting. I mean, the fallout from the Jim Bakker scandal and the Jimmy Swaggert scandal nearly killed all of us. But the Christian arts and media will survive because people need us. And I think guys like Bakker and Swaggert are, at heart, good men with the right intentions which somehow got thwarted. Men who sincerely love God, but made the wrong choice. And they became our religious superstars for a while. America loves its heroes, and we tend to elevate Christian leaders to that position. A position they are unable to maintain. We'll tolerate sin and rebellion from a rock star, but not from a Christian leader. And rightly so.'

But after acknowledging that the avarice of Rev. Bakker and the exuberant sexual proclivities of Rev. Swaggert hadn't been good for the Christian broadcasting business, Bill Butler then changed tack dramatically. For when I asked him if Swaggert wasn't ultimately a victim of his own charlatanism, Butler gave me the sort of glacial stare that quickly dispatched me to evangelical Antarctica. And he said, with icy deliberateness:

'Jimmy Swaggert was the victim of one – and *only one* – force: the force of Satan. Jimmy Swaggert brought millions of people into the Kingdom of God. And when the powers of darkness saw the work he had done, they decided they had to destroy him. And the Satanic attack on Swaggert must have been *huge* to have ravaged such a godly man.

'It was the Devil that forced Swaggert to visit that prostitute. It was the Devil that made him do it.'

It was hot. Blast furnace hot. So hot that my fingers did a St Vitus after I touched the seat-belt buckle in my parked car. So hot that, for the citizens of Sarasota, the world shrank in size. Life was reduced to a sequestered existence in a series of artificially chilled environments, with only the poor forced to confront the actual heat of the streets for any length of time. Heat accentuated the

city's economic divisions; heat made me want to get back on the road and away from Sarasota's enclosed society. So I drove north – and I drove straight into a rainstorm. A real Florida rainstorm. The sort of tropical rainstorm which is a tropical *Götterdämmerung*: the sky goes black and, to the sound of celestial kettle drums, there follows a frenzied five-minute deluge. Viewed through the windscreen of a car, this inundation makes you believe that you are in an aquarium where the barracudas and the sting-rays on show have been replaced by Volkswagens and Pontiacs and billboards advertising a restaurant called Buddy Freddy's ('Food Served Family Style'). But then – like someone wiping a massive grey smudge mark off the heavens – the tempest abruptly ends and you are returned to a world of blue skies without the slightest hint of inclement menace. And you wonder whether you have just been treated to a bit of climatic con-artistry – now you see it, now you don't.

What I actually saw, once the torrent ceased, was an exit on the highway for somewhere called Plant City. Check that: Plant City. . . *Winter Strawberry Capital of the World*. Who could resist such a place? So I turned off the interstate and found myself, for the first time since hitting the road, closing in on the American South. Geographically, Florida may be a southern state, but most Floridians will tell you that while its lower half is the Ethnic Melting Pot personified, once you head north a whiff of Dixie enters the air. And Plant City certainly exuded that pungent aroma of a sleepy backwater deep in the southlands. It was a town of big white clapboard houses – embellished with cupolas and spires – and kitted out with spacious front porches that seemed custom-made for venerable rocking chairs. And it was a town with a gem of a Main Street: solid, unprepossessing nineteenth-century brick buildings, with overhanging wooden balconies that shaded the sidewalks from the stultifying sun. There was a squat little 1940s Greyhound bus depot. There was an old Rexall Pharmacy which was having a sale on its stock of Nose-and-Ear Hair Clippers. There was a proper barber shop with real old-style barber chairs and a revolving striped barber's pole out front. There was a jewellers run by a portly gent whose trousers were kept aloft by a set of floral braces, and who had a sign in his window which read: *The Nicest People in the World Pass Through these Doors – Our Customers*.

And then there was North Collins Street. A cobbled street with a real 1930s-issue American high school. And a big white

flag pole on which Old Glory drooped languidly. And a further collection of more stately mansions, freshly whitewashed. Could this be Florida – the Condominium State? I had stumbled into an anomaly – the 1885 edition of what was once a nondescript burgh, but which had now become an artful anachronism in the midst of a monocultural landscape. Was that the fate of any small American town which had managed to keep its clapboard white and its streets cobbled: to be filed away under 'quaint' and looked upon as a cul-de-sac in a nation that was always obsessed with forging ahead; with going places?

Certainly, cruising into the city of Lakeland – a mere ten miles down the interstate – was like moving from a canvas by Norman Rockwell into one by Edward Hopper; trading the benign tedium of Main Street USA for the meretricious bleakness of the Great American Nowhere. But Lakeland was not simply a down-at-heel cityscape of disused warehouses, gun shops and enter-at-your-own-risk bars. Rather, it appeared to be a town which had taken sleaze to its ultimate extremes. Maybe it was its gasoline alley, with billboards like, 'Roman Spa for Men – Next Right'. Maybe it was a 'Fast Food With Style' restaurant with a neon sign that announced it was 'Hiring 18 Year Olds for Nights'. Or maybe it was its tumbledown city centre, with its collection of dull two-storey buildings in various stages of dilapidation. Whatever it was, downtown Lakeland looked like a vast outmoded Depression-era factory. And I sensed that its profound ugliness – the flop-house ambience of its cityscape – had a certain magnetic appeal for marginal people living marginal lives. Like the guy who approached me with a little proposition while I was checking into a cheap motel.

The motel was called the 'Scottish Inn'. It cost $21.95 a night, plus $2 key deposit, and had that fire-trap look of a $21.95 plus $2 key deposit motel. Its manageress was a thickly built, thickly spoken woman who operated out of a tiny office with cracked linoleum and an emphysema-ridden air-conditioner. While I filled in the registration card and handed over the cash, a kid around 21 came into the office. He was rail thin and wore a T-shirt with a box of Marlboros rolled up in one sleeve. A tattoo – *Lucy B* – was engraved onto his right arm; a right arm pockmarked by the occasional needle. But perhaps his most disturbing feature was his eyes. They were as glassy as an ice cube. They were eyes that made you wonder whether the kid's frontal lobe had been tampered with. They were eyes that spelled trouble.

'What you want?' the manageress said when the kid entered the office.

'Want m'room back,' the kid said.

'No way you ever gittin' a room here again,' the manageress said. 'Now you git or I call the *police*.'

'I jus' want the room.'

'Git, you som'bitch. Git!'

The kid left the office. When I had to duck out a few minutes later to get my driver's licence (which I'd left in the car), I found him standing by the Mustang, sizing it up.

'Nice car,' he said.

'It's rented,' I said.

His big catatonic eyes gave me the once-over. Then he said: 'Hey, you straight?'

This question was a little bemusing, but I still managed to say, 'Yeah.'

'You want a woman?'

'No thanks.'

'She's good.'

'Like I said, no thanks.'

'I tell you, she's good. She's real good. I *know* she's good. She's my wife.'

I returned to the office.

'What that punk say t'you?' the manageress asked me.

I told her.

'Damn', she said. 'He made the same offer t'my husband last night. Had to chase his ass off the premises.'

I went to my room. Thick red pile carpet, tatty curtains in a Rorschach test pattern, and a chain lock on the door with a ravine in the door frame where the chain had evidently cut deep in the wood, making me wonder how many times the door had been forced. Outside my window, another resident of the hotel – who bore a striking resemblance to Mr Charles Manson – was shouting up to someone in a room above mine.

'Yo, fuckhead – grab the stuff and let's roll.'

I decided that this night was going to be my only one at the Scottish Inn. As soon as Manson and his accomplice were safely out of the car-park, I left my room and drove up Lakeland's main drag, passing Benny's Oyster Bar ('All You Can Eat Large Catfish Special, $6.95 – No Doggie Bags') and two shops where semi-automatic weapons were on sale. A few miles along the road, I came to a housing estate with a big billboard out front, informing

me that I had arrived at the Carpenter's Home Retirement Community. Beyond this was a curiously monumental structure: a vast tan-and-red brick basilica, sprawled across several acres. This was the Carpenter's Home Church: an Assemblies of God operation with a seating capacity of 11,000, making it one of the largest ecclesiastical arenas in North America.

It was Bill Butler of GRACE FM who told me about this mega-church ('We're talking big time here'), and convinced me that, as I headed north through the state, a pilgrimage to Lakeland's foremost house of worship would be in order. So, here I was, standing in front of this New World St Peter's, staring up at its peaked dome which gave it the look of a big top circus tent. Inside, however, the main body of the church had been turned into a massive television studio. It was a vast arena-like theatre, with row after row of banked pews, all of which looked down on this immense stage that was flanked on either side by a pair of 20-foot-high video screens. A quartet of cameramen were positioned around the auditorium, and overhanging the stage was enough lighting and sound equipment to handle a re-staging of the Nuremberg Rally. At the very rear of the arena was a digital clock the size of an electronic scoreboard in a football stadium. The passage of time was writ large in the Carpenter's Home Church.

It was a Wednesday night. Midweek service night. 'The slow night', according to one of the ushers who handed me a programme after welcoming me to this house of worship. There couldn't have been more than 500 people in the entire auditorium. Had I been an agoraphobic, I would have fled on the spot, for it was easy to feel swallowed up by the wide open spaces of this 11,000-seat basilica. But despite the poor attendance, the faithful who had come out for the evening were, surprisingly enough, in their twenties and single. A neat, well-groomed collection of office workers and check-out cashiers – all of whom turned their attention to our host for the evening; a middle-aged master of ceremonies who stepped out onstage and was simultaneously enlarged to three times his size on the video screens. He was a fatherly sort of guy dressed in a fatherly sort of cardigan, and he asked us all to stand in prayer. Tonight, he said, the theme of the service would be Family Life, and he beseeched us to pray for parents and children. And he reminded us that it was better for the Carpenter's Home Church to minister to young people, rather than letting

71

them learn about life on the streets. Especially in a place like Lakeland.

Then the lights were dimmed and we were treated to a pre-service film show, in which a well-known Assemblies of God evangelist and writer, Josh McDowell, presented episode seven of his talk – 'How to Help Your Child Say No to Sexual Pressure.'

Josh McDowell was fortyish. He had a nice-guy voice and a nice-guy smile. A TV Dad kind of smile. As he began to explain his Christian solutions to the problem of kids confronting sexual pressure, it also became apparent that he saw the domestic battlefield of family life in TV Dad terms. For he explained that one way to teach your child the difference between pubescent lust and real love was by giving him or her a *love model* at home; by making it obvious that Mommy and Daddy really loved each other.

'Now here are some things that have helped me be *creative* in showing my kids that I love my wife,' Josh McDowell said. 'When I leave on tour, or on a speaking engagement, I leave Hallmark Card *love coupons* around the house. . . you know, those real cute coupons that say stuff like, "Redeemable for one Dinner Out", and that kind of thing. Well, once I gave my wife Dotty a coupon that said, "Redeemable for one Night Out at the Ballet", and she told our two daughters that their Daddy must really love their Mommy because she knew how much I hated the ballet. And you know what, folks? To this day, Dotty has never redeemed that coupon. . .

'Then, on our wedding anniversary, I told my kids, I said, "Kids, I need your help. Kids, I'm so lucky to be married to your Mom, I love her so much. So kids, what can I do for our anniversary to show that I love her so much?" And Kelly – that's my oldest daughter – said, "Take her to the beach, and then take her for a swordfish dinner", 'cause they all know that if there's one thing in life that my wife *adores*, it's swordfish. . .

'Now once I heard Kelly sass Dotty. And I turned to Kelly and I said, "You may talk to your mother that way, but you will never, *ever* talk to my wife that way. I love that woman!"

'And whenever I'm on the road, I call up and tell my other daughter – my beautiful little blue-eyed Katie – "Can I talk to that gorgeous woman I'm married to?" '

Dotty. Kelly. And beautiful little blue-eyed Katie. Josh Mc-Dowell certainly had a tough bunch of customers to deal with

at home. But, of course, Josh acknowledged that he wasn't really the *ultimate* head of his household. No, that role was filled by a man named Jesus. And Jesus played a crucial role in the *love model* for the McDowell home, just like he should play a crucial role in the *love model* for every Christian home. Mommy and Daddy mustn't just show Kelly and Katie that Mommy and Daddy love each other. Mommy and Daddy must also show Kelly and Katie that Mommy and Daddy love Jesus too.

After Josh McDowell finished his love model homily, we watched a commercial for a group of Christian hunks who broke cement blocks and preached an evangelical message at the same time. They were called 'The Power Team', and they were Coming To This Church Soon. Then, the house lights came up again and the master of ceremonies returned to centre stage and said that he hoped the congregation would pass the word around the community about the forthcoming show by The Power Team. Especially since, 'There are many young husbands out there who might not be Christians yet, but who might come to the church to see these boys at work.'

A chap named Pastor Gary now took over the proceedings. Pastor Gary was a visiting pastor from a new church in Tampa. A church called Green Pastures. A church, he explained, that was doing great work in Tampa because, 'Tampa is covered in darkness, and it's gonna take a lot of work for Jesus to be enthroned over that city.' Pastor Gary then called up a young couple from the audience. A couple who carried with them their two-month-old son named Chad. 'Chad was born with severe birth defects,' Pastor Gary said, 'so, Father, as they walk down the aisle, I ask you to heal little Chad. Just as I ask you to heal all of us. To heal our finances and our homes.'

While Pastor Gary laid his healing hands on little Chad's brow, the master of ceremonies asked us all to *reach out to Chad* – to extend our hands out towards this child. Five hundred pairs of hands shot out towards the stage, as Pastor Gary began to speak in tongues. And after the Holy Spirit left his larynx, allowing Pastor Gary to speak again in English, we heard a sermon about Preparing for the Return of Jesus:

'We're entering the very last of our days. And it could be that, even tonight, Jesus might just arrive. Yes, Jesus could come down tonight, right through the clouds. . .

'And I believe that we're gonna see a great deal more of God in America. An army of young people – of *young Americans* – will rise

73

up to minister the Lord's word. And I believe we'll see blind eyes open. The deaf will hear. The crippled will walk. And *all* believers will walk in the glory. In the collective anointing. Because God is passing out the spirit of faith.

'So, don't look at your circumstances – look at the world. Don't walk by sight – walk by faith. God said He won't let you down, and He *won't* let you down. God said He won't forget you – He *won't!*'

Then Pastor Gary asked those of us who needed Jesus to raise our hands. No one did. So Pastor Gary tried a new tack: 'Are you disappointed with life? If you are, make your way to the altar.' Suddenly, the aisles were flooded with people, and Pastor Gary was again speaking in tongues and laying his healing hands on a fat woman, who was immediately slain in the spirit and fell backwards into the waiting arms of a church usher. Pastor Gary now turned to another woman, laid his hands upon her head, and she too went into a dead faint. And before long, the scene at the altar was akin to watching ten-pin bowling as, one by one, the disappointed of Lakeland were slain in the spirit and collapsed.

I decided it was time for a beer, so I rode back downtown, looking for a bar that was away from the gun shop district of town. I found a dump on the edge of the city limits – a dump with a lot of cheap wood panelling on the walls, a lot of illuminated beer signs, a lot of smoke, a lot of dim lights, a lot of loud jukebox tunes, and a lot of cold beer for 70 cents a mug. It was, in short, a real joint. I grabbed a stool at the bar, and ordered a shot of Wild Turkey and a beer chaser from an anorexically-thin woman in her late thirties named Tina. She had an impressive drawl and an impressive cigarette habit, and she was in mid-conversation with the guy sitting at the stool next to mine. He was an obvious regular with a name that suited an obvious regular of a dive like this: Al. Greasy grey hair, a greasy moustache, and a distended gut that had solidified into a formidable beer belly. He appeared to be working on his eighth bottle of Bud.

'Like I tole you,' Tina said, 'my husband was a real no good. Beat on me. Beat on the kids. So when he went back to jail, I saw my opportunity and I left the little shit. I mean, my teeth cost me 200 bucks to get 'em right, and what'd he do before he went back to jail? Knocked 'em all out.'

Al took a philosophical swig from his Bud. 'Well,' he said, 'it takes two to tango.'

74

'Shit, yes', Tina said. 'Broke his arm once, so I did. And when he was back in jail, I goes up to visit him and I tole him, "I am havin' an affair. I am fuckin' your best buddy". Should've seen his face when I tole him that. But the way I figured it – and I figured it right – he couldn't do a damn thing about it, 'cause of all of them guards and guns in the visitors' area.'

'Still, was a poor time to tell the man', Al said.

'You know what I wrote him recently? Wrote him that, when I had my new baby three months back, doctors tole me I was free of A-I-D-S. Ran a check on my blood when I had Sally.'

'I don't worry 'bout that AIDS shit', Al said. 'And you know why? 'Cause the truth is I ain't had no woman for three years. I just don't have the *de*sire since what that last cunt did'e'me. After that ballbuster finished me off, I said, "Buddy, no more poontang for a while." '

Al turned to me. 'You sure as shit got a lot of writin' there', he said, looking at my open notebook. We got talking. 'What's an American like you livin' in that England place for?', he said. 'Hell, I've never been out of this country, 'cept for the army. And I don't give two shits if I ever set foot out of this country. Know why? Lots of trouble out there. Too much fuckin' trouble, if you ask me.'

Without probably realizing it, Al had just summed up a view of the world that was held by a majority of Americans.

'Tina, honey, give this man another Turkey and another brew.'

A second bourbon and beer chaser showed up in front of me, and I roamed between the two glasses while Al launched into a rendition of that favourite bar-room number, 'Hey Stranger, Lemme Tell You 'Bout My Life and Hard Times'. In Al's case, however, his hard times had really been major league hard times. He was 55 and originally from Pennsylvania, though he'd lived in Florida since his early twenties. He'd done a stint in Korea courtesy of the US army ('You ever kill anyone, son?'), and had been married for 23 years until his 'drinking and bad ways' lost him his marriage and his job as a mechanic in Tampa. But Al didn't just lose his family and his means of employment. The divorce settlement cost him his house, while his heavy juicing meant that he ran through every penny he ever had ('Pissed it all up against a wall, son'). At the age of 49, Al hit bottom and found himself on the street. Literally on the street. And he lived on the street as a vagrant ('A fuckin' derelict, if you wanna know

the truth') for five years. He slept rough in Tampa, he slept rough in Orlando, he slept rough here in Lakeland. And it looked like he was going to spend the rest of his life sleeping rough, until 'something real weird happened last year in Tampa'.

It was January in Tampa; an unseasonably cold January, which meant that Al couldn't take sleeping on the streets anymore, and was looking for some sort of indoor accommodation. What he found, eventually, was a tiny shelter beneath a building – a 10-foot by 6-foot niche in what was probably once a ventilator shaft. And he managed to rustle up a couple of blankets and turn this little space into a reasonably cozy little bedroom ('Believe me, son. . . when you've been sleeping in the gutter, a ventilator shaft's like the goddamn Hilton'). There was only one problem with this set-up – the building he was lodged in turned out to be a church; a church where the congregation frequently talked in tongues. 'You know what it's like, trying to sleep while listenin' to all that fuckin' gibberish? Drove me nuts, that talkin' in tongues.

'But then, one Sunday, this real strange thing happened. Woke up to the sound of 'em talkin' in tongues inside the church, and I lay there in my blankets and I started to cry. Cried real hard. And then, I got up and went across the street to a little park, and I got down on my knees and I confessed all to Jesus Christ. Just like that. Can't say I was born again on that day. Don't really know why the fuck I did it. But, I tell you. . . after a little while, God started to put it together for me. Met this guy who had this concrete business, and he tole me, "Al, I want to get you back on your feet. You come over here to Lakeland and I'll see if I can fix you up with a job." Well, I'd been savin' a little money from the occasional odd job I'd been getting, and I had 40 bucks to my name, and I blew half of it on the busfare to get here. And the very next day this guy gave me a job working the roads; a job that takes me all over this goddamn state. Even gave me a free room here in town.

'Like I said, I don't think I had a born-again experience. But God put things together for me. He really did.'

A young woman walked by us. She wore a pair of jeans that appeared to have been heat-sealed to her torso. Al took another philosophical swig from his bottle of Bud.

'Now the weather report on that piece of ass is stormy.'

'I want you to sit down and I want you to call me. I want you to sow right now a hundred dollar vow of faith. And when you send me that hundred dollar vow of faith, I'm going to send you a prayer cloth. And a book. And I'm going to anoint you through the Lord.'

This was the sales pitch of Robert Tilton – a Dallas-based televangelist who ran a church called 'Word of Faith' and hosted a syndicated show – 'Success in Life' – which I caught on the local Lakeland Christian television station. Rev. Tilton informed us that his was 'a programme designed to meet your needs and show you how to attain *success in life*'. And Rev. Tilton presented a filmed testimonial from a 'poor black couple' from Alabama with ten kids; a couple who, up until recently, were profoundly *unsuccessful* in life. The husband had been out of work for over two years, with the result that his landlord and all his other creditors were threatening him with the bailiff. But just when he was on the verge of permanently going under, his wife told him to watch 'Success in Life'. And, sure enough, after sowing that hundred dollar vow of faith (with his last welfare cheque), the Lord began to act in mysterious ways. For the very next day, the husband got a part-time job mowing lawns. But when that job still didn't bring in enough money, and his creditors continued to threaten him with all sorts of Gestapo tactics, they sowed another vow of faith with Rev. Tilton. And, lo and behold, their needs were answered with a full-time gardening job for the husband and a part-time job for his wife in a paper cup factory.

'The secret of our success', the wife said, 'was sowing that hundred dollar vow of faith.'

Rev. Tilton came back on the screen. 'Isn't that a sweet story?' he said. Then he suddenly got this mystical I'm-convening-with-Mr-Big look in his eyes and he said, 'There's a person out there watching me. You've been watching this programme several times, but haven't yet felt God's anointing power through me. You need to call me right now. Real quick. And you need to sow a vow of *one thousand dollars*.'

I cut off the television and cut out of Lakeland, never once looking back for fear of turning into a pillar of salt. Speeding north, I hit the interstate and the scanning button on the car radio. There was a news item on one station that must have been music to Robert Tilton's ears – despite the Wall Street crash and despite all the 'pulpit scandals' of the past year, Americans still reached into their pockets to give over $93 billion to churches, charities and

77

philanthropic organizations during 1987 – and around 88 per cent of all these charitable donations came from private individuals. Further down the dial, an oldies rock station was taking phone-in requests:

'I'm a police officer, and I just want to tell you that everytime I've got a prisoner in the back of my car, I turn on your station and it cools the dude right down.'

The cop then asked to hear a classic Aretha Franklin number: 'Respect'.

I continued cruising up the central spine of Florida until I reached Gainesville – home of the University of Florida and its football team, the Florida Gators. It was a cozy university town, replete with a mock Gothic campus as well as plenty of bookshops and cheap bars – the two essential requisites of academic life. But perhaps the most striking feature of Gainesville was the dozen or so churches which faced the university along the city's main drag. Seeing this ecclesiastical shopping precinct – in which just about every major Judaeo-Christian faith was represented, and there was even a mosque for Gainesville's Muslim community – I was reminded of a famous comment by one of America's legendary bank robbers, Willie Sutton. When once asked why he robbed banks, Sutton said: 'Because that's where the money is.' And why were all those churches strategically positioned opposite the University of Florida? Simple: because that was where the potential believers were. Or, in the case of the Crossroads Church of Christ, that was where the potential *recruits* were.

It was Crossroads that brought me to Gainesville. I'd first heard about this offshoot of the Church of Christ from Cathy in Miami. She told me that Crossroads figured prominently in her work with the Florida cult awareness network, and that she herself had dealt with several cases of university students who'd gotten drawn into this 'control oriented' sect, only to then find themselves in a spiritual Albania run by a regime which didn't like its membership to leave its borders. In fact, Crossroads had caused huge controversy within its parent church, the Church of Christ – one of the oldest of American religious bodies. The Church of Christ is a network of independent denominations which began as a nineteenth-century Christian movement to unite churches which were then primarily located on the American frontier. In other words, it was – and still remains – a federation of churches with no binding dogma, other than a fervent belief in Jesus Christ. Poke around and you'll find both fundamentalist and liberal Churches

of Christ, not to mention denominations which – in keeping with the old frontier traditions – still ban the use of musical instruments during their worship ceremonies. But Crossroads was a unique and (many believed) disturbing subdivision of this Christian federation – a 'soul-winning ministry' which (according to one sympathetic study of Crossroadsism I read) was dedicated to *restoring* the ethos of New Testament Christianity by practising a faith-sharing *one-another* religion. This was the sort of intimate, mutually shared spirituality that had been the basis of the early Christian church of the first century, when there was no such thing as institutionalized religion and fellow believers 'lived in close, active fellowship with Christian brothers and sisters'.

At Crossroads, this sort of 'active, communal fellowship' also existed. And to achieve this early Christian ideal, they recruited a primarily young student membership who were encouraged to live in church housing, to give all their free time to the church, and to follow a very rigorous Christian curriculum – the basis for which was found in such Biblical instructions as *encourage one another and build each other up* (I Thessalonians 5:11), *confess your sins to each other and pray for each other* (James 5:16), and *Submit to one another out of reverence for Christ* (Ephesians 5:21).

As can be gathered from those Scriptural directives, the notion of 'Christians sharing their faith consistently' was a key element in Crossroads ideology, where everyone was assigned a 'prayer partner', who essentially operated as their spiritual shadow. In 'prayer partner relationships' Christians were supposed to 'find encouragement and support to deal with and overcome besetting sins and problems', to 'help each other overcome personality flaws', and 'to correct, rebuke and encourage one another'.

It was this one-another idea that was cited by Cathy – and by a mainstream Church of Christ minister I spoke with later – as proof that Crossroads was cult-like. For the theory behind prayer partnership was similar to the theory behind having two men guard a nuclear missile silo – if one partner stepped out of line, the other partner was there to nail him. And though I myself wasn't interested in 'infiltrating' Crossroads – especially since Cathy told me horror stories of two trained psychiatrists who attempted to get behind the lines of a similar Californian Christian sect and were converted in the process – I was curious to see how they sold themselves to a potential innocent recruit. So, I decided to swing by their church and casually present myself as someone knocking around the South for a few months, with the

intention of eventually 'writing something' about the varieties of American religious experience. And to make myself sound like a possible convert, I would also say that I was an Unitarian who was very keen to learn more about a 'praise oriented' church like Crossroads. However, when I rang Cathy in Miami to explain this approach, she insisted that I call her before I visited Crossroads, so that – in the event she didn't hear from me again by nightfall – she could call the police. I thought such a precaution bordered on the melodramatic, but Cathy was insistent, reminding me once more of those two Californian shrinks who were now fully-fledged Moonies. So, shortly after arriving in Gainesville, I found a pay phone and left a message on Cathy's answering machine that I was about to take a leap into the void and – Allah willing – would buzz her back later.

Naturally – given the high theatrical build-up that I had received about Crossroads – the church itself turned out to be a profoundly ordinary modern stone-and-wood structure located on a leafy suburban street. There were no Berlin Wall-style look-out towers, no televisual surveillance equipment, no beefy security guards manning its front gates. I freely wandered through one wing of the building that was used as a nursery school until I was stopped by a sturdy guy around 30, wearing a polo shirt. He did a slight double-take when he saw this stranger in his church's corridors; a double-take that turned into a big smile when he said, 'Hey friend, can I be of help to you?' His name was Ron and he was one of Crossroads's pastors. When I gave him my spiel about recently arriving in Gainesville and wondering what Crossroads was all about, he said – a little too eagerly – 'Well, that is just fantastic.' And spinning me around, he led me to his office where – within minutes – he was gently, but thoroughly, questioning me about my family, my religious background, my reasons for travelling around Florida, my work. When he asked if I was planning to stick around town for a while, and I said that I had no set plans, his eyes lit up. And he told me that Crossroads had a membership of around 800, but that it was growing all the time; and that I would find a lot of students were members of the fold; and that theirs was a *love oriented* ministry.

'Man's fundamental needs, Doug, are love, companionship and a purpose in life. And all these needs are met in the person of Jesus Christ. And our church is all about getting people to understand that Jesus loves them. That He has a major place in their lives.

'You see, when *you* have a personal relationship with Jesus, then *you'll* be able to transcend things that you don't understand. And the central message of the Bible is that Man has a problem. He has sinned and has fallen short of the Glory of God. He stands in need of forgiveness. And in accordance with His infinite love of man, God sent His only begotten son into the World, who died for Man's sins. Jesus died for *you*, Doug. Just like He died for all of us. And what you'll discover at Crossroads is that we are a group of people with a simple, abiding faith. And when I came to Crossroads, I was going through some tough times, some tough changes – just like you're probably going through some tough changes now, in your thirties. And when I was befriended by the members of the congregation here, that friendship couldn't have come at a more important time of my life, because they gave me *love* when I needed it the most. And I realized that I was like that man who wanted to follow Jesus, and Jesus said that if he wanted to follow Him, he should give everything he owns to the poor. And the man said that was impossible for him to do. And Jesus said that with faith, it would be possible. . . that with God, everything's possible.

'Well Doug, with God in my life everything *is* possible. My life has improved one hundred times since I came to Crossroads; since I came to the Lord. I have deeper, richer relationships than I ever had. I even have *confidence*, which is something I never even conceived of having before. And it's a confidence that comes with knowing I have a personal relationship with Jesus. And with his personal presence in my life, all my needs have been met. *All of them*. And I realize that my purpose is to become like the Jesus Christ who saved me.

'That's why our movement could be called a *restoration movement*. Because it is our job to restore individual lives to Jesus Christ. Every man is called to be a devoted follower of Jesus Christ.' He narrowed me in his sights. '*Every man*. And what you'll come to realize, Doug, is that people are important, but only because God created them. And a man's life will have no importance unless he realizes that his real purpose – his only true purpose – is to serve the Lord. His *only* purpose, Doug. Have you ever thought of that? Of *your* purpose. . .?'

A ringing telephone saved me from answering that question. Ron picked up the receiver and was quickly involved in a curiously evasive conversation, during the course of which he swung around in his office chair and, showing me his back,

whispered into the mouthpiece, 'Look, I can't talk right now. . .'
Then he hung up and turned back to me, all smiles.

'Listen, I've got to go off and see a member of our congregation who has a little problem we've got to sort out, but how about getting together again tomorrow? You got a phone number in Gainesville?'

I said I was staying in a motel on the outskirts of town.

'Well lookit, Doug. . . here's my number here at the office *and* at home, and I want you to call me there tomorrow and we'll fix up a time to meet. In fact, you can call me tonight if you want to. You can call me there *anytime*. Anytime you want us to talk. And, after we meet tomorrow, I'd like it if you could come and meet our community and join us at our community worship on Sunday. We'd really like you to be there. *To be with us.*'

He put his hand on my shoulder as he said this. And I wondered: if I was at a loose end in my life – with no sense of purpose or direction. . . if I was shopping for some meaning to my day-to-day existence – wouldn't his offer of instant fellowship seem tempting? Especially since – as an added bonus – I would also have all my needs met once I accepted the Crossroads idea of 'simple, abiding faith'? Especially since this extraordinary offer of fellowship and total personal fulfillment was being given to me not by some fanatic with a glazed, brainwashed look on his face, but by a seemingly conventional, seemingly rational man who spoke in a thoroughly rational tone of voice. That was the chilling thing about Ron – his sense of total conviction, of absolute certainty. And his belief that we are all prospective Crossroaders, just waiting to be plucked off the vine.

'You *will* call me tomorrow?' Ron asked, his manner beseeching, yet firm. I promised him I would and left, thinking that the most dangerous sort of spiritual stalag was the one you entered by your own choice. Five minutes later, I was on the interstate roaring north at 90 mph, putting as much distance between myself and Gainesville as possible. I kept the pedal to the metal for an hour, until the state of my petrol gauge forced me to pull off into a service station and tank up. The 'pump jockey' on duty was a kid who wore nothing but a pair of shorts and a baseball cap, and who eyed up my Irish-issued Visa card warily.

'Hey, you're one long way from home', he said.

His accent was northern. 'So are you', I said.

'Yeah, Illinois.'

'Been in Florida for a while?'

'Six months. Hitched down here in December.'

'Why'd you end up this far south?'

He looked at me as if I'd just asked him the dumbest question in the world. 'What brought me here? Nothing, man. It was a cold day in Chicago, so I split. That's all. Got here. Got this job. Real simple shit.'

'You like it down here?'

'Hey, you don't "like" Florida – you *deal* with Florida. This place is a hothouse, man. You come here thinking you're gonna blossom, but all that happens is you get your ass burned.'

A *hothouse*. It was the perfect metaphor for life in a trashed paradise. A place of failed expectations. A place where – as I saw at Crossroads – anyone in the game of selling a slice or two of utopia could be guaranteed some business. After all, what else is there to do in a hothouse but dream of germinating into something better than you already are?

I rolled back onto the interstate and veered into the fast lane, chasing a souped-up Chevy with a bumper sticker adorning its rear. A bumper sticker which read: *SHIT HAPPENS*.

Existentialism Florida-style. And a signal that it was time to make a break for the state line.

CHAPTER 3

Down-Home

★★

'Now, David, I want you to get down on your knees and ask the Lord for forgiveness. You down on your knees, David?'

'I'm down,' David said, his voice fractured with sobs.

'Now, David – I want you to promise the Lord that you will never, *ever* pick up a divining rod again.'

'But like I tole you, reverend, th'only reason I was divining for water was 'cause of the drought. Lack a water's killin' my farm, reverend.'

'Divining for water is an occult practice! It's for the devil! You understand what I'm saying, David?'

David couldn't answer – he was crying too hard.

'And remember just one thing, David – the twitch you feel in your arm when you hold that divining rod will one day be replaced by the bend of the knee when you eventually kneel before the Almighty in judgement!'

I caught this little Christian psycho-drama on my car radio while cruising westwards across the panhandle of Florida. It was part of a religious phone-in advice programme – broadcast from somewhere deep in the circulatory organ of Texas – which encouraged listeners to call up and talk about their spiritual problems with a 'reverend' who assumed the role of the pious shrink and also acted as ecclesiastical judge and jury – especially when it came to anyone in possession of a divining rod. After getting David the Diviner to promise that his water-hunting days were over, the reverend took a call from a woman named Carol.

'How can the Lord help you, Carol?'

'Reverend, I got poltergeist problems at home.'

Five minutes later, after listening to Carol describe milk cartons that moved in mysterious ways and a tub of butter which just couldn't keep still in her fridge, I crossed into LA – Lower Alabama. But I didn't simply travel over a state line; I also moved across a major American frontier and into the true epicentre of the deepest Deep South. For Alabama is a state with *a reputation*. In the 1960s, it competed with Mississippi for the dubious honour of being the nation's leading repository of old-time racial prejudice: South Africa with a poor-white-trash drawl. This notoriety was fuelled by the actions of Alabama's governor during this period, George Wallace. His white supremacist views led him into direct confrontation with America's Attorney General of the era – Robert Kennedy – especially in 1962, when he personally blocked two black students from attending classes at the University of Alabama. Of course, given that the state refused to allow blacks to enroll in its universities – let alone sit in the front of its municipal buses – it's no wonder that Alabama was also a focal point for the civil rights movement.

Martin Luther King began his campaign of non-violent civil disobedience in the state capital of Montgomery, where he was also the minister at the Dexter Street Baptist church. The town of Selma, Alabama, meanwhile, was the scene of one of the more legendary confrontations of the time, when state troopers headed off a civil rights march at a bridge on the outskirts of Selma, and refused to let its participants continue their progress towards Montgomery for a protest rally. And when the marchers – in a display of Gandhian-style courage – continued to advance directly into a baton charge by the forces of law and order, the rest of the country (outside of the South, that is) was so appalled by Alabama's display of police state behaviour that Selma marked a major turning point in the campaign for racial equality, and one which essentially shamed the houses of Congress into accelerating the passage of legislation against the colour bar traditions of the southlands.

Nowadays, though, Alabama is considered to be a key player in that recent construct known as the *New South*, which promotes itself as a socially progressive, economically go-getting region that has been purged of its malevolent bigotry. But before entering this glossy realm, I wanted to spend some time lolling about its dustier fringes in a small town which might just serve as a way-station between two visions of the South: that brave new southern world of 'bottom line technocracy', and that archetypally grotesque

Faulknerian backwater, where the population was rumoured to rely on bourbon and incest to pass the time.

In short, I hoped to find a *down-home* sort of a place where a down-home religion was practised – down-home being a folksy American version of what the Germans call *Gemütlichkeit*. It speaks of provincial coziness, and good old country comfort, and life lived in an atmosphere of hospitable torpor. When I studied a map of Alabama, and saw a cluster of towns grouped over three counties in LA – towns with names like Opp and Elba and Ozark and Enterprise and Coffee Springs – I decided to point myself in that general down-home direction.

Which is how I came to be travelling north from Florida to Alabama on a narrow slip of tarmac called Rt 231. It was early evening and, as light receded, I passed a series of small decrepit farming communities with roadside stalls selling an esoteric selection of local produce: Vidalia Onions, Hot-Boiled Peanuts, Yellow-Meat Watermelons. Then, when night finally blacked out the landscape, I drove through what appeared to be a long dark rural tunnel with no signs of life – that is, until I reached Dothan, a town named after a geographic reference in the Book of Genesis. A town with a population of 49,000, making it the bright lights, big city of Lower Alabama. A town which was centred within an outlying strip of drive-in joints and convenience stores and motels.

I checked into one of those motels and asked the young woman behind the desk what passed for nightlife in Dothan. She shouted into an adjoining office:

'J.W., can y'all tell this man here where he can find some action?'

J.W. If I needed any proof that I was deep in Alabama, this was it. J.W. emerged from his office: a guy in his twenties, dressed in a short-sleeve shirt and a snap-on tie, with a plastic pen holder in his breast pocket.

'Well, there's two types of action in Dothan. The good action – that's in the Ramada Inn. And the bad action – that's in Cowboys. Real low-life sort of place.'

I dropped into the Ramada Inn, which was hosting a convention of representatives from the Alabama State District Attorney's Office. A dozen electric red and blue Corvettes adorned the car park: a sure sign that the Ramada 'nightclub' was a favourite rendezvous for Dothan's upscale bourgeoisie. Inside, the place was packed with beefy ex-footballers and their ex-cheerleader

wives, dancing to Elvis classics. I'd never seen so much blond hair congregated in one room before, and I was out of there within five minutes, moving on to Cowboys.

J.W. was right: Cowboys was pure undistilled low-life. A great big meat rack of a place on the outskirts of town, furnished with the sort of utilitarian tables and chairs that were probably chosen for their ability to stand up to the occasional brawl. There were a lot of heavyweight, heavily bearded guys at the bar, their Stetsons pulled low over their eyes; there was a contingent from the local We-Scare-Old-Ladies motorcycle gang; and there was a band onstage called Lois Lane, who bore no resemblance to Superman's girlfriend, since they all displayed the scars of punk rockdom (spiked pink Mohican haircuts, safety pins dangling from their nasal cartilages), and played *oeuvre de heavy metal* music.

Then there was Bubba. Bubba was a dude in his early thirties, shooting pool in a far-off corner of Cowboys. I'd drifted over there to get away from the eye of Lois Lane's aural typhoon, and was waiting for a table to free up when Bubba – who was playing on his own – saw me and asked if I'd like to shoot a rack or two with him.

'You live in *Eurpe*?' Bubba said. 'Damn, y'make me homesick. Dyin' t'get back there, tell the truth.'

It seemed that Bubba had lived in *Eurpe* for five years, was ostensibly married to a *Eurpean*, and came from the sort of convoluted ethnic background which you didn't expect to find in Lower Alabama. His mother was Filipino ('Which kinda accounts for mah Asian lookin' eyes', Bubba said) who'd met his army officer father in Manila during the 1950s, married him and accompanied him back to his LA hometown of Enterprise. Now if coming from Manila to Alabama scored a ten on the culture shock scale, then being abandoned by her husband a year after Bubba was born immediately elevated her to Madame Butterfly status. Especially since she had not been back to the Philippines since her emigration in the 1950s and – according to Bubba – remained very much a proper Filipino Catholic who spoke a Tagalog-inflected version of English.

No doubt, she must have occasionally felt bemused watching her only son develop a local drawl (given that Filipino-Americans with *good ole boy* accents are not exactly endemic in the South). And, no doubt, she must have also felt bemused when history somewhat repeated itself, as Bubba got himself involved in a

87

relationship with a foreigner that was destined to end in tears – and, of course, did. He'd met Mariella while serving with the US army near her native city of Pisa, and got hitched to her four months later. But when his tour of duty in Italy was over, and Bubba decided it was time to return both to civilian life and to Enterprise ('Cause mah Momma was real lonely without me'), Mariella refused to follow him – on the grounds that the marriage had been in trouble from the start, and she simply didn't think that it was going to have much chance of improving down in Lower Alabama. So they decided to try a trial separation – Mariella would stay in Pisa, Bubba would return to Enterprise, where an old army buddy had offered him a job with his real estate company. And though Bubba agreed to the separation, 'it kinda broke me up.' Mariella didn't take the estrangement very well either, but they appeared to be in the midst of one of those conjugal Mexican stand-offs where neither party was prepared to compromise in order to save the marriage. Which meant that Bubba was stuck in Enterprise, playing the real estate salesman while, all the time, longing to get back to *Eurpe*. Longing to get back to his wife, who kept calling up and telling him how much she missed him, but how she knew that they were never going to work out their problems.

Bubba admitted that he found himself tied up in a real emotional Gordian Knot, because though he couldn't leave his job and his Momma, he also considered Enterprise and environs a little stifling after his years in Italy. It was a realization that made the heartburn of his marriage bust-up twice as bad. So, to dull the pain, he spent a lot of nights driving the 25 miles between Enterprise and Dothan to hang out in Cowboys, shoot some pool, drink some beer and let the buzz saw sounds of heavy metal music deaden his brain.

I asked him what he did to pass the time in Enterprise.

'Not much to do t'pass the time 'cause Enterprise ain't exactly the liveliest place. Only got 12,000 population and most of them's at the army base, Fort Rucker. Only got one Main Street and a coupla shopping malls. And I guess the biggest attraction of the place is the monument to the Boll Weevil downtown. Local folks put up that monument 'round 1900, when the Boll Weevil – that's a nasty sort of beetle – ate up the town's cotton crop and forced Enterprise to turn to peanut farmin', and made the town rich, 'cause now it's one of the biggest peanut growers in the world. So the Boll Weevil monument is really a monument

of thanksgiving to a *critter* – which kinda says it all about Enterprise.'

It sounded exactly like the small town I was looking for. And I asked Bubba if he had time to show me around tomorrow.

'Shit, yeah, I'll be happy t'show you Enterprise. But I'm warnin' you – it'll only take five minutes.'

I met Bubba at noon the following day in the heart of Enterprise. Right in front of the Boll Weevil monument – a marble statue, festooned by flowers, of an ancient goddess holding a bronze Boll Weevil above her head. It was the only gaudy object on a Main Street that was noteworthy for its petrified aura. With its elderly five-and-dime stores, its old-style millinery and haberdashery shops, and a beauty parlour that still seemed stuck in 1937, Downtown Enterprise was a fossil of small-town American consumer life before chain stores and shopping malls began to wipe the minor league shopkeeper off the commercial map.

'Told you the place wasn't much t'look at', Bubba said. Bubba's car, on the other hand, was an eyeful. It was a Trans-Am sports coupé – a neon green road-hugger which probably screamed 'Make My Day' to any other vehicle foolish enough to try to pass it on the highway.

'Quite a car', I said, knowing that, had I not acknowledged the spectacle that was Bubba's wheels, I would have committed a major social gaffe – because a car like that is primarily purchased so all who see it *must* acknowledge it. Bubba was pleased with my response.

'Damn right it's quite a car. Cost me 18 thou., but I love it.' And though I was tempted, I stopped myself from asking him whether he purchased it in the wake of his marriage break-up.

We set off in his Trans-Am for a little tour of Enterprise and environs – the dull solidity of Downtown giving way to backstreets which yielded up spacious clapboard and red-brick houses, fronted by equally spacious parcels of lawn. There was something comfortably venerable about this district – no-nonsense turn-of-the-century architecture that hinted at the sort of no-nonsense unostentatious lives led by the town's professional classes who occupied them. But the further we drove into this residential area, the more modest the houses became – to the point where they ended up being dilapidated shacks. That's

89

when I realized that, somewhere during the course of our drive, we had crossed a dividing line which – though invisible – was known to every resident of Enterprise: the line between the white and the black districts of the community. What was intriguing about this boundary was that its frontiers weren't starkly delineated: white prosperity didn't suddenly give way to the black underclass. Rather, it was clear that there was one point in the ethnic geography of this quarter where the blacks and whites of Enterprise shared a similar economic standard. But then – after this patch of middle-class meeting ground – the gaps between the two communities became distinct, to the point where Bubba, pointing out a small Church of Christ, said:

'That there's a coloured church. You want to see a coloured service, you go there. But I won't go with you.'

Coloured: a politely derogatory term; a semantical mid-point between the racist extremities of 'nigger' and the social correctness of 'Afro-American' or 'black'. *Coloured*: a word evidently in common use in Lower Alabama, and one which sounded particularly odd coming from the lips of a Filipino-American (though Bubba, as I came to learn, wasn't looked upon in Enterprise as a member of an ethnic minority, but as a good ole boy who just happened to end up with a Momma from Manila). As he himself admitted, though the divisions between the races was not as pronounced as they once were, old habits still died hard down here:

'Like we got no actual segregation in Enterprise,' Bubba said. 'It's jus' that folks are still more comfortable separate, y'understand?'

Before I had time to state whether or not I did understand, Bubba slipped a tape into the Trans-Am's radio-cassette player: a tape of a German heavy metal band named The Scorpions, who were the rock-and-roll equivalent of a Luftwaffe raid. The quadrophonic music said it all: Bubba was letting me know that the subject of race relations in Enterprise was closed. I took his point. Just like those residents of Belfast who must get fed up with visitors asking them stock questions like, 'How can you live in this war zone?', so many Southerners (as I quickly found out) have come to expect any Yankee passing through to inevitably raise the issue of racial segregation. And – even if the Yankee meant no harm – the very fact that he broached the subject in the first place would inevitably lead him to be dismissed as some superior Northern boy who's taking pleasure in reminding a Confederate just who won the Civil War, while simultaneously hinting that he

90

too considers his Southern compatriots to be nothing more than a collection of bigoted primates. So I dropped the subject as Bubba gunned his engine and hauled us out of town.

We peeled down some narrow lanes before making a bee-line for the outer reaches of Coffee County – flat, arid acres of corn and peanut fields blanching under that merciless Alabama sun; a region nicknamed 'The Wiregrass' because of its scrubby vegetation. It was 101 degrees and Bubba had the air-conditioning on overdrive as he pushed the speedometer into a similar three-figure region, winging us at low-altitude through a collection of upcountry hamlets. Places with names like Ino and Jack and New Hope. Places with one general store, a church, a graveyard and little more. In one of these burghs – the village of New Hope – we stopped in the local shop to buy a six-pack of beer. Here, ceiling fans put up a useless fight against the heat, and a sign over the cash register informed all comers: *We Do Not Like Profane Language Around Here*. A pair of ageing farmers – both wearing white straw hats – were hanging around the counter which stocked anti-brucellosis products, talking about the heat.

'Tellin' you, Roy,' one of them said, 'I was up with the cows at 5am this morning and it was 79 *degrees*. Seventy-nine degrees in the middle of the night – can you figure it?'

'Yeah, I can figure it,' the other said. 'And I figure it's a heatwave.'

After this backroads tour, Bubba commandeered to the home of his sister, Billie. Only Billie – as Bubba explained to me en route – wasn't actually his sister; rather, she was his *adopted* sister. But, to make matters more complicated, it wasn't Bubba's parents who adopted Billie – it was Bubba and Billie who adopted each other just a couple of months ago. They even had an officially notarized piece of paper stating this fact, though they both knew that the adoption wasn't really legal in the eyes of the state. It's just that Bubba and Billie were such close buddies that they decided they might as well be brother and sister. Especially since Bubba and Billie had both had a terrible year, what with Bubba's marriage coming apart, and with Billie's boyfriend getting so dejected when Billie broke off their relationship that he put a bullet through his head ('And the guy used a .357 magnum', Bubba said, 'which meant he was kinda serious 'bout the job'). Needless to say, Billie was understandably depressed after this event, given that she'd never had an easy ride with men, having been married twice before. And so, when she met up with an equally depressed

Bubba at the local Enterprise sports club, well. . . it was only natural that they should either end up in bed, or end up adopting each other as brother and sister – and they both decided that adopting each other was the far simpler option.

Billie lived with her sister, June, in a ranch-style house in Level Plains, a town near Enterprise. She was 46, a short woman with a heavily grooved face and a deep involvement with menthol cigarettes. Three half-smoked packs of Salems and four brimming ashtrays dotted the kitchen table where June also sat, working her way through a tub of Mocha Fudge ice-cream while a Marlboro smouldered in an ashtray to her immediate left. June was a few years older than Billie; stocky, a little run-down, a little depressed today because her divorce papers had just shown up in the morning post. Not that she wasn't expecting them. After all, the court hearing had been three months ago, and she and Ray had been separated for over a year. It's just that the arrival of legal documents informing you that your 32-year marriage was over tended to get the day off to a bad start. Still, one had to look on the bright side of things. In the same post, a silver pen-and-pencil set had also arrived from one of the many mail-order houses that Billie and June patronized. And Billie was currently filling out an order form for an air ionizer from a catalogue which specialized in health products. Billie and June did a lot of shopping by post. Scattered amongst the cigarettes and the ashtrays were a dozen or so mail-order catalogues from places that dealt in stuffed furry animals, and car valeting equipment, and silk lingerie, and camping gear, and even a military supply outfit where you could mail off for a machete or a specialized set of sunglasses which shielded the eyes 'from dangerous high-speed projectiles'. Billie and June did a great deal of snacking as well, because any section of the kitchen table which wasn't taken up by cigarette packs, ashtrays or mail-order catalogues was taken up by bowls of nibbly food: nachos, cheese puffs, tortilla chips, guacamole, jalapeno dip, honey-roasted peanuts, chocolate chip cookies, butterkrunch popcorn. Looking at that overloaded table was like looking at an abstract vision of consumerism; a three-dimensional testament to the fact that gorging yourself was one way of coping with life's manifold traumas.

As it turned out, however, Billie and June had been brought up to believe that there was a different way to cosset yourself against feeling shortchanged by life, and that way was through a love of God. In fact, they had been raised by a father who was

thoroughly convinced that Jesus was a man's only true friend, and who spent much of his life wandering the country in search of Him. And while June excused herself to run out to the local supermarket ('We're runnin' short of supplies 'round here', she said), Billie lit another Salem, chain-dunked some more tortilla chips into the guacamole, and told me a bit about her father's spiritual odyssey and its devastating effect on their childhood.

Billie and June had been born in the Alabama city of Mobile, where Daddy was a sailor in the Coast Guard. Their mother deserted the family when June was five, and Billie was three, and one of Billie's first memories was asking her father why her Mommy had gone away, and being told that she had disappeared because she didn't love her two little girls anymore and wanted a life without them. Another of her early recollections was of a Christmas gift:

'I was five years old when my Daddy gave me my first bible for Christmas. He gave June one too, and I remember being real disappointed – not only because I was expecting a doll from Santa, but also because June got a red bible and I got a white one, and red was my favourite colour.

'Now, at that time, the three of us was living in this terrible motel on the outskirts of Jackson, Mississippi, 'cause you see, once my Mammy ran away, Daddy left the Coast Guard and started moving us around with him, finding odd jobs here and there. Never could hold down a job, my Daddy. So it was always six months in a motel in somewhere like Dothan, where he'd work as a desk clerk, then he'd get fired or just quit, and we'd move on to another motel in Montgomery or Birmingham or Selma, and he'd get another job as a bell hop or a night clerk. That was the pattern of our lives for the first couple of years Daddy looked after us. And, you know, it was kinda like being on the run. Especially since Daddy was always the restless sort. Never owned a piece of property. Never owned a car, or a stick of furniture. Never took out a life insurance policy. The only constant in Daddy's life was Jesus. Jesus was the one person he loved most in the world. Only problem was, just like he couldn't stay in a town more than six months, he also couldn't find a church which he ever felt praised Jesus enough. Which meant that Daddy went through a lot of churches during those years. He started off as a Presbyterian. Attended a Church of Christ Bible college for a while. Then got attached to the Assemblies of God. Then became a Baptist. Then started following Billy Graham. Like I said, he

could never stick with any one faith. He could never stick with *anything.*'

After these two years 'on the run', Billie and June were placed in a foster home by their father while he went off to find a new job. It was to be the first of 35 foster homes that they were to live in until they reached the age of 18. And each family was a member of whatever church that Daddy belonged to that year.

'One of the reasons we moved so often was that Daddy never gave the foster parents enough money to look after us. He'd find a church family to take us in, give 'em the cash to cover our expenses for the first month, promise to send the rest on, and then disappear for the next seven or eight months with no forwarding address, no way for the family we were staying with to get in touch with him. And I remember the attitudes of the family changing towards us once they realized he wasn't gonna send no more money, and that they were gonna have to support us until he showed up again. I tell you, it was terrible, seeing how much they despised having us around; realizing that a dollar bill was more important to them than we were.

'But then, one Sunday, he'd just show up out of nowhere, and take us away with him. Of course, the foster parents would scream and shout for the money he owed 'em, but there wasn't much they could do when he said he had nothing – 'specially when they was so desperate to get rid of us. I gotta hand it to our Daddy – he was a real operator when it came to getting other folks to pay for the cost of bringing us up. Like the usual amount of time we'd spend with a foster family would be nine months, which is the exact length of a school year, and then most summers he'd get us enrolled in some charity bible camp which didn't cost a penny. One summer, though, he did something that I'd still find unpardonable, even if I *could* forgive him for the way he'd made my childhood hell. We were at this one camp near Biloxi, Mississippi and on the last day of summer our father never came to collect us. All the other children had gone home with their folks, but there we were, waiting at the gate, waiting for Daddy to arrive. Finally, the preacher who ran the camp asked me didn't we have relations we could go to, but when I said no, he had to place us with another foster family for three months before Daddy finally showed up to get us. That's when June and I started crying real bad in front of him, begging him to send us to our Momma. Know what he told us? That he'd just heard our Momma had died a month ago and had gone to the angels.'

It wasn't until Billie graduated from high school that she was able to break out of this foster home cycle. 'The day after I left school, I started work as a receptionist at a hardware supply company and found a room to live in. June was already married by then and off in Germany where her husband was stationed in the army, so I was on my own in Birmingham and still going to this Pentecostal assembly every Sunday, 'cause that was the church the last family I lived with went to. And I kept going to church until I was 24, even though I didn't know who I was supposed to be praying to anymore – especially since every family I lived with went to a different kind of church. I'd been a Baptist, a Mormon, a Seventh Day Adventist, a Presbyterian, a member of the Assemblies of God, the Church of Christ, the Church of God. . . And when you've been in and out of just about every Christian faith imaginable, your belief systems tend to get real mixed up. I mean, when I went to the Mormons they had dances, but when I lived with some Baptists I was told dancing was sinful. So, like, I didn't know what to believe anymore. . .'

Then there was the business about her boyfriend. She met Ray through her work at the hardware supply company, where he was a driver. And when, after a couple of months, they decided to get married, she pleaded with him to come to church with her, because she had always been told that her marriage could never be blessed by God if she didn't marry a fellow religious traveller. 'Well I coerced Ray – who wasn't religious at all – to attend the Pentecosts with me and convert, which was a big mistake, 'cause the next thing I knew, he'd become a fanatic. Started feeling guilty about drinking a beer, about having sex with me. And then, a couple of months after the marriage, he started talking about how unhappy he was with his life – how he hated his job – and started falling into a real clinical depression. But when our doctor finally suggested he go to a psychiatrist, Ray would only go to a *Christian* psychiatrist, and he'd come back from a session quoting bible verses which the Christian shrink said he'd have to live by.'

Yet Ray never did benefit from such scripturally-based psychiatric treatment because his depression gradually metamorphosed into a spectacular case of schizophrenia. And when the Christian shrink decided that Ray needed an extended holiday at a Christian mental hospital, Billie took this opportunity to get out of the marriage, and make a final break with born-again Christianity.

'I tell you, even though I resented the fact that my Daddy and all those foster families kept me from the secular world for so long, it took me years to trust non-Christians again, since I'd been told they were all evil. And, even now, I *still* wonder sometimes if God's punishing me for leaving church. Like when I had my hysterectomy, and when my second marriage broke up six years ago, and when my boyfriend did what he did back last September, I started thinking that maybe this all was the Lord's way of getting back at me.'

'Course He wasn't gettin' at you', Bubba said, interrupting Billie's monologue. 'You've just had bad luck, that's all.'

'Bad luck' seemed like an understated choice of words to describe Billie's story. Suddenly, her addiction to menthol cigarettes, mail-order catalogues and piles of nibbly food appeared to be the zenith of self-control when compared to the extended horror movie that had been her life. And when I said that she must possess some sort of Herculean inner strength to have survived all that, she gave me a joyless smile and dunked a couple more tortilla chips.

'I ain't strong', she said. 'I just get through the day. Anyway, I. gotta be thankful 'bout a lot of things. Got my sister – who I moved in with when her marriage busted up – and I got my adopted brother here, so at least I ain't alone in the world. Not like my Daddy. He's still out there wandering around – somewhere in Mississippi, last time I heard – still looking for Jesus. And y'know what? The som'bitch ain't ever gonna find Him.'

That night – after checking into a local hostelry – I went out drinking with Bubba. He brought me to the Officers' Club at Fort Rucker – the vast army aviation base which dominated Enterprise and sprawled over 100 square miles, stretching into three counties.

'This here's the biggest army aviation base in the country', Bubba said. 'And I tell you, everyone else in America may think that Vietnam was a bad war, but in Enterprise it's considered the greatest war that ever happened, 'cause Fort Rucker was the place where all the army pilots were sent for training, and Enterprise really boomed. All them shopping malls and motels and new stuff you see in town only came about 'cause of Vietnam. And I predict that the next time we go to war, Enterprise is gonna turn into a real little city.'

Fort Rucker was already something of a city itself: mile after mile of barracks, administrative buildings, jerry-built housing compounds (for married personnel), workshops, recreation centres, playgrounds and, of course, clubs for enlisted men and officers. Inside the Officers' Club, a dinner dance was in progress, where a platoon of beefy crew-cutted guys – dressed up in tuxedos that fitted them like strait-jackets – were dancing with a lot of bouffant-haired women strapped into the sort of evening dresses that harked back to the Senior Prom days of the 1950s. Bubba steered us past this scene and into the main bar: a big comfortable place, where the beer was three bucks a pitcher and the juke-box genuflected in the direction of Nashville. We joined a table where four of Bubba's friends were already working on a couple of pitchers of lager and a couple of House Special pizzas (extra anchovies, extra pepperoni, extra tuna fish). When we sat down, a mechanic named Dale was having an impromptu confessional box session with Shirley, one of Fort Rucker's professional marriage counsellors:

'Damn, she don't jus' want the house,' Dale said, 'she wants my Camaro, she wants my clothes. . . damn, I think the girl wants my shoes and socks too.'

Dale broke off this emotional disclosure to pump my hand, offer me a brew and say, 'Scuse the sob story. I'm kinda goin' through a *dee*-vorce at the moment, and this lady's speciality is listenin' to stories like mine.'

Shirley smiled and said that it was all in a day's work. She also told me – after I asked what got her into the marriage counselling business – that she was a Kentuckian who married a military man and ended up at Fort Rucker, where the divorce rate was three times the national average. This made her figure that training as a marriage counsellor would guarantee her some employment once her schooling was through. She figured right, because just about everyone in Enterprise appeared to treat marriage as a sort of extended boot camp, where you only won your stripes by surviving your first exposure to it. Perhaps the transience of army life had something to do with the high level of marital carnage at Fort Rucker. Certainly, that was Jesse's experience. He came back from a tour of duty in 'Nam to discover his house shuttered, as his wife had not only emptied it of all its contents, but had also disappeared with their three kids as well.

'Took me four months to track the bitch down to Arizona', Jesse said. 'But the same night I found her, I met Ruthie here

in a bar in Phoenix, which kinda goes to show that you gotta take the bad with the bad.'

'Yeah', Ruthie said, 'that's what I think every morning I wake up and realize I was dumb enough to follow you to Enterprise.'

Jesse and Ruthie were the other two friends of Bubba's tucking into beer and pizza at that table in the Officers' Club. Only Jesse – being a Tennessee boy – favoured a drink called 'Jack and Coke': Jack Daniels bourbon topped up with The Real Thing. It seemed a shameful way to treat a premium sour mash whisky, but I didn't think it wise to accuse Jesse of abusing good booze, especially after Bubba got him to tell me about his stint as a member of an élite army hit squad during Vietnam.

'Yeah, the army would send us out to do their dirty work for 'em. If they wanted to chill some hard-to-get guy, we were the boys who were handed the job. And we were *good* at what we did. Too good, in fact, 'cause we were eventually disbanded for being *in*humane. Well, I loved the work, but I kinda have to admit that we *were* inhumane. One guy in our outfit collected human ears, and we always used these exploding bullets that detonated inside a target's brain. Man, we did some strange shit out there.'

But now, Jesse worked in the supply depot of the Fort Rucker gymnasium. It wasn't the élite sniper squad anymore – it was, 'Hey Jesse, got some sweatpants in my size?' And it was home every night to Ruthie, who weighed around 220 pounds, and was a self-professed psychic from a fundamentalist Christian background.

'I have always been able to predict the future, and tune into other people's *waves*', Ruthie said. 'But when I was a teenager, my Mom found out that I had these psychic abilities and she tried to put a stop to what she called my "Devil activity". Kept forcing me to attend these six-hour prayer sessions, where she'd beg God to show me the light and get me to give up the "prophecy sacrilege" I was into. All that praying really didn't do much good, so she eventually threw me out of the house – though I think that was more to do with me getting pregnant at 17 than having psychic powers.'

Enterprise, as I was beginning to gather, was a convention centre for folks with complicated lives – to the point where Ruthie's subsequent admission that she was already a grandmother twice over at the age of 42 somehow didn't faze me in the least. But what was most fascinating about all these

True Confessions was that they formed the internal landscape of a town which – according to Jesse – was predominantly run by strict Baptists. In fact, the Baptists had held such political power for years in Enterprise that this army town remained dry until 1986, when a bitterly fought referendum campaign (in which Jesse played a key campaigning role for The Wets) finally allowed intoxicating liquor to be sold within its city limits. But though booze was now available in Enterprise, the Baptist lobby still had won a few key concessions in terms of exactly where drink could be sold. If there was a Baptist church within 500 feet of any establishment serving liquor, then the establishment would have to permanently close down. And since the arrival of bars and liquor stores in Enterprise, the Baptists had been buying up property all over town, and announcing plans to open up an entire new batch of churches within the next few years.

'You might be able to now buy a Jack-and-Coke in Enterprise', Jesse said, 'but this is still one hard-line Baptist town.'

In fact, all of Coffee County was considered to be no-nonsense Baptist country. So much so that attending a Baptist service was almost looked upon as an essential component of any visit to the region. And when Jesse suggested that I seek out a Baptist congregation in one of the smaller outlying Wiregrass communities ('The kind of real tiny place that thinks of Enterprise as downtown Manhattan', he said), I set off early Sunday morning along Rt 84 until I came to the town of Elba. It wasn't exactly the lilliputian hamlet I was looking for, but it certainly was a soft-focus vision of what I always imagined an upcountry Southern town to be: wide, dusty streets fronted by roadside cafés with names like The Three Sisters, and garages that looked like they began business when Ford introduced the Packard to the American road. It was a daguerreotype of an Alabama 60 years out of date, perched atop a small hill from which a curving stream flowed gently down into a valley thick with tall evergreens. And in the midst of this pastoral scene was a modest, but proud First Baptist church. A service was beginning in ten minutes, so I parked the car and joined the summer-suited throng entering its portals.

The church was filled with what I sensed was Elba's élite – its bankers and doctors and dentists and leading small merchants. Then again, this was a *First Baptist* church – and in Southern towns, a First Baptist church was always the most mainstream (and therefore the most influential) of all Baptist congregations, so it was no surprise to see the church filled with well-heeled

99

folks – all seersucker suits and prim floral dresses. They greeted each other with polite, courteous smiles and handshakes, and made a point of giving me, the visitor, hospitable nods of acknowledgement. There was none of that robust spiritual *bonhomie* that I'd seen in the Pentecostal Assemblies of God – no bearhugs, no 'Howdy, brother!' backslapping – for this was the sort of congregation which believed that communing with God was a formal business, and one in which gregarious displays of sanctimony wouldn't win you points with the Almighty, let alone with your fellow parishioners.

And yet, once the minister – a conservatively suited man in his mid-thirties named J. Douglas Dortch – started to preach in a gentle drawl, the born-again message of his ministry became very clear. For, after we joined the robed choir in a couple of Baptist hymns that had a real gentle 'old time spiritual' swing to them, Pastor Dortch then called his little blonde-haired daughter of five up to the pulpit, sat down with her on the altar steps, and talked about playing tag as a kid, just like his daughter here played tag with her friends after school. But as Pastor Dortch had discovered – and as his little daughter would also discover once she got older – there was a remarkable analogy between playing tag and receiving the touch of Jesus. And he mentioned that story in the Book of Mark, where a woman reached out to touch Jesus' hem and had been cured on the spot of twelve years of illness because she had shown Him complete faith. How did this biblical story have parallels with playing tag? Well, when you touched someone in a game of tag, you had to shout, 'You're It!' Similarly, when you reached out to touch Jesus you also had to shout, 'You're It!' and proclaim your complete faith in Him.

It was a theme which Pastor Dortch took up again in his main address of the morning – 'Be Not Afraid: Only Believe' – where he spoke about how we can often run out of secular solutions to our problems and must turn to 'the spiritual' for assistance. But when we reached out for help from on-high – when we played tag with the Son of God – then we also walked with our saviour, Jesus. Walking with Jesus – dedicating our existence to Christ – was the greatest thing we could do in life. And we, too, could feel His healing touch. When we were debilitated by loss or grief – when life itself overwhelmed us – He would be there with us. And if anyone of us had doubts, had not accepted Jesus fully, then please, oh please accept Him now. In fact, if anyone wanted to stand up and

100

dedicate themselves for Christ they should do so right this moment.

As I later learned, this plea for lost souls was known as an 'altar call'. And it was obviously an essential component of every 'Christian renewal' service. But it didn't matter whether this plea was made in the spirit of 'Get saved or God is gonna git you' (like the approach taken at the Faith Assembly of God in Sarasota), or was couched in the dignified, soft-sell, 'invest now for future security' reasoning adopted by Pastor Dortch – the belief in the necessity of Christian rebirth was the doctrinal foundation upon which both faiths were built. So, despite all its *politesse*, the First Baptist Church of Elba, Alabama was still very much a part of a born-again Christian landscape – a reminder that revivalist Christianity wasn't always gift-wrapped in the trappings of charismatic worship or in the reverential certainties of fundamentalism.

Though nobody in the congregation actually answered Pastor Dortch's altar call, I gathered that there was something almost *pro forma* about this invitation; that even if someone was in the midst of a major spiritual crisis, it would take a great deal of nerve for them to stand up and admit to it in front of their fellow parishioners. Especially in a community as small as Elba. Especially in as well-heeled a congregation as this one, which probably looked down upon public expressions of faith or doubt as rather common. Even born-again Christianity had its class distinctions. And if the Pentecostalists saw themselves as the foot soldiers of the Lord, then the First Baptists could be considered His mercantile gentry, who didn't have to twist and shout in order to praise His name, since they already knew that they were His well-heeled elect.

But the First Baptist Church of Elba was also a repository of the sort of *ante bellum* courtliness for which the South was once renowned. And it was hard not to be genuinely charmed when an elderly gentleman seated behind me – his white hair and white linen suit giving him the cut of an old-style senator – made a point of shaking my hand at the end of the service and said, 'I am very happy you've been with us this Sunday.' At least a half-dozen other members of the flock also approached me with similar expressions of communal good will – never once asking me where I was from, what I was doing here, was I a Baptist?, or any other pointed queries. Rather, they afforded me an immediate and unquestioning hospitality, which let it be known that my very

act of worshipping with their community had immediately won me a certain degree of Christian respectability. It was a reminder of that old parochial truism: though a stranger is usually looked upon with suspicion in a small town, he is always made to feel welcomed if he shows up at church.

'I'm real glad that you prayed with the folks of Elba, Alabama this morning', Pastor Dortch said as he pumped my hand at the doorway of the church. And it only struck me a few minutes later, as I drove back towards Enterprise, that I hadn't seen one black face in his entire congregation. So, when I reached Enterprise, I prowled the back streets until I found that small Church of Christ which I'd passed the previous day – the *coloured church*, as Bubba called it. Several middle-aged women were entering its front doors and, when I asked one of them whether there was a service I could attend that evening, she said, 'We havin' some food an' then a family service right now, so why don't y'all come in?'

I followed them through the swing doors and into a small chapel with ceiling fans, eight rows of plain wooden benches and a small pulpit. The lack of any organ or piano immediately told me that this was a traditional Church of Christ which banned any musical instruments from its services, while the fact that I was the only white person in a black congregation hinted that an integrated church was still a very rare bird indeed in this corner of Alabama. There were about 30 people in the chapel, including a guy around my age named J. Carl Johnston who introduced himself to me as a fellow visitor to this Church of Christ – a Philadelphian, stationed down here (with his wife Arlene and their two kids) at Fort Rucker, where he worked as an air traffic controller. Like Bubba, J. Carl was another army man homesick for the big bad world of foreign parts. He'd done a stint in Korea ('Let me tell you something – Seoul has got no soul'), and was then transferred to Sicily which he adored.

'I used to travel all over the island on my motorbike. And the Sicilians always invited me into their homes, 'cause I wasn't just an American with the army – I was a black American with the army, and there aren't too many of them around Sicily.'

J. Carl was interrupted by a hefty man in his mid-forties with a bad eye and formidable gut encased in a white shirt that was stained by cartographic sweat patches and crossed by a pair of striped braces. The braces and the sodden shirt said it all: this was the preacher around here – Brother Robert Birt – still trying to cool off after going through the rigours of the morning service.

He welcomed us both to the Addams Street Church of Christ and said, 'Now you come on into our kitchen and eat somethin' the good ladies here have made for lunch.'

A make-shift buffet of bona fide Southern cooking was laid out in the church's kitchen: candied yams, black-eyed peas, squash, barbecued chicken, grits, and a high-calorific sweet called Mississippi Mud which was guaranteed to send one's cholesterol level into orbit. I joined J. Carl and his family in the queue for food, but the good ladies and a church deacon – Brother Williams – insisted that we be served first. And when we both protested that we didn't want to jump ahead of anybody, one of the good ladies said, 'But you're our guests. You *must* eat first.'

So we were handed paper plates piled high with all that down-home cuisine, and found a table at the rear of an adjoining recreation room. It was, indeed, a real family day at the Addams Street Church of Christ: everyone was dressed in their Sunday best (the good ladies sporting a bravura range of hats); the teenage kids were looking after their infant brothers and sisters; the adults were engaged in relaxed banter with each other. And as we worked our way through the barbecued chicken, J. Carl told me that he and his wife had grown up in the same section of Philadelphia, but didn't know each other until they attended college together at the University of Pennsylvania.

'You know, the university is an Ivy League school, so the only way I could afford to go there was on an army scholarship – which meant that I owed the military four years of active service after I got my BA. But going into the army didn't bother me, because I had this dream about being a pilot, and I figured the army was going to let me become one of their aviators.'

J. Carl had always dreamed about flying professionally – especially since his father was a commercial pilot, and he himself had held a private pilot's licence since his university years. So, after his stints in Seoul and Sicily, he talked his way into the army flight school and thought that his dream had come true. But then, within a few short months, he came to the uncomfortable conclusion that he loathed flight school. The instructors kept telling him that he handled the planes like a civilian, that he didn't possess *the right stuff* needed to be an army pilot. And realizing he wasn't what they were looking for, J. Carl decided that it was time for him to part company with flight school, and choose another area of army aviation to specialize in. He picked

103

air traffic control and, after receiving his training up north, was dispatched to a place he never believed he'd see: the state of Alabama.

'I nearly died when I learned where I was ending up', he said. 'But I eventually took a philosophical attitude about coming here. Figured this was a stage I had to get through before I left the military. Like my beliefs as a Christian run contrary to military thinking. And I really only look upon the military as a job – no more than that. So I've set myself two future goals. The first is that when I leave the army, I want to do some sort of work that will benefit people. And the second is that I want to put as much distance between my family and Alabama as possible.'

I asked J. Carl whether Alabama's one-time reputation as a white supremacist's paradise still held true today.

'I'll tell you this much', he said. 'Up North they talk one thing and do another. You know, it's like all those nice liberal white folks in Boston who used to talk about how there was no racial problem in their city. That is, until they tried to bus some of those nice liberal white folks' kids to a black school, and those nice liberal white folks turned real ugly about it. So, one thing I've got to say about Alabama – at least you know what you're dealing with. At least you know they're racist.'

He had a point. Alabama may have been legally forced by the courts to kill off its segregationist policies – it may have muzzled its bigoted public voice – but once race entered any private conversation, all the old grim attitudes claimed centre-stage again. For example, after she gave me the run-down on the 35 different foster homes she lived in as a kid, Billie launched into a real diatribe about blacks, saying, 'The coloured 'round here still sass too much. I heard one coloured jus' recently talkin' on the television 'bout how he expects his wife to support 'em, which jus' goes to show what every'un 'round here always knew: if a coloured can find a way t'live off some'un else without havin' t'go to work, he will.'

Now if such comments struck me as breathtakingly mindless – especially since they reinforced the vapidity of that atypical racist recitative, 'Give 'em half a chance and they'll never do a lick of work' – they also turned out to be commonplace amongst many white Alabamans. Earlier that day, over breakfast at my motel, I fell into conversation with the owner of a hardware shop from the north Alabama town of Decatur. He was an excessively cordial man who was terribly keen to know whether his state

was making a good impression on me, and who showed me photographs of his two teenaged children, speaking with great pride about his eldest daughter who'd just won a scholarship to Vanderbilt University in Nashville. Soft-spoken, utterly genial, yet dignified, this gentleman struck me as a perfect example of what American politicians like to refer to as 'a good citizen'. That is, until he mentioned that he'd served in the Alabama National Guard during the early 1960s. And when I asked him if he saw much action with the Guard, he said:

'You bet I saw action. 'Specially every time there was a civil rights march. And you know somethin' I never figured – how Martin Luther King ever got himself a Peace Prize. 'Cause every time the man came to town, the Guard had to be called out. That nigger was nothin' but trouble.'

I related this story to J. Carl. He shrugged his shoulders and said, 'You're not telling me anything new, since that's how we're all perceived down here: as troublesome niggers. And, you know, if it wasn't for my strong religious beliefs, I really don't know how I'd cope with comments like that. Because anytime I start feeling real angry, I tell myself that Jesus is colour-blind; that my Lord sees nobody's colour. Even here in Alabama.'

After lunch, we all went back into the chapel where Brother Birt led us in the singing of an a capella hymn, 'Just a Little Talk With Jesus'. It was a reflective, bluesy number which possessed just the right mixture of reverence and worldweariness to make it the perfect old-style spiritual – those sacred songs with swing which are indigenous to the South, having evolved out of the music sung by slaves prior to the Civil War. And since this particular spiritual reminded those in need that the hellishness of daily life can be countered through 'Just a little talk with Jesus', it was clear that it also directly reflected a black American experience of life in Dixie. It also unintentionally explained why most black churches engaged in such an emotive form of spiritual worship – in a region where a black was, until very recently, widely referred to as 'boy', one of the few internal defences he had against such second-class status was an intensely personal relationship with Jesus. No wonder, therefore, that the civil rights movement of the 1960s was led, in part, by black ministers who frequently cited Christian principles as a spiritual subtext to their civil disobedience. To them, Jesus was not simply a saviour to turn to in moments of crisis. He was also a great moral hero; the ultimate spiritual leader when it came to matters of equality and

humanitarian principles. Faith in Him had helped them face up
to the task of confronting the segregationist policies of the South.
Faith in Him still gave believers like J. Carl the strength to cope
with the racist undercurrents of contemporary Alabama.

Once we finished singing various members of the congregation
got up to perform a musical number. And as a quartet of kids
worked their way through another spiritual, and two of the
flamboyantly hatted matrons belted out a couple of hymns, the
object of the service became clear: by singing to each other, a
sense of community was being reinforced within a congregation
that lived in a town where (as Bubba had pointed out) 'folks
are still more comfortable separate'. It also re-emphasized the
church's leadership role within the black community; a point
that was stressed when Brother Birt asked three members of
the congregation who'd recently graduated from high school to
come forward and receive Certificates of Merit and gifts from the
church. Clearly, the Addams Street Church of Christ believed
that obtaining a high school diploma was an achievement worth
commending, and one which did the community proud, as only
a few years ago, the idea of a black finishing secondary school in
Alabama was considered an absurdity. It was an attitude which
Brother Birt summed up succinctly in a comment aimed at the
younger members of the flock:

'Remember – they can take away your job. They can take away
your house. They can take away your car. But they can never take
away your education.'

Then he asked us to all join hands while he said a short prayer,
which concluded with the following counsel: 'Only look down on
somebody if you plan to lift them up.'

It wasn't exactly the most Alabaman of benedictions.

The next day, I dropped back over to Addams Street and spent
a couple of hours chatting with Brother Birt.

'Let's forget the 'Brother' bit', he said when I started to address
him formally. My name's Robert and that'll do.'

He was, evidently, a casual man who didn't care much for the
trappings of his role as a minister of the Gospel. Then again, even
if he had craved the shoddy *gravitas* that many spiritual leaders of
a community adorn themselves with, his economic circumstances
would have kept such pomposity in check. For Robert Birt lived

poor. His house – located around the corner from the church – was a single-storey frame-and-shingle structure with terminally pockmarked paintwork and a front porch that was as riddled with holes as a slice of Emmental cheese. Inside, the furniture was broken-down, the walls cheaply beauty-boarded and, judging from the two mattresses in the sitting-room, there weren't enough bedrooms to accommodate his family. Granted, this set-up was a far cry from the depths of destitution, but it did give off an air of a life lived only a few yards away from the poverty line. And it served as immediate proof – if proof were needed – that Robert Birt certainly wasn't in the Church of Christ ministry for the money.

When I arrived at his home, his wife and three daughters were all engrossed in a game show on television. As the house was filled with some quasi-hysterical voice screaming, 'It's a self-defrosting fridge/freezer!' Robert suggested we move on to his office in the church. It wasn't really much of an office – more of a small airless breeze block room, in which the heat was overpowering. I now understood why Robert dressed in the sort of loose white cotton pants and shirt which made him look more like a refugee from an ashram than an Alabama-based preacher. As I quickly discovered, in the current hundred degree heat, any heavier clothes made his office intolerable. And when he saw me turning into a damp J-Cloth, he banged his office air-conditioner a few times with his fist until it wheezed asthmatically, and began the process of bringing the temperature down by a few digits.

If Robert's sub-continent style of dress was a little surprising, then so too was his age. He was only 29, though his one bad eye and substantial girth gave him the look of a man well into his forties. His manner was also middle-aged, as he presented a slightly grave face to the world. Yet, this graveness did not make him seem remote or withdrawn. Rather, he came across as a serious guy who was serious about his faith, his work and the people he ministered to; a man who may never have been outside of the South, but who had still encountered a great deal of life's manifold complexities and had thought long and hard about the contemporary implications of Christianity in his own small patch of the world. He'd also undergone something of an ecclesiastical turn-around in his own life, as he'd been raised a Pentecostalist in his home town of Jacksonville, Florida, but left the faith when he finally decided it was 'a lot of whoopin' and hollerin' and nothin' concrete'.

107

This little rebellion came about when he was in college and a friend brought him to a local Church of Christ one Sunday, where he immediately felt at home because 'I realized that this Christian church was as scripturally oriented as I was'. So he started to attend this denomination on a regular basis, eventually transferring to one of the church's Bible colleges, after which he was ordained and dispatched to the Florida city of Orlando as a youth minister. Then came the transfer to Enterprise.

'Coming to Alabama didn't bother me as much as I thought it would. Maybe that's because Enterprise is a pretty nice little place – especially after a rough city like Orlando, where I was dealing with kids on crack and cocaine. And I haven't seen much outward racism here, though I do think there's a quiet form of racism within both the white and the black communities in Enterprise. It's a racism which manifests itself in folks simply never mixing with each other. The two communities never talk; they never mingle. It's like this: there's a white Church of Christ around ten minutes from here, but we have no contact with it. It's not their fault. It's not our fault. We just don't get involved in each other's activities. And, yeah, it's a shame that people don't think about coming together, but that's just the way it is. Just like it's a shame that institutional racism still exists in the South, but you can only change so much in a certain amount of time. And it's gonna take another generation or two before the divisions between blacks and whites finally break down in the South.'

I asked him if – like J. Carl – he considered Jesus a source of moral strength, and one which helped him deal with his residency in Alabama.

'It wouldn't matter where I was residing', he said. 'Jesus to me will always be both a source of strength *and* a great teacher. Now I know a lot of Christians get worried when you start referring to Jesus as a teacher, because they think you're trying to bring Him down to a human level and forget about the fact that He is Lord. But my attitude to all this is: of course there was something extraordinary and God-like about Jesus. And yet, as extraordinary as He was, He was still only a man. And only a man can relate to man. T'ZGod can't directly relate to us, so that's why He sent Jesus down to earth – to relate to us and to die for our sins. In fact, the only reason our sins can be forgiven is that God *became* a man.

'But, frankly, arguing about whether or not you should try to make Jesus seem more like a common man is kinda irrelevant. Especially since so many religions these days are frankly forgetting

the message of Christianity and have turned themselves into nothing but a big business. There are a lot of religious pimps out there who use Jesus for all kinds of bad ways. Like Paul said in the Gospels, 'The Devil has ministers of light.' But I'm not just talking about the Swaggerts and the Bakkers. I'm talking about men who use religion to control their home. Or to gain some power in a community. And anyone who uses God as a way to gain some kind of power or control over others is, to my mind, nothing but an evil man. Because Christianity is ultimately about helping folks, not controlling them. It's about showing love.'

That was about the most concise distillation of the Christian message that I'd heard yet. Man's need for God, after all, arises not only out of a desire to come to terms with his own mortality, but also out of a need for a higher being whom he can turn to for unconditional love and support. And perhaps the most important of all Christ's teaching is this: that God's love for us should be manifested in temporal life through the love we show each other. Robert Birt was the first preacher I'd met on this journey who actually based his ministry around this idea; who saw that God's love for man must somehow be translated into a social philosophy of 'Only look down on somebody if you plan to lift them up.' And he himself realized that trying to live by such a creed was a formidable challenge:

'We've got all sorts of problems in this congregation. And I know that there are some folks in my church who just don't agree with my way of doing things. So it's hard sometimes to preach to people whom you know don't like you. But you can't throw rocks at folks like that; rather, you've got to learn to accept that they don't care for you and forgive them for that. It takes a lot of discipline and a lot of God to do that.

'But I live by that principle – because that was Christ's principle. And I may not know a lot of things, but I *do* know this: if you don't get to know God on a people level, then you never get to know God.'

I didn't get to know God through the people of Enterprise, but I certainly did get to know Enterprise. It was the sort of place where a stranger's lingering presence was regarded as major community news; where a clerk in the post office acknowledged my second visit to his counter with the comment, 'Sticking around

for a while?'; and where you were inevitably drawn into the sad banalities of people's lives. Like Julia's. She was one of the few British women in town. We met over a packet of Alka-Seltzer at the chemists where she worked as a shop assistant. And when she heard I lived in London, she treated me as if I was an emissary from western civilization.

'You don't know how good it is to speak to somebody from home,' she said. 'Because I sometimes think I've been sentenced to prison here.'

Julia was from Cardiff. She was 22 and addicted to Diet Coke, even though she was certain that the artificial sweetener in that beverage was riddled with carcinogens which were going to shorten her life. But that didn't stop her from going through two Diet Coke six-packs a day, because she still hadn't adjusted to the Alabaman heat and she needed a steady intake of fizzy liquid to keep her hydrated. Real Coke, she explained, was out of the question because it would make her fat and she'd already put on 40 pounds since coming to Enterprise 18 months ago.

'I snack all the time here,' Julia said. 'Charlie says I do it to tick him off, but it's really just because there's nothing else to do in Enterprise but eat.'

Charlie was Julia's husband. He was an art teacher at one of the schools located on the grounds of Fort Rucker. He met Julia while he was on some educational exchange programme in Wales, teaching drawing at a technical college where she was a student. He took her out a few times, they clicked, and when he had to return to the US at the end of his year in Cardiff, Julia was faced with a considerable dilemma. She knew she was madly in love with Charlie. She knew that the succession of secretarial jobs she'd picked up since leaving college were a one-way ticket to professional nowheresville. And she also knew that Charlie was a 45-year-old three-time loser in marriage, who'd landed a bizarre civil servant job teaching art at some Alabaman army base. A big decision had to be made, and Julia finally decided to take the big emotional gamble. So she bought a plane ticket to Miami and a bus ticket for a Greyhound coach that took a full-day to inch its way up and across the Florida peninsula until it crossed into LA. After 36 hours without sleep, she was reunited with her beloved in the bus depot of Ozark, Alabama – since the Greyhound didn't even stop in Enterprise.

That was a year-and-a-half ago, and Julia and Charlie were now very married and now very broke. Julia was also very homesick,

but she didn't think she'd be seeing Wales for a couple of years, because she simply couldn't afford the plane fare back. ('We make about $22,000 between us, but after taxes and the $600 a month Charlie has to pay in child support to two of his ex-wives, that only leaves us around $9,500 a year to live on, which is nothing.') And Charlie had started to drink heavily – as I discovered later that evening, when Julia insisted I join them for dinner at their apartment.

Charlie's tipple was cheap beer. He favoured a lager called Old Milwaukee which cost $1.95 a six-pack, and left you with the sort of 'anvil chorus from *Il Trovatore*' hangover which only cheap beer can provide. His nightly intake of the brew had given him a small pot belly and a nose that was a network of broken veins. But despite such physical evidence of his hefty beer consumption, his frizzy hair and Zapata moustache cut ten years off his age. And, judging from the graceful pen-and-ink still lifes that dotted the breeze block walls of their purpose-built apartment, he was a talented draughtsman, yet one who had somehow allowed circumstances to lead him to a job at Fort Rucker.

'Like I know Enterprise is just about the deadest dead end I could find myself in,' he said somewhat late in the evening, when the two of us were putting a dent into the third six-pack of Old Milwaukee. 'But the problem with a dead-end job in a dead-end place is this: once you've landed yourself in that cul-de-sac, it's hard as hell to pull yourself out of it.'

Wasn't that the curse of all small places? – they offered you the security of a tightly knit community in exchange for a lingering sense of claustrophobia and entrapment. In Enterprise, this feeling of being coralled and professionally stillborn was intensified by the fact that so many of its residents had lived elsewhere before ending up at Fort Rucker, and therefore knew that there was a world beyond the Boll Weevil monument. When I looked back over my notes of my evenings there, I realized that Bubba and Jesse and Charlie and Julia had all sung the same aria of insular despair. So too did a friend of Julia's named Wendy, who dropped over later that night in time for one of Charlie's hashish nightcaps. But when she started telling me about her ex-husband who abandoned her and their four children for a religious sect called The Word, which believes in obtaining financial success and corporate power through Jesus, I realized that the longer I stayed in this burgh, the more I would get sucked into such emotionally punch-drunk tales of woe.

111

So, the next morning, I did what so many residents of Enterprise wished they could do: I left town.

There was a Heat Alert on in the City of Montgomery. 'Downtown, we got a heat index reading of 115 degrees', said the announcer on some local Gospel station, 'so unless you gotta go out, don't go out. And remember, the Governor has proclaimed Wednesday "Pray for Rain" day, so be sure to go to church and ask the Lord to bust open the heavens and end this drought.'

The Lord looked as if he was going to take some convincing, for when I pulled into the Alabaman state capital, the skies over Montgomery were a hard, impregnable blue without the slightest hint of cloudy intimation. It gave the city a certain achromatic quality, making it almost painful on the eyes. The white concrete of the outlying shopping malls was blanched by the sunlight, while the downtown office buildings became hard angular washed-out slabs. Even the Capitol Building appeared to be bleached; the only suggestion of colour coming from the Confederate Flag flying atop its proud teapot dome.

The Confederate Flag was, perhaps, the most revealing feature of the Montgomery cityscape. It acted as a reminder that, despite outward appearances, Alabama was still salting its wounds from the Civil War, and had yet to silence its Rebel Yell. And the city's contradictory nature was deepened by the fact that, directly opposite the Capitol, the home of the Confederacy's only President, Jefferson Davis, was still lovingly maintained as a shrine. No matter how much Montgomery tried to promote itself as a New South city – no matter how many of its 'cultural facilities' and gentrified *ante bellum* streets were pointed out to you – you still couldn't help but feel that the Confederate banner over the Capitol provided the final word about the state government's historical perspective. And during my days in Montgomery – while staying with some old friends of my family – my mind kept returning to that flag; the Yankee in me marvelling at such a defiant exhibition of one of the biggest skeletons in the American cupboard.

Of course, quite a few Montgomerians distanced themselves from this display of the Stars and Bars over their State Capitol – especially members of the black community, who must have found it cruelly ironic to see that banner being flown in the immediate vicinity of the Dexter Street Baptist Church, where

112

Martin Luther King Jr initiated his civil rights campaign. Certainly, the family I was billeted with – the Epsteins – made a point of telling me about a recent feature which appeared in the city's main newspaper, the *Montgomery Advertiser*, in which the writer said that the state authorities should take down the Confederate flag and be done with it, putting it in a museum where it belonged. But, judging from the handful of guys I saw touring the Jefferson Davis museum – all of whom were sporting the old grey Confederate army hat with crossed muskets adorning its brim – there were still a considerable number of Alabamans who revered that banner and wouldn't look too kindly on the administration which made the decision to remove it to a glass case, where it could be viewed as an artefact from a divisive past.

Old South/New South. Montgomery, in its own lugubrious way, was a convergence point for these two disparate realms. With well under a half-million citizens nestled within its city limits, it wasn't the high-gear metropolis that Atlanta was purported to be. Instead, it projected an image of an overgrown seed store – a city of small merchants and old family businesses which, despite its collection of office blocks, still maintained its sluggish homeyness. And, like so many contemporary Southern cities, it washed its hands of its downtown after dark, leaving it to the destitute to claim as their own until daybreak.

The Epsteins, on the other hand, lived in an elegant suburb of the city; a leafy district of fine colonial houses. They were a long established Montgomery business family who ran a large millinery supply company with subsidiaries throughout the South. And they were Jewish – though their religion didn't make them as much of a rarity in the South as one might think, since just about every major Southern city had its own considerable Jewish community which, over the years, had withstood the anti-Semitism preached by the Klu Klux Klan and now played a small, but integral role in the South's civic life. The Epsteins, therefore, didn't see themselves as members of the Diaspora, but as true Alabamans who'd been in the state for well over a century. And, like any estimable Southern household, the family business remained 'family' - it was founded by an old friend of my grandfather's, Morris Epstein Sr; it was now run by his son, Morris Jr (with whom I was staying); it would be eventually passed on to his sons, Robert and Jerome, both of whom were already vice-presidents of the company in their early thirties. The Epstein home reflected this sense of being part of

113

the Montgomery establishment, for it was a true manse, filled with fine art and fine books and fine English antiques. But if the decor of the Epstein house reflected the tasteful formality of New World-style old money, then so too did the style in which their home was run. There was a black housekeeper who addressed Mrs Epstein as 'Ma'am'; there was a tie-and-jacket dress code at dinner; there was the way in which Mr Epstein's sons called him 'sir', as if he were a Southern general. Yet this was not a family caught up in some time-warp or attempting to out-fogey themselves. Rather, the courtly manner in which they dealt with each other was simply a reflection of a courtly etiquette that was evidently still practised by the well-heeled classes of the South.

Through the Epsteins, Montgomery assumed a certain cozy graciousness: a place of good restaurants and decent bars and the Alabama Shakespeare Theatre – one of the more up-and-coming regional playhouses in the country. Mr Epstein Jr, however, appeared less interested in what was presented in Montgomery's theatre and its new civic art gallery (due to open later that year) than in the very fact that his city now had these urbane attributes. That, in itself, was a telling point of view, for it hinted that, in the New South, 'culture' was considered an important yardstick by which a city could gauge its ever-increasing cosmopolitanism and show the rest of the country that it wasn't permanently stuck in some backwater groove.

But while the arrival of Shakespeare and French Impressionists in Montgomery may have heralded the emergence of a more worldly class of folks in Alabama, most New Southerners – like the Epsteins' youngest son, Jerome – were quick to point out that productions of Elizabethan drama weren't exactly the most telltale signs of the region's burgeoning sophistication. Over a couple of Wild Turkeys in what he called 'Montgomery's only Yuppie bar' (a hi-tech lounge, filled with young executives who, judging by their après-office clothes, had evidently increased Ralph Lauren's profits by a couple of dollars), Jerome gave me his own theory for the emergence of New Southdom:

'You know, when I was a student at Harvard, all my Yankee friends used to tell me that the only way the South was ever going to pull itself up out of economic stagnation was by finally accepting racial integration. And they were right: as soon as we started ending segregation, outside investment came flooding in. But it wasn't just integration that created the New South; it was also *air-conditioning*. Air-conditioning changed the way we

do business down here and increased our productivity level. Because, before there was central air-conditioning in just about every office and factory, you couldn't do much in the way of work in Alabama for four months a year, since it was too damn hot. And that's why the South got this reputation as being a kind of drowsy, inactive place – because it *was* drowsy and inactive every May to September.

'But air-conditioning's put an end to all that. In the last ten to fifteen years, air-conditioning has made us competitive. Air-conditioning has allowed us to take on the Yankee competition in business and show them that we can hold our own. I'm telling you, you want to understand the New South, you got to understand air-conditioning – and that was something they never taught me at the Harvard Business School.'

The Regis and Rodney Funeral Home also understood the appeal of air-conditioning, and hired an announcer with a sing-song voice to advertise this fact on Montgomery's Good Gospel radio station:

'The Regis and Rodney Funeral Home – where Today's Decision is Tomorrow's Peace of Mind. We have over 52 years of experience, plenty of adequate parking and an *air-conditioned* chapel seating 300. Remember – your loved one deserves the best, so choose the fully air-conditioned Regis and Rodney Funeral Home. . .'

Calvin Millar's home was centrally air-conditioned as well. So too were his Corvette and his Volvo, which he kept in a parking bay at the rear of his ranch-style house, located on a street of ranch-style houses in an outlying suburb of Montgomery. It wasn't a showy house; then again, Calvin Millar wasn't really a showy man, though he did actually act a little sheepish when he saw me steal a glance at the chunky Rolex Oyster that was lashed to his wrist. And when I made an admiring noise or two about his Corvette, he said, 'The Lord's looked after my automotive needs, Doug.'

Maybe his wariness about acknowledging such personal indulgences as a flashy sports car and a flashy Swiss timepiece stemmed out of his fear that – in the wake of the Bakker and Swaggert scandals – any evangelist who displayed the slightest bit of ostentation immediately gave off a whiff of corruption.

115

And Calvin Millar *was* an evangelist, albeit one whose financial fortunes rose and fell depending on the need for his sort of spiritual services. Which meant that Calvin was really a free-lance evangelist, who hustled for work and sold a speciality just like any other free-lancer. Only, in his case, his marketable skill was bringing people to the Lord.

I discovered Calvin Millar quite by chance. Driving through Montgomery, I saw a poster adorning a lamppost, featuring his picture and advertising a revival he was giving at a local Baptist church a week from now. Though I knew I wouldn't be in Montgomery to attend his service, I still called the Baptist church where the revival was due to take place, obtained Calvin's home phone number, and rang him to explain that I was interested in talking with a self-employed evangelist. He didn't seem to be fazed in the least by such a curious request for a meeting and agreed to see me the next day. He did ask me one question, though: was I a Christian? When I told him I wasn't, there was a momentary silence on the phone line and then he simply said, 'Right, catch you at noon tomorrow.'

When I arrived on his doorstep, I was greeted with a chiropractic handshake and a down-home expression of cordiality: 'I am real pleased to meet you, brother.' In his terry-cloth Chemise Lacoste shirt, his lemon coloured trousers, and his medium-rare suntan, Calvin Millar looked like he'd just stepped off the links after eighteen holes. He was a big guy who'd just recently arrived at that way-station marked Middle Age and possessed the big bear build and locker room *bonhomie* of a football coach. But though he came across as 'one of the boys', you could immediately tell that he was also an 'I play to win' type. And, in his mind, the game he was playing was the biggest game in town, because at stake was not simply your credibility on the grid-iron of temporal life, but the status of your immortal soul. To Calvin, Christianity was like a team sport and he saw himself as one of its scouts in the field, always on the lookout for another player.

His house, however, reflected nothing of his work or his religious convictions. No portraits of Jesus, no K-Mart tapestries of Joseph and his Brothers, no stacks of bibles or evangelical literature. Instead, it was suburban plush – all cream shag carpets and crushed velour armchairs and a fluffy French poodle named Toni. Maybe someone who professionally proselytized for Christ didn't need to advertise his faith on his walls. Maybe evangelists – like every other member of the workaday world – wanted to

distance themselves as much as possible from their means of employment when they came home. Maybe Calvin's wife – a local beautician – simply didn't think that ecclesiastical paintings fitted in with the interior decor.

We sat facing each other in the velour armchairs, drinking sweet iced tea. Calvin said that it was nice to collapse into an armchair for a change – he'd just come back from leading a four-day revival in Iuka, Mississippi, before which he'd done a six-day stint in Sparta, Tennessee. Being a roaming evangelist was like that – a couple of days here, a week there, with a lot of geography to cover in between engagements. Altogether, he figured he was on the road around 35 weeks a year, covering 19 states in the American South and Southwest.

'I'll preach anywhere I'm invited to preach,' he said. 'And I go to a couple of religious conventions each year – especially the Southern Baptist convention – where I make my contacts with pastors who might be in need of my services during the year. Of course, word of mouth is the way I get most of my engagements now. It's like any other profession – you get known for being good at what you do and work makes work, though I'm always on the lookout for new places I haven't preached in before.'

It certainly sounded like a free-lancer's sort of life – that constant awareness of the need to make new contacts and keep expanding your market, coupled with the usual neuroses about finances that come with having no fixed paymaster. And Calvin was very conscious of money.

'Don't you believe for a moment that the majority of evangelists make a lot of money, because most of us just about earn a proper living. Like I've never received any real big money in all my years on the road, and even now I can sometimes make only $50 a night, though I usually have to try to gross around $1,000 a week to make all my ends meet. And that's not a big amount of cash in this day-and-age. So I got my money worries just like everybody else, though like I said, the Lord's been good to me when it comes to meeting my needs. Like I've got no complaint with the cars I drive or the house I own, and I don't need more than I've got, but I've always got to keep an eye on my earning power and always be certain that it doesn't fall below a minimum level.'

Of course, Calvin was quick to point out that 'money is only important insofar as it helps me to do the Lord's work'. And from a very young age, he'd always felt he was destined for employment by the Almighty.

He was a Montgomery boy, born and bred. 'My Daddy was a representative for a tyre company and he was always on the road, 'cause his work took him up and down the state. But when I was five, my parents divorced and my Daddy simply went off down the road one day and we never heard from him again. Think he went West, but after no contact for 40 years in a country this size I don't even know whether he's alive or dead.

'Anyway, with my Daddy gone, my Momma had to go back to work to raise me and my brother, and she held down two jobs to keep the bills paid – a cleaner in a hospital by day and a waitress in a café three nights a week. Did those two jobs for 13 years to get the two of us through school. And when I later asked her what kept her going through all those years when she was on her own with two kids to feed and clothe she just said one word: "Jesus".

'She was a real Christian lady, my Momma, and she made sure we were always in church every Sunday, which meant a three-mile *walk* to the nearest Baptist church, since we had no car. But she just didn't make sure we went to church every Sunday. . . she also made sure we *listened* – and listened good – to what the preacher had to say. Well, when I was nine, I remember approaching the preacher and talking to him about how hard it was for me to forgive my Daddy for leaving us. And the preacher said that if I invited Jesus into my life, I'd be able to forgive him and put all that bitterness behind me. So we said a prayer together, and I asked Jesus to be my Lord and saviour, and I immediately felt at peace with my Daddy. It was like Jesus had touched my heart with His healing hands and made all that resentment which was lodged there just disappear like magic.

'That was my first encounter with Jesus. A couple of years later, though, when I was 11, I turned to him for help, 'cause I had this real bad speech impediment and I stuttered and stammered all the time. And with His help, I *overcame* that speech impediment – which kinda got me thinking that the Lord wanted me to talk right for a purpose. Well, just a week later my Grandpappy died, and I watched the preacher consoling my Momma and Grandmomma, and I sensed the Lord's presence, healing hurts. And that's when I first felt that, one day, I'd be the preacher helping folks at times like this.'

By the age of 16, Calvin was already preaching at youth revivals and rallies around Alabama. By the age of 20, he was married and supporting himself through college by 'pastoring' at a variety of

local Baptist churches. By the age of 25, he'd already done a stint as an 'evangelical worker' in New Orleans and Biloxi and was back in Montgomery, in charge of a church of his own, and making something of a name for himself as a very persuasive sermonizer who sold the Christian message with real theatrical flair.

'Next thing I knew, I was getting phone calls from churches all around the state, not to mention Mississippi and Tennessee, asking if I'd come preach a revival. And the more I started giving revivals, the more I realized that this was what God had been preparing me for all along; that this was why He helped me shake off that speech impediment all those years ago. But I didn't hear no clap of thunder or a voice from the heavens telling me that I was going to be a roaming evangelist. It was just another feeling of inner peace – of knowing that this is the job Jesus wanted me to do full-time.'

So the Calvin Millar Evangelistic Ministry was born, and Calvin hit the interstate full-time. Success came fast, for very soon he was a hit with the Baptists of Memphis, the Baptists of Little Rock, the Baptists ofbz Baton Rouge. But he didn't just stick to the big regional centres when it came to giving revivals – he also spread the Word in back-country places with double-take names: Chattahoochee, Florida; Demopolis, Alabama; Moncks Corner, South Carolina.

'I've preached in halls seating 3,000; I've preached in little country churches with a congregation of just 30; I've even preached on a Sioux Indian reservation. And I've stayed in every Holiday Inn, Day's Inn, Budgetel or any other motel chain you care to mention. I've slept on hundreds of cots in folks' living-rooms and I actually once bedded down in a chicken coop. Like I said, I'm an itinerant preacher, just like Jesus was. I've got no organization, no administration. My ministry is just me, and I plan to always keep it that way. 'Cause God didn't call me to be a big international evangelist like Billy Graham – who is the man I probably most admire in the world. No, God called me to do His work on a more *personal*, individual kind of level. To preach for souls. To rekindle the faith of those who used to be really *on fire* for Christ. To reach those who've never allowed Christ into their lives.

'And I preach *hard*. With *conviction*. I preach *power*. You can't talk about sin and treat it cuddly. But my main goal is to preach how much God loves man, how He'll forgive him his sin and give him the gift of eternal life if he invites Him into his life.

'So, the most important part of any revival I give is the *invitation*, where I invite people to come forward to publicly open up their souls and confess their faith. I guess you could say that this altar call is where I see the results of my work; see if I'm doing my job properly and getting the message of the Gospels across. 'Cause witnessing is just one beggar telling another beggar where to find bread. And I'm like a voice in the wilderness. Telling folks to prepare to meet God and live the godly life. To study the word of God daily. To pray daily. To worship regularly every week. To have a conversation with Jesus every day. I spend an hour chatting with Him every morning. And with Christ on my side, I can cope with life's problems. But, I'll tell you this much, Doug: I feel for people who don't know Christ, because they don't know what they're missing.'

He put his hand on my shoulder and gave me a paternalistic, 'I think we gotta talk, son' kind of smile. That's when I knew what was coming next.

'Now Doug, it's time for me to ask you a question or two. Do you know what an "audible" is in football? That's when a quarterback shouts out a number to let his players know that he's changing a play; that he's changing the entire *direction* of the way he's gonna go forward. Well Doug, don't you think it's time for an "audible" in your life? Isn't it time you changed the whole way you're gonna go forward from now on? Especially when you *know* that Jesus is there, tapping at the door of your heart, asking to be let in. God's got great plans for you, Doug. Great plans for you as a writer. But you could go out that door and crash your car in the next ten minutes, and then you would die without being saved. Think about that. Now I know that's highly unlikely, but you can have the gift of eternal life just by asking Jesus to come into your heart.

'So, can you give me one good reason *why* you shouldn't ask Jesus to come into your life? Can you?'

There was a lengthy silence before I finally said, 'Because I've never heard Him knocking on the door of my heart, and I really don't think He ever will, since I don't believe in Him the way you do.'

Calvin let out an 'audible' – a long sad sigh – and shook his head. Then he visibly brightened and said, 'Let's bow our heads and pray together.' Out of deference to him, I lowered my head as he prayed that I be shown a safe passage through America,

and that I accept Jesus in my heart, since he knew that, one day, I'd be saved.

When he finished his invocation, he looked up at me and said, 'I bet I'm not the first preacher who's tried to witness you on your journey so far.'

I told him that he certainly wasn't, and said that I was becoming something of an expert on witnessing techniques.

'But you gotta understand, Doug, that it's every evangelist's job to get you saved. And I want to bring you to God because I don't want you to be a lost soul.'

'But what if I don't mind being a lost soul?' I said.

'There is no such thing as a lost soul', Calvin Millar said. 'Everyone can and *must* be brought to Jesus – because He is the King and this is His Kingdom.

'Only an arrogant man refuses the gift of the King. Especially down here in Alabama.'

CHAPTER 4

Heavy Metal Evangelism

★★★

They arrive by helicopter, looking lean, mean and dangerous. There are four of them, and they all have heavily permed shoulder-length hair. Studded leather pants have been apparently heat-sealed onto their torsos, so that their genitalia stand out in graphic bas-relief. One of the bloods is bare-chested, with a pair of leather braces and a chunky gold chain that extends across his hairy pectorals. His other three colleagues wear silver neck halters, glitter jewellery and sequin-speckled black velvet shirts. At first sight, you think they are a quartet of bikers with bizarre hermaphrodite tendencies. But as they sprint out of the helicopter and into a waiting limousine, the scene then shifts to a smoke-filled stage (the backdrop for which is a huge blown-up photograph of a one hundred dollar bill), and you begin to get the idea that these guys aren't en route to a convention of bondage fetishists, but to a rock concert. A rock concert in which they are the main attraction.

And when they take to the stage and begin to thrash their instruments, and little explosions of light dazzle the eye, and an even thicker cloud of post-nuclear holocaust smoke wafts over the proceedings, you come to the quick conclusion that these boys aren't simply a rock band, but a heavy metal rock band.

The lead guitarist plays a crashing chord and starts to sing:

> Love can be so cold
> And loneliness gets old
> More than words or broken promises
> I want to show you what true love is.
> I'm always there for you

I'll always stand by you
When the world has closed the door
And you can't go on anymore
I'm always there for you.

Not exactly the sort of head-banging lyrics you'd expect from a band which appears to be such an archetypal bunch of head-bangers. But the stars of the rock video you're watching – a California outfit called Stryper - aren't your usual collection of neo-Nazi heavy metallists; a fact which is confirmed when you study the sleeve notes of their latest hit album. For, in that small-print Acknowledgements column where most bands thank the roadies who kept them supplied with the three Bs – booze, barbiturates and bimbos – Stryper lead off with a somewhat unusual expression of gratitude: *Special Thanks to the Ruler of the World and the World to Come, Jesus Christ.*

Suddenly, the lyrics to the song they're singing – 'I'm Always There For You' - take on new meaning. These boys aren't belting out some puerile expression of post-pubescent love; they're actually talking about the unconditional love of God's Only Begotten Son – the one dude who'll always bail you out of Heartbreak Hotel. He's Stryper's Main Man, and He can be your Main Man too, 'cause he's always there for you – that's the evangelical subtext to this Top Forty hit single by the hottest evangelical heavy metal band in America today.

It was Beth who introduced me to Stryper and showed me this latest rock video of theirs.

'I tell you, these guys are hot', Beth said. 'We've just shipped gold on their new album – "In God We Trust" - which means they've really cracked the *secular* market and have *total* crossover appeal. And you should see 'em in concert. A real dynamite stage show, with one of the best heavy metal finales I've ever seen.'

'What happens?' I said.

'They shower the audience with bibles.'

Beth was a music executive who talked like a music executive, peppering her conversation with the lingua franca of the industry in which she operated. Beth also dressed the way you'd expect someone who worked in an au courant business like pop music to dress: her T-shirt was Armani, her black lycra skirt was short, her shoes were Doc Martins, her sunglasses – dangling around her neck – were bright red Ray Bans. Pure King's Road. Only Beth didn't live in London. And unlike most pop music executives, she

kept a bible on her desk and had a hand-lettered sign – 'God Is Love' – taped to one corner of her office cubicle. This was nothing unusual in her office, as all of her neighbouring colleagues also had bibles on their desks and quotations from the Scriptures pasted to their cubicle walls. That's because the company where Beth worked only hired committed Christians, being one of the biggest Christian music companies in the country. Which naturally meant that its corporate headquarters had to be in 'Music City, USA' – Nashville, Tennessee.

I'd first heard about the corporation which Beth worked for – the Benson Company – while hanging around GRACE FM in Sarasota, Florida. It was Wally – GRACE's morning DJ – who talked about such eclectic musical genres as 'Christian Heavy Metal' and 'Christian Rap', and said that Benson were the 'market leaders' when it came to 'the best ecclesiastical sounds today'.

Now the idea of an entire record industry built around hard rockers proselytizing for Jesus was certainly news to me. Especially since, prior to visiting the studios of GRACE FM, I was under the impression that most contemporary Christian music was still stuck in that warbled old Salvation Army-esque 'What A Friend We Have in Jesus' conservative groove. But it only made sense that Christian music had gone pop, since the potential for winning souls through various brands of rock-and-roll was huge. After all, if some blitzkrieged fan of a mainstream heavy metal group like Napalm Death could be lured over to the equally 'heavy' tunes of Stryper, he might just be converted at the same time.

'I'm tellin' ya, when we're talking American Christian music, we're talking *growth*,' Wally said. And we're also talking Nashville. 'Cause outside of LA and Waco, Texas, Nashville is *the* industry HQ for Christian music today. You want to check out Christian music, you go to Nashville.'

So I decided to do just that, covering the 275 miles between Montgomery and Nashville in just over four hours before hitting a tangle of bisecting highways which announced my arrival in the Tennessee capital. Nashville, on initial inspection, appeared to be an immense webwork of elevated roads and overpasses, encircling a glass cliff of office blocks. I followed the signs to an inner suburb called MetroCity, cruised past a shopping mall which was attempting to resemble an old Mississippi steamboat, and pulled up in front of a red brick cube with a sloping Perspex roof that housed the Benson Company. Inside, the foyer was a cool angular arboretum with hi-tech tubular piping, a reflecting

pool with water-jet fountains, and lots of overhanging greenery – a corporate hothouse look, offset by a poster taped to a side wall, showing a trio of malevolent rock bands in a variety of slam-bang poses. *HOT METAL SUMMER!*, the poster screamed: *This Summer, a Christian Metal Shower is on the Horizon.*

I was directed by the receptionist on duty to Benson's press department, located in an open-plan office on the first floor. It was a real Music Biz press office – stacks of give-away records and cassettes, stacks of promotional posters for a variety of acts, stacks of 8x10 black and white photos of Benson's artists, and a collection of very busy men and women in their twenties, decked out in Calvin Klein jeans and Reebok sneakers and forty dollar haircuts. Beth – in her frizzy hair and her London wardrobe – slotted in perfectly with this hip corporate identity. We'd met by phone the previous day, when I called the press office and asked if I might be able to stop by Benson and learn more about their business. She was immediately welcoming – 'We always love to share the work of our ministry with anyone who's interested' – and arranged a meeting on the spot. Such high-speed enthusiasm was, I soon learned, Beth's forte. The moment I arrived at her desk she marched me straight off to a screening room to watch Stryper's new rock video, which had just been aired that week on MTV (Music Television – America's 24-hour rock video broadcasting channel), and immediately began to sing their praises.

'I just love these dudes', she said while, on screen, Stryper's lead guitarist hammered his Fender. 'I mean, it's not just the fact that we sold half-a-mil of their new album; it's the fact that they're committed evangelists as well.'

Her boss was a guy in his mid-thirties named Larry Curtin. He was dressed for African missionary work in a pair of khaki trousers, a khaki field shirt, and canvas hiking boots. Unlike Beth and the rest of her colleagues, Larry had his own proper office, replete with a state-of-the-art stereo system and a couple of gold records mounted on the walls. He also had a framed quotation from Proverbs hanging behind his desk:

Trust in the Lord with all thine heart: and lean not unto thine own understanding.
In all thy ways acknowledge him, and he shall direct thy paths.

'Best piece of business advice I've ever seen', Larry said when he saw me steal a glance at that framed quote. 'Trust in the Lord. . .

and keep your eye on the bottom line – what more else do you need know in corporate life, right?'

He let out the sort of fast chuckle that sounds like a hiccup and then said, 'Okay, down to work. What d'you want to know about the company? You want to know something about our history, right?'

He didn't wait for me to answer; he simply ploughed ahead.

'Okay – the Benson Company was founded 86 years ago as a music publishing company that started out printing the music used in Pentecostal revival services. The founder of the company was a man named John T. Benson, Sr, and he initially made his money out of religious sheet music and revival songs before eventually branching out into mainstream evangelical music. Now, around the mid-1950s, a new phenomenon came along in religious music called "all-night sings". This was like a jam session for Jesus, where a lot of the big Southern gospel groups of the time used to get together and do these all-night gigs which were real popular with folks who were also into Elvis and rhythm-and-blues, and therefore wanted a more upbeat kind of *praise music*. So the Benson Company saw a new market opportunity and went for it, signing up one of Elvis's early backing bands, The Stamps Quartet, for a record deal. And, I guess you could say that that record deal was when contemporary Christian music was born.'

Of course, the mid-1950s were the pre-natal days of rock-and-roll, and it took the excesses and social hypertensions of the l960s to firmly establish rock music as a force to be reckoned with. Similarly, it wasn't until the end of that frequently uproarious decade that Christian rock started to become recognized as a musical genre with broad popular appeal. And Larry said that the one opus which pushed Christian rock into the musical mainstream was a certain large-scale composition by an English musical theatre man.

'The best thing that ever happened to Christian rock was Andrew Lloyd Webber's *Jesus Christ Superstar*. 'Cause what that show did was this: it demonstrated that Christian concepts could be expressed in a new idiom. And the next big breakthrough after *J.C. Superstar* was an American musical called *Alleluia!*, which was very inspirational and was performed in churches across the country. Now the thing about *Alleluia!* was that it was 'pop', but it was the sort of 'pop' which didn't offend traditional church-goers. And the other thing about *Alleluia!* was that the

record album of the show sold a half-million copies – which kinda got the Benson Company thinking, "Hey, there are a lot of people out there who want to listen to the sort of Christian rock that will be the *soundtrack* of their lives; that will be part of their *belief systems*." '

After these early successes, the next great leap forward for Christian rock was a dude named Dallas Holm, who was a guitarist in some obscure band before he went to a revival, got saved and decided to use his rock-and-roll talents for the Lord. The result was a single – 'Rise Again' – which gave the Benson Company their first Christian rock gold record:

'Now, from this moment on, we started to see some real *genre diversification* in Christian music. I mean, there wasn't just something called "Christian rock" anymore; there were now several subdivisions of Christian rock – there was Christian "Adult Contemporary", which is kind of like a Top Forty sound; and there was Christian MOR, which is Mantovanni-style instrumental music with, of course, a distinctly Christian message; and there was Christian Hard Rock, which was bands like Stryper and Barren Cross. And the reason why, I think, you started seeing so many branches of Christian rock emerging during the 1980s was due to an *interface* between consumer and evangelical market forces. Like the beginning of the 1980s was a time when many Americans really started turning back to the Bible again. And since the evangelical church in this country has always called upon Christians to lead *qualitatively* different lives from non-Christians, it was real difficult for a true follower of Jesus to relate to the *values* put forward by mainstream pop music. I mean, a song like George Michael's 'I Want Your Sex' is a total *no-go* for any real Christian. And since so many songs you hear on the radio operate on that sort of lewd level, many active Christians began to reject the content of much pop music, yet still yearned for something stylistically similar. So what we had was a real *product gap* which the Christian rock industry really capitalized on – giving believers the sounds they wanted, but making sure at the same time that the content was 100 per cent Christ-like.'

Soon, Christian 'Adult Contemporary' and Christian hard rock stations began to spring up around the country, and with them came a Top Forty countdown of the hottest Christian tracks of the week. What's more, Christian rock began to attract such a widespread following that magazines geared towards, say, Christian MOR began to be published, while many of the bigger

Christian groups started putting out their own fan newsletters. And, of course, the music companies also used the same kind of marketing techniques that their secular counterparts engaged in to get their 'product' sold: advertising groups like Stryper in mainstream heavy metal magazines; offering special discount schemes ('Buy four albums; get a fifth free') to boost record sales; using promotional materials like sweatshirts, badges and bumper stickers to give their artists wider 'name identification'.

It was marketing strategies like this which helped build Benson up into a company with an annual turnover of $25 million – making it one of the Big Three Christian music companies in the US. And though half of its revenue still came from the sale of sheet music, the pop end of the market was certainly bringing in a sizeable amount of cash every year. That is, until May of 1987, when the Jim Bakker scandal broke and the entire Christian music industry hit the skids.

'Sales-wise, those were the worst months we ever had', Larry Curtin said. 'The whole Bakker affair cast a giant shadow over everyone who was in the business of merchandising Christian items, and nobody wanted to touch our product for a long while. Which means that the bottom line started to look real bad around here, and we had to cut a third of our staff. Terrible thing, letting people go – but that's business, right? And one good thing that came out of that whole crisis was a lot of *structured brainstorming* about our future as a company, and a drastic reappraisal of our entire marketing approach. It was a re-think that paid off, because during the last two quarters we've been in a definite turn-around situation, with sales up around 36.5 per cent on what they were this time last year.'

He hiccupped another fast chuckle and said, 'Hey, I'm sounding like a real marketing guy, right? Well, Doug, I may talk like a marketing guy – in fact, I may *be* a marketing guy – but what's most important to me about my work is the *mission statement* that my company makes. Like I know that most Christian music companies can't compete nose-to-nose with the big secular music giants. So our market focus is ultimately aimed at people who want music that reflects their Christian world-view. And we set out to produce God's *truth* through that music; to create a *lifestyle force* which inspires people to be truly Christian.

'Look at the history of the world and you'll see that, in its finest moments, Christianity can redeem an entire culture. Well, that's my personal goal for Christian music – to redeem

contemporary American culture. To bring it back to Christ. Through rock-and-roll.'

Larry had to go off to a meeting ('I've got to segue into a sales conference'), so he handed me back to Beth.

'Want to hear some of our product?', Beth said. She loaded me down with around a dozen cassettes and a bunch of music magazines, and brought me to a small soundproof listening room with a stack of stereo equipment and a set of hi-tech mission control headphones.

'I'll come back in an hour, see how you're getting on', Beth said. 'Enjoy the tunes.'

I plugged in a cassette by a heavy metal band called DeGarmo and Key, and listened to a track called 'Rock Solid' – a hard-driving, mega-electric song about some guy who's approached by a dark mysterious stranger, offering him 'anything you might need. . . If it's money, I got it. I've got a life of ease. . . If it's power I'll give it to you. . .' But the guy does not yield to Mr Satan's temptation, defiantly telling him:

> I got power
> I got spirit
> I got a message that's true
> My satisfaction comes from Jesus
> And He is so much better than you.
> I'm rock solid I know where I stand
> I'm rock solid in the Master's hand
> Rock solid grounded in love.

As this number ricocheted around my head, I browsed through DeGarmo and Key's fan newsletter. They were a Nashville-based group – a duo made up of a guitarist named Eddie DeGarmo (a frizzy-haired blond sporting the sort of long black floor length coat which was once popular among gentlemen cowboys), and a keyboard player called Dana Key (an intense chap with round wire-rim spectacles and a rabbinical beard, making him look more like a doctoral candidate in Philology than a rock musician). The newsletter announced that the band were about to embark on a 60-city 'Rock Solid' tour, and beneath the schedule of dates was a personal message from the two boys:

129

'Through the years, we've been asked the question many times, "What part of your ministry do you enjoy the most?" The answer has always remained the same: the live concert. It's the time when the elements of our ministry come together as one. It's the time when we see a thousand smiles on a thousand faces as the Lord brings us together. It's the time when we see tears of repentance on the countless faces of those wanting to commit their lives to Jesus. It's the time that makes all this worthwhile.'

Inside, there was a D&K Order Form, in which you could send away for a D&K video (*Rock Solid. . . The Rock-U-Mentary*), D&K T-shirts, D&K sweatshirts, D&K posters, D&K buttons ('Boycott Hell') and a D&K Special Souvenir Collector's Book ('featuring pictures, songs and pull-out colour poster. . . Only $5.00!!'). There were also letters from a number of fans, all of which praised the clever marketing ploy used by the Benson Company to sell D&K's new album – a 'Give One Away' cassette package, where everyone who bought a copy of *Rock Solid* received a second copy free. One correspondent signed himself *Steve, West Germany*:

'I'm an Air Force Security Policeman. I've been a fan of yours for about six years and I was glad when I found your new album, and even happier when I saw that there were two copies of the album in the package. I gave one copy to a Christian brother on the day flight in my squadron so he could use it to aid him in witnessing. We're not allowed to openly testify, but there are no rules stopping us from using music.'

Another letter was from *Jason, California*:

'I recently purchased your new album D&K and I love it! I let an unsaved friend borrow it and guess what? Praise the Lord – he became saved!'

But, perhaps, the most interesting item in the D&K newsletter was a special message of support from Josh McDowell – that Assemblies of God minister with the television Dad view of life who I'd watched in action on the big video screen of the Carpenter's Home Church in Sarasota, Florida. Josh was unstinting in his praise of D&K's work for the Lord:

A recent survey indicates that young people today listen to almost 40 hours a week of rock music. In many cases the lyrics to the songs are blatantly suggestive. Countless song lyrics allude to one-night love affairs and part-time lovers. This is why in an age when our kids are under constant sexual pressure it is important that the music they listen to,

130

rather than destroying their values, gives them the strength to stand for Christ.

The music and ministry of DeGarmo and Key can be and is a valuable source of strength for young people all over the world. Not only does their ministry play an important part in teen evangelism (with more than 5,000 decisions for Christ last year) but they also provide young people with a Christian entertainment alternative to the morally destructive rock world.

I switched cassettes, plugging in *Radically Saved!* – the new album by one of Benson's biggest Top Forty heart-throbs, Carman. Judging from his photo on the album cover – showing an Italianite dude in white tie and tails, with chiseled Italianite features and tightly curled blow-dried hair – Carman certainly fit the role of the John Travolta-esque hunk who appealed to disappointed-in-life housewives and their pre-pubescent daughters. And indeed, *Radically Saved!* – a concert recording of Carman live in Tulsa, Oklahoma – opens with his fans greeting his entrance onstage with the sort of sonic boom squeals that were once reserved for Elvis or that quartet of boys from Liverpool. But then – as his drummer pounds out a bump-and-grind beat – Carman makes it clear that he isn't some run-of-the-mill pelvis thruster, but a man with a message.

'Is Jesus alive in this building tonight?', he asks in his best nightclubby voice. His question is answered by a deafening barrage of screams, as his fans affirm that Jesus is very much *in situ* in Tulsa. The horn section in his band now starts blowing some real disco-funk riffs and Carman begins to croon:

> Jesus healed the blind man, made him see
> Cast demons out the man from Gaderene
> Cleansed the lepers too
> He made the lame brand new
> He put hope back in a hopeless life
> I testify to you
> I've been delivered
> I've been delivered
> The hold the devil got on me
> He ain't got no more
> I've been delivered
> By the hand of the Lord.

131

It was like listening to a Las Vegas interpretation of the Scriptures. Then again, Carman began his career in Vegas – a detail I discovered in a biographical fact sheet on the singer which Beth had given me:

Born in 1956 and raised in the suburbs of Trenton, Carman Dominic Licciardello lived in New Jersey for 20 years. His family is Italian and Carman is one of three children. His father was a meat cutter, his mother a talented musician. Carman credits his mother, Nancy Licciardello, with having been the inspiration that convinced him to take up music.

Years of practice later, Carman left New Jersey in 1976 at the advice of his agent. With his sight on Las Vegas, Nevada, he set out cross-country in his '73 Vega. While pursuing his career in show business in Las Vegas, Carman frequented the southern California area where his sister and brother-in-law lived. 'A straight club singer' is how he describes himself during this time. 'I did rock-'n'-roll tunes, Fifties and Top Forty. But I never wrote songs, nor ever used humour.'

Following several instances of meeting the message of Jesus Christ head on – through talks with, and the constant prayers of, his sister, Nancy Ann Magliato, the intercession of the church that would later become his home church, and his attending an Andrae Crouch concert one evening (one of Christian music's big names) – Carman gave his life to the Lord.

Of course – as his publicists were quick to point out – Carman's transformation from 'born-again, part-time Vegas entertainer to born-again, full-time contemporary Christian music performer/songwriter was not a short nor easy one'. He had to take part-time jobs as an upholsterer until he got his first break with *Some-O-Dat*, his debut LP, the main track of which was 'a rock-a-billy rendition of the Christmas story'. From that moment on, Carman's career went into top-gear – 'his intensified desire to make an eternal impact' gave him the impetus to make hit album after hit album. And though 'Carman's wide range of musical styles – rap, praise, ballad, story song, rhythm and blues, and rock-a-billy – have broadened his potential listenership. . . it is [his] appeal as a genuinely anointed, called-out and radically committed minister of the Word which seems to have the greatest appeal to those who buy his recordings.'

I read on, fascinated. Carman was obviously a publicist's dream, for his was a classic American case history of success through perseverance. Then again, all of Benson's artists seemed to have relatively similar case histories – after declaring for Christ, they hit the big time. There was Dino – a pianist promoted as the Christian Liberace (without, of course, the great glitterer's sexual proclivities) – who dedicated his musical talents to God while attending a church service at the age of seven and immediately discovered that he possessed an innate ability when it came to playing by ear. From that moment on, he became a *Wunderkind* whose career had (according to his publicity) been a non-stop series of artistic triumphs:

> Though a Dino performance is not quite as flamboyant as a Liberace concert. . . the music, a mixture of the sacred and secular, is stepped up and lush. You hear technicolour and sweeping autumn leaves. . . What does it take for a man to garner credentials like these: a discography of more than 20 albums, five Gospel Music Dove Awards, over 100 national television appearances, over *10,000* world-wide concert appearances, and several hundred original and innovative musical arrangements and piano books? Well, 'Talent' would be how most would respond to the question. But, to Dino, being a successful gospel artist takes more than credentials – it takes 'a deep religious commitment to make music become the kind that draws a person into a relationship with the Divine'.

For most pop music artists, fame gives them the cachet to buy a Lamborghini, finance a couple of expensive divorces and accept a guest appearance on some meaningful rich-guilt track like 'We are the World'. For a Christian pop star, however, fame means buying the Lamborghini *and* winning souls at the same time. And yet, like any 'creative business', the competition for evangelical music stardom is huge – especially since, as Larry Curtin told me, the Christian music market is not big enough to support a large number of people making a large amount of money. So, for every Carman or Dino, there must be a couple of dozen aspirants hoping for the big break. Did they – as good Christians – pray to the Big Record Producer in the sky asking Him for a career boost, so as to serve Him better? Did they possess a schizophrenic sort of ambition – justifying

their desire for celebrity and wealth (desires which are the modus vivendi of the pop music industry) by saying that stardom would provide them with a bigger platform to preach from, and therefore *upgrade* their ability to reach potential converts? And if their career never managed to ignite, did they simply accept the fact that they would never make the cover of *CCM* (*Contemporary Christian Music* – the *Rolling Stone* of the evangelical music industry) and, realizing that God had other plans for them, start scouting around for a new praise-oriented vocation? Or did they become bitter by their failure to make it as a proselytizing rocker?; a bitterness which, in turn, led to a crisis of faith?

No doubt, Nashville was a city filled with winners and losers in the Christian rock game – just as it was undoubtedly also filled with winners and losers in the country music game. For any town that called itself Music City, USA must be a town where success and thwarted ambition are contentious neighbours; where you don't simply need talent to serve Jesus through song – you need talent *and* a record contract.

Beth came back into the listening room carrying a box filled with marketing paraphernalia: a *Carman: Radically Saved!* bumper sticker, a *Radically Saved!* rubber stamp, and a boxed 'Give One Away' edition of DeGarmo and Key's *Rock Solid,* so I could 'give one away to a friend back in England', as Beth put it.

'What do you think of some of the product you've been listening to?' she asked me.

I said that, musically, DeGarmo and Key seemed to know a thing or two about rock-and-roll.

'Yeah, they can bang heads with the best of 'em,' Beth said. 'If you're here next week, you can catch them live, 'cause they're gigging in town.'

I said that I was only planning to be in Nashville for a few days. And I also asked her if she could recommend a local motel which was cheap, but not a freak show.

'Hang on for a minute,' Beth said, leaving the room. 'I'll make a few phone calls, see what I can come up with.' When she returned five minutes later, she announced:

'Right, you're fixed up with a friend of mine. Name of Shirley. Lives around ten minutes from here. She can put you up for a couple of nights, if you don't mind sleeping on a couch. I'm driving over there myself in about five minutes, so you can just follow me.'

Such spontaneous hospitality made me do a double-take. 'Are you sure she doesn't mind?' I said.

'If she minded, she wouldn't have offered. Anyway, Shirley used to be a roadie with a band, so she knows all about crashing on people's floors. Like it says in the Book, "I was a stranger and you took me in." That's Matthew, *dude*.'

Shirley was a seriously fat woman crowding 35. At first sight, she looked like an ageing tomboy, dressed in a beat-up sweatshirt, a Baltimore Orioles baseball cap and size 46 jeans. At second sight, she still looked like an ageing tomboy; an impression that was reinforced by the fact that the three guys she rented a house with had this habit of calling her 'Sis'.

The house was a standard-issue split-level suburban home, located in a middle-management district called Greenhills – the sort of area favoured by certified public accountants and junior vice-presidents for sales. Shirley and her housemates were an exception to this young executive rule, as they were all connected to the Christian music business. There was Adam, an easy-going, slightly chunky black guy in his late twenties, who was the tour manager of a group called Resurrection. There was Martin, who – with his long blond hair (carefully sculpted around the ears), his stretch singlet and running shorts, and his gold chain bouncing off his hairy pectorals – very much fitted the identikit image of Joe Los Angeles. Except that Martin ran a ministry which organized Christian dances at local schools and community centres; dances where the disco music had an evangelical edge to it. And then there was Fred – a weedy bass guitarist from Allentown, Pennsylvania, who'd been playing in a local church band before coming to Nashville only a month or so ago, hoping to break in to 'the business' as a session musician. But – like so many hopefuls in a city of hopefuls – Fred had discovered that Nashville was brimming with session bassists, making the competition for work downright ferocious. So, in order to stay financially afloat, Fred was 'in another business at the moment'.

'What sort of business?' I asked him.

'The pancake business,' he said. 'I'm a waiter on the night shift at the International House of Pancakes.'

He had Shirley to thank for the pancake job, since she was a part-time waitress in the same establishment. She'd only recently left the Christian music game and was now working as a social worker at a Baptist-run centre for disturbed children, but the pay was so paltry that she needed the International House of Pancakes gig to fill in the financial gaps. And it was the International House of Pancakes where Shirley and I ended up for dinner that night,

Adam and Fred having arranged to see a movie with Beth, while Martin was running one of his charismatic discos on the other side of town.

'Can't let you eat by yourself on your first night in Nashville', Shirley said, as we drove into the International House's parking lot.

'Are you sure you want to eat where you work?' I said, also thinking that a dinner of pancakes in 105 degree heat mightn't be the wisest of digestive ideas. Shirley, though, was insistent: 'I'm really up for a stack', she said.

Shirley, in fact, ate two stacks of blueberry pancakes, each capped with two scoops of vanilla ice-cream and drowned in a small lake of maple syrup. I was boring and ordered an unadorned hamburger and unsweetened iced tea.

'Wish I had your discipline,' Shirley said after I placed my order. 'Cause I know I eat too much, that food's my real bad sin. But, I guess, food's better than some of the sins I was once into.'

Shirley then told me that she'd grown up an atheist in Baltimore, had dropped out of college at the age of 20, and spent the next nine years criss-crossing the country, working as a roadie with some low-rent Top Forty band. They were a real second division outfit, permanently locked into the Holiday Inn and Sheraton lounge circuit. It was Tedium Ltd, and to break up the monotony of endless weeks in stimulating urban centres like Sioux Falls, South Dakota and Flagstaff, Arizona, she developed a taste for amphetamines, tequila and the kindness of strangers. Inevitably, after nearly a decade of non-stop, high-flying debauchery, Shirley crash-landed one day straight into a major nervous breakdown and found herself spending nearly a year back in her parents' house in Baltimore, trying to rediscover what the word 'equilibrium' meant.

'What finally pulled me out of the hole I was in was God. I had this sister, Jackie, in Baltimore who'd been born-again for years and who always told me that I was going to reach out for Jesus one day. Now – like I said – the Lord never played any big part in our family when Jackie and I were growing up, since my parents weren't religious and I used to think that God really didn't exist. And even when Jackie got saved – after her little boy drowned in a swimming accident – I put her conversion down to her trying to cope with her grief. But after I had my little "problem", Jackie started suggesting that I come to church with her on Sundays – a real nice Baptist church, full of good people who, once I started

getting to know them, were real supportive to me, really helped me get through the problems I was having.

'Anyway, it took some time for me to get saved. I mean, I didn't just wake up one morning and decide that Jesus was the answer to my problems. It was kind of a gradual thing; kind of a slow realization that Christ was my saviour and that, in order to serve Him, I'd really have to get out of Top Forty music.'

So, once the fragments of her psyche were put back together again, Shirley headed off to Nashville to break into the Christian music business and start anew. Before she knew it, she was back on the road, having landed a job with a Christian band called True Believers. But though she was now a roadie in the company of other Christian roadies – and though a True Believers tour was a sober and prayerful gig (therefore being the antithesis of her sex-and-drugs-and-pimple music exploits in the past) – Shirley finally reached the conclusion that laying down cables and adjusting microphone stands wasn't her true calling in life.

'It was time to switch gears and head out into some tougher professional terrain,' Shirley said. 'So I landed this job helping disturbed orphaned children in a home that's run by a Baptist charity down here. Though I don't like to think of it as a home – just as the place where the kids I work with live.'

She opened her handbag and brought out a snapshot of a black kid in his teens, wearing a track suit, a shiny new pair of high-top runners and a goofy smile.

'This is one of my kids,' Shirley said. 'Name's Willie. Took this photograph of him yesterday after we finally got him that pair of high-tops he'd been asking for for weeks. That's why he's got that big wacko smile on his face – 'cause we surprised him with 'em. Thing about Willie is, he don't smile too much. Doctors say that, though he's 16, mentally he's still not progressed beyond the age of six. That's because, when he was six, his mother – who was a prostitute – got stabbed to death 20 times by another prostitute during a fight. Thing about it was, Willie was in the room at the time. Saw the whole thing.' Shirley fell silent for a moment, shook her head and said, 'It's kind of a change of pace from worrying about whether a microphone's working or not.'

I said that, after dealing with cases like Willie's all day, doing a night shift here at the International House of Pancakes must seem absurd.

'I got no choice, money-wise,' Shirley said. "Cause I only pull in 15 thou. a year before taxes as a social worker, which is

like nothing to live on. And I can clear 50 a night here, which means that I can eat out and go to concerts and afford to run my car – stuff which I simply could not handle financially if I was just relying on my salary from the home. So the way I figure it – it's serve up pancakes three nights a week or never go out. So I serve up pancakes.'

What was so extraordinary about Shirley's explanation for holding down two jobs was that it was delivered without rancour or even the slightest hint of resentment. Had she been a British or Irish social worker forced into extra part-time employment, she would have rightfully blamed the government of the day for so underpaying people like her in the caring professions that they had no choice but to waitress at night in order to maintain a reasonable standard of living. But as an American – schooled in the 'you pays your money, you takes your choice' ethos of a free-market economy – she simply accepted the fact that the price of doing something worthy like helping emotionally disturbed children was spending every Friday to Sunday on the night shift at the International House of Pancakes.

A small tubby man in a short-sleeved green polyester shirt and clip-on tie approached our table. Shirley introduced us: his name was Leo, the manager of the restaurant.

'Any friend of Shirley's a friend of mine,' Leo said, throttling my hand. "Specially a Christian friend. I am always pleased to welcome a fellow Christian to the House of Pancakes.'

In fact, Leo was so pleased to greet a 'fellow Christian' that, when we approached the till to settle up, he reduced our bill by 50 per cent.

'Hope you didn't mind me not saying anything when Leo called you a Christian,' Shirley said as we walked into the car park. "Cause if Leo had found out you *weren't* a Christian, he would've started proselytizing you right there on the spot. And, quite frankly, I wouldn't have wanted to put you through all that. 'Specially since I've seen Leo in action. And though I know he's doing good work for the Lord – and though I love him as a fellow Christian – he still doesn't know when to shut up.'

Shirley had to be back at the House of Pancakes in three hours to start work on the late shift, but first wanted to stop by the home to see another one of her kids, who'd been going through an anorexic phase for a couple of days and was refusing all food. So we parted company, and I set out on an impromptu tour of Nashville, driving through areas like Belle Meade – the upscale

part of town, favoured by Country and Western millionaires with a taste for reproduction *ante bellum* mansions and discreet security cameras. And through White House – another beau monde suburb of substantial homes and six-figure incomes. And down Music Row – the famous record company district of the city, where all the executives seemed to be wearing cowboy boots and driving Japanese jeeps bought on the profits made for them by every big Country artist in the country.

But the geography of Nashville was ultimately subservient to its motorways. They turned the city into an automotive slalom course, along which you looped in and out of districts where shopping malls had become the central focus of community life. No main streets appeared to be left in any of its suburbs, as they had been replaced by concrete arcades fronted by vast car-parks. It gave Nashville a certain 'isolation ward' atmosphere – as if everyone here moved from air-conditioned car to air-conditioned office to air-conditioned supermarket to air-conditioned restaurant to air-conditioned home. Direct contact with city streets was limited to the brief amount of time it took to walk from your car into the sequence of air-cooled 'environments' that made up your day. Pedestrians in Nashville were either considered cranks or – worse yet – street people. And therefore, it was not at all surprising to discover that the area called Downtown was the one place in the city where you'd actually see people pounding the pavement, since that was where the homeless and the destitute congregated.

I consider myself fairly well versed in the nuances and subtleties of urban decrepitude, but nothing in my past experience (not even Lakeland in Florida) prepared me for the *premier cru* decrepitude of Nashville's Downtown. It was a black-and-white world of strip joints, terminally red-eyed bars, cheap men's clothing stores and flea-pit movie theatres catering for those with auto-erotic inclinations. Granted, most major cities have a corner of their landscape set aside for such low-lifedom, but the thing about this Tennessee variation on a derelict theme was that it was still visually rooted in another time, another place. Looking at the gaunt, unshaven drifters who loitered here – all possessing that haunted aura of men who'd realized that they had come to the end of the line – was like looking at one of those famous Walker Evans photographs of the 1930s which so bleakly delineated the monochromatic realities of life among the underclass in the American South. But what made this scene even more

affecting was the knowledge that this was the rock bottom end of a city which was fuelled on aspiration. For Nashville was a town of 'would-bes'; a place in which a sizeable number of people considered themselves to be bound for glory in the music business. And though it was doubtful whether the habitués of Downtown were all failed guitarists or burnt-out country crooners, their very presence was a potent reminder of how low you could go in a city (and, indeed, a culture) which operated according to the rules of survival of the fittest.

That was the thing about Nashville – you had this sense that everybody was scrambling to maintain a foothold on a glass mountain; a treacherously glossy sort of peak where only a combination of skill and ruthless tenacity would keep you from eventually tumbling off. And every waiter, every shop assistant, was a budding Tammy Wynette or Waylon Jennings, currently in a holding pattern while awaiting deliverance from terminal obscurity.

After circling Downtown, I stopped in a large record store near Music Row, where I picked up a cassette recording of a venerable old jazz album by the late great Thelonious Monk; a purchase which caused the guy behind the cash register (a guy around 30, wearing a B. Dylan patchy beard and a Meet-Me-In-Manila white Filipino shirt) to suddenly say: 'Hey, if you like Monk, you're gonna love my album.'

'Really?' I said.

'Yeah, it's like a jazz-rock fusion kinda thing, but with some real 1950s Thelonious Monk sorta piano riffs. You come in here in the autumn, you can buy it.'

'And get you to autograph it at the same time?'

'Fuck no. This job, this is like a part-time gig. It ain't no career, man. When my album hits the streets, I'm outta here for good.'

It was hard to trust such bravado talk – especially since, when I asked the cashier what record company was releasing his album, he had an attack of cagyness, saying, 'It's a new label you've probably never heard of.' Ultimately, though, it really didn't matter if the guy was on the level with me or not, since the most important thing about his bluster was that it obviously helped him get through the day. And in Nashville, the belief in your imminent elevation to stardom was a powerful and necessary faith. Like born-again Christianity, it held out the hope of personal reinvention, of casting off the past. Unlike

140

born-again Christianity, however, this cult of fame was far more selective about who it accepted into the fold – which was one of the reasons why, for every new believer in Nashville, there were dozens of one-time followers who were now suffering a crisis of faith. Or desperately bragging about a hypothetical album soon to be released by a hypothetical record company.

I left the record store and spent the rest of the evening listening to a couple of aspiring folkies strum their way through their respective sets at a café – located, naturally enough, in a shopping centre. The first folkie was an 'I'm a Sensitive *Artiste'* type who sang the sort of you-got-a-friend songs which appeal to young women who wear long Brontë-esque dresses and write poems about walking barefoot through the grass. The second folkie was something of a clown, who sang mock blues songs with lyrics like:

> I wonder how you gonna look, babe
> When I put my gun in your mouth.
> You think you goin' North, babe
> But your brains is goin' South.

The audience for this session appeared to be made up of other aspiring folkies, most of whom responded to the music on offer with a calculated diffidence. You got the feeling that everyone believed that they themselves should be up there at the microphone, so who the hell did these guys onstage think they were? But the curious irony of this aggressively competitive atmosphere was that playing this café didn't exactly mean that you had 'arrived' in the music business. Rather, this showcase was a very minor way-station on the road to potential celebrity; a place where a relatively new talent might just catch the ear of a record executive. And yet – in such a professionally hungry town like Nashville – even managing to get a gig at this shopping mall coffeehouse was considered a small triumph, and one worthy of envy.

Ambition and faith in yourself – the true religions of Nashville. Though, when I arrived back quite late at the house I was staying in, I discovered a different kind of exercise in faith going on, as Shirley and her three housemates were sitting in a circle, praying silently. Then, when they were finished, Martin hit a button on the television remote control and they all settled down to watch the latest rock videos on MTV.

141

Shirley and her housemates often prayed together. Just recently, for example, Shirley, Martin and Adam sought guidance from the Almighty when they were searching for a fourth Christian to rent their spare bedroom – and it was through His intercession that Fred answered their ad in the local paper. Similarly, when Martin's Christian disco ministry went into a slump a few months ago, they asked their Lord for help in finding Martin new bookings – and, sure enough, business began to pick up.

It was Beth who told me about these communal prayer sessions – which she herself took part in anytime she was over at their house. It was also Beth who told me that, in the Christian music business, the church you attended in Nashville was an important professional consideration. And it was Beth who told me that she had the makings of a big personal crisis on her hands at the moment.

Beth was in a talkative mood. We met for lunch the next day at Maude's Courtyard Restaurant – a famous Nashville establishment near Music Row, favoured by music industry executives, not to mention ladies who lunch. At a table adjoining ours was a quartet of local bejewelled women in their mid-forties – all glowing in an ultra-violet, fresh-from-the-sunbed sort of way, and all possessing larynxes which could double as loudhailers. Initially, Beth and I had to almost shout at each other in order to make ourselves heard over this Tennessee-twanged *nouveau riche* cacaphony, and finally convinced the head waiter to find us another table in a slightly more subdued corner of the room.

I'd asked Beth out to lunch as a way of thanking her for her help at the Benson Company, and for fixing me up with a place to stay in Nashville. She, in turn, picked my brains about London – as she'd never been outside of the US and was thinking about a trip to England later in the year. Eventually, though, the conversation veered back to Beth's work in the Christian music business, and she told me that she'd moved to Nashville three years ago after finishing university. She'd spent her first year waitressing while her c.v. did the rounds of the music companies, so when Benson finally did hire her, she was elated. Not only had she broken into 'the business', but she'd been taken on by a Christian company as well – which, for her, was an important professional consideration, since she had always planned to use her working life to serve Him.

She was a Kentucky girl, raised by a devout Christian mother and a good ole boy father who was a local fire marshall in her hometown of Frankfort. 'Daddy used to really like his Jack Daniels and his nights out with the boys – that is, until he got saved around four years ago.' Beth herself had 'accepted the Lord' at the age of nine. And though she remained a devout follower throughout her school and university years, she had something of a fall from grace during her 'waitressing period'.

'Like I'd just arrived in Nashville and didn't really know too many people, and I was doing eight-hour shifts in this real terrible restaurant and really hating the work. So, I was, like, unhappy – especially since I hadn't really found a local church which I was comfortable in. I mean, having a church you can really connect with is kinda like a *crucial* thing if you're a Christian. So I kinda felt messed up for a long time and, I think, that's one of the reasons I got into a couple of relationships where I really went way off-course for a while.

'Of course, I have now come to terms with my behaviour during this period. And though I've gone out with non-Christian guys since then, in terms of an ultimate *lifestyle choice*, I really couldn't see myself with anyone but a Christian. In fact, I couldn't really see myself with anyone but Adam ever again.'

Adam – the tour manager for *Resurrection* and Shirley's housemate – had been the best news in Beth's life for a long time. They'd met shortly after Beth had landed the job at Benson and became 'real instant good friends' during what Beth described as 'a real transitional year for me. Like it was through Adam that I found Christ Community, which is the second biggest music industry church in town. And it was also through Adam that I was able to get my head focused back on the Christian track again.'

Her friendship with Adam, however, eventually evolved into 'something more' - a situation which Adam was happy about and which Beth was happy about, but which a lot of other people weren't happy about at all. And for one simple reason: Adam was black.

'Like my Mom met Adam when she visited me in Nashville, and she told me afterwards that she thought he was a real great man. But that still didn't stop her from telling me that she was praying – *praying!* – that I'd grow out of my love for him. 'Course neither of us have dared to tell my Daddy about Adam, 'cause we both know that he'd take the news real bad. Fact is, if Daddy

knew I was thinking about marrying a man who was black, I don't think he'd ever speak to me again.'

But it wasn't just her Mom who was distressed about her relationship with Adam. Many of her 'Christian friends' - as well as quite a few of her professional colleagues at Benson – were seriously taken aback by the news that she was seriously involved with a black guy.

'I still can't get over their attitude', Beth said. 'I mean, it's so un-Christ-like. And it's not as if Adam and I are lovers. I mean, Adam's a *real* Christian and he and I agree on what we both want out of a dating situation. And, since the Bible says that the body's a temple and sex should only take place within the sanctity of marriage, we don't sleep together. It's a principle that Adam himself feels real strong about. Which means that – if we ever get married – we'll have one terrific wedding night. If. . .'

She fell silent for a moment, during which a waitress showed up with our lunch. Beth bowed her head and whispered a short blessing over her food. Then she looked back up at me and said:

'You know, sometimes I think that Adam and I wouldn't have this *acceptance problem* if we were in a secular business. . . if we weren't in the Christian music industry.'

'We actively seek out rockers who are ministry-oriented, but with a strong sales potential – a Christian artist who can bring a return on our investment.'

That was Ricky Drysdale talking. Ricky Drysdale was an 'A & R guy' – A & R being a well-known music industry acronym for 'Artist and Repertoire'. And, for any would-be musician – looking for a way into the business – an 'A & R guy' was the most powerful, most feared dude on the block. Because he was his record company's talent spotter – the gent with the power to offer record contracts; to pluck some kid off the morning shift at Burger King ('You want fries with the shake?') and turn him into a new sensation.

Ricky Drysdale didn't look like an all-powerful maker-and-breaker of careers. Rather, he came across as an affable, almost benign businessman who worked out of a nondescript office near Music Row. Still, if you were someone trying to break into Christian music, you'd most certainly knock on Ricky Drysdale's

door, since he was the Nashville 'A & R guy' for Word Records – the biggest Christian music company in the world.

Word Records operated out of Waco, Texas, with offices in Dallas, Los Angeles, London and, of course, Nashville. Word had such big-time artists on their books as Amy Grant and Sandy Patti (the Loretta Lynn of gospel music). Word had a music publishing division, a books division and a film division – all of which were almost as profitable as their record division. Word, in short, meant big bucks.

Word also meant inspiration. 'The kind of artist I'm looking for has to have that *inspiration thing*,' Ricky Drysdale said. 'A great singer may have a great sounding product, but without the inspiration thing, he won't make it in this segment of the market. So, when it comes to spotting new talent, I'm on the lookout for two attributes: the first is *commercial viability*, because talent isn't really talent in the music business unless it's a profitable talent; the second is *evangelical potential*, since a Word artist isn't just meant to be selling records, he's also supposed to be selling a way of life. And I'm also always on my guard against anyone who's turned to Christian music because he can't make it elsewhere. The way I see it, if you can't cut it in "secular", you're not going to cut it in Christian.'

Ricky was pretty confident that The Realm – a new band he was thinking of backing – was eventually going to 'cut it big in both markets'. At the moment, though, the only thing they were cutting was a demo disc – and Ricky asked me if I'd like to drop by the studio to hear them in action. So – after a phone call was made to confirm that they were at work – I drove out to a small town on the fringes of the city, where the band were working in a studio that was incongruously located on a suburban housing estate. Or, at least, I thought it was a suburban housing estate until I saw a mailbox with a guitar neck nailed to it, and turned down a narrow avenue which led me out of semi-detached land and straight into a bucolic rural scene: a split-level clapboard house, located by a pond with a few submerged trees breaking the plate glass veneer of the still water.

The house was owned by a guy named Phil, who was some-thing of a throwback to the 1960s. His hair was shoulder length (and was kept in place by a red bandanna encircling his skull); he wore a T-shirt that had been tie-dyed in 'memories of LSD' colours; and he was married to an earth-motherish woman who wore a bedouin tent for a dress and carried their first-born son

(named 'Moon') in an American Indian papoose on her back. But Phil's Woodstocky style belied the fact that he was still a true 1980s man: an ambitious entrepreneur who had installed a recording studio in the lower half of his house and was actively hustling for business in order to meet his bottom line.

Since giving up his job two years ago as a recording engineer on Music Row and going out on his own, the Christian music industry had largely kept Phil's studio afloat. Not that he was exactly thrilled with the idea of gaining a reputation of running an exclusively 'Christian' studio – since he struck me as someone who called himself a Christian more out of professional necessity than out of any profound spiritual conviction. Still, business was business. And in the acutely competitive world of Nashville – where recording studios were about as commonplace as McDonalds – it didn't pay to be too aesthetically choosy about the sort of bands you wanted crossing your threshold. Especially when – like Phil – you were scrambling each month to meet the payment on the $200,000 loan you'd taken out to set up your studio in the first place.

The cash which Phil had lavished out on his business was certainly in evidence, as the studio was a 24-track operation with facilities for analog and digital recording, a mixing desk which had more knobs than the instrument panel for a jumbo jet, hi-tech microphones, Italianite spot lighting. A very sleek set-up that some designer chic director might have chosen as a location for some designer chic commercial.

Eddie Swift, on the other hand, probably wouldn't have been a director's first casting choice for the role of a designer chic record producer. That's because Eddie Swift – though an actual producer – was the utter antithesis of contemporary chicdom. With his plaid bermuda shorts, nylon polo shirt and socks worn under his sandals, he looked like he was kitted out for an insurance company picnic. But though his clothes were middle-management, his vocabulary was pure music industry.

'Gotta 'scuse me if I appear a bit outta it', he said after Phil introduced us. 'The boys and I were up 'till five, which means we're all kinda suffering from creative overload at the moment. Guess you could say we were trying to reach that ethereal plane. . . but we just missed the flight.'

The boys were Gus and Gordie – otherwise known as The Realm. They were a pair of young instrumentalists who played synthesizers and keyboards and – according to Eddie – 'produced

a Mike Oldfield/Tubular Bells-ish kinda sound. A highly market-able sound with a high praise content. The sort of sound which makes me understand why I got into the Christian music business in the first place.'

Like Phil, Eddie used to work as an engineer at one of the big secular studios in downtown Nashville. But, since going free-lance as a producer, he'd mainly been dealing with Christian groups because he himself was a committed Christian and wanted to specialize in that sector of the industry. There was a problem, though: with the slump in the Christian market after the Swaggert and Bakker follies, self-employed Christian producers were having a tough time finding enough work to stay financially buoyant. Which meant that Eddie had recently picked up a part-time job selling insurance over the phone. Which also meant that Eddie was very much staking his immediate future on The Realm and was hoping to transform them into the kind of major-league success that would permanently end this current stint as a telephonic insurance hustler.

Gus, too, was hungry for an entree into the Big Time. He'd turned 30 the previous week and was having some of those 'It's now or never' feelings which generally accompany the thirtieth birthday of anyone who's still chasing that elusive notion called 'making it' with feverish conviction.

Gus sat next to Eddie at the mixing desk in the studio, tuning up his Fender Stratocaster and waiting for his partner Gordie to make an appearance on the scene. At first sight, Gus conjured up a distinctly Californian image: the blond, lanky Boy of Summer cruising towards Malibu in a Thunderbird convertible with a surfboard protruding from the back seat and a coke-spoon protruding from his nose. As soon as Gus opened his mouth, however, this Beach Boyish image collapsed, for his accent was pure Hillbilly; the sort of pronounced twang which informed the world that he was a Virginian boy, raised in the Blue Ridge Mountains of that state. In a real upcountry dorp where his Granddaddy had been the local Pentecostal Holiness minister, and where you were encouraged to get rowdy when it came to worshipping the Lord. So – as he put it – 'faith has always been a rock-n-roll thing for me', and he spent his adolescent years playing guitar in the church band, dreaming about hitting the road one day with a real rock band. Well, as soon as he finished school he did get his chance to go on the road with a band, but they were a Top Forty outfit similar to the type which Shirley

once travelled with. And six years of playing 'Proud Mary' in two-bit towns finally got him down too.

'You know, a lot of Christians who are musicians get into "the business" before they get into "The Word" ,' Gus said. 'In my case, I'd been saved long before I started playing my Fender. So when the crunch came – when I realized I needed to better my life, to stop living in bars on the road – I simply quit the business and went back home and picked up odd jobs for a while. Until, finally, God gave me the direction to go back to music.'

That direction came in the form of hearing an album by an Atlanta-based rocker with the show-band name of Mylon LeFevre. Mylon was one of the early pioneers of 'Christian metal' and his *oeuvre* proved to be something of a revelation to Gus, because his was music that 'seriously boogied, yet contained a Christian message at the same time'.

It was a revelation that made Gus pack a small bag one night just over a year ago, sling his Fender over his shoulder, and catch a Greyhound bus to Nashville. Within a week he'd rented a room, landed a part-time job cleaning carpets and – most importantly – had been led to a church called Christ Pentecostal. And at the first service he attended there, he found himself seated next to another guy around his age with a similar rock star-in-the-making demeanour about him.

'Hey, we look like a band here', Gus said to the guy, whose name was Gordie. Gordie concurred and they got talking, discovering that – besides being fellow Pentecostalists – they were also aspiring musicians who shared 'a mutual vision of spreading the gospel electrically'.

Twelve months later, Gus and Gordie were now The Realm and poised for the big professional breakthrough. 'Like The Realm is still a project in its infancy', Gus said, 'But we're both pretty confident about the tunes we've written so far – particularly because Word Records has agreed to underwrite our demo tape, and also because we've gotten Eddie here all fired up about producing 'em. So we both think that – if God wills it – we could really start going places. Maybe eventually get picked up by a secular label, which would let us reach more people. Maybe start doing some concerts – since Gordie and I both feel we'd really excel in a live audience situation. Like Gordie and I both have pretty heavy personal ambitions for The Realm, but that ambition is also *evangelically focused*. I mean, every career decision Gordie and I make is usually derived out of prayer.

We try to feel an inner peace before we go ahead. And because we've prayed about the direction our professional lives should take, God has looked after us and really kept us on the success escalator so far.'

Eddie glanced at his watch and suggested to Gus that they shouldn't waste any more time waiting for Gordie to arrive, but should start laying down another guitar track for the song they were currently recording.

So Gus finished tuning up and then played a long thousand-volt riff on his Fender; the sort of insanely high-pitched riff that could shatter glass.

'That's part of the guitar solo in the tune', Gus said.

'What's the song called?', I asked.

' "Don't Stop Now" ', Gus said. 'It's kinda got an uplifting lyric to it. Tells folks to keep going when they feel down. It's kinda like what Paul says in the Gospels about fighting the good fight. Believing in yourself. Going for it.'

'Sounds like good advice for anyone trying to make it in Nashville', I said.

Gus smiled. 'It's the *only* advice, bro. By the way, you a Christian?'

'No', I said.

'If you don't check Jesus out, you'll never know what you're missing.'

The door to the studio opened and Gordie walked in. He wore pony-tailed hair, granny glasses, and a T-shirt that read, *It's Only Rock-and-Roll*.

'Yo', Gordie said.

'Yo', Gus said.

'Yo', Eddie said. 'Ready to do some serious praise?'

And as these three would-bes in this city of Would-Bes settled down to celebrate God in pure digital sound, I said my goodbyes and hit the road back to central Nashville. En route, the radio blared Willie Nelson at full funky throttle. Then an ad for a local Nissan car dealership came on the air.

'If you don't check us out', the announcer screamed, 'you'll never know what you're missing.'

In the distance, the glass cliffs of the city centre came into view. Nashville looked so inviting from afar; so loaded with possibilities. No wonder so many flocked to its promise. No wonder so many would-bes thought: if you don't check it out, you'll never know what you're missing.

149

CHAPTER 5

Kingdoms of God

★★

Howard Finster has a garden. A garden which he calls a paradise. A garden in which the remnants of a throwaway society are cultivated. A garden brimming with such curious fauna as old bicycle parts, rusted Cadillacs, chicken wire, broken fragments of glass and mirror imbedded into concrete, old dented mailboxes, insulating wire from telephone polls, an Exit sign discarded from a nearby highway, and the occasional eggbeater.

It is a garden of scrap metal; a garden of tangled steel, copper and chrome. One that looks like some crazed visionary has been allowed to act out his most extreme fantasies in a junk yard. Note the Tower of Bicycles in the centre of the three-acre plot, topped off by a Holy Cross made out of lawnmower handles. Note the mailbox, on which is painted the message: *Get in on messages from Heaven*. Note the corroded licence plate – *God is Co-Pilot*. Note the concrete icons of Elvis Presley, which God asked Howard Finster to sculpt.

Yes, God has everything to do with this garden, for Howard Finster isn't just a visionary; he is, in truth, a religious visionary. And a man on a mission from the Almighty.

'I'm kinda like a second Noah', Howard Finster says, 'sent down here from God t'straighten out the wobblers. I'm a man of vision. I got so many visions, I cain't keep up wit'em. And I ain't got just one Ark in my garden. I got me ten Arks. My garden's like a flowin' river spring o' water, takin' out messages to th'world. That's why folks like you come t'see me from all over th'world. That's why the *Wall Street Journal* an' *Esquire* an' *People* magazine come on down here t'do stories 'bout me. 'Cause y'all are mah missionaries. 'Cause I come here from God. Just like He

sent Henry Ford here t'create th'horseless chariot. Just like He sent Edison here t'create 'lectricity, so he sent me here t'create th'Paradise Garden. T'be a Man of Visions.'

Howard Finster lives just a few miles across the Tennessee state line in a small, insignificant Georgia town called Pennville. Or, at least, it used to be a small, insignificant town until Howard Finster's Paradise Garden put it on the map, and folks from the Atlanta and New York art world began to make pilgrimages to his three-acre contemporary Ark. After these pilgrimages, the word went out that a major new American folk artist had been discovered in some forgotten cranny of Georgia. But it wasn't just Howard's push-bike religious sculptures that drew the dealers and the jargon-laden critics, who labelled his work 'naive'. Rather, it was his paintings that really made his reputation – especially since he's turned out 6,000 canvases since that day in 1976 when he received an on-high edict to devote his energies to art.

'Tell you how this art thing happen'a'me. I used t'be a preacher. Fact was, I'd started preachin' when I was jus' sixteen, so I was a preacher fer forty-five years. Finally gave it up. Figured I'd do some kinda different work for th'Lord, so I started fixin' up ole bicycles fer poor kids 'round here. An', one day, I was out in my shed, paintin' this here bicycle, and I dipped mah finger inna tin o'white paint, and when I looked at it, I saw a *human face* 'pear on that finger. An' then I heard this voice sayin', "Howard, paint sacred art. Paint sacred art". And I said back t'the voice – which I knew was th'Holy Spirit – "I cain't do that. I cain't paint". And 'nother voice says t'me, "How you know you cain't?".

'So what I did was this: I takes this dollar bill outta mah back pocket, an' I stuck it onna this plank o'wood, an' I dipped my finger back inna that tin o' white paint, and I starts paintin' George Washington's face right there.

'So that's when I began t'paint, an' when I starts puttin' mah paintin's on th'gate o' mah house. An' then people starts showin' up, askin' t'buy 'em. An' that's when I realize God wants me t'start the garden, live off my paintin's.'

Not only did God want Howard Finster to make a living from his paintings; he also wanted Howard to be a famous artist as well. So God arranged for Howard to be represented by a well-known New York gallery owner (Phyllis Kind), who could easily sell one of his small free-standing wooden angels for $1,000 and his canvases for considerably more. And God arranged for Howard to be commissioned to design the cover of the Talking

Heads album, *Little Creatures* (the original painting for which is now worth around $100,000). And God arranged for Howard to be the subject of a one-man show at the Smithsonian Institute (an honour only bestowed upon major American painters). And God even arranged for Nancy Reagan to commission Howard one year to paint the annual White House Easter Egg Hunt poster.

Howard, however, was hardly shy about all the publicity (and money) he had received since the Holy Spirit convinced him to try his artistic luck. On the contrary, the simple frame house which served as his home and studio had an entire room which functioned as a small gallery-cum-bookstall, where you could buy Howard Finster Scrap Books (*Howard Explains How To Make Folk Art*) and Howard Finster Postcards and Howard Finster Cassette Tapes (*Howard Talks On His Art*) and, of course, Howard Finster *objets d'art*. And yet, when I spent an afternoon with Finster, what struck me most about the man was the complete matter-of-fact tone in which he discussed his professional triumphs. Here was this 73-year-old true original – dressed like some backwoods farmer, speaking with a molasses Georgian drawl, stretched out on a tumbledown couch in his studio with a plastic bucket by his head, into which he expectorated a steady stream of tobacco juice – and casually talking about his appearances on national television, his friendships with assorted rock stars, and the $20,000 which one Atlanta-based corporation had recently paid him for an original Finster to hang in the foyer of their offices. None of this remarkable success fazed Howard in the least – because it was, after all, God's will. And he, in turn, saw himself as one of the Almighty's leading creative emissaries on the planet today:

'God said t'me, He said, "Howard, if you want t'do mah work, you gonna hafta become a full-time artist." An' since I *became* that artist, I believe mah ministry's influencin' great nations, coverin' th'world. An' I know that if ev'ry human bein' came t'God at this p'ticular hour. . . right now, at 4.09 in th'afternoon. . . if ev'ryone said they believed in God, then God could clean this world up. We'd be reinstated from the fall o'Adam. We wouldn't need no wars. We'd be floatin' 'round on wings.'

But since Howard knew that such a universal expression of belief was impossible, he had set out to create his own little patch of heaven on earth. And so, his Paradise Garden – with its concrete Elvises and its celestial mailboxes and its three-storey high World Folk Arts Church (which looked like a demented circular wedding cake) – wasn't simply an

KINGDOMS OF GOD

environmental gallery for the Lord. It was, verily, a Kingdom
of God.

Fashioning your very own temporal idea of heavenly bliss is
nothing new in American life. In fact, this impulse towards the
construction of a customized version of God's dominion on earth
has always been an essential component of the nation's religious
landscape. Ever since the Puritans proclaimed the Massachusetts
Bay Colony to be a City on a Hill in the early decades of the
seventeenth century, numerous communities – almost inevi-
tably led by one highly intense man of visionary conviction –
have attempted to construct model religious enclaves amidst the
worldly secularism of this 'promised land'. Consider the Shaker
villages of the mid-1800s, which believed that communal celibacy
and a profoundly ascetic approach to life placed them above
the rudimental state of man. Consider the Mormons – who
saw themselves as New World Israelites, fleeing persecution in
the East to found their own ecclesiastical city-state in the Utah
wilderness. Consider – by way of an extreme and somewhat toxic
contrast – Jim Jones and his People's Temple: that thoroughly
sinister San Franciscan faith healer-cum-prophet who led 900
of his ardent supporters out of the 'tyrannical repression' of
contemporary America and into the jungles of Guyana. Here, they
set out to build a 'paradise' of Christian socialism, a malevolently
cancerous Eden, in which Jones and his flock of 900 ultimately
stunned the world through an act of mass suicide.

Thy kingdom come, thy will be done: a directive that, throughout
American religious history, has spurred on many a Christian
to seek what they consider to be a terrestrial facsimile of the
Almighty's heavenly realm. For Howard Finster, his Paradise
Garden was his very own Ark in which to weather the torrential
floodtide of modern life. And while I toured his scrap metal
domain, it struck me that, in my journey to date, I had met a multi-
tude of believers and backsliders, yet had spent little time looking
closely at some of the God-fearing principalities to which many
born-again Christians gravitated. So I resolved to dwell for a while
in a more institutionalized version of American Christendom; to
drop myself into two highly distinctive and original Kingdoms
of God operating within the contemporary Bible Belt.

And, having landed myself in a soporific corner of Georgia, it
only made sense that my first stop after the Rev. Finster's divine
building site should be the biggest building site in the South –
the city of Atlanta.

153

There is a sign in Atlanta which every pilgrim must, at some time, pass by; an electronic sign on the edge of an upscale residential section of the city that informs you of the population of Atlanta at the very moment you cast eyes on it. As you stand there – watching Atlanta's citizenry increase from, say, 3,070,018 to 3,070,021 in a matter of moments (while simultaneously wondering if there are statisticians posted at every maternity ward in the city, racing to call a central census office everytime a new Atlantan pops into the world) – you quickly realize that any city which broadcasts *with pride* its escalating population must be a city which considers its stock to be rapidly rising.

And there's no doubt that Atlanta has transformed itself into the ultimate urban emblem of New Southdom – one of the key metropolitan centres in the United States. For this city – which the Union Army levelled to the ground in one of the more malevolent acts of a malevolent Civil War – has undergone a second sort of architectural levelling, courtesy of the city planners and the property developers. Approach Atlanta – as I did – via the byzantine convolution of highways which encircle and criss-cross the metropolis, and you'll begin to wonder why the civic authorities haven't commissioned a massive sweeping arch to overhang the skyline, with the words – *Under Construction* – emblazoned in neon lights. Everywhere you look, Atlanta appears to be permanently under the influence of the wrecker's ball and the builder's crane; permanently letting its urban belt out a notch or two to accommodate yet another spur of motorway, yet another corporate tower. It's a city which can't say no to the idea of adding another bauble to its urban crown. A city which is utterly intoxicated with the notion of reinventing itself and gradually disassociating itself from any contact with its prior incarnation – almost like a *nouveau riche* adult who grew up in humble circumstances, and will literally move heaven and earth to obliterate any contact with his past identity.

I drove into Downtown, along Peachtree – Atlanta's main drag – a collection of gleamingly mercantile office blocks and climate-controlled indoor precincts by day and a 'proceed at your own risk' shadowland after dark. I moved on, driving out through Midtown and into the city's inner suburbs – all centrifugally based (like Nashville) around that ultimate architectural celebration of the consumerist ethic, the shopping mall. But – as befitting any town which had throttled its city centre, yet is still trying to maintain a cosmopolitan posture – the shopping mall took on a certain

high aesthetic grandeur in Atlanta, and constantly appeared in an ever-changing series of stylistic guises: reproduction art deco rubbing shoulders with South of the Border hacienda; Greek revival in the immediate vicinity of something vaguely Bauhaus.

It was a stylistic conflict which spoke of economic arrogance and a naive boom town philosophy of embracing the garish and calling it 'progress'. And it was a reminder that Atlanta's rapid expansionism was largely a reflection of the board room muscle behind the city today. Atlanta's political machine may be black (especially as the city was always the headquarters for the civil rights movement, and its current mayor – Andrew Young – was one of Dr Martin Luther King's principal deputies), but the money that runs the town is very much white and very much corporate. Coca-Cola has its worldwide base of operations here. So too does Ted Turner's Cable News Network (one of the biggest television broadcasting operations in the country today), while the city has also established itself as a major centre for financial services and computer software – thus making it a metropolis of profound economic stratification. The further I drove into those young and upwardly mobile suburbs, the more I became aware of the planners' blueprint for Atlanta; a blueprint in which deep respect is shown towards the value of land and little consideration is given to the human price of maintaining a sense of neighbourhood, a sense of community, a sense of social continuity.

And then there was Route 285. This was Atlanta's orbital road; a vast tarmacadam wheel which hooped the city. Driving it was like driving some elaborately inane metaphor for the repetitive nature of big city life. A semiologist would have adored Route 285 – its geographic enormity, coupled with its circular design, would have given him great hyper-*aesthetique* scope to rant on about the *treadmill Weltanschauung* of western capitalistic endeavour or the *curvilinear boundaries* of the American mind. Personally, I found Route 285 big and boring, and was pleased to be freed from its grip shortly after entering its confines.

The exit I took off Route 285 brought me to the outskirts of a suburb called Decatur. I travelled along a boulevard with the aquatic name of Flat Shoals Parkway; a parkway which landed me at the gates of a kingdom that followed a religious doctrine called Kingdom Theology. And being a contemporary American Kingdom of God, the initial territory within this realm had been designed to accommodate the parking requirements of several

thousand members of the faithful who came to the Chapel Hill Harvester Church every Sunday to swear fidelity to the body of Christ, and who saw themselves as members of an élite with the goal of restoring 'the kingdoms of this world to the Kingdom of God and of His Christ'.

It was a late Sunday morning when I entered the gates of this Christian principality, and the car-park was already packed. But it wasn't simply this choc-a-block landscape of cars on display that first caught my attention; rather, it was the serious ostentation of so many of the automobiles crowding that immense lot which was rather startling. Had I not known that this was a church, the sheer volume of Golf GTIs, BMWs, Mercedes and Porsches on display (intermingled, it should be noted, with quite a few *déclassé* domestic vehicles) would have led me to believe that a convention of bond salesmen was in progress. Then again, I doubted very much whether bond salesmen carried bibles with them, or used salutations like, 'Hello, Brother' as a substitute for 'Good morning'. Nor, to the best of my knowledge, did bond salesmen embrace each other soulfully – which is what the 3,000 or so members of the Chapel Hill Harvester Congregation appeared to be doing when I entered their cathedral.

The 'cathedral' was actually a temporary structure – a huge barn-like arena that looked like a sort of convention centre, and was acting as Chapel Hill's stopgap house of worship while a new cathedral was being built on an adjoining patch of land. Rows of folding chairs fanned around a central stage, upon which a small orchestra in black tie was tuning up. There were several banks of television monitors scattered around the auditorium, as well as a trio of cameramen linked by headphones to a director in a control room overhead – a reminder that Chapel Hill Harvester services were transmitted nationwide every week on the Trinity Broadcasting Network. And, indeed, entering this sanctuary was a bit like entering a makeshift television studio, in which a light entertainment special was about to be recorded.

The 'audience' for this event were, by and large, in their thirties and forties and exceptionally well-dressed. There were button-down, horn-rimmed lawyerish types exchanging felicitations with Euro-trashy dudes in slick Italianite jackets who were simultaneously greeting women executives in charcoal grey business suits. And they, in turn, were hugging flamboyant characters with heavyweight jewellery and designer dresses. Granted, quite a few parishioners were less discernibly affluent than these

obvious upscale types, but they still formed a minority within a congregation that was evidently well-positioned on that economic escalator marked 'Up'.

The orchestra onstage was now joined by a choir, known by the showbizzy name of the K-Dimension Singers (the 'K' naturally referring to 'Kingdom'). Their Las Vegas style set the tone for what was to come, as the orchestra struck up a funkyish beat and three men and three women in tuxedos and cocktail dresses came forward, wielding hand-held microphones and singing a number called 'Jesus is Alive' in a manner reminiscent of one of those now forgotten middle-of-the-road Motown groups of the 1960s. In the midst of this number, six girls in lace and ribbons appeared onstage and did the sort of choreographed dance routine which you'd expect to see accompanying the floorshow at Caesar's Palace. Then again, this *was* a floorshow – albeit one with a distinctly spiritual subtext to it – and the crowd loved it, keeping up a syncopated hand-clapping rhythm, waving their arms exultantly heavenward and giving the performers an extended cheer when they finished.

Now, after this warm-up, Bishop Earl Paulk – the founder of Chapel Hill Harvester. . . the man behind Kingdom Teaching – stepped forward into the spotlight and up to a plexiglas pulpit. He was a lean, patrician gent in his early sixties, with silver hair, electric blue eyes, and exactly the sort of upright New World aristo demeanour required of a senior public representative. Only it was highly unlikely that any legislator (even one invited to address a religious gathering) would have uttered the sort of charismatic comment that Bishop Paulk uttered at the beginning of his service: 'Let's give the Lord a big round of applause.'

Immediately, a thunderous handclap filled the Chapel Hill Harvester Church as 3,000 of the faithful gave the Almighty a massive ovation. Then Bishop Paulk asked everyone to repeat after him, 'The Lord is God' - and 3,000 voices affirmed that He was the big boss. After this, Bishop Paulk relinquished the microphone to an evangelical folkie named Ted Sanquist, who played guitar and sang a low-key sentimental tune about God being his king. Then Bishop Paulk reclaimed the microphone and we had a few commercial announcements: At 6.30am on Tuesday, there was to be a Church Business Breakfast at a local restaurant ('And, as we all know', Bishop Paulk said, 'there's a real movement of spirits operating in our business community today'). And on Friday, there was going to be a Chapel

Hill Harvester 'Baby Boomers Bash Beach Party', to be held at some nearby pool.

'Now, how many of you know that God wants *you* to have a good time?' Bishop Paulk asked his brethren. They responded with another extended burst of applause. 'And how many of you *also* know that the best thing to do is to *give* to the Lord?' Another burst of applause, and as five kids in colourful peasant costumes marched onstage and began to sing 'It's a Small World' (while imitating the movements of those brightly painted mechanical dwarves who pop out of clocktowers in medieval German towns), a small team of ushers moved around the auditorium collecting 'covenant envelopes' filled with this week's financial offerings to the Lord, their God.

After this interlude, it was showtime again for the K-Dimension Singers, who broke into a number called 'O Magnify the Lord' – a hippishly Handelian anthem, which again had everyone on their feet, beckoning towards the sky and engaging in some real 'high energy praise'. Then it was Fellowship Time and Bishop Paulk gave us the following kindergarten-style directive: 'You have one minute to find someone you don't know and say hello to him.'

Suddenly, the aisles of the auditorium were flooded, as everyone went dashing about, pumping the hands of strangers. As all this chummy camaraderie took place, it struck me that 'fun' was an essential component of a Chapel Hill Harvester service. It was what I always imagined attending one of those adult summer camps would be like: lots of nightclubby entertainment, lots of team spirit, lots of chaste jollity. Even the service itself was almost structured like a variety show – a musical number followed by a sales pitch followed by an audience participation activity followed by another musical number. But behind all this recreational activity was something considerably more forceful, more potent than mere Christian frolic. For Chapel Hill Harvester not only saw itself as an Ark withstanding the crazed inundation of late twentieth-century life, but also as the purveyor of a theological world-view which offered its followers the keys to the Kingdom of God. A world-view which Chapel Hill Harvester was determined to spread around the globe (and was currently using church missionaries and satellite broadcasts of its services to do so).

'We are now on in prime time in South Africa!' Bishop Paulk said during yet another sequence of announcements. More thunderclap applause from the congregation, as yet another

triumph for Kingdom Teaching was cheered. Then, a Costa Rican missionary named Arturo was introduced and launched into a homily – delivered at tommy-gun speed – about how he praised the Lord for 'Kingdom strategy' and for Bishop Paulk's television programme which 'has been a great blessing in Costa Rica', where many people had actually written to the national television station, saying that Bishop Paulk's programme was going to help their nation.

'The Kingdom of God is being preached in Costa Rica!' Arturo shouted. And in prime time as well.

But what exactly *was* Kingdom Strategy? The guest star preacher of the morning – a guy named Dennis Peacocke – helped define some of its philosophical parameters for me. Peacocke – a free-lance evangelist in his mid-forties, built like a quarterback and remorselessly energetic – stepped up to the plexiglas pulpit and began by doing a short commercial for his new lecture series on cassette, *Winning the Battle for the Minds of Men*: 'It's a four-part series where I get down and get real with a bunch of teenagers; where I try to get teenagers to form adult values, not teenage ones.'

Having gotten his sales pitch over with, Peacocke then turned to matters theological:

'You know, I was a radical back in the sixties. And I was a radical for one reason: because there was something in me – backslider that I was – which believed that it was my generation's destiny to change the world.

'Well, let me tell you something – God *has* brought forth a generation that *will* change the world. And *you're the ones!*'

Massive applause. Peacocke smiled at us. It was the sort of smile that performers smile when they know they've got an audience on their side; when they know they're winning. His voice grew more authoritative by the moment:

'I'm here today as a man who *hates* religion. Except, of course, the religion that is pure and undistilled according to the word of God. But do you know why the world is ridiculing Christendom these days? It's because, for most people, Christendom is a set of ideas that is not related to their own lives. It's because Christendom has fallen into the delusion that belief is an intellectual concept, and has nothing to do with Jesus – who, when you touch Him, has this habit of incarnating his ideas into your head.

'GOD MUST BECOME FLESH! GOD'S IDEAS MUST BECOME INCARNATED INTO THE REAL WORLD! And when God is

getting ready to do something, He sends a man or a woman to carry out his plan. He does not deal in disembodied concepts. He deals in human flesh! And the God who loves us is about to bring justice down on the nations. A famine is coming. And God's hand is moving towards America. Towards the West. Towards all nations to bring them to reality. And God – who *loves* people – never tears down the old until the new is taking over.

'What that means is this: you and I are living in an age when *we are getting ready to rule*! Everything is beginning to rock and roll. And as God is preparing to bring everything down – and to bring it down out of *love* – He is preparing a people as a safety net. *We are that people!*'

Roars of approval. Peacocke now headed into high gear.

'And remember this: when God brings it all down, the people of Atlanta are going to *freak*. But when they *freak*, you will catch them as a safety net in a time of famine. And do you know what's worse than God *not* answering your prayers? It's God *answering* your prayers. 'Cause that's when you start going, "Whoa. . . this is no game. This is for *real*!"

'I've told you about my background – how I smoked my way through 300 pounds of dope. How I had Marxist and Buddhist ideas rattling around my head. But, my God, when the Lord hit me, He hit me like a white shark! And I said, "LORD I WANT TO KNOW TRUTH." God wanted to take me out of my intellectualism. God wanted to take me out of my Marxist philosophy. God wanted to give me truth. And God made me. . . *belch*!. . . yes, belch with indigestion when His truth hit me. . .

'How many of you here have belched with indigestion when the Word of God hits you? Well, when I look at what *I* believe is coming, I belch real loud because I feel that truth get me in the gut. And I get down on my face before God and I say, "Lord, I don't know if I'm able to go where I see we *must* go."

'So right at this very hour, this very moment – when the mass of Christendom is meeting with their pastors; pastors who are telling them *nice* things – I have a *tough* message for you: See the way the spiritual tide is turning! See the way that tide is turning towards *us*! And then say, "O Father, get your word into me. . .so when the stuff hits the fan, I will have grain in the day of famine".'

There was a long, long silence after Dennis Peacocke finished his homily, followed by a long, long acclamation from the congregation. It had been a manic, yet masterful performance, and one which obviously told this congregation what it wanted

to hear: we are the chosen people. And in an age of uncertainty, not only do we possess the certainty that we are God's elect, but also the certainty that *'we are getting ready to rule'*.

It was hard to know what to make of such proclamations. Just as it was hard to know what to make of the black and white heavily yuppified brethren who cheered Peacocke on. Was Kingdom Teaching really based upon the notion that Christians can – and should – control this planet in the here-and-now? If that was the case, then could it stand accused of being a restoration movement whose immediate goal was the creation of a Christian America? Or were Peacocke's statements about God 'preparing a people as his safety net' simply the worst kind of self-congratulatory evangelical bluster imaginable?

In search of some answers to these questions, I dropped into the Chapel Hill Harvester bookstore after the service and – in the section devoted to Kingdom (which essentially meant books by or about Earl Paulk) – I bought a copy of the Bishop's pamphlet, *20/20 Vision: A Clear View of the Kingdom of God*. Later that afternoon, I took it to lunch, propping it up against a half-bottle of California Chablis in a downtown Atlanta restaurant and attempting to fathom the theological niceties of God's Kingdom in between the clam chowder and the trout. It was a curious lunchtime companion, this pamphlet, for it read almost like a manifesto. Consider these highlights:

Kingdom has to do with authority and government and rule. Probably one of the reasons that *Kingdom* is so opposed in our day is because of what it means. It speaks into a permissive era worldwide, and says that God intends that His will be done on earth as it is in heaven. That is going to involve bringing the order of heaven into earth until the earth is a response to heaven in terms of how it functions. . .

Jesus Christ taught one message – the Kingdom of God. Paul founded churches in the first century by preaching and teaching on the Kingdom of God and of His Christ. Kingdom teaching is not a new theology, new interpretation of the Scripture, nor new revelation. It is as old as the Scriptures.

Jesus has built His Church to continue what He began to 'do and teach'. Please don't think of *Church* as a building where you go on Sunday mornings. The Church – (and) all born-again Christians infiltrating hostile world systems everyday in education, business, politics, athletics, the arts,

etc. – is called to challenge the gates (the authority) of hell.

Jesus said that the Holy Spirit will equip believers to be witnesses. Because the Holy Spirit empowers us to witness *for* the rule of God and *against* the rule of Satan, confrontations with world systems and worldly authorities are inevitable. World systems refer to institutions, systems and even people who are ruled by selfish motives rather than the rule of God. Their goals may even sound noble and humanitarian, but their works glorify man, not God.

Now, after advocating a confrontational (or activist) brand of Christianity, the Bishop brings out the heavy artillery:

Allow me to state what I believe God is doing in the world today. We live in a critical hour. The constrained influence of the Church upon society over the centuries (and especially in modern society) must become far more pronounced in order to challenge the kingdoms of this world with the power and authority of God.

I believe that world systems will collapse. Babylon will fall. No one needs prophetic gifts to recognize the fragile state of our world economy. Our political, scientific and educational kingdoms do not have the answers to the perplexities of our day. Famine. Terrorism. War. AIDS. We stand on the brink of unparalleled devastation from a nuclear arms race which includes all the major powers of the world.

The gospel of the Kingdom is good news. The gates of hell will not stand against spreading this good news if we are willing to plow the field. . . Don't let anyone convince you that your witness, your ministry, is not essential to the fulfillment of God's plan. Jesus started a world revolution with twelve men. Only 120 people prayed together in the upper room on the Day of Pentecost. *One* preacher, the Apostle Paul, planted churches that evangelized the world. You are important to God's mission in this critical hour in history. Together, we will make an impact that will shake Babylon (worldly kingdoms) because we have the power of God within us.

Infiltrating hostile world systems. Confronting worldly authorities. Shaking Babylon! This was heady, aggressive stuff. No

wonder one-time counter-culturists like Dennis Peacocke had become such ardent converts to Kingdom Teaching – it had a strong whiff of insurgency about it. It challenged the status quo and advocated a cataclysmic social and moral upheaval. It held out the romantic possibility of an ideal world. It was, in brief, a revolutionary theology – and one which saw Jesus as the greatest radical of them all. Only this was a revolutionary theology that appealed to the filofaxed minds of the upwardly mobile – a kind of 'power fantasy' about ruling the world that was tailor-made for a congregation who largely worked within a corporate culture where power and success were the ultimate objects of the exercise.

Power without guilt. Power underpinned by a sense of moral righteousness. Success with spiritual impact. On one level, Kingdom Teaching sounded like a course in Christian business assertiveness. Yet I knew that to write off such a theological doctrine as nothing more than Christianity for car phone owners would be a major over-simplification – especially since I was still curious to know whether the Christian Reconstruction movement (to which 'Kingdom Teaching' belonged) really was thinking in terms of a terrestrial *coup d'état* when they talked about establishing God's hegemony on earth as it is in heaven.

<p style="text-align:center">****</p>

Next morning, I worked the phones and managed to set up an appointment later that week with Bishop Paulk. I also managed to wangle a meeting with one of the leading theoreticians of the Reconstruction movement in the country today; the Rev. Joseph Morecraft of the Chalcedon Presbyterian Church, located in the Atlanta suburb of Dunwoody. To get there meant negotiating Route 285 again, which was, more and more, beginning to resemble an Atlanta version of the *Mappus Mundi* – a somewhat truncated and enclosed vision of the world as we know it; the sort of vision that might just appeal to a conservative theologian.

For Rev. Morecraft was widely regarded as a deeply conservative theologian, and one who strongly preached a major tenet of Reconstructionism: the creation of an earthly theocracy, of a 'Christian republic' in which there was a clear separation between church and state, yet where both sectors were ultimately answerable to God and Jesus Christ. I'd first seen him in action on a Public Television documentary about Reconstructionism and the

<p style="text-align:center">163</p>

rise of the religious right, where he came across as an exceedingly erudite man who voiced exceedingly extreme views in an exceedingly reasonable manner. And when I met him in his office in Dunwoody – an office that looked more like a lecturer's bookish study than a theoretical think-tank for right-wing Christianity – he struck me as a thoroughly genial man in his mid-forties who carried a lot of excess ungenial weight on his sizeable frame. He offered coffee; we exchanged small talk about his forthcoming visit to London and my sojourn to date in the South; he told me a surprisingly black (and unrepeatable) joke about Jimmy Swaggert. . . he was, in brief, a perfectly affable host, with not a whiff of the heavy demagogical aftershave which Christian fundamentalists are supposed to exude. Instead, he used the same moderate, genial, small-talky tone of voice to speak about an ecclesiastical revolution in the making:

'What is going on in the religious life of this country at the moment is remarkable, because you're seeing a "revival" with a difference – a revival which is all about Christian political awakening. And there are two basic principles behind this revival: firstly, Jesus Christ is Lord of every area of life; and second, the Bible is authoritative about everything about which it speaks, and it speaks about everything. And it is our duty to bring everything into the realm of Jesus Christ and not to rest until the world is covered by Him.

'But what we're talking about is *not* a movement which believes in imposing anything on anybody. Rather, the sort of *coup d'état* we want is a *coup d'état* that takes place in the heart. For our movement to succeed, we are going to have to change men's hearts. And if we can capture the heart, we can capture the society. Because Jesus *is* the answer to man's temporal problems. And the choice is Christ or chaos.

'Now I know that what we've set out to achieve is an unbelievable task, and one which is fit more for the shoulders of angels than for the shoulders of man. But it *is* the mission that God has given his church. And we believe it is our responsibility to stand up for the Crown rights of King Jesus, and to call all institutions to the submission of His rule. So, yes, I am in favour of theocracy – not the kind of Khomeini-style theocracy that exists in Iran, but one where God's laws govern every area of life, and where the Bible is the bedrock of all institutions.'

Rev. Morecraft also assured me that the greatest strength of the Reconstruction movement was the fact that it was totally

decentralized, with no fixed leader and no headquarters. What's more, it was not specifically allied with any particular Christian denomination, so it had broad ecclesiastical appeal. It really didn't matter, therefore, if you were a Presbyterian like Morecraft or a Pentecostalist like Bishop Paulk. What did matter was a shared belief in 'Victory Orientation' – the overwhelming desire to see the world fully Christianized and the certainty that God will reward the faithful through the triumph of their crusade.

'This movement is a radically God-centred movement,' Rev. Morecraft said, but it was also a movement which was a sworn enemy of all humanistic philosophies. 'Biblical Christianity will not rest until every shred of humanism is banished from American society', he said, and ended our interview with the following 'heartening' commentary on the state of mankind today:

'At the end of every civilization, you have fear. You have terror. Look at the terror and the fear that marked the end of medieval culture. Well, our civilization is now coming to an end, and we now live in an age of fear, an age of terror. And though I know that, as long as I am alive there will never be a Christian utopia on earth because I am a sinner (as all men are sinners), that's not to say that we can't make life great and glorious in Christ's name.'

In many ways, Rev. Morecraft was a good old-fashioned Calvinist who considered man to be in a fallen state of grace and maintained that salvation from sin could only come from Jesus Christ. And because He died on the cross for man's sins – because He was the saviour of mankind – He was also the absolute monarch over every man and every institution. At the same time, though, there was something rather chilling about Morecraft's pronouncements like, 'Homosexuality is sexual depravity punishable by death'. Or his belief that the New England Puritans failed to create a City on a Hill because they weren't Puritan enough – a reminder that Morecraft's type of Reconstructionism hinted at a return to the morally pure society advocated by the theologians of the Massachusetts Bay Colony.

This was, of course, the tough talk of a bellicose theologian who was convinced that a war was being fought for the soul of contemporary America, and that the battle lines were drawn between Biblical Christians and Secular Humanists. And though Rev. Morecraft had been to the front lines of this conflict – having once run for the Congressional seat vacated by the death of the ultra-conservative representative, Larry McDonald (who was killed in the Soviet downing of Korea Airlines flight 007),

and having garnered a highly respectable 50,000 votes for his overtly Christian campaign – he still struck me as something of an armchair theoretician, providing the intellectual muscle behind the Reconstruction movement.

Bishop Paulk, on the other hand, came across as a true empire builder, yet one who – though striving for the same spiritual goals as Rev. Morecraft – spoke a far more moderate language of accommodation and churchly *rapprochement*. Then again, Bishop Paulk had made a reputation in Atlanta as a master of *rapprochement*, especially in the 1960s, when he founded the Gospel Harvester Tabernacle in inner-city Atlanta, which was one of the few truly integrated churches during an era when the racial tensions in Georgia were as combustible as a stick of primed gelignite. And the vision which led Earl Paulk to create his first tabernacle in Atlanta – a tabernacle which eventually evolved into the Chapel Hill Harvester Church – came during a time of great spiritual crisis several years earlier, when his liberal views resulted in him being all but driven from a Church of God he had been pastoring in suburban Atlanta. He didn't just lose his ministry then; he also lost his home, his possessions and the fellowship of the denomination in which he was raised.

Thus began a period in the wilderness, during which Paulk, his brother and his brother-in-law joined together as prayer partners and – according to Paulk's biographer Tricia Weeks – 'began to express longings for a ministry of restoration for people who felt abandoned and bruised. They shared scriptures as the Holy Spirit stirred in their minds. . . They felt called to minister to "scattered sheep" referred to in Matthew 9:36-8. One of the men read that passage aloud, knowing somehow that the words were spoken as God's audible direction to them: *"But when He saw the multitudes, He was moved with compassion on them, because they fainted, and were scattered abroad, as sheep having no shepherd. Then saith He to His disciples, The harvest truly is plenteous, but the labourers are few; Pray ye therefore the Lord of the harvest that He will send forth labourers into His harvest."* '

So it was that the name 'Harvesters' became attached to this new ministry, as it 'represented the compassion of Jesus at seeing people who were scattered "as sheep having no shepherd" '. And packing their families and worldly goods into two white Chevys, Paulk and Co. set out cross-country to Los Angeles to begin their new work for the Lord. En route, however, one of their party was offered a little church to minister in downtown Phoenix and, for

a time, the travelling Harvesters settled in Arizona. But Paulk –
still devastated by the loss of his ministry and still trying to find
a way out of his very own pastoral no man's land – found that
the new ministry in Phoenix gave him little in the way of inner
peace, and he suffered from extended periods of desolation. That
is, until one day – while ministering a Tuesday morning service –
'he suddenly felt himself unexplainably caught up in the Spirit'.
And – as his biographer notes – when he knelt down at a bench
to steady himself,

> He began to see a panoramic vision within his mind in
> distinctive, unmistakable details. . .
>
> First, God told him that he must return to Atlanta. In
> the most unlikely location for Earl Paulk to be, God would
> raise up a mighty church of powerful spiritual demonstra-
> tion to all the world. This church would be known for
> its restoration of people who had been wounded, hurt
> and abused by life's storms and religious traditions. This
> church would be a 'City of Refuge' for those needing
> forgiveness.
>
> He saw unforgettable individual faces of people as God
> spoke to him. They were a diverse blend of every race
> and culture. He saw hundreds of youths, elderly people,
> families walking side by side, people in wheelchairs and
> some who were sick being helped by others into the doors
> of the church. People were coming to this worship centre
> from every direction from around the world. . .
>
> In this church God would raise up people who truly
> knew His compassion, people who would hear His voice
> and move according to the Spirit's direction to love and
> restore others. This would be known as a mighty church
> of spiritual demonstration in the last days. . .
>
> This church represented a 'Joseph' ministry to the univer-
> sal Church. The dreamer who was sold into Egypt, stripped
> of his heritage and put into prison would in the end offer
> solutions for the famine in the land to his brothers locked
> away in legalistic traditions. In a time of need, God would
> allow him to minister to those who intended him harm. His
> ministry would offer solutions in a spirit of forgiveness and
> healing. God promised Earl Paulk that those things in his
> life which were intended for evil would eventually be used
> for good to bless the world.

And from this vision, the mighty fortress that is the Chapel Hill Harvester Church was born.

In many ways, Earl Paulk's story is a classic American spiritual fable: the backwoods boy, raised within the insular confines of a rigid Pentecostal church, discovers that God has other plans for him and – after being reviled and exiled by his brethren for his individualistic vision – eventually returns home in triumph to construct the Kingdom of God which the Lord commanded him to build.

Visionary individualism: the true stuff of New World myth. But while reading Paulk's biography – *The Provoker* – what struck me most about his story was its Promised Land overtones: 'God had given a vision to a man in the desert. . . And like a mighty tree planted by streams of living water, God made a covenant with His visionary that if he walked in obedience, true to the mission he had received, whatever he did would prosper.'

Not only did Earl Paulk's church prosper; he ended up with 10,000 parishioners walking behind him in obedience as he himself walked in obedience to the Lord. And Paulk's biographer was evidently someone who thrived on the heroic nature of his life. 'God's glory shines through this man's life and ministry', she writes in the introduction to the biography. Throughout the text, the tone of the narrative is similarly reverential, to the point where she almost gets quasi-mystical when it comes to statements like, 'In obedience to God, the people become like a city set on a hill, the light of the world, the glory of Mount Zion. Seekers of light look at their faces and see the glorious face of the King!'

Such high-flying ethereal prose was very much Tricia Weeks' style both on and off the page – something I discovered when she acted as my guide later that week through the Chapel Hill Harvester kingdom. She was a one-time schoolteacher in her thirties; the sort of ceaselessly cheerful woman who could best be described as 'pert', and who'd joined Paulk's church in 1980 and, three years later, became his 'editorial assistant' – which essentially meant that she was his in-house writer. She'd worked with him on his last six books, and she had that breathless eager-to-please style which is an essential part of the territory which every publicist must occupy. When we met at the main entrance of the temporary church, she immediately marched me over to a large diagram of the proposed new cathedral, and explained that it was being planned as a *mall concept*, in which the basilica, along with all administrative and pastoral offices, church-related shops

and conference centres would be located under one roof – just like an indoor suburban shopping centre. Then she marched me down a corridor, past a computer centre where the names of all Chapel Hill members and contributors were data based, and where weekly donations were tabulated.

I asked her how much the church received in offerings from their three Sunday services. 'Around $125,000 a week', she said, 'which averages out at around $20 a person for the 6,000 people who come to Chapel Hill every Sunday. But that's only a *weekly* offering. Most Harvesters give around 10 per cent of their income on top of that weekly offering – because they know that people who tithe prosper. And we emphasize tithing as an essential part of one's covenant with God. In fact, tithing is not an option – it's a duty.'

We travelled down some more corridors and into a large television editing suite, filled with monitors and mixing consoles, where two technicians were preparing a videotape recording of last week's service for transmission around the country on the Trinity Broadcasting Network, and for satellite relay to a variety of Third World hotspots. And as Tricia gave me details about how many regional stations and foreign countries the Harvesters were beaming into, she also kept emphasizing that this wasn't simply a ministry for folks with incomes in the high five-figures, but that it was a *blended* congregation covering a wide variety of economic, educational and racial groupings.

More corridors, more doors, and we stepped out onto the mainstage of the church itself, the set for which still looked more variety show than ecclesiastical. I mentioned to Tricia that I'd never seen a religious service quite like Chapel Hill Harvester's, and enquired whether the musicians, singers and dancers involved in the 'ceremony' were professionals hired by the church.

'Absolutely not. They're all volunteers who are members of the Harvester family. We don't need professionals when we have talent like that within our own congregation.'

In fact, Bishop Paulk's sister, Clariece, was Chapel Hill's 'Minister of Worship and Arts', and had not only developed that unapologetically glitzy and upbeat style of 'music ministry' which the church had become noted for, but had also been instrumental in staging 'Kingdom musical comedies' and 'Kingdom dramas' and even starting a 'Kingdom dance company'. However, as Tricia was quick to point out in her biography of the Bishop, the

Harvesters didn't look upon these endeavours as entertainment, but as Pure Praise: 'Singers, dancers and musicians simply lead the worshippers, helping people to clear their minds of distractions and open their spirits to express love of God in the intimacy of each person's own individual, yet blended worship expression.'

Blended – that distillery term again. It was an apt one, though, for Chapel Hill Harvester was all about communal and godly synthesis. This Kingdom of God was built on the notion of coalescence; of harmonizing stratified elements in a stratified city. But it also saw itself as a city within a city and one which – though actively welcoming all social and economic classes – still encouraged its congregation to strive for a *blend* of material and spiritual success that would enable them to overcome daily struggles and be 'a soldier in God's army in the world'. Moreover, it was a burgeoning city that was becoming increasingly self-contained. It had its own fee-paying primary and secondary school, as well as an Institute for Advanced Education (where overseas students attended classes in Kingdom theology). It had its own publishing house – K-Dimension Publishers – in addition to its own television studios. It even had plans for its own residential housing estate, as 40 homes were under construction at present, with plans for more 'units' to be built in the near future. And once the 'mall concept' cathedral was completed, the entire Chapel Hill Harvester realm would almost start looking like its very own dormitory town.

A suburban Kingdom of God? And one with a strong achievement orientation to boot? It struck me as the perfect metropolitan version of charismatic Christianity for the 1980s: a chosen people joining together within their very own secure, self-contained 'burb, getting ready to *go for it* when God rattled the foundations of earthly life. And when Tricia finally brought me to meet Bishop Paulk, the first question I asked him was whether he considered Kingdom Teaching to be allied with the whole emphasis on 'excellence' which had been so much part of this decade's ethic.

Earl Paulk had fantastically blue eyes – a real pair of glow-in-the-dark aquamarine dazzlers. They possessed an hypnotic allure, and had been put to use, no doubt, as a formidable evangelical tool over the years. Sitting opposite him in his small office (decorated, yet again, in that pseudo-Pickwickian style so beloved by just about every other evangelist I'd met), I found that I frequently had to avert my own eyes from his persuasive, penetrating headlamps, as they radiated the kind of overpowering glare

that made me want to squint. Tricia Weeks, on the other hand, appeared downright transfixed by their phosphorescent glow. Sitting next to me, she stared at the Bishop with a reverential intensity that almost mirrored the hero-worship tone of her writings about the man. Paulk, for his part, didn't seem fazed by such adulatory attention. In fact, what struck me most about him was his composure. He didn't come across as a guru-ish spiritual leader, or as someone in love with his own perfume. Instead, he gave off an aura of calmness; a man in control of his domain.

'You ask me about *excellence*,' he said in a voice that was perfectly modulated. 'Excellence is certainly one of our bottom lines at Chapel Hill Harvester – especially the idea of achieving excellence in what you do in life. In getting the best potential out of human beings. And that philosophy of excellence is reflected in our people's work – both professionally and for the church. So, yes, we believe in *success orientation*. But we also believe that this success is to be shared. As Jesus said, good news to the poor doesn't keep them poor; it gives them solutions.

'And, you know, I think we're the most integrated church in America. And that's why it's so important that our services be broadcast to South Africa – because we can be a tremendous influence there. Because the solutions for man today rest with the church. And we've got to show governments that only religious experience can change the heart. Like I said to George Bush: "In America, you can't do with the government what the church can do with people."

'And we're about to see a major revival of the church in America; to see the church *channel* into the government system. Now the problem with making a statement like that is that it smacks of theocracy. Which is why it is our job to put the church into the marketplace. To make it a viable force. To make Kingdom a *lifestyle*. Just as it is the church's job to reclaim the arts, as we have done here. To become a custodian for the finer things in life.

'The traditional churches in this country, however, aren't trying hard enough. They're more worried about what vestments to wear than about changing the hearts and minds of people. Folks need to get involved in *cause-oriented* ministries. Especially because the revival that's happening in the church isn't just going to remain in America. It's going to be picked up in the Third World as well, where it's going to confront Liberation Theology. Where it's going to take the sword out of the Christian's hands and give him a Christian lifestyle instead. That's the Gospel of the Kingdom.

171

That's what we're striving for – not to make revolution, but to influence people's lives.

'Remember how the Early Church turned cities upside-down. We have to do the same. And the only way we'll achieve our goals is by touching the Spirit of Man.'

Putting the church into the marketplace. Making Kingdom a lifestyle. Touching the Spirit of Man. Were these the utterances of a theocrat? Or simply the aspirations of a Christian idealist? If anything, Bishop Paulk struck me as someone who understood the competitive realities of the sector in which he operated: a man of God totally in tune with his society and the spirit of the age. Kingdom Teaching offered its followers the hope of personal fulfillment and membership in a corporate entity that was a godly *market-leader*; that had a future rendezvous with destiny. And therefore, this Kingdom of God appealed to the American belief in self-improvement, and the equally strong American belief in being a moral force in the world today. In influencing lives.

My interview with the Bishop was over – he was a busy man. As we shook hands, he clasped my shoulder, shined his blue high-beams upon me, said how much he enjoyed our conversation and wished me well on this and all other journeys ahead. It was a highly personal goodbye, and one that was curiously touching. At that moment, I understood exactly why Paulk had been such a successful evangelist: he had this remarkable ability to radiate paternalistic warmth and concern – to make you momentarily feel as if you were the most important individual in his world; to bestow on you the sort of warmth and attention that is usually absent from so many folks' lives.

After all, you don't change people's hearts and minds by merely telling them to put their faith in a saviour. You change them by giving them what they lack: a sense of place, a sense of belonging. The true keys to the Kingdom.

I lingered on in Atlanta for a few days, spending much of my time with an artist friend – Clyde Broadway – who lived in one of the few remaining corners of the metropolis that hadn't been shopping centred or tower blocked. Clyde was a well-known local painter, whose most notable work, a Hieronymus Bosch-like canvas called *Real Estate Developers in Hell*, was his own revenge on the property hucksters who'd gutted his city. But spending time

with Clyde was a bit like spending time with someone out-of-sync with the realities of New Southdom. His studio-cum-apartment was a chaotic *La Bohème* set-up, stuffed with in-progress canvases and dirty dishes which had last been washed in 1985; he drove a 14-year-old car with more holes in the body work than a chunk of Emmental cheese; and he was always dancing a pirouette on a financial tightrope, barely surviving on his earnings as an artist. Seen from his perspective, Atlanta was a city which had transformed itself – at the expense of everyone else – into a paradise for young stockbrokers and bond salesmen who were usually called Brad; a city which had ghettoized anyone who wasn't driving at top speed in the corporate fast-lane.

'You know what the New South really is?' Clyde told me one evening in a local bar. 'It's a place that's rushing headlong towards the dollar sign with blinders on its eyes and its memory on erase.'

It was the perfect summation of Atlanta. And the very next day, while doing time once again on Route 285 (in the process of moving hotels), I suddenly decided that I'd had enough of this tinsely outgrowth of a city. So I turned off the automotive circus maximus and headed out of town, catching another interstate that marched me southeasterly through Georgia. Cranking the Mustang up to full velocity, I blitzed past a collection of extravagantly christened burghs – Dry Branch. . . Dublin. . . Santa Claus. . . Denmark – before cruising into Savannah, where I stopped for the night and attended a Baptist revival during which the evangelist in charge gave us the following household hint: 'The best way to avoid getting AIDS is by loving God.'

The following morning, I was back on the road, crossing the South Carolina state line and stopping for breakfast in another fancifully-named town: Coosawatchie. Here, I pulled into a roadside joint called the Dixie Boy Truck Stop. Out front, a crowd of vacationing Quebecois were grouped in front of their parked camper-van, playing an impromptu game of football, and using a large, very dead lizard as the ball. Across the road, in a little grocery store, I tried to buy a local newspaper.

'Ain't been no paper here for two weeks,' said the guy behind the till. 'Fucker who delivers 'em ain't been 'round. Fucker seems t've forgotten us.'

The Dixie Boy Truck Stop was a choice establishment. Buffalo antlers and a Confederate flag decorated one wall; an old Winchester rifle and framed photographs of several Legendary Truckers

covered the other. The main event of the Dixie Boy menu was a 'Trucker's Special': steak, two eggs, hash browns, grits, gravy and biscuits – all for $4.50. The waitress was a woman about 50 with a pencil in her hair. She took my order and then moved on to a trio of charmers at a neighbouring table. One of them – a guy wearing a T-shirt for the heavy metal band called Guns 'n' Roses, and possessing a face criss-crossed by so many scars that it looked vaguely like a railroad map for Yugoslavia – was describing a recent altercation with a fellow trucker:

'Gonna cut that shit-fer-brains next time I see him. Gonna cut 'im good.'

After breakfast, I was back on the road and was immediately passed out by a massive throne-like Honda motorbike which was pulling a small cart attached to its rear. A man and woman sat bunched together on the seat of the bike, wearing matching silver crash helmets that appeared incandescent in the morning sunlight, and holding a conversation with each other courtesy of a pair of radio mikes attached to their head armour. They, in turn, had to swerve to avoid a moving ranch house which was being transported down the highway atop a flat-bed truck. And I nearly ran myself off the road when I caught sight of a billboard which read:

> *South of the Border Motel*
> *Honeymoon Suites*
> *(Heir Conditioned!)*

Accompanying this collection of curious images was a voice on the radio; a voice of a black preacher relating the story of Jesus and Nicodemus in heavily embroidered language:

'An' then Jesus said to Nicodemus, "You come by night, but I'm gonna turn on the light. 'Cept a man be born again, he cannot see the Kingdom of God."

'Now why you think Jesus said, 'cept you get born a second time you ain't gonna see no Kingdom of God? And what does gettin' born again mean? Well, it don't mean goin' back to your zero years. You don't have to be no baby again. No. . . what it means is this: if you don't get born again, then you still got Satan in your life. Hell without God is where you headin.' But when you've been touched by Jesus, you'll walk new. . . you'll talk new. . .'

While this rap version of John 3:1-21 filled the car, I clocked up more geography, barrelling north and passing en route a vast

174

box of a building finished in mirrored glass called the Evangel Cathedral. It had a huge electric sign near its entrance which provided motorists with the temperature and the time and then flashed the message, *All Things Are Possible With God*.

A few miles later, I hit the outskirts of a city called Greenville and drove into an educational institution which also had been built on a philosophy that God *did* make everything possible. In fact, the founder of this school once commented that, 'This college is the greatest educational miracle you ever saw. To God Almighty be the glory. No human could have wrought what has been wrought here.' And just to emphasize how much of a miracle he considered his college to be, he dubbed it: The World's Most Unusual University.

However, by calling the university which bore his name 'unusual', the late Bob Jones Sr wasn't simply referring to the school's blessed link with the Almighty. He was also – one gathers – calling attention to the fact that Bob Jones University was simply the most unique college on the planet. And with the exception, perhaps, of the school for ayatollahs in the holy Iranian city of Qum, his audacious claim might actually still be justified. Because, from the moment I drove onto the grounds of BJU (as it is known locally), I sensed that I had not just driven into a time-warp, but a deliberately maintained time-warp which had essentially slammed the door on the late twentieth century.

It was the clothes that hit me first. Everyone seemed to be wearing 1940s blue serge suits with wide lapels (the sort of suits that make your average Mormon missionary look like he's been outfitted by Giorgio Armani), or flowery below-the-knee dresses of the type favoured by spinsterish librarians. And the next thing I noticed were the buildings: they too were permanently grounded in the Roosevelt era, as they were squat, government-issue style structures, finished in a black and tan brick which was vaguely reminiscent of the colour scheme for a pair of two-tone shoes.

I parked the car and walked down to the university's main administration building. Inside the foyer there was an oil painting of Bob Jones Sr, as well as a pair of Woolsworthian photo-realistic portraits of his son and grandson – Bob Jones Jr (currently the university chancellor) and Bob Jones III (the university's president). It was quite a dynasty, and one which traced its roots back to the old-time Bible thumping, 'get saved or else' style of evangelism which Dr Bob Sr espoused. In fact, when he was finally 'called home' (as his biographer refers to his

175

departure from the planet) in 1968 at the age of 84, Bob Jones Sr was considered to be the last of the real hellfire-and-damnation fundamentalists who got his start on the Southern revival tent circuit, and built up a reputation for himself in the 1910s and the 1920s as a thunderbolt orator with a rabbit-punch style of evangelical delivery. Consider this account of a homily called 'Outstanding Sins of America' which he gave in the Florida town of St Petersburg in 1921, during which he fired pious buckshot at a variety of ungodly targets:

> There are many frizzy headed high school girls who can give your boys lessons in cursing. . . There are more women swearing today than ever before. . . There is no danger of a Blue Sunday, but you are about to have a Red Sunday. . . The bootlegger spits on the Stars and Stripes and tramples the Constitution under his feet. . . If I were a prosecuting attorney, I would prosecute these poker-playing women. . . There was a time when a bad woman was kicked out of society, but now you elect her president of your club. . . Folks are pleasure-wild in this country. . . The most cruel theory the world ever saw is the materialist theory of evolution. . .
>
> We have enough people here tonight to run the Devil out of St Petersburg.

As can be gathered, Dr Bob Sr was something of an antediluvian moralist, and one who also apparently cast women in the role of Eve-like temptresses, with the potential to drag good Christian fellows down into a Satanic, poker-playing, foul-mouthed under-world. It's not surprising, therefore, that when he started his own educational institution, Dr Bob Sr took steps to ensure that his college would be off-limits to all corrupting *pleasure-wild* citizens of the United States, and that spiritual and moral purity would be an essential component of its curriculum. Nor is it surprising that Bob Jones University continues to see itself as a fundamentalist Kingdom of God. And like all fundamentalist organizations (whether they be Islamic or Christian), it still believes that the only way to achieve godly purity is by withdrawing from the world at large and regressing to an aggressively outmoded and simplistic vision of life.

In the case of BJU, the vision it had chosen to hark back to was that well-scrubbed, homogeneous America which the

Reader's Digest or Norman Rockwell traded in. And Wilbur – the 'university host' assigned to guide me around BJU – was undoubtedly an embodiment of the kind of well-scrubbed, model Christian citizen which the university strived to turn out.

Wilbur was 23 years old; a crew-cutted guy decked out in the regulation BJU post-Dust Bowl pinstripe suit which was a little frayed at the cuffs. He also had a very formal manner and – despite my attempts to get him to call me by my Christian name – insisted on addressing me as 'Mr Kennedy, sir'. As we headed off on our walking tour of the university campus, Wilbur gave me a potted history of BJU: how Dr Bob Sr started out founding a college in northeast Florida in 1926, moving it subsequently to Cleveland, Tennessee before 'The Lord opened Greenville to us' in 1947.

Wilbur's use of the pronoun *us* was intriguing, since it hinted that he saw himself as very much a member of the BJU family – a fact which was confirmed when he told me that he'd done his BA at the university and was currently working towards a doctorate here in Bible Studies. He'd also just gotten married three months earlier to a woman whom he'd met while an undergraduate and who was also working on an advanced degree at BJU. And, 'God willing', he would get his doctorate in two years' time. And, 'God willing', he would then get a position on the faculty here. And, 'God willing', he would stay at BJU *forever*.

Wilbur also said that he and his wife had just moved into a dormitory apartment on the grounds of the university – and that was 'kinda neat' because, before their marriage, they had always lived apart in separate dormitories on the opposite ends of the campus. And another 'kinda neat' benefit of being married was that he and his wife could now take walks together at night, since university rules forbid unmarried couples to be seen strolling together after 7pm.

'This rule isn't a moral thing,' Wilbur said. 'It's just to make sure that you study.'

How then, I asked him, did Christian men and women meet each other socially? He brought me to a large lounge above the student union, furnished with about two dozen sofas.

'This is the dating parlour,' Wilbur said. And he explained that, since undergraduate men can't freely associate with 'girl students' outside of the classroom, they have to come to the chaperoned dating parlour on weekend nights if they want to spend an evening with the opposite sex (though seniors had

the 'kinda neat' added privilege of checking out the action at the dating parlour on weekday nights as well).

'You never minded such restrictions?' I said.

'Frankly, I never found it to be a problem,' Wilbur said, 'because the idea behind these rules is to make your relationships with girls spiritual, mental and social. That's why holding hands is forbidden.'

Wilbur saw me do a double-take. 'You've got to understand that the purpose of this university is to prepare students to be Christian witnesses to the world. Every Christian is here to serve. To show the world that the purpose of life is to be more Christ-like. So, stuff like holding hands. . . well, it's not like we think that holding hands is the Devil incarnate. It's just. . . where do you draw the line?'

At Bob Jones University, the line between good Christian behaviour and bad Christian behaviour was as clearly delineated as the Berlin Wall. Good Christians accepted the hands-off dating parlour approach to courtship without question. Good Christians adhered to the dress code which stipulated that skirts should not expose regions above the knee, and that men should not enter a classroom without wearing a jacket and tie. Good Christians did not complain about the lack of newspapers or periodicals in the college bookshop, or question the mandatory chapel service every morning at 10am, with assigned seats and attendance takers making sure everyone was there. And Good Christians were in their dorms every night at 10.30pm for group prayers led by a student 'prayer captain' before lights out at 11pm.

But these rules weren't simply an anachronistic throwback to an old-fangled morality; they were also used as a way to highlight and preserve the gulf that existed between the secular world and the tight ethical universe of BJU. The unusualness of the World's Most Unusual University lay in its determined efforts to filter out any sense of temptation in life; to suppress what they considered to be the carnal allure of a heterogeneous society and create a kingdom which was morally climate-controlled, and therefore free of as many sinful impurities as possible.

'We've got nearly 6,000 students here,' Wilbur said, 'and though not absolutely every one of them is religious, if they complete the programme then their *mindset* has probably been permanently changed.'

We toured the art museum, filled with a lot of dark dour Old Testament-ish Northern European religious paintings. We toured

the library where, encased in glass, was the Bible which once belonged to Billy Sunday – a notoriously strident evangelist of the 1920s who (from all accounts) made Dr Bob Sr appear downright Unitarian when it came to his assaults on the godlessness of America. And we toured the theatre, where there were a good dozen or so photographs of Dr Bob Jr in a variety of Shakespearean roles – which, judging from the costumes and settings, very much looked like the wrinkly tights school of Shakespearean production that toured provincial theatres in the 1950s. Wilbur said that Dr Bob Jr was quite the thespian: 'He's listed in *Who's Who International* as an actor, and Warner Brothers once offered him a contract, but he decided that the Lord really wanted him to stay here.'

The university produced two Shakespearean productions and one opera a year, and for many students this was their first introduction to the 'finer things in life'. Dr Bob III was also quite the thespian – there were framed photos of him playing Iago, and of Dr Bob III's wife playing Catherine of Aragon, and of Dr Bob III and his wife in the roles of Romeo and Juliet.

I asked Wilbur if there was a possible conflict between fundamentalist theology and the production of dramatic work onstage.

'Well, Shakespeare is an okay dramatist to perform', Wilbur said, 'because there's always a conflict between good and evil in his plays. And because there's a body of thought which considers him to have been a *serious* Christian.'

We left the theatre and toured the Bob Jones University film studios, where there was an actual sound stage and a small production staff that taught 'filmmaking in a Christian setting' and also produced a major feature film once every five years. In fact, BJU had its own production company, *Unusual Films*, run by their very own Orson Welles – a director named Katherine Stenholm who, prior to her recent retirement from the faculty, had been responsible for helming the six feature films which the production company had turned out since the 1950s – all of which, Wilbur assured me, were 'expertly made dramas which contained a strong evangelical message'.

A Christian film unit and a Christian approach to Shakespeare: Bob Jones University was certainly full of surprises. Then again, like Chapel Hill Harvester, it too believed that a Kingdom of God should reclaim the arts, and should create a Christian-oriented culture for those who inhabited its realm. Unlike Chapel Hill Harvester, though, BJU had somewhat more rigorous ideas about

179

the rules governing such a kingdom, especially when it came to small social matters like the subject of interracial dating; an issue which, in fact, had embroiled the university in something of a legal tangle which ended up in the United States Supreme Court.

'Sometimes I think the government is going to hound us out of business,' Wilbur said. What he was referring to was the 1983 Supreme Court ruling which stripped Bob Jones University of its tax-exempt status as an educational institution because of its policy – based on its understanding of the Bible – that forbade interracial dating and interracial marriage among its students.

'Of course, the rules didn't just mean that whites were forbidden from dating blacks,' Wilbur said. 'It also stopped whites from dating orientals and orientals from dating blacks as well.'

Such arguments about BJU's universal application of this dating policy didn't cut much ice with the Supreme Court, which ruled in an 8 to 1 decision that '. . .the Government has a fundamental, overriding interest in eradicating racial discrimination in education', and therefore, 'an educational institution engaging in practices affirmatively at odds with this declared position of the whole government cannot be seen as exercising a "beneficial and stabilizing influence in community life" and is not "charitable".'

By losing the case, BJU didn't simply lose its tax-free status; it also had to pay around $2.5 million in back federal employment tax, and was also liable in the future for federal income tax should it make any income over and above its expenses. More crucially, financial donations to the university would no longer be tax-deductible, thus killing off an essential incentive for potential contributors to Bob Jones University.

But besides being financially calamitous, the Supreme Court decision also evidently heightened BJU's sense of persecution and internal exile within a godless state. Writing in the *Miami Herald* a few weeks after the ruling was announced, Dr Bob III invoked the Scriptures to assail the court's decision:

'And judgement is turned away backward, and justice standeth afar off: for truth is fallen in the street, and equity cannot enter. Yea, truth faileth; and he *that* departeth from iniquity maketh himself a prey. . .'

These words from Isaiah 59:14-15 encapsulate America's spiritual dilemma. Justice is possible only when supported by truth.

The unjust and unlawful Supreme Court decision of May 24 against Bob Jones University and First Amendment guarantees of religious freedom heralds a new day of totalitarian assault on Christian schools and churches in America. . .

Bob Jones University. . . accepts no government funds. Its 6,000 students voluntarily elect to attend and put themselves under the regulations governing student conduct. It is a pervasively religious school and believes whatever the Bible says is so. You will not find among its number dopers, drinkers, fornicators, or those of other morally debilitating lifestyles. In every way the school is anachronistic. It seeks to produce solid citizens for our nation – the kind that make good employees, good neighbours, good fathers and mothers.

Would it not seem that such a rare and beneficent place should be protected and encouraged by our government, rather than attacked, maligned and stepped on by our highest court?

Us versus them – it was the familiar refrain of many an intensely Christian community. Bob Jones University, however, didn't just see itself as a pious oasis in a profane desert; it also considered itself to be a sort of Christian *Légion étrangère*, turning out God's toughest, most fiercely loyal soldiers.

'I consider this place to be a training camp,' Wilbur said, 'pumping people out to serve the Lord. And it's an education that teaches you discipline. As Dr Bob Sr always told the students and faculty, "We're a Christian show window", so we've got to be disciplined,' Wilbur said. 'We've got to show the world we can live the pure Christian ideal.'

God's own boot camp, replete with prayer captains, attendance takers and lights out at eleven. This Christian citadel was certainly run on military lines. And it made no apologies for its spartan, stern regime. Or the fact that – as Wilbur told me with some pride – Bob Jones University actually awarded an honorary degree to the Rev. Ian Paisley.

After my official tour of the university, I phoned the public affairs office of BJU and suddenly found myself in a bit of verbal dustup with one of its officials – a woman I'll call Elizabeth Gray – about

181

obtaining an appointment with the former director of the Bob Jones film unit, Katherine Stenholm. This little contretemps didn't surprise me, since – from the moment Ms Gray and I had first spoken a few days earlier – we'd been having what a pop psychologist might call 'communication problems'. It all began when I'd called from Atlanta, said that I was planning to visit the university and mentioned that I would very much like to meet some faculty members or students. The response I'd received was downright glacial, as I was told that the faculty and students of Bob Jones University simply didn't talk to members of the press or writers, so the answer to my request was an emphatic 'no', though I could go on a campus tour like any other member of the public.

Now, hearing my voice again, Ms Gray became even more Siberian. She was terribly occupied with work, she explained, and didn't have time to deal with every scribbler who landed on BJU's doorstep. As to my query about meeting Katherine Stenholm, hadn't she told me earlier that faculty members didn't give interviews? I said that I was simply trying my luck again. She said the answer – 'for the fourth time' - was *no*. I said, say I gave Dr Stenholm a call and simply arranged to see her myself? She said that, as soon as she was finished talking to me, she was going to phone Dr Stenholm and tell her not to see me. I said, Dr Stenholm was a grown-up woman – couldn't she decide whether or not to see me herself? She said that Dr Stenholm would never do anything to hurt the university. I said, why would an interview with me 'hurt' the university? She said, because writers never understand us. I said, perhaps if you weren't so reticent about letting journalists and writers meet your faculty, you might find a greater understanding about BJU appearing in print. She said – 'for the fifth time' - the answer was no. I said (now getting desperate), well. . . could I, at least, see one of Dr Stenholm's movies? She said (after a considerable pause), if I was going to be such a nuisance, she would simply have to see what she could do about setting up a screening.

And that is how I found myself in a darkened classroom the next morning, watching the latest production from the Bob Jones University studios – an intimate epic called *Sheffey*. It was a 2 ¼ hour panoramic stroll through the life of Robert S. Sheffey, an actual nineteenth-century 'circuit rider' - or roaming evangelist – who wandered the Southern hill country saving souls, running campside revival meetings and spreading the Gospel. But this film

wasn't simply one of those 'inspiring' tales about some spiritually inspiring Christian folk hero; it was also a manifesto.

Told in flashback, the narrative begins with young Sheffey growing up in Virginia and behaving like an 1800s version of a juvenile delinquent, committing an act of heavy-duty sacrilege one night when he tags along with a gang of local low-lifes who break up a revival meeting by throwing corn husks at the faithful. Afterwards, however, Sheffey is so remorseful about this incident that he returns to see the preacher and apologizes.

'All you have to do now is ask God's forgiveness and be saved', the preacher tells him.

'Can I do it now?' young Sheffey asks and, getting down on his knees, he is born again as a Christian. However, when he returns home and informs his aunt (with whom he lives) that he 'accepted the Lord tonight', she is thoroughly horrified: 'If you had to make some sort of commitment, why couldn't you do it in our church and in a gentlemanly fashion?'

'But I was saved', young Sheffey says. 'I thought you'd be happy I became a Christian.'

Auntie informs him that he was already born a Christian, so why should he make such a big song-and-dance about being born again? Young Sheffey counters that he knows he's done the right thing, and that he can no longer abide the 'misplaced values' of this family. So he leaves home and heads out into the wilderness, initially stumbling on a job teaching in a backwoods schoolhouse before getting started as an itinerant preacher. But the local church authorities won't give him a licence to preach because, as the head of the licencing committee tells him, 'Your prayer is abnormal. You pray for hours by the side of the road. One boy says you sound like you're talking to God.'

'Who do you talk to when you pray?' Sheffey asks. And realizing that he is never going to fit into any established church, he sets off on his faithful horse Gideon to begin his ministry; a wandering ministry which, he says, will be patterned after Jesus'.

So Sheffey and Gideon hit the road, drifting through the southlands, having spiritual adventures, growing old together. And when he's not bantering with his horse ('Well, Gideon, God has given us a beautiful day') he's doing the Lord's work. He convinces a moonshiner to give up his sinful work after correctly predicting that the Lord will arrange for a nearby oak tree to topple and smash his still. He gives away his only pair

of socks to a shoeless tramp he discovers freezing in the snow. Coming upon a rural revival meeting, he climbs a nearby hill to pray for those unsaved souls in attendance and – lo and behold – folks respond to the preacher's altar call and come forward to accept Jesus. He marries a woman many years his junior who has this habit of always looking at him with an adoring gaze ('Eliza, you're a pearl of precious worth', he tells her in one of the film's major romantic moments), and who bears him several children. He gives away his beloved Gideon to a family in need of a horse, and the Lord rewards such selflessness by providing Sheffey with a new Gideon, who subsequently saves the evangelist's life when he falls into a stream. He runs into further trouble with mainstream church authorities when they decide to ban his camp meetings, and prove themselves to be people who 'want to call themselves Christians, but [who] tear down everything Christianity has ever taught'. He suffers great tragedy, when his beloved camp ground is subsequently burnt to the ground and his beloved wife collapses that day and dies. And then, some years later, the young man responsible for the accidental incineration of his camp ground visits the sick, elderly Sheffey and confesses all, begging the old man's forgiveness.

'I forgave you long ago,' Sheffey says. 'My dear sweet Lord took the hardness from my heart.'

'Forgave me?' the young man says, astounded. 'But I ruined everything for you. And the camp ground will never be rebuilt, will it?'

'The camp ground is gone not because you burnt it,' Sheffey says, 'but because God's people didn't want it. Every time we give up part of our faith, we lose the precious spirit of God's promise. And some day, when the world tells us we can have no religion and God is driven from our schools and our government and our homes, then God's people can look back and say that God's religion wasn't taken from us. It was handed over, bit-by-bit, until there was nothing left.'

After delivering this last cautionary homily, Sheffey is 'called home' and heads off to his eternal reward. And as he's planted in the good earth, the final credits roll.

Fadeout.

In many ways, *Sheffey* was the kind of movie John Ford would have made had he been a born-again Christian. It was pastoral in tone, yet majestic in its vision of the American landscape. And, like so many of Ford's greatest films, it was centred around

184

the idea of a 'quest' - a highly personal, self-searching journey through a New World wilderness. But while it followed the classic Hollywood book when it came to its narrative form and its visual style, the film was, at heart, a work of spiritual propaganda. It was an idealized portrait of a supreme Christian – a man who was so 'on fire for the Lord' that he sacrificed everything for his faith and lived his life attempting to emulate the Christly example which Jesus gave mankind. At the same time, though, the film was also a distillation of the BJU world-view – especially in its distrust of mainstream Protestant churches (which were portrayed as espousing a benign and weak-kneed faith in God that was a watered-down, almost counterfeit type of Christianity), and in its steadfast belief that God's people must fight to maintain God's predominance in a society riddled with God's enemies. So – underlying the film's leisurely pace and its pious composure – there was a far more militant statement about the need for a saintly, yet rigorous breed of Christian to militantly carry forth the standard for Jesus.

After all, militant Christianity was the *métier* of Bob Jones University. And Elizabeth Gray certainly saw herself as a militant Christian – something I discovered when we finally met up with each other after the film showing.

We arranged to rendezvous – ironically enough – in the university's dating parlour. Elizabeth was not the flinty spinster I'd expected, but a stylish, intriguingly attractive woman rapidly approaching the end of her thirties. She dressed carefully, but with a certain subdued *élan* which hinted that she had ideas about fashion which extended beyond Greenville, South Carolina. And though she was a bit heavy-handed with the pancake base and the lipstick, she had a handsome face and deported herself with an aggressive urban professionalism. We sat primly at either end of a long settee. Had anyone entered the parlour at the time, they might have mistaken us for an unchaperoned courting couple. Except, of course, that we immediately started to argue after saying hello.

'You were very pushy on the phone yesterday,' Elizabeth said.

'I was only being pushy because you were being so cagey.'

'We're all very busy around here,' she said. 'We all work very hard. We don't really have the time to talk to writers.'

'It's the summer. School's out. Everyone's got a half-hour to spare.'

She smiled tightly. And to get us out of the rhetorical boxing ring, I asked her if she was from Greenville.

'What does that have to do with the university?' she asked.

'I'm just interested.'

'Yes, I grew up in Greenville. My father's a professor here at BJU.'

'So you grew up in a Christian household?'

'Of course, it was a Christian household,' she said with some annoyance. 'Like I said, my father's a faculty member, and he wouldn't have been a faculty member here if he wasn't a Christian, because there's no point having non-Christians teach Christians in a university which is dedicated to preparing its students for Christian life. That's why so many of our faculty also have degrees from Bob Jones – because it's hard to train someone in your philosophy. It's a lot easier if they went here.'

She herself had left BJU after receiving her BA and headed out to Oregon for a while, where she was a librarian in a college near Portland. But though she loved that part of the Pacific Northwest, she was unhappy at work and 'missed having a wide choice of Christian friends.' So she returned to Greenville and to the BJU family. She didn't regret coming back, she said. She liked her job in the university's public affairs office. And Greenville was a growing city, which had more churches than any other city in the South. It was the Buckle on the Bible Belt. She was happy here.

But – I asked – did she believe that BJU was right in remaining so rooted in the 1940s; in being such an isolated City on a Hill? For example, did she really agree with a university rule forbidding students to go to movies in town without a chaperone?

'You're wrong about that rule,' she said.

'Oh, students can go to movies in Greenville without a chaperone?' I said.

'No, they're not supposed to go to *any* movies off campus.'

'Isn't that a bit extreme?'

'How do you judge life?' she challenged. 'How do you judge the people you meet?'

'I suppose I judge them by my impression of them, whatever that's worth.'

'Well, I judge life by the Bible,' she said. 'My personal view of Christianity is this: a Christian is someone who has accepted Jesus Christ as their personal saviour. Christ died for our sins because we are all sinners. We cannot meet his standard, and he

– in turn – cannot let us into heaven because it is a perfect place. Which is why we must repent our sins and accept him into our lives. Because then we will be given the gift of eternal life. And if a person has never come to that moment in his life when he has accepted Jesus, then that person is *not* a Christian.

'A true Christian also follows the teachings of the Bible. And a true Christian *knows* that the Bible demands morality. So, as a truly Christian university, we do expect students to behave morally, as in accordance with the Bible. And the students understand that we expect a very strict mode of behaviour. They don't have to come here if they don't want to – but the reason they *do* come here is because they know they'll get the Christian training they want.

'At BJU, we meet the world on God's terms. No one else's. Though I don't suppose that *you* – as a non-Christian and someone who lives outside of the country – would understand that.'

I said, 'Travel broadens the mind.' She snapped back, 'I know it does. I like to travel as much as possible.' In fact, she had just returned from Italy. And for several minutes, she momentarily discarded her intensely formal manner, and we had a pleasantly neutral conversation about her recent three-week sojourn there. It had been her second visit to the country. She spoke a bit of the language. She adored it. Especially Venice.

'Venice is so *rotic*,' she said. 'Do you know what that word means?'

'No.'

'It's a word my girlfriends and I thought up. It means *romantic* without the *man* – a place like Venice where you really wish you were with someone you were crazy about.'

I asked her if she was married. She shook her head. Boyfriend? She shook her head again. And casting a quick glance around all the empty sofas in the dating parlour, she said: 'I guess I've never really been in love with anyone.'

There was a momentary lapse in the conversation. Then Elizabeth quickly reached for her briefcase and stood up.

'We've talked too long,' she said. 'I must get back to work. There's so much to do.' She proffered her hand, turned on her heel and marched off back to her office. Back to her work in this isolation ward for the hyper-pious. In this *un-rotic* Kingdom of God.

I left the dating parlour and strolled over to the grave of Dr Bob Sr. It was located in the centre of the campus, on a small island floating within a man-made reflecting pool. You had to traverse

a small bridge to get there. And on the simple gravestone was the following inscription:

A Fight Well Fought
A Course Well Run
A Faith Well Kept
A Crown Well Won

As I stood there, surveying the realm that Bob Jones built to glorify the Lord, I could see beyond the grounds of the university to the dual-carriageway which ran by its main gates. A dual-carriageway of congealed traffic, restless car horns, black belches of exhaust fumes. Within this domain, however, all was calm and clean. All was under control. Outside was a world of grubby chaos; inside, a world of manicured purity that was safe and secure. It was a real foretaste of heaven; a way-station en route to Kingdom Come.

CHAPTER 6

Going to Extremes

★★

Here are the basic facts of the case: on 6 December 1980, a brief encounter took place in a motel room in Clearwater Beach, Florida that sparked off one of the biggest scandals in American ecclesiastical history. On that day, an up-and-coming television evangelist named Jim Bakker was introduced to a young woman named Jessica Hahn, the secretary to a Pentecostal minister on Long Island. Ms Hahn had been invited to Florida by a chummy faith healer named John Wesley Fletcher, who was a friend of Bakker's, and who had met Ms Hahn when he preached at the church where she worked. (She, in fact, had baby-sat for one of Fletcher's kids during his visit.) The idea behind this Florida jaunt was that Ms Hahn would be able to attend the filming of a charity telethon in which the visiting Bakker would be taking part. However, as it turned out, Ms Hahn didn't just spend her time at Clearwater Beach watching Bakker in televangelical action. For she later alleged that, several hours after meeting the reverend, he coerced her into bed and all but raped her.

Those are the essential details of a *liaison dangereuse* which became international news, and above which much confusion still hovers. Though the two parties have separately acknowledged that they were alone together in a motel room on that fateful December day, the details of the encounter remain in dispute. Jessica said that the 'event' lasted somewhere between 60 and 90 minutes; Jim countered that it was nothing more than a 15-minute quickie. There are also conflicting reports about whether Bakker had been able to consummate the act, while the reasons why Ms Hahn was really invited down to Florida in the first place remain equally unclear. Did Fletcher bring Hahn to Clearwater

189

simply to introduce her to a Christian star like Bakker – who was starting to gain national attention for his religious variety show, the *PTL* (Praise The Lord/People That Love) *Club*? Or was she dispatched down to the Sunshine State in the hope that she and the televangelist might become 'friends'? Or had Bakker requested the services of a woman during his stay in Clearwater and Fletcher decided that Ms Hahn – a Page Three Pentecostalist – fitted the bill perfectly?

While there is a divergence of opinion about the motive behind the Florida invite (and, of course, just how long Jim and Jessica spent together in the sack), there's general agreement that, by 1984, Bakker's organization had given in to Ms Hahn's increasing demands for hush money and had paid her the sum of $10,000. There's also general agreement that in February of 1985, the PTL ministry paid her another $15,000 outright, with an additional $150,000 set aside for her in a trust, and that they laundered this payment through PTL's building contractor.

This latter payoff, though, was small beer compared to the allegations later levelled at Bakker. Allegations that he used his remarkable skills as a fundraiser to garner $70 million in donations for the construction of a new hotel at Heritage USA – his Christian amusement park and spiritual centre in Fort Mill, South Carolina – but defrauded his benefactors in the process by supposedly promising them that, if they each contributed $1,000 towards its construction, they would be entitled to an annual three-night stay at the hotel for the rest of their lives. Not only did Bakker fail to deliver on this promise – as the hotel remains uncompleted to this day – but it is said that he sold far more 'lifetime' stays than the hotel could ever accommodate. And that's major league fraud by definition.

Then there was the business about 'Kevin's House'. This was a home for disabled children – built on the grounds of Heritage USA – for which $3 million in donations had been raised, though it only cost $1.5 million to construct. It was also apparently built without any regard for the various codes and specifications demanded by the state of South Carolina for a home caring for severely handicapped children (it lacked, for example, a sprinkler system), and was therefore sold to its patrons as something it could never be.

Add to such accusations of illegality the rumours that Bakker indulged in homosexual activities – one PTL Club employee was purported to have occasionally 'serviced' the reverend in his

dressing room (an allegation which Bakker has never convincingly refuted) – and you can begin to see why the one-night stand with Jessica Hahn was the least of Bakker's problems. Still, when the fling with Hahn was made public – thanks, in part, to Ms Hahn herself, who happily talked to the press about her sexual skirmish with the reverend, and also had her God-given physical charms splayed across the pages of *Playboy* – Jim's manifold sins hit the proverbial fan. And, like any public figure caught up in a major scandal, he soon found himself under siege – his past personal and professional conduct ended up being scrutinized not just by the press, but also by such well-known American institutions as the Justice Department and the Internal Revenue Service.

Of course, the Bakker affair grabbed the public imagination because a man of God was revealed to have engaged in some horizontal evangelism. But what also made the whole scandal so irresistible – so exuberantly baroque – was the glitzy nature of Bakker and his entire 'ministry'. He was, without question, something of a visionary – only his was a spiritual vision that traded on such questionable elements as cheap sentiment, the American tendency towards hyper-consumerism, and success-fully underestimating the taste of the public. What's more – like any visionary – he had always been a man of ferocious ambition. Having been raised in a strict Assemblies of God family in Michigan, he was ordained a minister of that church at the precocious age of 21. A year or so later – in the mid-1960s – he broke into the then novel field of television evangelism when he landed a job at Pat Robertson's new Christian Broadcasting Network (CBN), hosting a children's religious show with his wife, Tammy.

But Jim didn't remain in the kiddies' slot for long, as he was one of the pioneers of the first Christian talk show, the *700 Club*, which he frequently co-hosted with Pat Robertson (who still fronts it today). Eight years passed and, having gained considerable exposure on CBN and the *700 Club*, Bakker decided it was time to begin building his own ambitious ministry. So it was that – as an in-house biography of the Bakkers, *The Story of People That Love*, later put it – 'through a series of God-ordained circumstances, Jim and Tammy arrived in Charlotte, North Carolina to found and establish the ministry of Heritage Village Church and the PTL Network.'

From the outset, God was naturally on their side:

191

Through the tireless labour of Jim, Tammy and a small staff who shared their vision, an empty furniture store was transformed into a 'House of God' for proclaiming the Gospel. Together, they built a chapel by hand in the centre, as a meeting place of prayer. This became the heart of the ministry. The daily two-hour television programme proclaimed God's love and invited viewers to pray with volunteer counsellors on the 24-hour-a-day prayer phones.

The warmth, the testimonies, and the simple message of God's love proclaimed by Jim and Tammy Bakker, swept the country as local television stations across America began broadcasting the programme.

The purchase and construction of Heritage Village and Bruton Parish Church Studio, PTL's first church home, fulfilled Jim Bakker's dream for a place of beauty, excellence and Christian heritage for God's people. Only the Lord could have foreseen the ensuing growth, estimated by experts at 7,000 per cent within the next 18 months. During that same period more than 100 new television stations began airing the broadcast; the staff doubled, then quadrupled; the first-ever private satellite licence was issued to PTL; a Spanish version of PTL was born to reach the Spanish-speaking world; hundreds of thousands of visitors came to Heritage Village; and thousands of calls for prayer poured into the phone lines daily. Pastor Bakker's vision of reaching the whole world for Christ stood on the verge of realization, but the 25-acre Heritage Village site was inadequate for such a goal.

Heritage USA, the place God chose for the fulfilment of Jim Bakker's greatest dream, was begun on his birthday, 2 January 1978. With his pastoral staff, he laid a master plan for a 21st century ministry of world evangelism on the four square mile site, designed to equip believers for total Christian living. Out of this natural wilderness a beautiful 400-unit campground was created, along with an outdoor church and camp meeting amphitheatre, teaching and recreation facilities and a new office centre to serve as world headquarters for the ministry.

But having realized his dream, Jim decided he needed more facilities immediately. He wanted 'an expanded church complex with space for education, prayer and counselling, a Bible-centred school for on-hands training in world evangelism, television

production studios, suitable retreat lodging for members and visitors, and additional permanent housing for church staff and volunteers. In the face of severe opposition and unrelenting criticism, the task seemed overwhelming. But again and again, as Pastor Bakker and the church prayed, God sovereignly guided them to victory against the odds.'

As can be gathered, Jim Bakker was a boundlessly energetic fellow who consistently over-extended himself and his ministry. And – according to seasoned Bakker-watchers – this compulsion to incessantly expand his empire was one of several self-destructive tendencies which the reverend increasingly displayed as Heritage USA enlarged and enlarged. It led him into scams like raising far more money than was necessary for certain projects, and into misdirecting funds. But Bakker simply never knew when to stop – especially since he had a particular genius when it came to amassing donations for his ministry. With his baby-faced aura of innocence, his up-beat game-show host style of delivery, and his ability to cry on cue, he built up an intensely personal relationship with his nationwide flock – thousands of whom were 'PTL Partners', paying a minimum of $22 a month to be part of the Jim and Tammy Ministry. And when he pleaded for more money, they delivered. . . in abundance. And Jim subsequently spent their money. . . in abundance.

But Jim wasn't just spending his followers' financial gifts for the glory of God; he was also (so it was later alleged) spending their cash for the glory of Jim and Tammy Bakker – to the point where they had a combined annual income of $1.6 million by the time the scandal broke. And if Jim's synthetic emotionalism and his lachrymose fundraising tactics were questionable, then Tammy's on-screen antics pushed back all established boundaries for bad taste.

Indeed, Tammy Faye Bakker developed a reputation as the Imelda Marcos of the televangelical circuit – thanks, in part, to her lavish spending habits, her self-trumpeted career as a singer, and her astonishing personal appearance. Her face was a multi-layered landscape of Kabuki-style make-up; her eyes were always embellished with the sort of false lashes that looked as if some particularly repellent insect had attached itself to her eyelids; her clothes and her jewellery went way beyond the usual extremities of gaudiness; and if Jim had the ability to bring tears to his eyes whenever a sales pitch warranted it, then Tammy could literally cry herself a Mississippi on demand.

193

In short, Jim and Tammy Bakker were considered to be schlock merchants extraordinaire – that is, of course, by everybody except their loyal millions of fans who steadfastly tuned into the PTL Club and made a hajj to Heritage USA whenever possible. But even after Jim's downfall, a considerable number of fans remained *semper fidelis* to the Bakkers. In fact, faction fighting broke out between those – both within the PTL organization, and within the PTL faithful itself – loyal to Jim and Tammy and those who believed that the only way the PTL Club and Heritage USA would survive was by permanently detaching itself from its original founders.

Worst yet, in the wake of the scandal, hundreds of PTL employees had lost their jobs, thanks to monumental cash flow problems which now threatened to permanently shut down the entire operation. And with several entrepreneurs currently expressing interest in buying the amusement park section of Heritage USA – and with Bakker himself desperately trying to raise $100 million to win back control of his empire – 'the place God chose for the fulfilment of Jim Bakker's greatest dream' now appeared from a distance to resemble one of those eternally beleaguered and corrupt Central American republics which had undergone so many palace revolutions that it was no longer certain who was in charge of its destiny anymore.

Heritage USA was a mere 90-minute dart up the interstate from Greenville and Bob Jones University. Having just done time in an isolation ward for the super-pious, it seemed only fitting that I now move on to a spiritually disgraced dominion – an evangelical 'worst-case scenario' of a godly dream gone ga-ga. So I cruised northeast on I–85, weaving into North Carolina and passing the mini-Manhattanite skyline of Charlotte – the big banking city of the New South – before bobbing back into South Carolina and the town of Fort Mill. This criss-crossing of state lines was a geographic reflection of the enormity of the Heritage USA complex – though its actual postal address was in South Carolina, its territory spilled over into North Carolina. In short, Heritage USA was neither here nor there – it was everywhere.

Coming off the interstate, I was confronted by a billboard strategically erected near a road sign for Heritage; a billboard displaying a picture of the amusement park's founding father and mother, and the caption:

Welcome Back Jim and Tammy
Bring Back Bakkers Club
The Dream Lives On.

Imagine the Nicaraguan Contras constructing a billboard on
the road to Managua which read, *Bring Back the Somoza Family*,
and you'll begin to have an idea just how provocative this
pro-Bakkerite hoarding was to the new administration attempting
to keep Heritage afloat. Then again, the Bakkerites – as I
came to learn – almost considered themselves to be religious
Contras who'd sworn loyalty to the *ancien régime* and were
determined to engineer a coup that would bring their leaders
back to power. This 'Welcome Back Jim and Tammy' sign
was but one salvo in a propaganda war that the BBBs ('Bring
Back Bakkers') were waging at the moment for the hearts and
minds of devoted PTL viewers. It was pure 'cult of personality'
agit-prop, reinforcing the banana republic aura of Heritage
USA.

I followed further road signs into what appeared to be a
vast suburban community. I drove past landscaped gardens
and residential complexes with Winnie the Pooh-ish names like
Dogwood Hills and Mulberry City. This was Heritage's own
housing estate, in which many PTL Club followers had bought
property. Up ahead was a set of arches, signalling my official
arrival at the amusement park (or '21st Century Christian Retreat',
as Bakker himself preferred to call it). The first sight that came
into view as I turned a corner was a half-finished tower block
lying dormant in the Carolina sun. There were no signs of further
construction plans for the structure – it had the forlorn look of
a forsaken enterprise, as if the builders simply one day downed
tools and walked off the job permanently. Just as they had
evidently walked away from a nearby half-finished Disneyesque
structure that resembled a fairytale castle crowned with fairytale
steeples. One of these steeples was resting on its side by the
incomplete structure, giving it the look of a deliberately designed
visual metaphor for the collapse of Jim-and-Tammy Land: The
Fairytale Abandoned.

Behind this discarded castle was a hotel. The Heritage Grand
Hotel. Reproduction *ante bellum* architecture with lots of pseudo-
New Orleans ironwork. Inside was an open-plan foyer covering
several acres. It was constructed like a courtyard, around which
all the floors of the hotel were stacked, so the effect was a bit like

walking into some Old South quadrangle, with wrought-iron balconies looking down upon life below. Only in this Old South quadrangle, plexiglas lifts transported guests up and down to their temporary lodgings, while directly below them – in the centre of the foyer – a pianist played Mantovanni favourites on a reproduction Victorian grand piano. This piano was located on a large stage, near to which were a cluster of reproduction Victorian couches and a reproduction Victorian restaurant.

So far, this hotel looked like nothing more than some curious attempt to recreate a bygone ambiance of bogus high classdom. But, of course, this wasn't simply a hotel; this was a Christian hotel. Behind the reception desk, in foot-high gold plated letters, was the statement: *JESUS CHRIST IS LORD*. And on nearby Main Street – an ersatz Victorian shopping precinct off the foyer with ersatz cobbled streets – was an art gallery which specialized in unusual portraits of Jesus. One of them showed Jesus talking to a little girl. He was outfitted in a white Dr Kildare-style operating theatre tunic and looked very much the young medico who might just need a haircut – though the rather neat set of holes in his hands and his feet tended to give the game away. And the little girl was pointing to this well-known set of wounds and saying (according to a caption below the painting), *'Does it hurt?'* In another painting, Christ was seen riding a white stallion while dressed in white robes and a white scarf (making him look like a member of the Bee Gees). The caption here read: *'Jesus is coming again.'*

Main Street was filled with shops either specializing in religious kitsch or trading under religiously kitschy names. There was, for example, the *Heavenly Fudge Shoppe* and the *Heaven Scent Perfumery* and the *Ye Olde Bookshoppe*, where you could buy such intriguing volumes as *Tammy Says: You Can Make It*. Or a pamphlet co-authored by Jim and Tammy called *How We Lost Weight and Kept it Off*. Or two books written by Jim himself (prior to The Fall), with vaguely ironic titles: *I Got To Be Me* and *Survival: Unite to Live*. All of these Jim and Tammy books were remaindered, however. As was a big coffee-table book – *Jim and Tammy Bakker Present The Ministries of Heritage Village Church* – which once retailed for $100, but was now all yours for the once-only price of $5.95. Judging by the pile of volumes still for sale, no one was taking advantage of this bargain. Or of any other Jim and Tammy bargains on offer.

I bought some postcards in the bookshoppe. As I handed over the cash, the woman behind the till said, 'God bless you.' I

thanked her for the sentiment and asked if it had been a rough couple of months around here.

'Well,' she said, leaning forward and speaking in a conspiratorial whisper, 'I have to admit that I've been through calmer periods of my life than the last year and a half. But we're still here – praise God – because the Lord wants us to be here. And with His strength, we'll still be here in times to come.'

I wandered back into the foyer, where a hundred or so people had gathered around the stage, waiting for the morning's entertainment to begin. The audience was largely made up of white pensioners, though there were a sprinkling of young families and the occasional black or Hispanic couple in attendance. Largely, though, it was blue and frosted hair, pot-bellies, and polyester clothes – the once struggling, now retired lower-middle classes gathered together in fellowship. Like Joe – a big balding man from Toledo, Ohio with a terrible stutter. Joe was sitting next to me in the foyer and we got talking. He'd worked for 40 years in the same paper mill as a cutter and had only retired a year ago. His wife, Agnes – '62 years young', he said – still did a 9-to-5 stint in the cafeteria of a local factory, and had done two months of extra shift work in order to be able to finance the holiday here at Heritage USA.

'We've been watching the PTL Club for eight years. And we've been PTL partners for six of 'em. So comin' here – well, it's a real big thing for us. Real big thing. And worth all the savin' we had to do. And, way I figure it, we really got to forgive Jim for what he done. Talented man like that should be given 'nother chance. Especially since him and Tammy mean so much to folks like Agnes and me.'

We were interrupted by the arrival onstage of a middle-aged couple, who were greeted with loud applause.

'That's Bob and Jeanne,' Joe said. He was referring to Bob and Jeanne Johnson – the two singing stars of the PTL Club. Only – among the PTL faithful – surnames were never used when talking about the stars of the show. It was always 'Bob and Jeanne'. Just like the programme's jovially fat co-host was known as 'Uncle Henry' and his wife, 'Aunt Sue'. Jim and Tammy. Bob and Jeanne. Uncle Henry and Aunt Sue. One big happy family. Under God.

The applause died down for Bob and Jeanne. Then Bob – a haberdasher type in an electric grey speckled jacket, black

197

trousers, a yellow shirt, a yellow polka dot tie, and a matching yellow pocket handkerchief – stepped up to the microphone and said, 'Good morning! Now speak when spoken to. Repeat after me, "Good morning!" ' And all the adults in the audience did as he asked and said, 'Good morning!' Welcome to Playschool with Bob and Jeanne.

After getting everyone to speak when they were spoken to, Bob then told us an anecdote. A domestic anecdote about how he'd bought a new type of washing-up liquid yesterday, and how Jeanne had thought it was a new type of dishwasher liquid and used it in the dishwasher, and how they both spent most of last evening wading through an ocean of soap bubbles on the kitchen floor, and – hey, folks! – we're all human, right? And isn't that just the cutest story you heard all morning?

After this, Jeanne – a low-fat alternative to Tammy Bakker – asked the audience if any of them had bought Uncle Henry's sweet new book, *Hugs*. When only four people raised their hands, Jeanne chided them and said, 'Now, y'all got to get a copy of Uncle Henry's new book and record album before you leave.'

Bob came in here: 'And y'all got to get a copy of *our* new album before you go. And if you want to buy two tapes, we've got some right here by the stage. And after the show, we'll sell you two for $15. That's a three-dollar saving on what you'd pay in the bookshoppe over there on the Grand Hotel Main Street.'

More discount offers. Everyone connected with the PTL Club acted as if they were up for sale and going cheap.

Bob now got down to 'ministering': 'Okay! We're going to sing you a couple of songs. Don't exactly know what we're gonna sing, 'cause you can't programme the Holy Spirit! Isn't that right, honey?'

'You bet!' Jeanne said, picking up the cue. 'And, you know something, folks. A lot of people only saw the turmoil here last year. But we've recently been in some planning meetings, and we predict some exciting times ahead for this ministry. Yes, we do. Because we're soon gonna cross over to the Other Side!'

With that, Bob hit a cassette player and we got a blast of bossa nova music and, as the audience clapped in syncopation, Bob and Jeanne belted out a song about 'Going to the Other Side' with Jesus in their boat and the knowledge that He will never fail them; that God's gonna see 'em through. Considered in the light of recent events, this song sounded almost defiant. So too did Bob's up-tempo patter before the next song:

198

'We're gonna minister the word of Jesus Christ! That's our goal! That's what the new ministry is all about! And lemme ask you something: have any of you ever been disappointed by Jesus?'

The crowd roared, 'No!'

'Have any of you been made sick by Jesus?'

Another roar of 'No!'

'Have any of you had your finances hurt by Jesus?'

More of same.

'None of you have ever had anything bad done to you by Jesus! You know why? 'Cause it's Satan who's the guy who dumps all that bad stuff on you. I mean, who do you think brought you to this hotel today. That's right. . . *Jesus*! He brought you here instead of sending you to another hotel which knows nothing about Jesus. So let's all stand and let's all say that name – *Jesus*. And let's all say, "We have the power to push Satan under our feet." '

Everyone was on their feet and everyone was repeating what Bob told them to repeat.

'And while we're saying that', Bob said, 'let's lift our feet and march right on top of Satan. Step on him real good.'

One hundred adults – most of whom were in the evening of their lives – suddenly began to stomp wildly up and down, grinding Satan into the plush red carpet of the Heritage Grand Hotel foyer. As they joined in a song called 'We'll Not Be Defeated Anymore', I looked around and saw nothing but shining faces. They loved this 'activity'. Especially since, after a lifetime of struggling to make ends meet – of attempting to stay afloat on middling incomes in an acquisitive society – they were well acquainted with the forces of Satan. For Satan – as Bob described him – was the evil dude who made you default on your car payments. Satan was the evil dude who gave you kidney stones or prostrate troubles. Satan was the evil dude who kept you puffing away on 40 Lucky Strikes a day. Satan was, in other words, the underlying cause of every deficiency or trauma in your life. Yet here – in the company of fellow Christians – you could sing songs about not being defeated and you could tramp upon your cigarette addiction, your bad debts, your urinary tract problems, and momentarily convince yourself that, by accentuating the positive (i.e., your faith in Jesus), you could overcome all your failings, all your hassles. And watching all those ageing couples do the Satan Stomp, I realized that Heritage

USA wasn't just a make-believe theme park; it was also a land of spiritual make-believe as well.

When the congregation finished goose stepping upon the Devil, Bob introduced the man who was struggling to ensure that this ministry would not be defeated. . . the man who was the new president of the *new* ministry which was rising phoenix-like from the rubble of the old PTL . . . ladies and gentlemen, will you give a big welcome to Brother Don Edwards!

Brother Don was all jowls. Brother Don had a hefty chandelier of flab overhanging his waistband. Brother Don did not look healthy. And Brother Don openly admitted that he wasn't healthy when he told us a bit about his background. He was a former executive with the Ford Motor Company, who did a 24-year stint in their budgeting and financial division before taking early medical retirement because, 'I have a blocked heart. I am a *pacemaker dependent.*'

Brother Don also lived on the grounds of Heritage USA, with his 'lovely wife, Betty'. And Brother Don was a Christian witness. He loved the Lord. So much so that he'd come out of retirement to try to make the new ministry succeed.

'I've been in business all my life,' Brother Don said. 'As far as I'm concerned, the harder the business problem, the better. And this is the hardest business problem I've ever encountered.'

He then explained that, since the 'trouble' happened, the PTL organization had gone through six different administrations in the past 13 months. And the new master plan for the future of this corporation was as follows: the amusement park side of Heritage USA was being sold off, and six different financial consortiums were currently bidding for its assets – including one headed by a certain Jim Bakker, who'd submitted a letter of credit for $100 million from an offshore financing source as part of an offer to buy back his baby. (Brother Don, however, didn't think the reverend's bid had much hope of succeeding, since there were quite a few 'legal and other impediments to his proposal'.) Now, though the theme park was being sold off, a new ministry (which Brother Don was in charge of) called Heritage Ministries Inc had been created out of the past ministry, which had now been declared bankrupt. And this new ministry was being created with zero assets and zero liabilities. A clean slate. And they'd lease, on a month-to-month basis, the television studios and the church on the grounds of Heritage USA and begin once again to 'minister the gospel of Jesus Christ and Him alone through television'.

There was a catch, though. The judge administering the bank-ruptcy proceedings had stated that the new ministry would have to raise the necessary operating costs of $60,000 per day to keep their new television programme on the air. If they didn't make that figure, they'd be wound up – which is why Brother Don was calling this new ministry the toughest business challenge of his career. Still, he remained devoutly optimistic about the future:

'We have a great opportunity to show the world that we want Christian television. So let's be encouraged. Let's be inspired. Let's raise our contributions. Let's be part of the gospel message of Jesus Christ. Have a great day.'

Big applause greeted Brother Don's departure from the stage. Jeanne returned to the microphone. She looked *moved*:

'I don't know if you know the dangers of being a *pacemaker dependent*,' she said. 'But I tell you, Brother Don is giving us the best years of his retirement. And when he talked to us just now. . .' (her voice began to break and the mascara began to run) '. . . I really felt Brother Don's *caring* love toward us all. And his hope. 'Cause, you know, I've been prayin' real hard through all this turmoil, and God has not told me to sell my house. Or to look for another job. God wants me here.'

More tears. I decided it was time for a break. So I rambled over to the payphones, with the intention of booking a room for the night in a local hotel (as the Heritage Grand Hotel was somewhat out of my price range), but all the phones were occupied for the moment, so I dropped myself in a nearby armchair and shuffled through some notes. Then I heard a voice addressing me:

'Bet you're a reporter.'

I looked up and saw a woman in her mid-forties seated in an armchair opposite me. She was overweight, she had a bad squint in her right eye, she wore stretch pants and a polyester blouse, she spoke with a flat Midwest accent.

'Bet you're a reporter,' she said again.

'Not really,' I said.

'I've seen your type round here before. Bet you're writing something about Jim and Tammy.'

I said nothing.

'Hey, I'm not challenging you or anything', the woman said. 'I'm actually glad to see you here. 'Cause the more that's written about what's happened to this place, the better.'

'You work here?' I asked.

'Used to,' she said. 'Was a clerk in the administration department. Been laid off. Me and 1,600 other employees. I'm waiting around, seeing what's going to happen next.'

I asked her if she could afford to wait around. She barked a bitter laugh. 'I can afford *nothing*,' she said. 'But I can't afford to leave here either, 'cause everything I've got is tied up with this ministry. So I got to wait around – 'till I see what God really wants to do with this place.'

Her name was Marcie, and up until five years ago, she'd spent her entire life in St Louis. In fact, she'd always lived with her parents, having never married. And, up until five years ago, she'd also spent her whole working life in the same job – as a bookkeeper for a local removals company. It was, she said, a pretty routine life, which was given definition by the PTL Club. From the moment she first tuned in to the show in 1978, she was afflicted by a serious *amour fou*.

'I really fell in love with Jim and Tammy when I first saw them on television,' she said. 'And I really fell in love with their ministry as well, because it was all about love and serving the Lord and stuff like that.'

So she became a PTL Partner, forking out $22 a month for the privilege of being a member of the Jim and Tammy Club. But, over the years, as her passion for Jim and Tammy deepened, she knew that simply watching PTL wasn't enough of a commitment to this ministry of love. And it became her dream to one day move to Heritage USA and work for Jim and Tammy.

That dream came true in 1983, when she had a falling out with her new superior in the removals company's accounts department. This row, she decided, was God's own way of calling her to Fort Mill, South Carolina – and that's when she wrote to the PTL organization, asking for a job. They wrote back, telling her not to apply for work in advance, but to first move to Heritage and then seek employment with the ministry.

'I knew it was a big gamble', Marcie said, 'but I decided to "step out in faith" and take the risk.' So, she gave up her pensionable job and she convinced her retired parents to sell their house in St Louis and buy a new place in one of those fancifully named housing developments on the grounds of Heritage. That was June of 1983. Two months later, God answered her prayers when she landed a job as an office clerk with PTL. A job which paid her $150 a week – a meagre wage, barely enough to live on. But though Marcie knew that the money was paltry, this fact didn't bother

her because she'd gotten her dream – she was working for Jim and Tammy.

Though she was now employed by the Bakkers' ministry, she still paid her $22 a month tithe as a PTL Partner. And when Jim pleaded with the faithful to donate additional funds for special projects, Marcie always tried to do her bit. When Jim asked the Partners for $1,000 each to build new television studios, Marcie stepped out in faith and wrote a cheque. When Jim asked the Partners for $1,000 each to build the new Heritage Grand Towers Hotel, Marcie stepped out in faith and wrote a cheque. When Jim asked the Partners for $1,000 each in exchange for a Heritage USA 'Silver Membership' (which essentially entitled the donor to free entry to all Heritage events where admission was charged), Marcie stepped out in faith once again and wrote a cheque.

Altogether, she donated around $4,000 dollars to Jim Bakker's ministry – 'that's like $4 million to someone like me, who only earned $7,800 a year here', she said. And therefore, when 'Jim's sin' was made public, she was devastated – especially when she learned about the cash paid to keep Ms Hahn's mouth shut.

'My first reaction was, how could they do that? How could they mismanage all that money? I mean, it hurt. It really hurt. You give $22 a month for seven years, plus a couple of thousand dollars on top of that, and what do they do with it? They use it to pay hush money for a minister's sin. And now, there are a whole group of people who want that minister back. Well, I think that's wrong. It's not that I don't forgive Jim his sins – I do forgive him. It's just, him coming back isn't going to get this ministry started again.'

But was it worth hanging on, hoping that the new ministry would be able to keep Heritage alive, let alone employ her?

'Like I told you, I got no choice but to hang on. Got no money, for starters, since I got no unemployment benefit when I was laid off. And I'm surviving on the bit of pocket money I get from my parents – who're both living on pensions, which means they don't get much money either.'

'How about getting a job in Charlotte and commuting?' I asked. 'There must be a lot of work available there.'

'There is, but I don't drive,' Marcie said. 'Which means that I'm real stuck here. But – like I told you – I feel that I was called here. Just like a lot of people felt they were called here. And we stay because we love the place.'

'Is it worth such love?' I asked.

'Of course it is', Marcie said. 'Because I know if I leave, then the Devil will have triumphed. And I'm never going to give in to Satan.'

On the other side of the foyer, Bob and Jeanne finished singing another song. And then Bob's voice boomed over the loudspeakers, reminding everyone that it was now time for the Morning Offering:

'I tell you, folks – I love giving. And every time Jeanne and I can write a cheque, it gives me a thrill. How many of you believe that God loves a cheerful giver?'

I took a ride on the Heritage USA tour trolley. The driver-cum-guide for this journey was the original Mr Cheerful, who told terrible jokes:

'On your right is the Heritage USA general store,' he said. 'That's where we sell generals.'

He also talked in a camp counsellor patois:

'Now let's all turn around and introduce ourselves to our neighbours.'

My neighbours behind me were a retired couple, Ben and Ellie Webber from Lexington, Kentucky.

'Know Lexington?' Ben said. 'Home of fast horses, fast women, and good bourbon.'

'Now, Ben. . .' Ellie said.

I immediately decided that Ben Webber was very good news. He told me he'd been a hotel chef for 35 years, but since he'd stopped working, he and Ellie had been knocking around the country in their camper van.

'We dropped down to Heritage, 'cause we were already in North Carolina, so we decided to see what all the fuss was about,' Ben said. 'Now – as you may have gathered – I ain't the religious type, but I got to admit this is a mighty fine place. Mighty fine place indeed. The man did one helluva job getting it all together. Pity he couldn't keep his ding-dong to himself.'

'Now, Ben. . .' Ellie said again.

The driver came back on the tannoy, saying, 'Right, folks, let's introduce ourselves to someone else.'

'Hi, there!' said one of two middle-aged women sitting in front of me. 'We're Judy and Claire from Tampa, Florida. Where you

from?' I told them. 'You came all the way from London to visit Heritage USA?'

'Not exactly,' I said.

'Are you a Christian?' Judy said.

'Not exactly.'

Judy reached into her handbag and handed me a small printed leaflet. 'You must read this', she said. I did as I was told. The leaflet was entitled 'A Love Letter', and it read:

Dear Friend,

How are you? I just had to send a note to tell you how much I love you and care about you.

I saw you yesterday as you were talking with your friends. I waited all day, hoping you would want to talk with Me also. As evening drew near, I gave you a sunset to close your day and a cool breeze to rest you – and I waited. You never came. Oh, yes, it hurts Me – but I still love you because I am your Friend. . .

I know how hard it is on this earth; I really know! And I want to help you. I want you to meet my Father. He wants to help you, too. My Father is that way, you know.

Just call Me – ask Me – talk with Me! Oh, please don't forget Me. I have so much to share with you!

All right, I won't bother you any further. You are free to choose Me. It's your decision. I have chosen you, and because of this I will wait – because I love you!

Your friend,

Jesus

'If you need a new friend, you know who to turn to,' Judy said as I looked up from the pamphlet.

'I'll keep that in mind', I replied, as the trolley lurched down a small tree-clad road and the driver came on the tannoy to call our attention to a hefty pair of satellite dishes berthed in a field near an administration building. These satellite dishes, he said, could transmit a television signal 24,000 miles up into the atmosphere and back down again within a quarter-of-a-second. And wasn't that a miracle of technology, campers? Especially since the PTL Inspirational Network had put the dishes to such good use by reaching millions overseas with their inspirational programme.

In front of me, Judy and Claire and several other passengers extended their hands towards the satellite dishes, as if they were

trying to absorb their spiritual waves. The driver continued with his on-the-road narrative:

'Now on your right, you'll see a little pond we call Lake Galilee, where a lot of folks come to fish or make a retreat. And on your left, you'll see a big pagoda-like building over there. That's the World Outreach Centre – which is the main administrative office building for the ministry. And if you were to fly over that building and get an aerial view of it, you'd see that it was shaped like a Star of David.'

'Well, I'll be a som'bitch,' Ben Webber said.

'Now, Ben. . .' Ellie said.

We passed 'Fort Hope' - Heritage's charity home for street people. We passed places with names like Candy Cane Lane and Christmas City. We passed the childhood home of Billy Graham, which Rev. Bakker had had moved – brick by brick – from its original location in Charlotte. We passed the Avenue of Flags – a boulevard of flagpoles upon which were draped the national banners of all the countries into which the PTL Club was, once upon a time, beamed. We passed Morris the Moose – a 17-foot-high wooden moose, which presumably was supposed to lend an outdoorsy, rustic touch to life at Heritage USA. We passed the Heritage Recreation Village, with its old-style carousel. We passed the Fort Heritage campground – 'fully equipped with water, electricity and cable-TV hookups'. We passed the Heritage Lakeside Lodge – and a 'treetop village' where there was a jacuzzi in every holiday home. We passed the amphitheatre, where a passion play was staged nightly. We passed the television studios and the Heritage Village Church – the main house of worship for the complex. We passed the Upper Room – a reproduction of the original Upper Room in Jerusalem, and open 24 hours a day for prayer and meditation. We passed the Goodie Barn – a gift shop 'full of goodies'. We passed Annie's Hobby Horse, where you could 'make, fire and glaze your very own clay gift to bring home with you'. We passed the Heritage Island inspirational water park – with its giant water slide, its fake rocks, its imported sand; a water park that provided 'fun, recreation, live Christian music, refreshments and fellowship in a wholesome Christian atmosphere'.

In a way, Ben Webber was right: Jim Bakker had done 'a helluva job' creating the world's first Christian theme park. And, whether or not you agreed with Bakker's questionable aesthetic sensibility, you did have to admire the sheer enterprise

and scope of his endeavour. For Heritage USA was the creation of a romantic. And though many outside observers had used the adjective 'Disneyesque' to describe the vision behind it, the interesting thing about the whole set-up was that it was a theme park that craved ecclesiastical respectability. On one level, it was a mass exercise in infantilism; a 'return to childhood' fantasy, tailor-made for a beleaguered silent majority wanting to temporarily escape into an uncomplicated Christian dreamland of goodie barns and inspirational water parks and Morris the Moose. At the same time, though, Bakker had also attempted to create his own godly kingdom, where prosperous Christians lived in cartoonish suburbs like Dogwood Hills, and impoverished on-the-street Christians were given shelter in a modern hostel with the frontierish name of Fort Hope, and where you could pray night or day in a facsimile version of the room where Jesus hosted the Last Supper, and there were satellite dishes big enough to beam broadcasts from this Christian community to anywhere on the planet within seconds.

Piety in Never-Never-Land. Jim Bakker obviously wanted to be taken seriously as an international evangelist in the Billy Graham mould (hence the shrine to Graham himself on the grounds of Heritage USA), but he also wanted Christianity to be Fun; to be a replica of that idealized chocolate-box childhood no one ever had. It wasn't surprising, therefore, that a man with such profoundly disparate visions of evangelical Christianity finally self-destructed so spectacularly. For how could someone with a candyfloss sensibility simultaneously playact the role of the serious spiritual leader? (Could you, for example, imagine casting Jerry Lewis in the role of Brigham Young?) It was as if a Little Boy Lost had built himself the biggest toy shop imaginable, and called it an act of faith. No wonder things fell apart. No wonder Jim Bakker's centre did not hold.

And, no wonder, entrepreneurs like F.D. Franklin were now housed in the all-but-empty offices of the World Outreach Centre, trying to pick up the financial pieces of the ministry Jim Bakker founded.

Franklin Delano Franklin was a businessman – a committed Christian businessman who believed that the Lord had been good to him. The Lord gave F.D. a successful Cadillac dealership in Cincinnati. The Lord gave F.D. a scenic little retirement home when he stopped hawking Caddies a few years ago ('With the money God provided, I bought me a little ten-acre mountain

down here in South Carolina'). And the Lord also gave F.D. the thick gold ring, encrusted with diamonds, which adorned his left hand and which almost had me reaching for my shades whenever the sunlight caught it.

'I've been blessed financially,' he said, 'because I've put to use the talent God has given me as a businessman.'

But now, along with Brother Don Edwards, F.D. had taken on the toughest business challenge of his career. As a voluntary member of the new management team, he was attempting to get the new, improved Heritage Ministries Inc off the ground; 'to save this ministry' - as he put it - 'for America'.

I telephoned for an appointment to see F.D. after being released from the tour trolley, and was told by his secretary to come by straightaway. A few minutes later, I found myself walking through endless empty corridors inside that Star of David-shaped office building. Corridors that had been stripped clean of all desks and filing cabinets and telephones; corridors that resembled an administrative ghost town. At the end of one corridor was a small suite of offices where the new ministry was camping out. Literally camping out, for everything here was still in boxes and the skeletal staff were making do with the few pieces of office furniture that had been left behind. When I walked into his office, F.D. Franklin was on the phone with a colleague discussing a small administrative problem: where to find the money to feed 300 volunteers who were spending the day stuffing fundraising brochures into envelopes for the new ministry. There was simply no cash on hand to meet the cost of hot dogs for the 300 helpers, so F.D. hit on a novel solution: he reached into his own pocket and came up with the $150 needed.

'What's $150 to someone like me?' F.D. said when I complimented him on his largesse. 'Especially since I have received a pretty good payoff from the Almighty over the years.' And because God kept him very much in the black, he wanted to balance the books and do a little quid pro quo action for the Lord. Which was why he was volunteering his business expertise to help Heritage Ministries Inc get launched.

'I tell you, people's lives have been shattered over this whole business', F.D. said. 'Especially with all the layoffs that happened after the old ministry went under. But the judge who's overseeing the bankruptcy proceedings for PTL really wants the new ministry to survive. And the commitment of the people still left here is fantastic. Like it's really beyond belief just how dedicated the

208

folks here are. So it's really gonna be the grace of God and America that's gonna keep us going. And I'm praying real hard that God gives us the wisdom to inspire people to support us. 'Cause the judge has stipulated that we gotta raise that $60,000 a day to meet our costs, and that, son, is one tall order.'

'Can you do it?' I said.

'I personally think we can do better than $60,000 a day', F.D. said, "cause I got faith in God. And I'll let you in on a little secret why I think God wants this place to survive. 'Cause he knows that, in the business world, money talks and bull walks. But here, at Heritage USA, he *really* knows that it's His gospel that talks.'

Jerry Bradlee also believed that God wanted Heritage USA to survive. Where Jerry parted company with F.D. Franklin, however, was on the subject of who should be running the ministry, since Jerry maintained that Jim Bakker – and only Jim Bakker – could keep the whole operation alive. And Jerry – like many other Bakkerites – was convinced that Jim's fall was a set-up by his enemies to bring him down. I mean, that Hahn woman was nothing more than a blackmailer; a real cheap piece of stuff – so why should anyone have trusted her accusations? And Jerry Bradlee said that he knew a predatory type when he saw one, since he was a retired private detective from Las Vegas, Nevada.

Jerry Bradlee was a prime mover behind the BBBs – the Bring Back Bakkers club; a group of Jim and Tammy supporters currently engaged in anti-propaganda activities against the new regime which had taken over their beloved ministry. Besides erecting that provocative billboard – *Welcome Back Jim and Tammy* – on the road to the main gates of Heritage, they also made a point of visiting the Heritage Grand Hotel regularly to distribute leaflets to visitors, encouraging them to shun the new administration and give their love to the *real* People That Love – the Bakkers.

'We want Jim back,' Jerry said, 'because he was given the vision for the PTL Club and Heritage USA through the Lord, and it was because of his vision that he got the financial support to build what the Lord bade him build. I mean, the Scriptures are poured into the concrete of Heritage USA. There's nothing else like it on this earth.'

Jerry Bradlee spent most of his time these days at the BBBs headquarters – a storefront office in a shopping centre a few miles away from Heritage, and positioned right next door to a shop called 'Romance Unlimited'. When I showed up to meet him, he was one of ten volunteers seated at one of several tables piled high with leaflets waiting to be stuffed into envelopes (stuffing envelopes obviously being a popular activity both with the supporters of the new Heritage Ministries junta and with the Bakkerite government-in-exile lurking beyond its frontiers). Photos of Jim and Tammy in happier times covered the walls, along with numerous Jim and Tammy books which Jerry's wife, Josie, foisted upon me when she heard why I was in the locality.

'I want you to go back to London,' Josie said, 'and tell everyone that we forgive Jim Bakker, and that we don't believe an incident which happened years ago should have brought down a ministry of love like the PTL.'

Josie's voice broke a little when she made that last statement. It was hard to talk about 'the tragedy' and not cry, she said. Everyone else in the room agreed with her. And like Josie and Jerry, the other Bakkerites were largely men and women in their sixties and seventies who had formed a deep and abiding bond with the PTL ministry over the years, and had bought retirement homes in Dogwood Hills and Mulberry City in the hopes of spending the rest of their days in the ever-upbeat company of Jim and Tammy.

'I had my own very lucrative business in Vegas, before Josie and me decided to retire here,' Jerry said. 'Used to be a private investigator and marshal. Did a lot of leg work for law firms. When they needed someone to serve papers, I was the guy they called. Could be dangerous work, but faith in God and a gun kept me steady. And Josie and me always watched Jim and Tammy. Started coming here soon as Heritage opened. And we both decided to retire here and work in the ministry as volunteers. So, we sold our house back in Vegas – made quite a nice half-mil profit on it – and bought a real nice Williamsburg Colonial in Mulberry City. No regrets about coming here. No regrets about all the money we tithed to the ministry, 'cause we know that Jim Bakker will be back.'

There was spontaneous applause amongst the other Bakkerites.

I said, but how do you respond to the fact that Jim Bakker was now under investigation by the IRS and the Justice Department

for allegedly defrauding his 'partners'. The BBBs responded by suddenly shouting answers to my query all at once. I had obviously touched the rawest of Bakkerite nerves. Finally, over this din Jerry said, 'We all believe Jim ran his ministry completely above board.'

Another woman in the group shouted, 'Jim Bakker never deceived me. And I know that God's gonna get the ministry back for him, because Jim believes in paying his bill.'

And the accusations that Bakker's sexual misconduct extended beyond his one-night stand with Ms Hahn? 'Lies!' the Bakkerites said. Jim would never engage in such sin. Jim was a truly Christian man.

'You've got to understand that the reason we're so fiercely loyal to Jim and Tammy is not just because we love 'em', Josie said, 'but also because of a pact we all made with the Lord to support this ministry.

'And I'll tell you something: Jim and Tammy built their ministry around two four-letter words.'

'What are they?' I asked.

'*God's love.*'

<div align="center">****</div>

That night, there was a Camp Meeting in the Heritage Village Church. The church was actually a huge auditorium, with folding chairs and a simple stage – real early secondary school. There were only around 200 souls in this enormous meeting hall. It looked empty, it felt empty. A quartet of singers filed onstage – two men in blazers with unfortunate moustaches; two women in frilly pink below-the-knee dresses. Their spokesman came to the microphone, looked out at the rows of empty seats and said, 'We are not entertainers; we are warriors for Christ. And this is a Camp Meeting. You can do what you want. Stand. Sit. Clap. Shout out praise if you want.'

But while this quartet worked their way through a tune actually called 'Praise', nobody stood, clapped, or shouted out praise. Instead, they sat there in silence.

The congregation perked up when a preacher named Hal hit the stage. Green blazer. Green shirt. Light green tie. The green-on-green look.

'Hey, I love Jesus and I'm glad you're here tonight', he said. 'I'm Hal Morgan and these are the Praise Him Singers from Muncie, Indiana, so let's give 'em a big hand. . .

<div align="center">211</div>

'Now, who was at my seminar today?'

Around 30 hands shot up.

'Now I want all those folks to turn to their neighbour and say, "You really missed something!" '

On cue, these 30 souls turned to their neighbour and said, 'You really missed something!'

'And what did you learn in my seminar today?' Hal said.

In unison, they stamped their feet and bellowed, 'Stand firm!'

'And if the Devil tempts you?' Hal said.

'Stand firm!'

'That's right! Stand firm!' Hal said. 'And when you stand firm, you're on the brink of a miracle!

'And speaking of miracles. . . you know, folks, I'm from Indiana. I don't work for PTL, so I don't have to say this, but. . . I *love* this ministry. I really do. But folks, this ministry only received $3,000 in contributions in the mail the other day, and it needs $60,000 a day to keep it growing. And God wants it to *grow*. So, remember, it's not how much you give – it's how much you've got left.

'Now let's pray and talk to the Father quickly. And then I want you to turn to somebody and say, "Behold, God is my salvation." '

I could take no more; it was time to make a fast and permanent exit. But as soon as I hit the pavement outside the church, it began to rain. Typhoon-style rain. The kind of rain which is so frenzied, so dense that the world appears drowned. I stood there, waterlogged, unable to see where I was anymore. It was as if the Flood had finally arrived. To wash Heritage USA away.

I wanted to get lost; to put a few counties between myself and the remnants of the People That Love. So I took off for the Carolina hinterlands; the real backwoods centre of the state. To get there required some hard driving on roads that were predominantly two-lane blacktops; narrow, meandering by-ways along which the signs were frequently hand-scrawled and announced local sporting events like this Sunday's Coon-Dog races. Or posed philosophical questions like: *Who Woke You Up This Morning?. . . Jesus!* Or simply announced that you had just passed through a hamlet called Apex.

As I tooled along Route 64, a crooner on some nearby country music station was singing a lament for the late, great Buddy Holly: 'Buddy's singing for God now. . . up there in the sky.' Up ahead was an 'unincorporated' town called Complex, beyond which was a stream with the name of Sweet Water Creek. It was a world of shotgun shacks and decrepit trailers, this parish; of 15-year-old cars and rusted discarded vehicles with grass growing out of their bonnets. I pushed on, sauntering down an empty, virginal road with swamp on either side until I saw a tiny white Church of God set back from the road, with a trailer parked next to it (presumably acting as a presbytery). A few crippled cars were parked out front – a hint that a service was in progress. So I pulled over and wandered into a curious scene.

The church was a six-pew church, with beauty board on the walls and a supermarket tapestry of the Last Supper behind the simple altar. The ceiling couldn't have been more than eight feet high, making this house of worship a claustrophobic's nightmare. And the congregation – all 12 of them – were deeply redneck. There were two girls for whom the word 'fat' would have been a compliment, since they had long since gone beyond the obese point of no return. There were two old guys with big red faces and thoroughly malevolent eyes. There were two jailbaity teenagers, snapping gum. There were a couple of tough, leathery-skinned women who looked like they'd experienced and survived a great deal of life's innumerable deprivations. There were two Down's syndrome children. And up on the altar were a pair of guys with guitars, who were supposed to provide musical accompaniment. The problem was, they couldn't play their instruments. They simply strummed discordant chords while a young woman stood at the pulpit, screaming hymns at the top of her lungs. There was no evident structure to the service. She bawled one hymn, while the guitarists played a different tune entirely, and the congregation shouted whatever they felt like shouting. Then the reverend in charge – Brother Pete – would step up to the pulpit and go berserk.

'Who gonna pray wit me?' he roared. 'Who gonna feel presence o'Je-*sus* here tonight? I feel 'em! I feel 'em!'

Brother Pete was a big stocky man, with grey Brillo-pad hair, a faded waistcoat, a frayed shirt and tie, and only two fang-like front teeth still resident in his mouth. As I quickly discovered, Brother Pete wasn't an advocate of quiet meditation when it came to communing with the Almighty. Instead, he would hoot and

213

howl and provoke the congregation into hooting and howling with him. It was electric, all this mutually induced hysteria. And when it momentarily died down, Brother Pete would then ask his flock who needed prayer. One woman requested that he pray for her sister, who had been in remission from cancer, but was getting weak again. So Brother Pete went into action, initially muttering an invocation that became one long caterwaul. Everyone else began to wail or cry out whatever came to their lips, while the guitarists kept strumming wildly dissonant chords. Suddenly, Brother Pete's body went into spasms, as if he'd been taken over by some external force, while directly in front of me one elderly woman went into near convulsions.

This wasn't simply raw, unbridled spiritual insanity; this was a free-for-all. And though its beyond the pale dementia made my flesh creep, there was, at least, a frenetic honesty to the faith on display. This was no gimcrack Heritage USA camp meeting; this was elemental upcountry Pentecostalism as still practised in forgotten swampy corners of American poor white-trashdom like this one. I had stumbled upon the outer limits of godly worship. I had stumbled upon a New World.

The elderly woman kept convulsing; Brother Pete kept convulsing; the rest of the congregation kept convulsing. Nobody noticed when I slipped out of my pew and got back on the road.

I went west. Over 900 miles west, from North Carolina straight across Tennessee before crossing the Mississippi River into Arkansas. A 17-hour drive west, with frequent stops for coffee, food, juice for the Mustang and more coffee. Driving 900 miles in one go requires a lot of coffee and a lot of loud radio. And a lot of old bluesy songs like:

> *You can steal my best chicken,*
> *But you sure can't make her lay.*
> *You can steal my best woman,*
> *But you sure can't make her stay.*

There was no real need for me to drive 900 miles non-stop. In fact, when I set off from Charlotte in the early morning, the idea was to cover that stretch of territory in two days, with a

motel stop-over en route. But once I got myself caught up in the clutches of the interstate – the Mustang's Cruise Control locked into a steady 65 mph – I quickly succumbed to that peculiar mental numbness which accompanies all long stints on the highway; a numbness I was well acquainted with after months on the move. For an American interstate is like a long monotonous corridor – you point the car, you go. You blare the radio. You sing along with country heartbreak favourites like 'I love you. . . but I'll walk before I crawl.' You pull into a truck stop in Crab Orchard, Tennessee, where you hear one ole boy tell another ole boy, 'Shoot that coon Jesse Jackson if I could'; to which his buddy replies, 'Shit, you don't wanna do that, 'cause we don't need 'nother public holiday.' You drive on, crooning along with more Nashvillified marital crisis songs ('We hardly talk and we never touch no more'). You listen to a disc jockey introduce a record as, 'Bobby's second big hit since his release from incarceration'. You pass a car with a bumper sticker, *Clean Up the South: Buy a Yankee A Bus Ticket.* You look at your mileometer. You note that you've already clocked up 400 miles. You think, 'what's a couple of hundred miles more?' So you push on – and, as light recedes, you cross into Arkansas to the sound of a Bible Belter talking about 'the wonder working power in the Blood of the Lamb' as if he were advertising a laundry detergent. You drive straight across the state, keeping yourself going on truck-stop coffee and a heavy metal radio station which is broadcasting a two-hour salute to Motorhead – a band which sounds like a demolition site, but which is so loud that you're in no danger of dozing off at the wheel. And finally, at nearly two in the morning, you pull into the town of Fort Smith and collapse into the first motel you can find, having chewed up a significant piece of American geography in just under a day.

'Nine hundred miles in a day? Herb Shreve said when I told him about my North Carolina to Arkansas jaunt. 'Sounds like light stuff to me. Then again, you're talking to a man who's clocked up around a half-million miles on the roads in these United States, so 900 miles ain't a lot of territory, if you know what I mean.'

Herb Shreve was a Baptist minister. A very unlikely looking Baptist minister, since he was decked out in denims, black

cowboy boots, a black leather jacket and a black belt adorned by a big chunky Harley Davidson buckle. The belt buckle said it all: the Rev. Herbert Shreve was a biker. A Christian biker, and the head of the CMA – the Christian Motorcycle Association, who lived by the motto, *We Ride for the Son*.

I'd first heard about the CMA from a guy I knew who was a lecturer in religion at Columbia University in New York City. He was something of an authority on the quirkier side of the Bible Belt and mentioned – before I began my journey – that if I happened to find myself in Arkansas I should check out a Christian motorcycle gang that operated out of a little town in the Ouchita Mountains called Hatfield. So, before heading west, I called directory enquiries for Hatfield, Arkansas, got the number for the local cop shop, rang the police and asked if they happened to have a Christian motorcycle gang in the vicinity.

'Ain't no gang', said the desk sergeant on duty. 'It's an *a-ssociation.*' Then I heard him turn to some colleagues and say, 'Any of you got Herb's number?', and that's how I made contact with the Rev. Shreve.

'Sure I'll talk to you', Herb said when I phoned him to ask about setting up a meeting. 'Warn you, though, we ain't no Hell's Angels or anything like that. Had a reporter here recently from *Rolling Stone* and he was one disappointed fella, 'cause he thought we was gonna be some outlaw outfit. But what he discovered is that we mainly talk two things: tyre dirt and Jesus.'

Hatfield, Arkansas (Pop. 410) was a 90-minute drive south from Fort Smith along a hill-skirting road labelled Route 71. It made for compelling driving, not simply because it brought me through the Ouchitas – a gentle, low-lying, heavily timbered range of mountains – but also because it landed me smack in the midst of a new geographic region. Arkansas was still ostensibly a Southerner, but with Texas and Oklahoma in the vicinity – not to mention towns within the state itself that bore such aromatically frontierish names as El Dorado and Texarkana – there was a decided whiff of the Southwest in the air. And Route 71 brought me straight into stetson and shit-kicker boot country: gangly looking dudes driving pick-up trucks, the occasional cowboy outfitters, the occasional sighting of a string tie, and lonesome little towns like Y City and Acorn and Hatfield which possessed that sawdusty lethargy of last chance saloons.

216

Hatfield wasn't exactly a looker. A blink- once-you-miss-it Main Street and a collection of hang-dog frame houses which needed a collective white-washing. Herb Shreve's house was located on the side of a narrow hilly road: a simple wooden A-frame structure, with an unapologetic crash pad feel to it: the home of someone who spent much of his time on the road and cared more about flop-out comfort than the virtues of prim house-proudness.

Herb was a big, muscular man on the edge of 50: a guy who could obviously fend for himself if placed in a tight corner; a guy only a first-class fool (or a masochist) would want to pick a fight with. His wife, Shirley, was an attractive, yet frail woman who had been tragically stricken with multiple sclerosis several years ago. When Herb first started his motorcycle ministry, Shirley and he would bike around the country together. But since her illness, they'd taken to travelling in their own motor home and towing Herb's bike behind it – though I gathered that Herb was having to spend an increasing amount of time on the road without Shirley, as she was now so weak that she needed a small motorized golf caddy to get around the house.

When I showed up on their doorstep right after lunch, Herb had just gotten out of bed, having pulled in at five that morning after an all-night journey from a cycle rally in Sherman, Texas – a mere 350 miles down the road from Hatfield. A spitting distance sort of trip for Herb and his 1988 Harley – 'my cross-country cycle', as Herb called it, 'and the one I use for ministering the gospel of Jesus Christ. Though I also got me a 110 hp Kawasaki, which is kinda my play toy.'

Ever since he'd been a kid, Herb had always had two great loves: fast vehicles. . . *and* the Lord. He'd been saved when he was eight years old, while listening to his mother (a serious Baptist) witness a neighbour at home in their house. 'I was in another room at the time', Herb said, 'but I could hear what my Momma was saying about Jesus and eternal salvation, and I felt a love then that I'd never felt before.

'Still, I never really intended bein' a preacher. Really had my heart set on fast cars. And my number one dream was to compete in the Indie 500. Or, if I couldn't make it in car racin', then to play pro baseball. Was a pretty good second baseman too. Played while I was a student at Ouchita Baptist University. But I started preachin' at the university too. First sermon I ever gave was on a Thursday night in February of 1952 – remember it was about "Soul Winning". After that, I preached a sermon a day for the

next 23 years. Preached all over the South during those years. Preached in churches, in open-air revivals, on street-corners – anywhere I could find someone who'd listen to me, I'd preach. 'Course I was always considered a rebel by my denomination, who I had a lot of fights with. Weren't really used to my style of doing things.'

Nor were they used to his predilection for fast cars and fast horses. In fact, while being a Baptist pastor, Herb and his son trained horses for speed events. 'But my son started losing interest in horses, started getting real excited about motorcycles. And since I was pastoring all over the place and away a lot, me and my son grew apart. So, one day, deciding it was time we tried to get close again, I bought us a pair of Honda 450s – that's your basic economic cycle, which is still big enough for cross-country travel. Now, I got to tell you that I really didn't like motorcycles back then. Thought they were real dangerous. Fact is, until I bought them Honda 450s in 1972, I'd never even *sat* on a motorcycle, so it was a whole new world to me.'

Herb took to this whole new world of biking with amazing speed. And a few months after his first ride on a Honda 450, he and his son took off for a motorcycle rally in San Antonio, Texas. 'Hopped on our bikes and went on down there, stopping at churches en route. Thing was, we was rejected by most of the church folk we met, 'cause we were on bikes. Most pastors wouldn't even talk to us. So, when I got to the San Antonio rally and saw all them bikers there, I started doin' some witnessin'. I'd listen to bikers talk about their businesses, their families, and about how nobody gave a damn about their needs. And that's when God suddenly spoke to my heart about doin' something for bikers – 'cause they got hurts just like we all do.'

A year after the San Antonio revelation, Herb founded the Christian Motorcycle Association and had a friend draw up the 'colours' (or emblem) for the association – a bible held in open praying hands – since bike gang etiquette states that you can't ride the roads en masse as a motorcycle organization without a set of colours to identify you as friend or foe. And, luckily enough, the guy who created the CMA colours also edited the BMW Road-Rider association magazine. And Herb placed a classified ad in that newsletter about his new association, and letters enquiring about membership came flooding in.

That was 1974. Now, 14 years later, the CMA was an evangelical organization of consequence, with 28,000 members in

300 chapters nationwide. The evangelical office was here in Hatfield, while the association's financial affairs were handled in a 'fully computerized office in Levelland, Texas'. What's more, besides Herb and his son, Herb Jr, they also had eight full-time evangelists on the road who travelled to rallies and spent time trying to convert gang members. But the CMA wasn't just an American-based outfit – they had foreign missionaries as well.

'We just did a big "Run for the Son" fundraising event to buy 30 motorcycles for a bunch of preachers down in Guatemala who live in rural districts and have to pastor five or six churches spread out over a big area. And when one of our members – who's been doing a lot of missionary work for the CMA down in Central America – told us about these preachers having to walk a lot of miles to minister to folks, well. . . we decided to help 'em out and get 'em a small bike to ride. So that's when we organized a fundraising weekend. And Herbie Jr is flying off to Guatemala himself later in the week to personally deliver the bikes, and the guy who heads up our video departments is going along as well to film the presentation.'

Video departments. . . computerized offices. . . Guatemalan missionaries – the CMA was certainly no bush-league operation. Yet its annual budget was only $400,000 – all raised through private benefactors – and Herb only took $35,000 a year for his salary: a rather modest sum, when compared to the $1.6 million income that Jim and Tammy were pulling down before The Fall. But Herb Shreve wasn't in this game for the money. Like Calvin Millar in Montgomery, Alabama, he too was an itinerant evangelist in love with the romance of wandering a promised land, saving souls.

'The CMA believes in *total evangelism* – in living the Christian life. Walking the Christian walk. Preaching the good news. Winning converts to the Lord. And most of our membership are professional folk – doctors, lawyers, businessmen – who get on their motorcycles at the weekend and become bikers. Still, we've had quite a few converts from Outlaw groups. And we work the three big annual Outlaw rallies in the US – in Sturges, South Dakota, in Daytona, Florida and in Loudon, New Hampshire. Fact is, we always have a big presence at each of these events. And Outlaw gangs are not as hostile to us as you might think. Like the Hell's Angels are rough, but they're a lot easier to get along with than some of the younger gangs – nasty folk like the Banditos and the Dirty Dozen – 'cause the Angels

don't have much to prove. And they'll frequently call us if they need our help for a funeral or some kind of preaching work like that. And we're always happy to oblige. 'Cause it don't matter to us if a biker wears Outlaw colours or not. What does matter is getting that biker to know the Lord; getting him to understand that without Jesus they can be victimized by Satan without even realizing it.

'But, you know, soul winning ain't hard. Like most motor-cyclists got some rebel in their heart. I mean, they wouldn't be riding around on two wheels if they didn't. And if you can show 'em how the Holy Spirit can meet a need in their lives, they'll open up and allow you to share Christ with them.

'That's the thing about the CMA – we're an inter-denominational motorcycle club. We don't care what evangelical church you belong to – all we care about is the Holy Spirit. And the road, of course. We all love the road. I've biked through every state in this country, 'cept Hawaii. Even ridden up the Alaska Highway. And even though I've had open-heart surgery twice, I still love the road. Like next week I'm off to a rally at Sipipu, New Mexico, and after that I'm headin' up to another event in Cody, Wyoming.'

Listening to Herb Shreve was like listening to an old-time pioneer who considered the ethereal adventure of a communion with God to be synonymous with the actual physical adventure of the American continent. For in this land of reinvented lives – where the road always held out the prospect of change, of remaking oneself anew – didn't all journeys touch upon questions of belief and personal renewal? Wasn't so much of American life caught up with the idea of chasing happiness, and possessing the freedom to turn one's very existence inside out in order to strive for that slippery customer called contentment? And therefore, didn't the road itself become a symbolic tabula rasa down which a new, improved you could be found? And in this elusive search for some measure of inner peace, hadn't many travellers discovered that 'being saved' was a form of spiritual road movie which held out similar prospects for personal rejuvenation and serenity? Wasn't the romance of the road a romance of faith as well?

Herb Shreve thought so. Picking up a bible and a Rand McNally Road Atlas of the United States, he said, 'These are the two Scriptures I live by. These are the only two Scriptures you need to travel God's country.'

CHAPTER 7

In the Valley of the Shadow

★★

It is a wooden chair with a high back; a rugged, no-nonsense chair with a substantial set of arms adorning its two sides and a narrow plank acting as a crude headrest. At first sight, it almost looks like a bare, elemental throne. Maybe that's because it's usually located on top of a small platform or positioned behind glass, giving it a certain aura of authority; a sense of terrible majesty. Leather straps adorn its frame: straps to hold down its occupant's arms and wrists, his chest and thighs, his ankles and legs. A surfeit of straps designed to keep its temporary tenant securely tethered to its varnished chassis. For this is a chair designed for a traveller who is being sent on a final great adventure: a wild two thousand volt ride into the ultimate wilderness.

Heavy cables are the conduit through which he will be dispatched to this new frontier. Once he has been firmly battened down in preparation for take-off, these cables will be attached to metal plates which, in turn, will be lashed both to the shaved crown of his head and to one of his ankles. Beneath these plates will be some form of moist spongy material, sufficiently waterlogged to guarantee that a current of electricity will pass through his body with ease – as these electrodes and cables are wired to a generator in an adjoining room. And after a leather hood or mask has been placed over his face – and an overhead fan has been turned on – a switch is thrown on the instrument panel of the generator. At that moment, two thousand volts of electricity are blasted into the prisoner's body and he is thrown forward against the restraining straps. As the charge continues for two straight minutes, the occupant will lose control of all bodily functions and may defecate or urinate or vomit blood. At the same

221

time, his skin will change colour, his eyes will bulge grotesquely (hence the use of a mask over his face), flames may erupt from the electrodes attached to his head and ankle. An aroma of burnt flesh will always be discerned when the power is switched off and there is a five-minute wait while the overhead fan extracts the stench from the execution chamber and reduces the heat of the prisoner's body. When this time elapses, several doctors enter the chamber armed with stethoscopes. After listening to his stilled heart, they pronounce the man dead.

Or, at least, they should pronounce him dead. Quite frequently, the initial two-minute jolt fails to kill the condemned prisoner and further charges of electricity are required to finish the job. In one particularly grim case – an electrocution in Alabama in 1983 – three separate doses of 1,900 volts over a 14-minute period were required before a convicted murderer, John Louis Evans, was declared dead. To make matters even more gruesome, the electrode attached to his leg burnt through and had to be repaired before the next charge was administered. And when Evans was hit with this second jolt, smoke was seen bursting forth from his left temple and his leg.

Of course, ever since the state of New York first introduced electrocution as a legal means of taking life in 1888, advocates of capital punishment have always defended the use of the electric chair by stating that it is a far more humane form of execution than, say, hanging. Death by electrocution is supposed to be an instantaneous sizzle: 'Just like tossing a piece of steak onto a red hot grill' was how one seasoned Death Row observer described the process to me, stating that the condemned felt nothing after the initial explosion of electric current through his body. Recent medical evidence contradicts this 'quick char' theory. One well-known French electrical scientist conducted extensive research into the workings of the electric chair and reached the following terrible conclusions:

In every case of electrocution. . . death inevitably supervenes, but it may be [a] very long and, above all, excruciatingly painful [death]. . . The space of time before death supervenes varies according to the subject. Some have a greater physiological resistance than others. I do not believe that anyone killed by electrocution dies instantly, no matter how weak the subject may be. In certain cases, death will not have come about even though the point of contact of

the electrode with the body shows distinct burns. Thus, in particular cases, the condemned person may be alive and even conscious for several minutes without it being possible for a doctor to say whether the victim is dead or not. . . [This] method of execution is a form of torture.

If death by electrocution is true physical torture, then the wait for one's final appointment with 'Old Sparky' - a common nickname for the electric chair in many a state – is psychological barbarism *in extremis*. For a prisoner under sentence of death in the United States can usually expect to linger for at least five years on Death Row while his appeal against execution wends its way through the legal machinery of the courts. In many cases, however, the wait is far longer. Last year in Florida, for example, a convicted murderer named Willie Darden was put to death 14 years after his conviction, despite international calls for clemency. And several times during his 14-year stay on Death Row, Darden also had to cope with the mental nightmare of being temporarily reprieved from the electric chair only a few days before his scheduled execution. Almost every condemned prisoner faces at least two or three such last minute stays of execution during the entire appeal process. It is also not uncommon for an inmate to have gone through the anguished ritual of a last meal, a final visit with his family, and prayers with a chaplain. . . and *then* be granted an eleventh hour reprieve – which essentially means that, unless the courts or the state governor commutes his sentence, he will be put through the same appalling pre-execution ritual several months later.

Besides contending with this catalogue of horrors, a condemned convict must also cope with the desolate routine of life on Death Row – the fact that he is locked into a tiny cell for all but a handful of hours a day, is barred from any prison work, and essentially languishes while waiting for his life to be officially terminated. No wonder that there is such a high incidence of mental illness amongst prisoners under death sentence. No wonder that a Death Row is an emotional equivalent of a thermo-nuclear pressure cooker. No wonder that in such a dark netherworld of the damned, so many of its inmates turn to Christ for succour.

Except a man be born again, he cannot see the kingdom of God. To someone under sentence of death, the attractions of such a theological doctrine are obvious – especially since the ultimate

223

fringe benefit of being saved is eternal life in God's heavenly domain. After all, our lives are shaped by the knowledge that we will die. But at least most of us can take some minimal comfort in the idea that death is a nocturnal terrorist – we can't predict when he will decide to hijack us. A prisoner on Death Row, however, doesn't have the comfort of such innocence. He wakes up every morning knowing the exact date of his demise.

Wouldn't anyone – facing up to such calendrical certainty – reach for God? If you were forced to walk through the valley of the shadow of death, would you really fear no evil? Would His rod and His staff comfort you?

After three months of meandering through a variety of idio-syncratic Christian landscapes, I had yet to enter that most radical and outlying of all born-again territories: the realm of imminent death. The realm where the limits of faith are put to their most stringent test. And as my time in the southlands was ebbing away, it seemed only right that the last stop I made on this journey was the Ultimate Last Stop: a place where the notion of dwelling 'in the house of the Lord forever' might just give you the strength to remain sane and handle the drastic nature of your situation. A place where your status as a true pariah – so beyond the pale of acceptable human behaviour that you have been judged worthy of extinction – might make you seek a higher form of redemption in the eyes of a Supreme Being.

So – when a late-night telephone call from an Arkansas truckstop put me in touch with a man named Zack Leonard, and Leonard heard me out and said, 'OK' to my request – I did a massive geographic U-turn and headed back east. East to South Carolina. To the city of Columbia. To the state's Central Correctional Institution. To Death Row.

Zack Leonard was a Baptist clergyman who ran a prison ministry in South Carolina. He'd taken the cloth late in life, after retiring from a previous career in armed robbery: a career which had kept him in jail for over half of his 50 years. I'd heard about him from a lawyer I'd met in South Carolina earlier in the summer – a lawyer who was a very committed Baptist and did volunteer counselling work in a local penitentiary for a Christian fellowship group. And he said that if I wanted to understand the whole idea of Christian witness – of lives changing through a commitment to Christ – then I should meet Zack Leonard; the ex-con whom the state's former commissioner of prisons once called the meanest man he'd ever seen. That is, before Zack got

saved, and underwent something of a personal transformation.

Not only had Zack converted to Christianity during his final years inside; he'd also been ordained as a Southern Baptist minister as well. Now he travelled the state ministering to inmates in various South Carolina houses of correction. And every Tuesday afternoon, he paid a visit to Death Row: that no man's land of the forgotten, the accursed. It was without question, said the lawyer, the toughest beat of any prison ministry. 'If you're interested, you should give Zack a call – see if he'll take you along to The Row one Tuesday.'

I did just that, phoning Zack's home several times over the course of the next few weeks, but never finding him in, until – at that truckstop outside Little Rock, Arkansas – I finally managed to nab him. After I explained my interest in his Death Row ministry, he said, 'Sure you can come along, brother. Men on The Row always like to see a new visitor. Can you be here by Tuesday at noon?' It was Sunday evening and Columbia was 760 miles away. It was my last week in the States; I had no choice but to say yes. So, after a short night's kip I spent another manic seventeen hours behind the wheel before reaching Columbia in a jumbled, quasi-catatonic condition in the early hours of Tuesday morning, and collapsing into a motel bed.

I was still suffering from the after-effects of Interstate Overdose when I met Zack at twelve that day in a gasoline alley restaurant on the outskirts of Columbia called Applebee's. As I drove into the car park, a beat-up Nissan van pulled in beside me, and a tough little street-fighter of a guy jumped out of the cab. 'You the fella with the funny accent?' he said. I nodded and got out of my car. He stepped forward and gave me a big hug. 'Hey, brother. Glad you could make it.'

Zack Leonard was short – about five foot five – but built like a particularly menacing Pit Bull. His head was shaped like a big, battered cauliflower; his hair scalped down to a bristly crew cut. Surprisingly, his face retained a certain youthful edge to it – except for the fact that his nose was almost non-existent. It appeared to have been flattened, as the septum dividing the two nostrils was gone and there was a prodigious amount of scar tissue where his nasal cartilage should have been. Whatever happened to that nose didn't happen under anaesthetic.

No doubt about it: Zack Leonard came across as a potentially dangerous customer; the kind of 'Proceed With Caution' gent – with a gruff upcountry Carolina drawl – whom you wouldn't

want to push too far. And yet, I took to him immediately – perhaps because Zack himself was well aware of the bad-ass persona he gave off and worked very hard at attempting to soften this impression of walking malevolence. When we entered the restaurant, he steered me into a booth and – correctly sensing my unease about the afternoon ahead – told me:

'Now, when we go to The Row, you'll find the men pretty easy to talk to. And I want you to tell 'em about why you're travelling 'round the country and I want you to share with them your love of Christ.'

I had to explain, once again, that I wasn't a Christian. Zack's eyes opened wide.

'What you mean you're no Christian?' he said. It was as if I had admitted being a member of a rival gang, and I sensed danger. So I quickly explained that, though I personally hadn't committed my life to Christ, I did hold very much to the Unitarian notion of Jesus-as-teacher. And even if He wasn't *my* personal saviour, that didn't lessen my respect for Him and for those who followed Him. A moment passed before Zack decided to accept my point of view, though he did say, 'Had you told me you weren't born again a year ago, I might've tried ramming Christ down your throat.' Then he gave me a slight smile and said, 'I used to be one real bad dude. And I'll tell you something – you might feel anxious 'bout going in to visit The Row. You might feel real anxious about bein' inside a prison for a coupla hours. But I feel real anxious out here – in what's called the "normal world" – having to cope with 200 responsibilities a day.'

Then he told me that he'd spent a total of 27 years in 'the slammer' for a variety of offences: Armed robbery. Assault with a deadly weapon. Homicide. He'd been born in the mountains of North Carolina, the son of a building contractor and a school teacher – a middle class kid from a nominally Baptist family. He'd had a reasonably cordial relationship with his mother, but he could never understand why his father refused to show any affection towards him ('You know, I've never met anyone in prison who ever had a good relationship with their father'), and he began to mutiny against paternal authority as soon as possible. At the age of 16, he became involved in some petty breaking-and-entering scams. At the age of 17, he enlisted in the Marine Corps and – while on a weekend pass – robbed a supermarket of $3,800. That was his first armed 'job' and it had been easy. So he went AWOL a few weeks later and pulled

another supermarket hold-up in the South Carolina resort of Myrtle Beach. This time, though, the Military Police caught up with him and he did time in a Marine retraining centre in Virginia. He didn't stay in the centre for long, as he went AWOL again and, when caught, was dispatched to a psychiatric hospital, where he caused a riot one night while drunk and eventually forced the Marines to wash their hands of him by drumming him out of the Corps with a bad conduct discharge.

'I was determined that this bad conduct discharge wasn't gonna be a set-back, wasn't gonna hurt me,' Zack said, "cause I really wanted to go to college and was thinkin' about being a doctor.' Instead, he got a girlfriend pregnant and that ended the idea of college, as he needed money to support his newly-acquired family. So he started working for his beloved father as a brick-layer while pulling armed robberies in his spare time. 'Started off with supermarkets,' Zack said. 'Moved on to distribution offices for oil refineries. Then I got into doing banks.'

Zack discovered that he had a definite talent as a bandit, since he spent four happy balaclava'd years without getting caught. But his luck finally ran out during a bank job in Asheville, North Carolina and he pulled a hefty 20-year sentence for his efforts. Sent to a federal penitentiary in Lewisburg, Pennsylvania, Zack's third day there was particularly memorable, as he killed a man who propositioned him.

'Was a guy from upstate New York,' Zack said. 'Real tough guy who told me I was pretty and that he wanted me as his boyfriend. And he ordered me to meet him up in the showers in 15 minutes, ready to fuck or fight.'

Zack chose the latter option and beat him to death – quickly garnering a concurrent 20-year sentence for that crime. He was also transferred out of Lewisburg to another federal pen in Atlanta. Then he was bounced over to Leavenworth. Then to Alcatraz, where he was certified a psychopath. After this peripatetic career in America's leading maximum security prisons, he was shipped to a mental institution in Springfield, Missouri, where he served a three-year stretch – 14 months of which were spent in solitary confinement.

'Springfield was the worst institution I was ever in. They gave me forced electric shock treatments. Tried to make me take medicine that woulda turned me into a zombie. It was like being in the shithole of the world.'

Somehow Zack got through his period at Springfield, and halfway through his 20-year sentence for robbery and murder he was miraculously paroled. Once out of the joint, he was determined to start anew. He remarried (his first wife having divorced him during his spell inside); he enrolled in college back in South Carolina. But old habits die hard, and three months after his release, he brought his woolly face mask and his Saturday Night Special out of mothballs and was caught stalking a finance company on the outskirts of Greenville. Only this time Zack also shot a man during the attempted hold-up.

'Shot him just above the heart,' Zack said. 'Meant to kill him. Didn't.'

Zack drew two 15-year sentences for these transgressions and served five-and-a-half of them before making parole for a second time. Again, he promised the authorities that a fresh start was in the offing. Again – after a short spell in the masonry business – he was back in the armed robbery business. Again, he got nabbed. Now the sentence was 18 years, and it looked like any chance of further parole was strictly out of the question. Especially since, during his first year back in prison he found himself in solitary confinement for two lengthy stays: the first for fighting and carrying a knife; the second for getting into another fight with a dude who matched Zack in the ferocity stakes, and bit Zack's nose off during the brawl.

After being rushed to the prison hospital for emergency reconstructive surgery, Zack was brought back to solitary and found two books left on his bed by a member of a Christian prison ministry; a man whom Zack had tried to punch when he'd attempted to speak to him the previous week. One of the books was the Bible, the other, an autobiographical testament by a well-known hood named Nicky Cruz, who went from being a street gang heavy to a fully-fledged member of the God Squad. And Zack found himself 'hooked' by Nicky Cruz's story, relating to it in a way which he had never related to anything before.

'Don't know why it was that that one specific book started changing things around for me. Don't know why that day turned out to be the crucial point when I suddenly allowed myself to be real vulnerable for the first time in my life. All I know is, as I read that book, I started thinking about my own irresponsibility. How I was always running from the responsibility of love. Here I was, 43 years old, and my life was flashing before me. And when I thought back to that Christian volunteer who I'd tried

to punch, that's when I realized what he was trying to do: he wanted to show me the love of God. And when I understood that, I got down on my knees. Pleaded for forgiveness. Asked Christ to change my life. And all of a sudden, I had somethin' I never had before: peace.

'I started crying then. Couldn't quit for three, four days. At first, I was ashamed. Ashamed of everything I'd done. Then, when I was finally let out of solitary, I found myself relating to the other prisoners for the first time ever. Scared the hell out of me, because it was a totally new emotion for me, and one which I knew was going to cost me my pride and my reputation as a terrible fighter, a bad guy. But, still, it happened.'

Over the next two years, Zack gradually convinced the authorities that he was a reformed man. And when he was accepted as a student at a local theological seminary, they allowed him to attend classes on a day-release basis. Two years after finishing his course of study, he was granted a final parole. That was 1984. Upon his release, he was ordained a Baptist minister and spent some time as an assistant pastor at a local church until a prison chaplain and a Columbia attorney convinced him to start up a ministry that would send him back into the state's penitentiaries to work in the environment he knew and understood best. Ministering to the men on Death Row had been one of his principal preoccupations since then.

Zack finished his story as lunch arrived. And reaching for my hand, this convicted murderer – a man once certified a psychopath, once deemed the nastiest convict in the state of South Carolina – asked me to join him in thanking God for this food and for the fellowship between us.

As we ate, I asked him if he could fill me in on the backgrounds of some of the men we were about to meet on The Row. Zack said that he tried to learn as little as possible about their personal histories, because he wasn't interested in the frequently atrocious nature of their crimes. 'I don't want to know about what they've done; I just want to take care of 'em. To show 'em that the love of Christ can help 'em get through all this.'

The South Carolina Death Row was, he said, sparsely populated by American standards: at present, there were 44 men incarcerated there, whereas Florida and Georgia had nearly four times as many guests on each of their respective Rows. And, unlike those two states, the South Carolina judicial authorities weren't exactly voltage happy when it came to executing convicts.

In fact, it had been well over two and a half years since anyone had taken that final walk to the death house – and though the population of The Row kept increasing, its growth was counter-balanced by the 23 condemned men who'd had their sentences commuted to Life Imprisonment over the last few years.

'What nobody seems to understand – especially those folks who keep screaming for more electrocutions – is that, when we execute a person, we reinforce our own failure as a society to deal with that person and his problems. And we also reinforce the biggest sin in our legal system: the fact that, if you commit a murder and can afford a good lawyer, you'll probably avoid a death sentence. 'Cause just about everybody on Death Row comes from a poor or working class background, hasn't got much education and was probably defended by a court-appointed lawyer who didn't give two shits about his case. Take it from me: you don't meet no middle class murderers on Death Row.'

We finished our lunch and set off down the highway in Zack's Nissan van. Five miles later, there it was: the CCI – the Central Correctional Institution. The Joint. The Slammer. The Big House. A group of low squat elderly brick buildings which could have fooled you into believing that they were a large outmoded Victorian factory. Except, of course, no Victorian factory ever possessed wire fencing, armed guards, electric gates.

We drove up to the main gate. It slid to one side to allow our vehicle through, then slammed shut again. We were now boxed in by another closed electric gate directly in front of us. The Checkpoint Charlie look. Zack stuck his head out of the cab and said, 'Howdy, brother' to the guard in the sentry post.

'Can't come in this way today, Zack,' the guard said. 'This area's off-limits 'cause of some big inspection goin' on. You got to go 'round t'the other parking lot.'

Zack shrugged his shoulders and, as the rear gate slid open again, he backed up and drove us along a ring road to the alternative car park.

'Way I used to be,' Zack said, 'if that guard had told me I couldn't come in that gate, I would've allowed myself to get pissed off. Real pissed off. 'Cause I was always looking for something to get me angry. Real angry.'

We pulled into the second prison car-park. It was located on one side of a highway and was connected to the main grounds of the penitentiary by an overhead walkway. Half-way across this enclosed ramp was a security checkpoint.

'Yo, Zack,' said the guard on duty.

'Hey, buddy,' Zack said.

Zack Leonard was evidently a well-known visitor to the Central Correctional Institution. The guard signed us in and asked me for some form of identification. I handed over my US passport. The guard looked bemused.

'What's this?' he said.

'That's my passport,' I said.

'I don't want no passport from you,' the guard said. 'I want some *eye-dee*.'

'But a passport is an identification document,' I said.

'Not here it ain't. I want some real *eye-dee* – like your driver's licence.'

'I left it in the car,' I said, and then pointed out that, since my passport was issued by the State Department in Washington, it was about as official a piece of *eye-dee* as an American could possess.

'Well, that may be,' the guard said, 'but I ain't seen one of these before, so that's why I'm kinda suspicious. But since you're here with Zack, I'm gonna accept it. But the next time you come here, you bring some real *eye-dee*, y'hear?'

If I needed a reminder of the fact that only around 10 per cent of my compatriots bother to own passports, this was it. Insularity ruled supreme in more ways than one at the South Carolina CCI.

Once past the checkpoint, we crossed into an open concrete area fronted by a baseball field and an extended perimeter fence. Just beyond the fence – overlooking the prison grounds – was an office block for the Southern Bell telephone company. In this penitentiary, the outside world loomed large.

The front entrance to the prison was sealed off by a heavy set of reinforced steel bars, painted an institutional green. Next to them was a sign:

> *Visitors Consent to be Searched:*
> *By Passing This Point,*
> *You are Deemed to Have Consented to a*
> *Search.*

An electric motor hummed as the bars heaved open. We crossed the threshold; we were in.

'Yo, Zack,' said the woman guard on duty.

231

'Yo, beautiful', Zack said.

'Beautiful' weighed around 280 pounds and packed a hefty service revolver on her hip. She too didn't like the idea of my passport *eye-dee*, but Zack stepped in to smooth things over. As they bantered, a group of prisoners were being escorted out of the prison under tight guard. There were a dozen of them standing in single file, each with handcuffs binding their wrists, from which extended a metal leash that was bound around their waists, in order to prevent any drastic movement of their arms. They looked like a contemporary chain gang.

'Yo, Zack,' shouted another guard. 'You goin' on in today?'

'That's right, brother,' Zack said and he led me through an airport-style metal detector. Once we cleared that hurdle, we had to wait while another set of metal bars were mechanically yanked to one side, and then we formally entered the world of the incarcerated; the socially impounded.

It was a world of dark, ill-lit corridors, thronged with prisoners – all of whom wore denim trousers (the only official prison uniform, and the reason why Zack told me in advance of my visit not to come dressed in jeans). In this section of the prison, Zack explained, free-association was allowed, which is why this dingy labyrinth of passageways was so crowded with inmates, many of whom shouted greetings at Zack as we passed by.

'You're quite a celebrity around here,' I said to Zack.

'That's because I did time in this joint.'

We stopped by a solid metal door; an inconspicuous door fitted with a small peep-hole and a bell by its frame. Zack rang the bell, an eye appeared at the peep-hole, the door opened, an alarmingly corpulent black guard blocked our path. This was the entrance to Unit CB2 – Death Row.

'Hey, brother', Zack said. The guard gave him a quick nod, but exchanged no greeting. Only: *'Right, spread 'em.'* Zack raised his arms above his head and shuffled his legs apart while the guard conducted a very thorough frisk of his body. Then it was my turn to 'spread 'em', as I too was searched for concealed contraband. In the very near distance, I could hear the sound of showers in use; a sound which corresponded with a pervading locker room smell in the air – that moist, acrid aroma of sweat and damp socks. As soon as the guard had finished frisking us and let us through, I saw that we were actually standing next to a set of shower cubicles. Only these shower cubicles were unlike any other shower cubicles I had ever seen before, as they each

were fitted with a barred door that was padlocked shut while a prisoner washed himself down.

The showers were located in a dark, low-ceilinged area. Only a few steps away from these cubicles the ceiling vanished and I found myself standing in a vast, high-vaulted enclosure of cages and wire meshing and steel walkways. The roof was now around 80 feet above me, turning this area into the ultimate echo chamber. The slamming of barred doors, the cascade of showers, the clamorous din of voices – all of these competing noises were magnified to the power of ten and ricocheted off the chipped masonry, making the soundtrack of Death Row one of ceaseless babble. But if the sheer sonic volume of the place was disorientating, then so too was the light. For this was a place of harsh fluorescent tubes and naked bulbs; a place starved of any real glimpse of the sun. A few sloped panes of glass in the roof were the only windows for the entire cell block, through which shafts of light bounced off the bars and the mesh grilles, casting Death Row in an abstract, almost spectral glow.

Three tiers of cells were stacked up along the right-hand wall of the block. A cell was a tiny 10 feet by 5 feet rectangle, fitted out with a narrow bunk bed, a flush toilet, a hand basin, a simple table and chair. Except for a two-hour exercise period three times a week, a shower every other day, and the Tuesday afternoon chapel service with Zack, an inmate spent all his other time locked into this closet-like room with no view. Some of the men had televisions – bought by Zack in local pawnshops whenever someone gave his ministry a donation towards helping the men on The Row. Some of the men had electric fans – an absolute necessity in an antiquated prison where the heat of a Carolina summer was overpowering. Some had attempted to decorate their cells with calendars, *Playboy* fold-outs, drawings they had made themselves to pass the time in this realm of enforced idleness. Others had simply left them stark and bare and dungeon-like.

And since this was a maximum security wing of the prison, one set of bars wasn't deemed enough to keep the condemned caged in. For three feet beyond the doors of the cells was another wire fence, which meant that any visitors to The Row found themselves talking to a resident through two sets of barriers.

'Yo, Zack!' one guy shouted.

'Yo, Pete,' Zack shouted back. 'Meet my buddy here, Doug.'

Pete was a middle-aged man with a bookkeeperish demeanour: thick horn-rimmed glasses, a wispy moustache, thin, stringy hair.

His cell even had a bookkeeperish ambiance to it, as it was set up like a small office, with a large plank of wood acting as a desk, and a lamp illuminating the work area where Pete (not his real name – as Zack asked me to disguise the identity of anyone I met on The Row) was busy designing a new set of postcards.

'What you workin' on today, Pete?' Zack asked.

Pete held up a drawing of a green dinosaur. 'This is from my new line of cards,' he said.

'Pete's quite the artist,' Zack said. 'Draws these cards, sends 'em to friends all 'round the country.' Pete – I discovered later – was also the worst mass murderer in recent South Carolina history, having killed 12 people before the authorities finally nabbed him.

'Yo, Zack!' shouted another inmate.

Zack moved down the line to another. 'Yo, Charlie, you all right, brother?'

'Had my appeal hearing last week,' Charlie said.

'And?' Zack said.

'No news is good news,' Charlie said quietly.

'Yo, Zack!'

'Hey, Phil – you lookin' OK, my man.'

'Give us a dollar, Zack. Need to buy a new pen.'

Zack dug a dollar bill out of his pocket and punched it through the wire meshing. 'Thanks, my man,' Phil said. 'I owe you one.'

At the end of the first tier of cells was a heavy steel door with a sign on it: *God Loves Us*. Inside was a small box of a room with a seven-foot high ceiling. A couple of rough wooden benches were set against the walls and in one corner was a barred cell, now filled with broken-down furniture.

'I used to be kept in here,' Zack said, 'when Death Row was located on the other side of the prison, and this place was used for solitary confinement. Funny, ain't it? Solitary confinement's now been turned into a chapel.'

Outside the door a guard shouted, 'Who's for chapel?' and the room started filling up with men. The first guy through the door was named Neil – around 30, rail thin, wearing an American Indian headband, carrying a notebook.

'You a writer?' Neil said after Zack introduced us. 'I'm a writer too. Writing a book about my life. About the way my case was twisted against me. Writing's a real bitch, right?'

'Right,' I said.

234

'You know about my case?' Neil said. I shook my head. 'I've been here since '79. I wasn't accused of a killing, though – but of being an accessory to a killing, which down here is the same thing. I was 200 feet away when the actual killing took place – when this woman hitchhiker my cousin and girlfriend and I picked up got stabbed. Wasn't me who did the killing. Was my cousin. He's here too. 'Course my girlfriend got off, even though she was involved in the killing as well. Prosecutor gave her immunity from justice if she'd testify against us. Which, of course, the bitch did.

'Been on The Row now for ten years. Had a retrial and a bunch of appeal hearings, but lost all those. I've been sentenced to death three times now. And you know what really gets me: the state's probably spent millions of dollars trying to get me into the electric chair. But, instead of trying to kill me, why didn't they put all that money towards trying to educate me in here? Like I finished my high school diploma here on The Row, and I now want to work towards a college degree, but the state won't allow anyone on The Row to study for anything higher than High School. 'Cause – the way they see it – why should they educate some dude they're gonna kill?

'Right now, my attorney's trying to get me off on a mental charge. My last hope, except for clemency from the Governor. I've had the hearing. Looking pretty good is what I hear. Got to pray. That's all I can do. Pray.'

Everyone on Death Row had a story – a story which they had to live with; a story which they constantly replayed in their minds day-in, day-out. And if you were an emissary from 'normal life', the inmates generally wanted to tell you that story, because by crossing into their world for a few hours you were judged to be someone who didn't look upon them as homicidal vermin, but as men in an impossible situation with a story to tell. Men whose lives had been reduced to that story, and whose futures ultimately depended on how the courts interpreted that story. Because that story was all they had left.

So, as the room kept filling up with men, I found myself talking with Eric – a quiet, irrevocably sad looking guy with a salt-and-pepper beard and a voice so calm, so subdued I almost had to strain to hear him tell me, in a matter of fact way, that, four years ago, he went crazy one night and killed his estranged wife and her father and buried their bodies in some nearby woods – but that he didn't remember committing the murders at

the time. And I also met Leo, who'd been born and raised in a mental institution – the by-product of the rape of his mother by her father – and who killed his grandmother shortly after being kicked out of the institution at the age of 19. And I also met Marvin who, up until two years ago, couldn't read, and whom the courts had once labelled mentally subnormal. And the chapel kept filling up and soon I was sitting amongst 30 or so convicted murderers in a former solitary confinement cell where the heat was over 100 degrees F, and where the pastor in charge had once beaten a man to death who'd tried to rape him.

Notebook-style hymnals were passed around and Zack got Leo to lead the group in a hymn of his own choosing. He picked a famous old spiritual, *Swing Lo, Sweet Chariot*. We all sang loudly, though everyone got rather quiet when we reached a verse that went:

> *If you get to heaven before I do*
> *Comin' for to carry me home*
> *Tell all my friends I'm-a-comin' too*
> *Comin' for to carry me home. . .*
> *Sometimes I'm up, sometimes I'm down*
> *Comin' for to carry me home,*
> *But still my soul feels heaven-bound*
> *Comin' for to carry me home.*

To hear a group of condemned men sing those lyrics was to be rendered inarticulate. Then again, this was a religious service that walked an emotional knife-edge. And Zack ran it almost like a spiritual group therapy session; he tried to get the men to directly address the bleakness of their circumstances, to speak openly about their fears, their anguish. Zack raised the case of one of their number named Jerry, who'd just had his sentence commuted to 30 years life imprisonment. What did the group think of that? 'Anyone feel anxiety or anger or jealousy because a man got off?' Marvin raised his hand and said that he thought God might have gotten Jerry off The Row to test his faith – 'Like I rejoice to see a brother get off, but I wish it was me.'

'You all got to rejoice for what God's doing for other people's lives,' Zack said. Then Eric raised his hand and said that he found a passage in the Book of Luke which he wanted to read out to everyone, because he thought it was relevant to all their situations:

And, behold, a certain lawyer stood up, and tempted him, saying, Master, what shall I do to inherit eternal life?

He said unto him, What is written in the law? How readest thou?

And he answering said, Thou shall love the Lord thy God with all thy heart, and with all thy soul, and with all thy strength, and with all thy mind; and thy neighbour as thyself.

And He said unto him, Thou hast answered right; this do, and thou shalt live.

Thou shalt live. Everyone in the chapel hung on to that phrase for a moment before Zack offered up a prayer:

'Father, we thank you for this time together. Father, we get anxious and we get frightened. Father, help us to minister to each other. Because we feel your presence in this place. We feel your mighty power and your grace.'

Was God here? Had He made a special appearance on behalf of the inmates in Unit CB2 of the Central Correctional Institution, Columbia, South Carolina? I looked around the congregation: men in old T-shirts and beat-up denims and tattered gym shorts; men sweating in the heat; men with sunken eyes and tattoos and the occasional facial scar; men who had committed – or had been an accessory to – the ultimate crime. Did these men transform themselves into a bunch of pious choir boys when faced with the supposed presence of God? Absolutely not. If anything, there was a definite lack of awe in this makeshift house of worship. But what was present in this former dungeon was a sense of mutual care; of shared compassion. For Death Row was a true voyage of the damned. Yet what Zack had done was to make these forsaken and despised men realize that the only way to cope with the terrors of their journey ahead was by banding together to keep each other afloat. And he had done so by showing them that God's love for them was unconditional and forgiving.

Don't we all seek love? And yet, doesn't human love so frequently disappoint? Don't we all seek a modicum of happiness and constantly fail to find it? In this most overwhelming of centuries, aren't we all scrambling for some sort of placebo, some sort of faith to get us through the day? To help us slouch toward Bethlehem? And when one has failed to find a sense of self in the material world – and in the emotional minefields of human relationships – mightn't one then consider projecting

237

one's needs upon the sky? Upon a Supreme Being who rewards belief in Him with a love that is unconditional?

In short, isn't all born-again Christianity tied up with a search for love? And in a society so helplessly involved in the frantic pursuit of happiness, mightn't the final option in that hunt be the uncomplicated, limitless love of God? If all else fails you, isn't He the true end of the line?

Here – in that extremity called Death Row – there was no doubt that the idea of godly love was crucial for the sanity of the condemned, the doomed. But in the world beyond this shadowland, don't many feel doomed? Don't many believe they're on Death Row too?

<p style="text-align:center">****</p>

The highway was dark; the highway was empty. It was five in the morning and I was moving south. Hours earlier, I had said goodbye to Zack in Columbia and headed off down the road in search of a motel. But a few miles out of town, the urge to keep moving – to drive straight across the night – caught up with me, and I put the pedal to the metal for one final sprint into the geographic equivalent of infinity.

At first light, I crossed the state line into Florida. Up ahead, a small orange smudge defined the horizon. Dawn – the most contrary time of day. At dawn, you can choose to see promise or despair in the day ahead. At dawn, you can be converted to an idea or put to death for it. At dawn, you cannot afford to be neutral about things.

I had been driving for hours in silence. Now I needed company. So I turned the radio on and heard a voice I had come to know over the past three months. The voice of a preacher – any preacher – greeting the beginning of another day in the New World. A voice which asked:

Have you been slain in the spirit?

My journey was ending where it had begun. It was time to catch a plane back to an older world.

Acknowledgements

A few thank you's are in order.

Several companies were extremely helpful when it came to assisting in transportation arrangements for the journey. They include: Avis Rent-A-Car Inc; Aer Lingus; TWA; Virgin Atlantic; and Continental Airlines.

For hospitality above and beyond the call of normal civility, I would like to thank: Margaret and Alex Bass, Happy and Laura Lee, John and Carol Davis, Margee and Harold Bright, Duke and Brenda Jackson, Clyde Broadway, Clive Rainey, Tess Irwin, David and Vicki Hurewitz, and assorted Ropers in Memphis.

The following books proved to be invaluable sources of background information: *Religions of America* by Leo Rosten (Simon and Schuster, New York, 1975); *The Oxford History of the American People* by Samuel Morrison (Oxford University Press, New York, 1965); *Everyday Life in Colonial America* by Louis B. Wright (G. P. Putnam, New York, 1965); *Heavens on Earth* by Mark Holloway (Dover Publications, New York, 1966); *Holy Terror* by Flo Conway and Jim Siegelman (Delta, New York, 1984); *Builder of Bridges* by R. K. Johnson (Bob Jones University Press, Greenville, 1982); *The Provoker* by Tricia Weeks (K-Dimension Publishers, Atlanta, 1986); *20/20 Vision* by Earl Paulk (Kingdom Publishers, Atlanta, 1988); and Amnesty International's *USA Death Penalty Report, 1987* (special thanks to Stephanie Koorey in Amnesty's press office for all her assistance). Acknowledgement is also made to Word Music (UK), a division of Word UK Limited, for permission to reproduce the lyrics from 'Rock Solid' and 'I've Been Delivered'.

239

While on the road in the South, and during the course of my extended sojourn at my desk, I also wrote about aspects of my journey for a variety of newspapers and magazines. Hats off, therefore, to the following publications and editors: Peter Fiddick, Susan Jeffreys and James Saynor at *The Listener*; Will Ellsworth-Jones at *The Sunday Times*; Frankie McGowan and Suzanne Askham at *New Woman*; Liam McAuley at *The Irish Times*.

Three people kept me buoyed while this book was being written. My brother Roger provided extensive amounts of Budweiser and sympathy. My wife Grace was, as always, one very tough, very good critic, not to mention exceedingly tolerant of the quasi-obsessional side effects of book writing. And my agent Tony Peake was, quite simply, a great friend.

At Unwin Hyman, I owe several stiff drinks to Helen Wythers and Alison Black. And finally, I would like to acknowledge the fact that this book owes its existence to Merlin Unwin who – besides being a remarkably supportive and shrewd editor – is also that rare thing: a true gentleman.

D. K.